W9-ADM-977

DISCARDED

843.009
B64i

133453

DATE DUE			

The Impact
of Art
on French Literature

The Impact
of Art
on French Literature

From de Scudéry to Proust

Helen Osterman Borowitz

CARL A. RUDISILL LIBRARY
LENOIR RHYNE COLLEGE

Newark: University of Delaware Press
London and Toronto: Associated University Presses

© 1985 by Associated University Presses, Inc.

Associated University Presses
440 Forsgate Drive
Cranbury, NJ 08512

Associated University Presses
25 Sicilian Avenue
London WC1A 2QH, England

Associated University Presses
2133 Royal Windsor Drive
Unit 1
Mississauga, Ontario
Canada L5J 1K5

843.009
B64i
133453
Sept. 1985

Library of Congress Cataloging in Publication Data

Borowitz, Helen Osterman, 1929–
 The impact of art on French literature.

 Bibliography: p.
 Includes index.
 1. French fiction—History and criticism. 2. Art
in literature. 3. Artists in literature. 4. Art
and literature—France. 5. Art criticism—France—
History—6. Romanticism—France. I. Title.
PQ637.A77B67 1984 843'.009'357 83-40317
ISBN 0-87413-249-5

Printed in the United States of America

In memory of my parents
For my children
And for Albert who introduced me to Henri de Latouche

Contents

Foreword

Interrelationships between the visual arts and literature have long been the subject of considerable interest and investigation on the part of writers and art historians. Yet few have tried to reveal fully how literature was deeply affected by the visual arts in technique, attitude, *mise en scène,* and philosophy. This lacuna has been squarely addressed and carefully examined by Helen Borowitz in *The Impact of Art on French Literature: from de Scudéry to Proust.*

To illuminate the interplay between the arts the author has chosen both well-known and little-studied episodes to lend the proper focus to her narrative. Neglected art critics such as Henri de Latouche are paired with famous writers including Balzac, Mme. de Staël, and Marcel Proust to develop a subtle web in which the historical precedents for certain ideas are revealed and then recast in later guises. This process of literary relationships provides clues to the way in which some writers worked on their own manuscripts, revealing a procedure that is akin to the methods by which some painters created their own compositions from earlier sources.

At the heart of this volume, however, is the overriding theme that there was a certain unity to all of the arts, that a synaesthetic experience dominated painters and writers—often with the art critic acting as an intermediary—from the late seventeenth century through to the end of the nineteenth century. Writers did not work in a vacuum as they selected ideas, portraits of individuals, and environments from the art work around them. They also infused their social gatherings with a sparkle and incandescence that demonstrated that the arts were alive with possibilities of stimulating interchange. The author demonstrates that the private salons, the meeting rooms of editors of leading journals, public expositions of a given period or the studios of various artists became the arenas where the world of art experienced an exchange of ideas that affected how works in both literature and painting were created and perceived. It has been no small achievement for the author to show how the worlds of the "sister arts" meshed: a lasting picture has

been created of the aesthetic dialogue of artists and writers and the powerful influences they underwent through wide reading in contemporary art criticism, their passion for the newest literature and plays, and direct encounters with seminal works of art.

Throughout the volume another thread also appears. Borowitz has correctly seen that writers and certain painters were seeing art in a special way, as a domain for the creation of a highly aristocratic sensibility. Writers were raising their sights to the highest plateaus, and those readers who followed de Scudéry, Balzac, or Proust were able to develop an intellectual awareness that went far beyond the tastes of the everyday. Art was seen as existing above the mundane, in a rarefied climate where genius created a personal vision that reflected the thinking of a cultivated, sensitive intelligentsia. In a sense, the author has selected her heroes since they were poet-leaders whose innate romanticism exerted a lasting impact on the literary worlds of their time and ours.

In reality, this volume must be seen as a long-needed study that goes far toward examining how literature was deeply in debt to the visual creator. At the same time, Borowitz sees art criticism not only as a creative expression of the taste of an era but as an essential resource that writers tapped as a basis for redefining their philosophies and reshaping their works. As a volume rich in allusions to literature and the visual arts it goes far toward convincing us of the crucial importance of interdisciplinary studies for art historians, literary historians, and museum curators. For those eager to see art as a basis for the history of ideas, and literature as one way of developing a more cultivated understanding of these ideas, *The Impact of Art on French Literature: from de Scudéry to Proust* will prove to be a vital pioneering study.

Gabriel P. Weisberg
Assistant Director, Division of General
Programs, National Endowment for the
Humanities

Acknowledgments

I wish to thank the museums, galleries, private collectors, photographers, and photographic institutions that have provided photographic material and permitted its reproduction: Bibliothèque Nationale; Documentation photographique de la Réunion des musées nationaux; Musée des Beaux-Arts, Strasbourg; Musée d'art et d'histoire, Genève; Musée des Beaux-Arts, Lille; Musée des Beaux-Arts, Bordeaux; Calouste Gulbenkian Foundation Museum, Lisbon; Cini Foundation, Venice; Deutsches Archaeologisches Institut, Rome; Wallraf-Richartz Museum, Cologne; The Fogg Art Museum, Harvard University; The Art Institute of Chicago; and The Cleveland Museum of Art.

I am also indebted to the many libraries that have provided research material for the book: The Newberry Library, Chicago; The Library of Congress; The University of North Carolina Library; Ohio State University Libraries; Harvard University Library; Case Western Reserve University Freiberger Library; The New York Public Library; The Cleveland Public Library. I particularly appreciate the help I have received from the staff of The Cleveland Museum of Art Library, especially from Georgina Gy. Toth whose doggedness in tracking down difficult-to-find interlibrary loans was essential to my research.

Portions of some of the chapters of this book appeared, in somewhat different form, in the following journals: *Gazette des Beaux-Arts, Criticism, Art Journal, Nineteenth-Century French Studies, Romanic Review*, and The Cleveland Museum of Art *Bulletin*. I would like to thank the editors of these journals for their interest in my work.

Finally I wish to acknowledge the encouragement and patience shown by my husband who has acted as a sounding board for my ideas and has reviewed the manuscript.

The Impact
of Art
on French Literature

1

Art in French Literature from de Scudéry to Proust

There is a strong paradox in the attachment of the French Romantic writers of the nineteenth century to the Classical concept that poetry and painting are "sister arts." The Classical idea, expressed in Horace's phrase *Ut pictura poesis* ("as in poetry so in painting") stipulated that both arts, though differing in means, had the same goal—to instruct, as well as delight, through the depiction of noble deeds. This concept, revived during the Renaissance, had a strong impact on French poets and artists in the sixteenth and seventeenth centuries. Paintings were criticized according to the nobility of their subject matter and their adherence to the rules of decorum, and little leeway was allowed for the artist's personal expression. By the eighteenth century the idea of the sister arts was interpreted more loosely, but even then the highest compliment that could be paid to a painter was to call him a poet. Thus the painter Antoine Coypel, in a discourse to the French Academy in 1720, stated: "The painter in the grand manner must be a poet . . . not only must he be filled with the same spirit that animates poetry, but he must of necessity know its rules, which are the same as those of painting."[1]

Considering the close association between the concept of *Ut pictura poesis* and Classicism, it is surprising that the French Romantics, though turning their backs on the Classical tradition, still supported the idea of the close relationship between literature and art. In his article on Eugène Devéria, Gautier pointed out this paradox: "Although the precept *Ut pictura poesis* was classical, the new school adopted it, and there is no doubt that every man profited by being familiar with both these forms of art."[2]

Diderot's writings on art and literature appeared very timely to the Romantics who rediscovered his reviews of the state-sponsored Salons

when they were published early in the nineteenth century. During Diderot's lifetime they were available only to the collectors, aristocrats, and intellectuals who subscribed to Friedrich-Melchior Grimm's *La Correspondance littéraire*. Among these subscribers was Mme de Staël's mother, Mme. Necker, who sometimes helped Diderot with the text of his Salon reviews. She credited his genius with animating paintings that had previously appeared as merely "flat colors" to her untutored eye.[3] Members of the broader audience who were to read his *Salons* after publication were impressed with the eighteenth-century critic's understanding of problems that still confronted nineteenth-century artists and writers. *L'Artiste*, the art and literary periodical to which many of the Romantics contributed, began, in its founding year of 1831, to publish fragments from Diderot's *Salons*. In a note to the readers the editor stated that Diderot, "in enriching the ideas of his century, moved into the terrain of questions agitating our times."[4] In their emphasis on the artist's creative imagination Diderot's *Salons* reflected the eighteenth-century trend away from adherence to Classical rules and toward interest in the artist's vision. His interpretation of relations between artists and writers not only took into account the analogies between the arts but also pointed out the differences, thereby freeing the painters and poets from slavish adherence to the Classical doctrine of the sister arts. His writings transmitted the concept of the unity of the arts in a more flexible mode that was palatable to the emerging Romantics.

To Diderot the sister arts enriched each other. He saw a continual borrowing and lending of ideas between artists and writers. "One recognizes poets in painters and painters in poets. The sight of paintings of the great masters is as useful to an author as the reading of great books is to an artist."[5] His view of the interrelations between art and literature looked forward to the nineteenth-century Romantic concept of a dialogue between artist and writer, a kind of *camaraderie*. The caricaturist and writer Henry Monnier described one aspect of this mutual dependence when he said: "How many times do writers call to the rescue those painters whose style and manner correspond to the scene which they want to describe."[6] Gautier put it more broadly when he recalled in his *History of Romanticism:*

> This interpenetration of poetry by art was and is still one of the characteristic traits of the new school, and explains why its first adherents were recruited from the ranks of the artists rather than those of the men of letters. Innumerable objects, images, and comparisons believed inexpressible in words, entered into our language and have remained in it. The scope of literature was enlarged, and now within its mighty compass it embraces the whole sphere of art.[7]

My book traces certain strands in the development of this intimate interplay between French art and literature (fiction and criticism), from the seventeenth century to modern times, with emphasis on *préciosité*, Neo-Classicism, Romanticism, and Symbolism. In many different eras and settings these chapters demonstrate the reciprocal effects of encounters between the visual and the literary arts. On the one hand, we can observe the literary imagination working and revising concepts of the artist's function and his relationship with his work. On the other side of the ledger, we can note the manifold influences of specific works of art and of art criticism on fiction and on the novelist's world view.

Before beginning a study of the interrelations between art and literature in France, the chief points of contact between artist and writer must be ascertained. During the period under consideration, these meetings occurred principally at the private salon; the world of art criticism encompassing both the official art Salon and the editorial offices of the journals that reviewed it; the studio of the artists and other gathering places such as the café and the *cénacles;* and last, the commercial world of art dealers and publishers.

The literary salon dates back to the mid-seventeenth century when this regular assembly, held in a private house, was instituted by *précieuse* hostesses like Mme. de Rambouillet and Mlle. de Scudéry. Both of Italian descent, these hostesses transmitted Renaissance humanistic values to Parisian society. Mme. de Rambouillet entertained both the aristocracy and the intelligentsia in her blue chamber where she set a new style not only in conversation but in interior design as well. Many of the writers who frequented her salon commissioned artists to illustrate their works, and an example of the interpenetration of art and literature produced by the salon was the little booklet *The Garland of Julie,* which consisted of poems about flowers, written by members of the salon and illustrated by one of their favorite painters, Nicolas Robert. Similarly the salon of Mlle. de Scudéry, her famous "Saturdays," brought together many literary people whose favorite topic, the rules of courtship decorum, was transposed visually into the map of loveland, the famous *Carte de Tendre.* This map, devised as a salon game, appeared later in Mlle. de Scudéry's novel *Clélie* ⸱ an illustration that translated *précieuse* ideals of courtship from words into an image.

Although the art and literary salons were initiated in the seventeenth century, during the eighteenth century they began to flourish in the homes of Mme. Goeffrin, Mme. du Deffand, Mlle. Lespinasse, and Mme. Necker, to name a few. Mme. Necker's salon, fashioned on those of the *précieuses,* served as a center for Enlightenment thinkers as well as a literary training ground for her daughter, Germaine, later to become the important author of Romantic criticism and fiction, Mme. de Staël.

Mme. de Staël's salon in Coppet, Switzerland, which drew intellectuals from all over Europe, was dominated by discussions of politics, although the hostess herself expounded many of the new German Romantic ideas on art and literature that would later appear in her writings.

The Parisian salons continued in the nineteenth century to attract both artists and writers. Delécluze's "Sundays" or Viollet-le-Duc's "Fridays" gathered together Stendhal, Balzac, Delacroix, and Henri de Latouche. Latouche dazzled the salons with his witty conversation to the distress of Balzac whose words flowed more easily on paper. Another favorite meeting place for the Romantics was the salon of Charles Nodier at the Arsenal Library. There ladies were invited, and conversation was interspersed with both recitations and dancing. Nodier, who had studied painting in Jacques-Louis David's studio before he turned to letters, brought together members of both the literary and artistic worlds, including the artists Isabey, Delaroche, David d'Angers, and Delacroix, as well as his friends, Balzac and Latouche. Toward the end of the century Mallarmé's "Tuesdays" performed the same function for the Symbolists such as Huysmans and Redon. At the turn of the century Parisian salons afforded the young Marcel Proust entrée to the upper echelons of society as well as to the world of letters. Taken up in his youth by Mme. Émile Straus, Bizet's widow, who entertained many intellectuals, Proust later visited the salon of Mme. de Caillavet where he met Anatole France who wrote a preface to Proust's first book; he also attended the salon of the rose painter Mme. Lemaire who would illustrate it. Aspects of these hostesses inspired the fictional Mme. Verdurin, who held court on "Wednesdays" in Proust's *Remembrance of Things Past*, and the society hostesses to whom he paid court are mirrored in the Duchess of Guermantes.

The second point of contact for artists and writers in France was the world of art criticism. The official state-sponsored Salon was usually reviewed, following the precedent set by Diderot, by men of letters working for periodicals or newspapers or sometimes simply publishing their art criticism in book form, as in the case of Latouche's *Letters to David.* Many nineteenth-century novelists worked as Salon critics. Stendhal reviewed the Salon of 1824 for the *Journal de Paris* and Merimée reported on the Salon of 1839 in the *Revue des Deux-Mondes.* Gautier's *Salons* appeared in *La Presse* and many other journals, and Latouche's review of the Salon of 1817 was published in the *Constitutionnel.* Moreover, the success of Gustave Planche's *Salon of 1831* assured his future as art and literary critic for the *Revue des Deux-Mondes.* In the course of reviewing current exhibitions writers came into personal contact with artists. Thus Diderot walked through the

Salon exhibition with Chardin, whose job it was to install the paintings, and learned much about looking at paintings from Chardin's comments. Latouche came to know artists whose work he praised, like Ary Scheffer, David d'Angers, and Delacroix.

For these writers art criticism was both an important source of income and a forum in which to express and exchange ideas on current art and literary problems. The battle of the Classicists and the Romantics was played out in the Salon as well as on the stage and in the world of letters. Art criticism was written by some of the authors discussed in this book, and it was also an important source of ideas and images for novelists who did not become professional art critics themselves. Thus we shall see how both Balzac and Proust found material for their fiction in current art criticism.

Writers and artists also had opportunities for direct dialogue in the editorial offices of newspapers and journals. *L'Artiste,* for example, not only hired artists as illustrators but published art criticism by such artists as Delacroix, Paul Huet, Achille Devéria, and Alfred and Tony Johannot, among others. From 1844 to 1848 the editorial offices of *L'Artiste* became the meeting place not only of staff members but of members of the artistic or literary communities who wanted to converse on subjects of mutual interest. Champfleury called the office of *L'Artiste* "an open salon" where in the 1850s people came "to talk more than to write."[8] At the turn of the century Marcel Proust was to make the acquaintance of the Nabis painters Vuillard and Bonnard when they all contributed to *La Revue Blanche,* and it was Vuillard's slangy style of conversation that Proust immortalized in Elstir's remarks to Marcel.

The writings of the Romantics as both critics and creators of imaginative literature found an eager audience among the young art students of Paris. In the studios the budding artists talked about new ideas circulating in the literary world. Thus the studio became another point of contact between artist and writer. Artists were called upon to join in the battle for the new school of Romanticism on the opening night of Hugo's *Hernani.* Gérard de Nerval asked Gautier, then an art student, to bring along friends from his atelier as a claque in the theater. Gautier recalled: "Men read a great deal in the studios of that day. The students were fond of literature, and their special training leading them to close communication with nature, they were better fitted to appreciate the images and rich colouring of the new poesy."[9]

Before the nineteenth century certain writers had visited artists in their studios. Diderot visited Pigalle's studio and included among his friends the artists Falconet, Van Loo, and, as mentioned earlier, Chardin. André Chénier visited the studio of David where they discussed paintings in progress. Salon reviewers often commented on differences noted between the appearance of a painting in the studio and

in the exhibition, thereby drawing attention to their visits to the artist's atelier.

In the nineteenth century, the studio became a salon as well as a workplace. François Gérard entertained many writers including Stendhal, Mérimée, and Balzac on the popular "Wednesdays" in his atelier. Delacroix's studio was visited by his writer friends Hugo and Baudelaire. In Rome the studio of the sculptor Canova was a meeting place for French travelers and emigrés. Mme. de Staël, Latouche, Lamartine, and Lucien Bonaparte all visited Canova's atelier. The literary man's enthusiasm for conversation with artists was expressed by Lamartine who said, "No one speaks with more originality than a painter."[10] While artists followed the example of Courbet, who included Baudelaire and Champfleury in his portrait of his studio, literary men described both real and fictional studios in their writings. Valéry described Degas's studio, the Goncourts, the studio of Gavarni; Mme. de Staël set a scene in *Corinne* in the studio of Canova. Gautier wrote of the studio of "Albertus" as a mystical place "like pictures by Rembrandt in which the canvas shows a white star shining through the blackness. . . a universe apart. . . a fantastic world. . . in which everything is poetical."[11] In contrast Proust presented the studio of the Impressionist painter Elstir as "the laboratory of a sort of new creation of the world."[12]

Many of the Romantic writers knew artists from the days when they themselves had studied art. Stendhal, Fromentin, Mérimée, Gautier, Hugo, and Nodier had all been art students. Delécluze and Nodier wrote memoirs about life in the studio of David. Amaury-Duval described the atelier of Ingres. Other writers frequented the cafés of like-minded artists; the Realists met at Brasserie Andler; the Impressionists at Café Guerbois. Artists and writers also participated in the *cénacles,* societies that formed around the early leaders of Romanticism. The *grand cénacle* met at Hugo's home, while the *petit cénacle* met in the studio of the sculptor Jehan du Seigneur.

The final point of contact between artists and writers was in the commercial world of art. Artists and writers met at private exhibitions, at dealers' showrooms, and at the offices of printers and publishers. Many artists were engaged as book illustrators. Artists like Monnier, the Johannots, and Gavarni were popular illustrators to the Romantics. Later in the century major artists like Manet, Bonnard, and Redon interpreted Symbolist poetry in their etchings. They produced books in which images were only distantly related to words. Redon's mysterious graphics were first given prominence by Huysmans in his *Against the Grain,* where the hero des Esseintes collects Redon's work. Thus Huysmans promoted the work of a generally unknown artist in his novel. Mallarmé too tried to interest his friends in the work of his

favorite artists. He took friends to see the paintings of the Impressionists hanging in the gallery of art dealer Durand-Ruel. It was in this gallery, as well as in the homes of friends, that Proust first saw Impressionist paintings that he would later, in his novel, describe as the work of the fictional Elstir.

The many points of contact between artists and writers that I have discussed gave rise to the risk, alluded to by Balzac and Proust, that the dialogue between the two groups might distract them from their creative work. Balzac describes how the sculptor Steinbock is seduced away from creative work by social life: "he discoursed admirably on the subject of art, keeping up his reputation as a great artist among fashionable people by means of the spoken word, by criticisms and explanations," and in the quest for "drawing-room fame," Balzac points out, Steinbock "acquired a growing distaste for hard work."[13] These comments look forward to Proust's painter Elstir who began his career as a regular member of the Verdurin salon only to decide that his dedication to his artistic vocation demanded a reclusive life. When he meets and talks to Marcel about art, he is already leading the lonely life of genius. However, though aware of the dangers of distraction from creative work, both Balzac and Proust—who emulated in life the monkish writing habits of their fictional heroes—sought new dimension to their fiction through the visual arts.

For all the novelists discussed in this book a close association with art and artists resulted in a deepening of the meaning of the fictional world. Although each novelist worked out his own techniques for combining art and fiction, four principal strategies can be identified: First, an artist may appear as a character in the novel. Second, an art work may be used as an emblem to define character or as a visual analogy to a literary theme. Third, the novelist himself, or with a character as his spokesman, may play the role of art critic. Finally, art may be taken as an aesthetic standard applicable to both literature and life.

The appearance of the artist as a character in fiction began in the seventeenth century, not in the nineteenth century, as is generally believed. Mlle. de Scudéry introduced the painter Robert Nanteuil, a favorite of the *précieuses*, into her novel *Clélie* as the artist "Nelante." He is learned and witty, every inch the ideal *honnête homme* admired by his patrons. Numerous real artists appear in nineteenth-century novels, generally as secondary characters. Mme. de Staël presents Canova as a character in *Corinne*. Marmontel introduces Guido Reni in one of his tales. Balzac mentions many artists: Bouchardon is the teacher of Sarrasine; Poussin and Pourbus appear in *The Unknown Masterpiece;* Girodet visits Sommervieux's studio, and Guérin, Gros, and Horace Vernet also step into the pages of *The Human Comedy.* When fictional painters appear in French novels, they are more likely to play the role of

protagonists as Cariolis or Bazoche in the Goncourts' *Manette Salomon* or, much earlier, Munster in *The Painter of Salzburg* by Charles Nodier. Often a fictional painter is a composite figure based on several real artists. Proust's Impressionist painter Elstir is derived from many painters whose work Proust admired or whom he had met personally. In the early nineteenth century the artist is usually presented as a romantic hero of aristocratic background, perhaps based on Delacroix. In later Romantic fiction the bourgeois artist appears, generally shown "on the way up" to artistic and social success. Men like Manet, Whistler, Helleu, and Blanche were all real-life examples of this type of artist.[14]

The introduction of the fictional artist into the novel allows the writer to explore aspects of art that might ordinarily appear only in critical essays. The novelist can discuss the artist's training, technical aspects of his art, the creative process, the artist's relationships with the official world of the Salon, with the commercial world of dealers and patrons, with society in general, and with women as well as with other artists and writers. These fictional artists bring both art criticism and the sociological aspects of the art world into the sphere of the novel.

Art also serves the French novelist as an emblem to define character or as a metaphor that creates a visual analogy to a literary theme. This function can also be traced back to the seventeenth-century writings of the de Scudérys. The popularity in *précieux* circles of disguised portraits in art is reflected in the portrayal of character through visual emblems in the novel. In *Cyrus* the pretentious bluestocking Damophile chooses to have her portrait painted by Nelante as a Muse. In contrast the heroine Sappho, Mlle. de Scudéry's self-portrait in the novel, chooses to pose as a simple shepherdess, a fictional decision that set the style for such portraits into the eighteenth century. Thus the painted portrait as an emblem of character reinforces the literary depiction in Mlle. de Scudéry's novels. Paintings also appear in seventeenth-century fiction as visual analogies to moral precepts. In Georges de Scudéry's *Cabinet* mythological paintings are discussed in terms of the lessons they teach. A central theme of *précieux* literature, the punishment of the insistent lover, is the subject of paintings of the flight of mythological heroines that earn praise from de Scudéry for their moral content. This tradition is continued in the nineteenth century in Mme. de Staël's *Corinne* where the heroine, taking Lord Nelvil on a tour of her collection, evaluates the political content of well-known French paintings. Mme. de Staël also used paintings as emblems of character when she compared Corinne and her English rival Lucile to paintings that reflect their roles in life: Corinne resembles Domenichino's *Sibyl* and Lucile, Correggio's *Madonna.*

Other nineteenth-century writers expressed central themes in their

novels through art. In the fiction of Balzac and Latouche the feminized male image in painting and sculpture symbolizes the theme of sexual ambiguity in life. Both Huysmans and Proust invoke the feminized image of the poet in Moreau's paintings to suggest the passivity and the feminine sensibility of the artist. Moreau's paintings of Salomé also epitomize for both Huysmans and Proust the menacing power of female sexuality.

Third, the writers under consideration in this book are united by their desire to play the role of guide and critic to the reader. Mlle. de Scudéry takes her readers on a tour of Versailles and points out how the palace embodies the king's devotion to the arts. She sees it as her duty to emulate Classical historians by preserving for posterity descriptions of the great monuments of her day. Although her novels are set in the remote past, many of the places described are disguised portraits of French monuments she has visited. In *Corinne* Mme. de Staël's heroine plays the role of guide through museums and monuments of Italy. She relates the architecture of Rome to the society that produced it in order to illustrate her theories on the close ties between art and politics. In many of the novels to be discussed, the reader is guided through fictional collections. Corinne's collection affords Mme. de Staël the opportunity to introduce her culture-climate theory in her heroine's discussion of northern and southern landscape paintings. Huysmans's description in *Against the Grain* of des Esseintes's collection reveals the personal taste of the Decadent collector, and his placement of paintings by Moreau in his library points up their relationship to Symbolist literature. Echoes of des Esseintes's collection appear in Proust's description of Jean Santeuil's room, and the relationship between Jean and his favorite objects illustrates Proust's ideas on man's affinities with the inanimate. Imaginary collections not only demonstrate the taste of the owner but also the depth of his response to art. Thus Balzac's Pons treasures his paintings above everything, while Proust's Guermantes shock the narrator with their lack of interest in the Elstir works that decorate their drawing room. A collector himself, Balzac portrayed the passion of the collector for his hard-won objects. On the other hand, Proust, who had no interest in collecting art, often described private collectors as philistines.

Finally, the novelist uses art as an aesthetic standard that functions as a measure of literary achievement and a guide to experience. In *Sarrasine* and *The Unknown Masterpiece* Balzac transposes into the field of art the problems that beset the Romantic-Realist writer who seeks to balance observation and intuition in his literary creation. The failures of both Sarrasine and Frenhofer illustrate the dilemmas that confront the writer as well as the artist. Proust presents the work of Vermeer as a standard of excellence for his fictional novelist Bergotte

who exclaims as he looks at the little patch of yellow in the *View of Delft:* "This is how I ought to have written."[15] In Proust's work, Vermeer's lesson does not define the limits of art's didactic function, for painting has the power to enlarge and deepen the narrator Marcel's love and understanding of life itself. For example, Marcel is awakened to the beauties of everyday objects through the still-life paintings of Elstir. These impressions help him to see that within his own life there is material for a literary masterpiece.

All the authors represented in this book make art a major theme in their literary work. As will be shown, their writings linking art and literature form a direct line of descent from the *précieux* novel that established a Romantic-aristocratic tradition. This tradition may be characterized as Romantic in its celebration of creative genius and as aristocratic in its attachment to inherited tastes and values. Its legacy was preserved by nineteenth-century Romantics and Symbolists and became part of the heritage of Proust who enriched the pattern of Symbolist and Balzacian art novels with borrowings from earlier styles from the *précieux* era.

Central to this tradition is the rejection of servile imitation of reality. Mlle. de Scudéry insisted that art should surpass nature when she said in *La Promenade de Versailles:* "It is necessary to propose a general rule that Art embellishes Nature; that palaces are more beautiful than caverns, that beautifully cultivated gardens are more agreeable than untilled lands."[16] Diderot maintained in his *Salon of 1767* that the artist must not copy nature but alter it, and he urged the artist to find a balance between the exterior model in nature and the interior model in his imagination. Though the Romantics turned away from the Classical ideal, they upheld Diderot's notion that a work of art should recreate nature as seen through the imagination of a particular artist. Thus Latouche praised Prud'hon as an artist who "sees everything across the prism of his imagination."[17] Later Balzac used a similar image, the interior mirror, to suggest the second sight of the great artist and held that the originality of true genius depended on a fusion of intuitive vision with reality. Though traditionally classed as a Realist, Balzac's writings on the artist reveal the visionary aspect of his work. To account for the artist's unique vision of the world Balzac summoned up an image of "an indefinable concentric mirror, where following his fantasy, the universe comes to reflect itself."[18] Proust too saw the artist's vision as different from the observed world when in his essay on Monet he characterized that painter's landscapes as appearing like a magician's "lunette" or "magic mirror" that reveals to the viewer the artist's individual vision and sends him out into nature to see the real world through the eyes of the painter. In *Remembrance of Things Past* Proust

also rejects the Realist aesthetic as failing to embrace the broader reality of time:

> The literature that is satisfied merely to "describe things," to furnish a miserable listing of their lines and surfaces, is, notwithstanding its pretensions to realism, the farthest removed from reality, the one that most impoverishes and saddens us, even though it speak of nought but glory and greatness, for it sharply cuts off all communication of our present self with the past, the essence of which the objects preserve, and with the future, in which they stimulate us to enjoy the past again.[19]

Like Proust, the novelists considered here all stand opposed to the concept of art as an uncorrected record of nature. Though Zola's definition of a work of art as "a corner of creation seen through a temperament"[20] echoes the language of Latouche, the emphasis of the Realist-Naturalist aesthetic on accurate observation and detailed recording of everyday life of the common man held little attraction for the novelists in the tradition I describe. Not only did they reject the role of observer and recorder, but they also refused to share the Realist's view that the primary concern of art is with the lot of the common man. The Romantic tradition to which they belong was also essentially an aristocratic one. Mme. de Staël had coined the term *vulgarité*, and even the republican Henri de Latouche was an intellectual elitist who scorned the bourgeoisie. Many of the Romantic writers and artists looked back with nostalgia to the cultivated style of life in eighteenth-century France. The art-for-art's-sake practitioners looked down on democratic forms of society as inhospitable to poetic genius. Thus Baudelaire faulted American democratic society for failing to provide status and livelihood to Edgar Allan Poe, and Flaubert blamed universal suffrage for the problems of France in 1871.[21] The retreat of the Symbolists from the ugliness of the industrial environment was a rejection of the Naturalists' concern with the urban masses. They turned from the real world to an artificial ambiance where art surpassed life and life itself was transformed into art.

The novelists considered in this book share an aristocratic view of the artist as a superior being whose personal vision of reality reflects the thought of a cultivated intelligentsia. Many of these authors presented themselves as descendants of noble families. Perhaps harboring feelings of resentment at their exclusion from positions of power in society, many of them sought in their writings to establish themselves as poet-leaders, to exert power as literary and artistic taste makers.[22] These novelists were active at crucial junctures in the cultural tradition I have described and in French political and social history; their work reflects the intellectual ferment that is characteristic of periods of historical

transition, while at the same time preserving the continuity of the fundamentally aristocratic aesthetic view that binds them together.

One of the pioneers in the tradition that I will trace was Madeleine de Scudéry, the *précieuse* author who developed the heroic novel in France. As a leader of the *précieux* circle, she strove to improve the manners of the vulgar members of the new society that emerged after the upheaval of the Fronde and to produce a pure language that avoided the common phrases of the middle class. Though of upper-bourgeois origin them-selves, the *précieux* created a new elite that set the style in interior decor, art, and literature not only for the nobility but for the court as well. Mlle. de Scudéry and her brother Georges, the playwright and poet under whose name her early works appeared, saw themselves as declassed nobility. Tallement des Réaux, in his *Historiettes*, joked that when Georges de Scudéry spoke about the misfortunes of his family, one might have thought he were relating the tale of the fall of the Roman Empire.[23] Mme. de Rambouillet's salon, which brother and sister attended, brought together literary men and members of the nobility. Yet in this salon, frequented by Classicists like Malherbe, there was a strong element of Romanticism, evident in the revival of old French diction in the poems composed there and in the taking of pseudonyms from old epics and romances. Antoine Adam notes that:

> The romantic ideal was very powerful, to the point where it was perhaps more than a simple game, and that it was a token of the attachment the aristocracy still had for the ways of thought and life of former times. . . . The most obvious role of the Hotel de Rambouillet, and of the salons that imitated it was, therefore, not that of subjecting writers to a doctrine. It was rather to link, more closely than during the preceding period, the world of literature with the world of fashionable society.[24]

It was the close alliance between the humanities and social life that led to the founding of the French Academy in 1634. Many of the original members, including Georges de Scudéry, chosen by Richelieu were members of the *précieux* circle, and admittance to the academy was largely controlled by the literary salons. Though Mlle. de Scudéry's salon was more literary and less aristocratic than the *chambre bleue* had been, she was considered an arbiter of social conduct. Her novels, which recalled pastoral romances, provided both escapist adventure and didactic analysis of the refinement and elegance of behavior necessary to rise in the changing society of her day. Her novels were popular not only in France but in England and Germany as well. She was accorded many honors during her lifetime; one of them, the award of a pension by Louis XIV, was recorded by her friend Mme. de Sévigné: "She was received in utter perfection; it was an audience designed only to receive

this marvelous Muse. The king spoke to her and before she could kneel to kiss his knees he lifted her to his embrace."[25] Though she was nearly forgotten a century after her death, her reputation was revived in the mid-nineteenth century by Victor Cousin who asserted that Molière's *Misanthrope* owed a debt to her *Cyrus.*

Mlle. de Scudéry's rehabilitation had not yet taken place, however, when Mme. de Staël (1766–1817) penned her *Corinne, or Italy,* which as I shall demonstrate in chapter 2 owed a debt to the "marvelous Muse" of the *précieuses.* Mme. de Staël grew up in the *précieuse* setting of her mother's Parisian salon, which attained for her parents a social prominence that money alone could not win. A Genevan banker of bourgeois background, Jacques Necker was to become finance minister under Louis XV. In Paris the Necker couple were at first considered unpolished and excessively ambitious, and Voltaire, who was drawn into their salon, ridiculed them to his friends. By entertaining the *philosophes,* however, the Neckers became preeminent in intellectual and political circles. The publicity provided by their guests coupled with Necker's own self-advertising publications on financial policy resulted in his appointment as minister of finance in 1776, when his daughter was ten, and he was in and out of office until 1791 when he retired. In 1786 when Germaine was married—following many high-level negotiations—to the Swedish diplomat Baron de Staël, she was in a position to open her own salon in Paris as a rich and titled ambassadress. Her salon attracted the artists, writers, and liberal aristocracy who were active in the early phases of the Revolution, and she became a political intriguer on behalf of her friends. Fleeing from France during the Revolution, she returned and reopened her salon in 1797 with the hope of insinuating herself into Napoleon's good graces. But even though his brothers Lucien and Joseph frequented her salon and intervened in her favor with Bonaparte, his aversion to her as a "meddler" in politics, and his dislike of her as an intellectual woman (who in her writings compared the current era to the decline of the Roman Empire), resulted in his exiling her from Paris. Angry at having to leave the center of political and intellectual activity, she reopened her salon in Coppet, Switzerland, where she presided over, to use Stendhal's phrase, "the Grand Assizes of European opinion." But although she attracted the greatest minds of the period, she never attained the political power she sought. An exile, she had to be content with conversation and publication. Her travels brought her into contact not only with European intellectuals but also with many French emigrés displaced by the Revolution. As Henri Peyre has pointed out, many of these refugees, who had admired Rousseau's brand of Romantic literature, now appeared to be living the melancholy, nostalgic existence he had

described. Mme. de Staël's *Corinne, or Italy* captured their mood, a mood of questioning that opened the way for the political and literary changes later to be demanded by the Romantics. Chateaubriand in his *Mémoires d'outre-tombe* capsulized the impact on nineteenth-century Romanticism of this displacement of Frenchmen: "The literary changes of which the nineteenth century is so proud are a result of emigration and exile."[26]

One of the early Romantics upon whom Mme. de Staël's *Corinne* made a powerful impression was Henri de Latouche, poet, novelist, dramatist, and art critic, best known as a journalist who played an active part in the early battle of the literary Romantics against the Classicists and as the first editor of André Chénier. He spoke of *Corinne* as an "imperishable memoir" and a "masterpiece" and predicted: "So long as the language of France, living or dead, will be listened to by men, and so long as Italy will remain both the country of great memories and the promised land of the imagination, one will admire the book where the paintings of the past lend their magic to the living impressions of love; and love, its agitations to ruins, to shades, to tombs that it seems to warm."[27] Latouche patterned his most popular novel *Fragoletta, Naples and Paris in 1799* on *Corinne, or Italy.* As an ardent follower of Mme. de Staël he also brought many of her ideas on art and society before a broad audience in his two Salon reviews, in 1817 on the first exhibition after the Bourbon Restoration and again in 1819. An inveterate polemicist, Latouche analyzed the Salons from the point of view of a Romantic and a republican and attacked those works of art which he viewed as royalist propaganda. As was true of Mme. de Staël, however, Latouche's republican sentiments did not make him a democrat; he regarded himself as a member of a literary and social elite. Born into an old provincial family, he substituted for his florid baptismal name Hy-acinthe-Joseph-Alexandre Thabaud, the pseudonym Henri de Latouche, which suggested noble descent. In salon society Latouche cut an elegant figure and dazzled his audience with his wit. His one-time collaborator Émile Deschamps recalled that he "spoke like a book, better than a book" and, ironically, that he "wrote like a careless conversation."[28] His voice, which Sainte-Beuve likened to "the song of a siren," and his penchant for epigrams were admired by Balzac, who tried unsuccessfully to emulate Latouche's conversational style.

Latouche was already well established in the Parisian literary world when in 1824 he met the then unknown Balzac. Latouche played the roles of mentor, editor, promoter, and creditor to the aspiring novelist. Not only did Balzac turn to Latouche for criticism of his writing, but he relied on the older man in forming his own taste in art and in the decoration of his apartment. Although eventually he was to become

disenchanted with Latouche as a literary advisor, Balzac continued after their friendship ended to try to imitate Latouche's lifestyle and aristocratic bearing. Like Latouche he affected a "de" to give his name the aura of nobility.

The influence of German Romanticism, particularly the writings of E. T. A. Hoffmann, on Balzac's early novels about artists was probably transmitted to him through Latouche, who had already plagiarized (or as he put it more flatteringly, "translated") Hoffmann's *Mlle. de Scudéry* in his *Olivier Brusson* a year before he met Balzac. Latouche's choice of the Scudéry tale reflected his characteristic ability to anticipate themes that would flourish later in the century. Mlle. de Scudéry was later to receive recognition as a major figure when Cousin wrote his study on the *précieuses.* Latouche's long-standing interest in *femme auteurs* may have played a part in his choice of the Hoffmann tale. His liaison with the poet Marceline Desbordes-Valmore, his sponsorship of Georges Sand, and his debt to the writings of Mme. de Staël all demonstrate his respect for the work of literary women. As a follower of Mme. de Staël, Latouche urged Balzac to read foreign Romantic literature: Hoffmann, Scott, and Cooper. Balzac, following the method of Latouche and de Staël, who described sites they had visited to give authenticity to their Romantic novels, traveled to Brittany while at work on *Chouans or Brittany in 1799,* the novel whose original title bore a striking resemblance to Latouche's *Fragoletta, Naples and Paris in 1799.* Though the novel, later called *The Last Chouan or Brittany in 1800,* was probably the only book Balzac wrote under the tutelage of Latouche, the debt to his mentor can still be seen in the art novella *Sarrasine. The Unknown Masterpiece,* on the other hand, documents Balzac's disenchantment with his former mentor, as I shall indicate in chapter 6.

Latouche's influence on Balzac, however, went beyond literary criticism and artistic taste setting. Both Swedenborgians, they shared an interest in the occult. Latouche reinforced this interest, which Balzac had inherited from his mother, by introducing him to a circle of followers of Saint-Martin when he played host to Balzac at his house at Aulnay, a center for the cult. This interest in spiritual philosophies reinforced Balzac's mystical conception of artistic genius. Balzac believed the great artist to be a mediator between the spiritual and the material worlds. This notion is most clearly brought out in his novel, *Séraphîta,* the story of a mystical androgyne, although in the earlier novellas treated in chapters 5 and 6 we see him exploring aspects of this theme. Balzac could find support for his concept of genius not only in the Swedenborgian ideas of Latouche but in the writings of Mme. de Staël as well. Balzac's concept that men of genius, endowed with a "second sight," formed a select band that extended beyond national

boundaries recalls Mme. de Staël's comment in *On Germany:* "Men of genius of all countries are able to understand and esteem each other."[29] Corinne, the "enthusiast," with her supernaturally inspired song, is a fictional example of such a genius; Balzac's Louis Lambert, a partial self-portrait, with his faculty of *"spécialité"* is another. Significantly in this novel Balzac introduces as a character Mme. de Staël herself, who is the first to recognize the young Lambert's genius.

Balzac's mystical view of the artist was a Romantic legacy that would be of great importance for later French writers, particularly those of the Symbolist school. Though Balzac is usually classed as a Realist, this mystical aspect of his personality and his writing has been generally overlooked. A few of his contemporaries, however, recognized the visionary elements in his work. Taine, the theorist of Naturalism, was among the first to note his mysticism, and Gautier later referred to him as a "seer." Baudelaire, perhaps, put the paradox of the mystical Realist most effectively when he wrote: "It has always astonished me that Balzac owes his fame to the fact that he passed for an observer. To me it has always seemed that his chief merit lies in his having been a visionary, and an impassioned visionary."[30] To Baudelaire, Balzac appeared to be a visionary of superhuman power. Though an admirer, Baudelaire himself felt humbled by Balzac's literary achievement. "I don't have Balzac's courage, I don't have his genius, and I have all the difficulties that made him so unhappy."[31] In contrast to Balzac's perception of himself as a powerful genius, Baudelaire, like the Decadents who followed him, saw himself as weak and melancholy; this self-image reveals affinities with fictional characters like Lord Nelvil in *Corinne* or Balzac's narcissistic Lucien de Rubempré. These passive Romantic figures are precursors of the Decadent hero, epitomized in Huysmans's des Esseintes. Sensitive but sick, the Decadent hero suffers but does not produce. Another forerunner of the Decadent hero is Zola's failed painter Claude Lantier, whom Zola contrasted to the powerful Naturalist writer Sandoz in *The Masterpiece.* To Zola Lantier was a case study of "the frightful psychology of artistic impotence."[32]

Des Esseintes's character and taste were inspired by the aesthete and socialite Count Robert de Montesquiou, who was also to be the prototype of Proust's Baron de Charlus. Although Montesquiou had early served him as an arbiter of artistic taste, the mature Proust came to the view that "celibates of art" like Montesquiou "are more wrought up over works of art than the real artists."[33] Proust's narrator, on the other hand, moves from penetrating contemplation of art to the creation of his own work. In the novel the Impressionist paintings by Elstir inspire the narrator to create his own vision of the world. Proust turned away from the Symbolist transpositions of art that he had emulated in his

early poems toward an attempt to rival in words what the Impressionists had achieved on canvas. An important step in this transition was his study of art criticism and his attempt in his early essays on artists to formulate his own philosophy of art.

That works of art provided models to Proust as a writer is demonstrated in his description of his projected novel as a series of paintings by Monet: "Imagine today a writer to whom the idea would occur to treat a theme twenty times under different lights, and who would have the sensation of creating something profound, subtle, powerful, overwhelming, original, startling like the fifty cathedrals or forty waterlilies of Monet."[34]

His novel cycle, *Remembrance of Things Past,* places a series of impressions before the reader's eye, images of people, places, relationships that change as the protagonist matures, so that by the end of the cycle the reader comes to realize that the first impressions made by many of the characters had been false. Characters reappear in the novel changed, in the eyes of the narrator, from their original personae. In this way the reader experiences the effect of time in the novel, much as Monet shows us the passage of time in the changing light effects on his cathedrals or his water-lily ponds. No omniscient writer describes a person or a place for the reader; instead we experience the effects of people and places through the changing perceptions of the narrator. This literary Impressionism was derived, according to Proust, from such diverse sources as Elstir and Mme. de Sévigné, both of whom refrained from explaining causes in favor of describing effects. The *précieuse* Mme. de Sévigné, admired by Proust's mother and grandmother, is a grey eminence in his novel. Her spontaneous response to the world around her and her poetic gift for evocative and perceptive description is likened by the narrator to Elstir's Impressionist's eye: "Madame de Sévigné is a great artist of the same school as a painter [Elstir] whom I was to meet at Balbec, where his influence on my way of seeing things was immense. I realised at Balbec that it was in the same way as he that she presented things to her readers, in the order of our perception of them, instead of first having to explain them in relation to their several causes."[35]

Just as Proust borrowed the Impressionist vision from the letters of Mme. de Sévigné and from Monet's series of paintings, so he enhanced the sense of the passage of time in his novel cycle by borrowing from Balzac's *Human Comedy* the device of recurring characters. In a conversation with Albertine the narrator comments that Balzac's idea of bringing back his fictional personages in different novels was "the last and most sublime stroke of the brush" that unified the cycle.[36] Proust must have realized, as Harry Levin points out: "If psychology added a

third dimension to the flat, old-fashioned technique of characterization, Balzac's system of cross-reference added a fourth—the dimension of time and change and growth in which Proust was to move."[37]

Thus Proust ends the line of descent traced in the book. Though a twentieth-century innovator, Proust has roots in past French literary and artistic traditions that go back to the seventeenth century. The writers treated in this book belong to the Romantic tradition of the art novel, a tradition with roots in the writings of the *précieux* circle, which saw its last expression in the novel cycle of Proust. For although in many ways Proust is a Modernist, his novel remains, as Shroder has pointed out, "one of the last major statements of the Romantic faith in art."[38]

Having indicated the outlines of the art and literary tradition to be explored in this book, it is time to turn to specific comparisons between text and visual image. Although the chapters that follow are related partly by method and partly by theme, each presents its own particular issues in art and literary relationships. Certain chapters, therefore, are more concerned with literature, and others concentrate more heavily on the visual arts. The validity of such a variety in approach in interdisciplinary studies is supported by Jean Seznec who said in his 1962 Hull University lecture, "Literature and the Visual Arts in Nineteenth-Century France": "The main question is always to establish and elucidate a connection between a text and a work of art. The connection, however, is more or less remote, more or less meaningful; therefore according to the circumstances it will have to be considered from a different angle, and at a different level."[39]

2

The Unconfessed *Précieuse*
Mme. de Staël's Debt to Mlle.
de Scudéry

The peculiarly French delight in encounters between art and literature can be traced back to the seventeenth century when both visual and verbal portraiture flourished in *précieux* circles. The "literary portraits" were short, self-contained passages that served the dual purpose of providing detailed description of the appearance and personality of an individual character and inculcating a general lesson derived from understanding of the moral force of the character portrayed. Though brief character studies had appeared in French literature since medieval times, they attained new complexity and popularity in the novels of Mlle. de Scudéry. The literary portraits that ornamented her lengthy heroic novels paralleled the many paintings of heroic women produced in France during the reign of Marie de Médicis and the regency of Anne of Austria. One of Rubens's paintings depicting the life of Marie de Médicis presented the queen as the Roman war goddess Bellona, a symbol of the powerful woman. In the Palais Cardinal, Philippe de Champaigne and Simon Vouet painted Marie de Médicis, Anne of Austria, and Joan of Arc, among other French heroes and heroines. Images of heroines also appeared in books of pictorial poetry in which engravings were coupled with poems in the Classical tradition of the "speaking picture," revived during the Renaissance.[1] The Italian poet Marino's *Galleria*, a series of poems on real and imaginary paintings, went into sixteen editions and inspired Georges de Scudéry to write his poems on a collection of pictures entitled *Le Cabinet de M. de Scudéry* (1646). When in 1642 he wrote a tribute to Richelieu, Georges de Scudéry titled the literary description of the cardinal a "portrait." He

further emphasized his own role as a "portrait painter" by ending his essay with the words "there he is," as though he had just laid down his brush.[2] In the same year he collaborated with his sister Madeleine de Scudéry on a series of essays on celebrated heroines, entitled *Famous Women or Heroic Addresses (Les Femmes illustres ou les harangues héroïques)*, that set out to demonstrate the eloquence of women. Another such collection of feminist character studies was the *Gallery of Forceful Women (La Galerie des femmes fortes)* written by Le Moyne in 1649, which juxtaposed engravings of historical and legendary heroines with eulogies of their triumphs and made comparisons between these powerful figures and modern French women. In 1646–47 the Italian artist Romanelli, summoned to Paris to decorate the *Galerie Mazarine*, painted the portraits of the leading *salonières* as Muses in Apollo's entourage. Similarly Mlle. de Scudéry portrayed in her novels her salon friends in the guise of famous heros and heroines. These "disguised" portraits of contemporaries stimulated the curiosity of her readers, who could catch a glimpse of the social life in the exclusive salons of the *précieux* circle through her *romans à clef. Artamène or the Grand Cyrus* (1649–53), which featured the Prince de Condé as the hero Artamène and the Duchesse de Longueville as the heroine Mandane, included in the supporting cast many "disguised" portraits of other visitors to the blue chamber of Mme. de Rambouillet. Similarly, *Clélie, A Roman History* (1654–61) reflected the social life of Mlle. de Scudéry's "Saturdays."

The novels in which Mlle. de Scudéry's literary portraits were interpolated included tales of adventure and love largely based on events from ancient history. Though her heroes bear famous names, they act out of love rather than devotion to country. Their chief concern is to win through deeds of bravery the esteem of their beloved. Although these novels were innovative in some respects, the author acknowledged her debt to earlier writers in her preface to *Cyrus*, where she named as her "only masters" Heliodorus and Honoré d'Urfé.[3] Heliodorus's immensely popular Greek novels, translated into French in the sixteenth century, recounted the adventures of chaste lovers who were separated by overwhelming obstacles. These novels anticipated Mlle. de Scudéry's not only in the love theme but in the detailed descriptions of the lovers' great beauty. D'Urfé's *L'Astrée* (1607–27), a romance between a shepherd and shepherdess set in the pastoral land of Forez, which was ruled by women, had many feminist and romantic elements that appealed to the *précieuses*. D'Urfé created, in his story of courtly love, a romance that would be viewed by its readers as a guide to elegant manners. Mlle. de Scudéry's novels were influenced by the numerous subplots that embellished *L'Astrée,* as well as by the interruptions of plot for long descriptions of paintings or protracted conversations. She

rejected, however, the many supernatural aids to plot used by both these earlier "masters." No nymphs or fairies appeared in her novels, for though Mlle. de Scudéry's plots sometimes strained probability, they never relied on the miraculous.

The increased importance of literary and artistic portraiture in her fiction marked an advance in the direction of a more natural plot and motivation. She said in her preface to an earlier novel, *Ibrahim* (1641): "I am not interested in external things or the caprices of destiny: I wish to know the impulses of his [the hero's] soul and the way they are expressed."[4] Because of her interest in inner motivations, she expanded descriptions of characters, telling her reader not only about their physical attributes but about their moral qualities as well. In *Clélie* her "portrait" of the painter Nelante (Nanteuil) capsulized her own goals as a literary portraitist: "a mirror does not represent more justly those whom he paints . . . for he penetrates the hearts of men in order to animate their portraits; he makes visible their wit and their temperament; he expresses even the least movements of their soul in their eyes."[5]

Though Mlle. de Scudéry's books were largely forgotten a hundred years after her death, still there were some readers who continued to be captivated by these early novels in the Romantic tradition. Rousseau had read *Cyrus*, and Chateaubriand recalled that his mother had learned it by heart. An unconfessed admirer of the *précieuse* author was Mme. de Staël, whose mother Mme. Necker continued the tradition of the *précieuses* in her literary salon. The pedantic Mme. Necker, characterized by William Beckford as a *"précieuse-ridicule,"* set rigorous standards for her daughter's education.[6] Though disapproving of frivolous reading for Germaine, she may well have made an exception of the de Scudéry novels, since Mme. Necker (née Suzanne Curchod) had, in her youth, patterned her first salon—in Lausanne, 1757—on the seventeenth-century *ruelles.* Her literary group, known as the *Académie des Eaux* or *Académie de la Poudrière,* reflected the society pictured in Mlle. de Scudéry's works. As president of the *Académie,* Suzanne Curchod had taken the names Thémire and Sappho for herself and had had a new *Carte de Tendre* drawn up showing her temple situated on an island in the middle of the stormy sea of sentiment. The *Académie* had a literary and feminist cast: its members produced essays and verses, and some of its meetings were held to discuss the rights of women.[7]

It was probably during these years that Suzanne Curchod made her first attempts as a *femme auteur.* Though her passion for writing continued after marriage and generated her journal, and a stream of maxims and *pensées,* her husband's disapproval precluded a literary career. When she engaged in a competition with her daughter Germaine to produce literary portraits of M. Necker, that conservative pater-

familias showed some concern that his daughter might follow the path he had forbidden to her mother. His views did not escape Germaine who recorded his reaction in her journal:

> My father could not put up with a woman author and during the four days that he saw me writing his portrait, anxiety already took hold of him, and he would call me jokingly *"M. de Saint Écritoire"* (Sir-Saint Writing Desk). He wished to warn me against this weakness of vanity. Mother had a powerful taste for literary composition; she sacrificed it to him. "Imagine," he said to me often, "how worried I would be, that I would not dare enter her room for fear of disturbing an occupation which would be more agreeable to her than my presence. I would see her, in my arms, still pursuing an idea." Ah how right he was, that women are seldom made to follow the same career as men.[8]

Though in her journal the dutiful daughter agreed with her father's views, she was to achieve in her career her mother's literary aspirations. Yet while she pursued the forbidden literary laurel, Mme. de Staël's persistent memory of the nickname her father had bestowed on her, "M. de Saint Écritoire," with its covert threat of loss of femininity, seems to have merely kept her from owning a writing table of her own. Like her heroine Corinne, she developed many of the thoughts that were later to appear in print during the long spoken monologues that she performed in her salon. Only after the stunning success of *Corinne,* when she had established herself as a professional writer in the mode of the Muse with lyre, did she allow herself to purchase the furniture of her profession, the *écritoire.*[9]

Growing up in her mother's salon, Germaine, an authentic child prodigy, had a vast literary background and a conversational virtuosity that were admired by the visitors to Mme. Necker's *Vendredis.* Many eminent callers paid tribute to the young genius. Under the pseudonyms of Louise, Milane, Aglae, and Zulmé, word portraits described the extraordinary Germaine Necker. One of these literary encomia was presented to the eighteen-year-old Germaine by the salon gallant, the Comte de Guibert, famed for his success with women.[10] He patterned his heroine Zulmé on the young Mlle. Necker:

> Zulmé is only twenty, and she is the most famous of the priestesses of Apollo; . . . Her large black eyes sparkled with genius; her hair, the color of ebony, fell on her shoulders in wavy curls; her features were more pronounced than delicate; one sensed in them something above the destiny of her sex. In such a way one would paint the Muse of Poetry, or Clio, or Melpomene. . . . She takes the pitch of her lyre and speaks to the assembly of the great truths of nature, of the immortality of the soul, of love, of liberty, of charm and of the danger of the passions. . . . She becomes completely

silent; then the temple resounds with applause. Her head bows with modesty; her long eyelashes lower over her fiery eyes, and the sun remains veiled from our sight.[11]

This description of the young Zulmé as inspired Muse singing to the accompaniment of the lyre and drawing the overwhelming applause of the multitude was later to be transformed by Mme. de Staël in *Corinne* into the opening scene of the crowning of the Roman *improvisatrice* at the Capitol in Rome. Madame de Staël described Corinne in her first appearance as "a priestess of Apollo," the very words with which Guibert had characterized Zulmé.[12]

But though this dramatic introduction of Corinne in the novel grew from the description of Zulmé in Guibert's word portrait, the characterization of the heroine had its ultimate source in the literary portraits of the *précieuses*. Both the use of a pseudonym and the portrait of the literary woman in the guise of a Classical poet were devices that had been established by Madeleine de Scudéry. Moreover, it was Mlle. de Scudéry's literary self-portrait under the pseudonym of Sappho that was to become the model over a century later for Mme. de Staël's fictional heroine Corinne. Renowned in her lifetime as "the Muse of our Century," Mlle. de Scudéry offered to Mme. de Staël a model for the literary portrait of Corinne.[13]

The theme of the ancient lyric poetess had made its appearance over two decades before the publication of *Corinne* in Germaine's first attempts at verse. In 1784 when she was eighteen, she penned verses entitled *Romance sur l'air: Nous nous aimions dès l'enfance* that told the story of Sappho and Phaon. The theme of talent bringing with it lovelessness—the central theme of *Delphine* and *Corinne*—made its appearance in the very first stanza. Genius and love shine in Sappho's eyes and she attracts "a thousand lovers" as Corinne was later to do. Anticipating the later self-portrait, the young writer identifies herself in these verses with her tragic heroine.[14]

In 1785, a year after she had composed her poem on Sappho and Phaon, Germaine began inscribing in her journal word portraits of her friends.[15] The depiction of Corinne, an idealized self-portrait, was in part inspired by Guibert's description of Germaine. But although Guibert had given her a dramatic image of her heroine as Muse, the details of Corinne's history and character were provided by Madeleine de Scudéry's literary self-portrait as Sappho in *Cyrus*.

Both Sappho and Corinne are high-born and independent of their parents. Sappho lost her parents at six and, according to Mlle. de Scudéry, her childhood is unnecessary to describe for by twelve, her wit and judgment were already formed. Corinne's birthplace is disputed, her family name unknown, and her first book carried "only the name of

Corinne." Her past too is mysterious: "No one knew where she had lived nor what she had been before this time" (bk. 2, chap. 1, p. 662); Sappho's claim to beauty is modest. Of middling height and lusterless complexion, she has one redeeming feature that has been charitably attributed to plain women through the ages: fine eyes. Mlle. de Scudéry, no beauty herself, was careful to give a full description of Sappho's amorous and sparkling eyes, which shine "with a fire so penetrating and have such a passionate sweetness that vivacity and languidness are not incompatible in Sappho's beautiful eyes."[16] Avoiding any close description of Sappho's face or figure, Mlle. de Scudéry praises her hands as "so admirable, that they are indeed hands which capture hearts: or, if one considered how beloved of the Muses this learned lady is, they are hands worthy of gathering the most beautiful flowers of Parnassus" (332–33). The source of Sappho's power is beyond physical beauty. The charm of her wit surpasses others, and she is capable of inspiring greater passions than "the greatest beauties of the earth."

Corinne's pretension to beauty appears stronger than Sappho's, although Mme. de Staël emphasizes bearing and garb rather than a detailed picture of her features. Surrounded by the cortege of her admirers, she is hailed by the crowd, "Long live Corinne! Long live genius! Long live beauty!" Corinne, like Sappho, has an overwhelming effect on men, and when first viewed by the melancholy hero, Oswald, Lord Nelvil, the power of her attraction "electrified the imagination of Oswald." Comparable to Sappho's admirable hands are Corinne's arms "of a striking beauty," and her stature is described by the full-figured Mme. de Staël as "slightly robust in the mode of Greek statues" (663). Corinne's beauty and her dress recall antiquity, but, like Sappho before her, her charm is not closely linked to her appearance.

The power of attraction of both heroines recalls the Muses. Part of their charm is the mingling of genius with simplicity. Sappho, despite her literary genius, wants to learn how to do domestic tasks: "She knows how to play the lyre and to sing: she dances gracefully: and she wishes to know how to do all the work with which women who do not have her cultivated mind occupy themselves" (334). Corinne, too, is capable of both the extraordinary and the ordinary: "She gives the impression at once of a priestess of Apollo advancing toward the temple of the Sun and of a perfectly simple woman in the daily relations of life" (663).

Both women create literature, not as hard-working writers bent over their *écritoires* but, rather, as effortless improvisers of poetic song on the lyre in the manner of their ancient namesakes. Thus Sappho improvises a song more moving than written words: "an improvised song which is a thousand times more touching than the most plaintive elegy. . . . She expresses so delicately the most difficult sentiments, and she knows so

well how to analyze the anatomy of an amorous heart" (333–34). Corinne, too, has a genius for improvising poetry to the lyre: "One said her voice was the most moving in Italy; another that she danced like a nymph, and that she drew with as much grace as invention: everyone said that no one had ever written or improvised such beautiful verses" (662). Yet while both women improvise song to the lyre and dance like ancient nymphs, they also converse with simplicity. Sappho's conversation is "so natural, so easy and so elegant" (334), and she has the talent to speak equally well on serious as on playful subjects. Corinne exhibits similar versatility: "in daily conversation she had by turns a grace and an elegance which charmed all" (662). Both women are beloved by their friends. At the official crowning of Corinne Prince Castel Forte pays tribute to both her genius and to her "qualities of soul" that only her friends can describe. Her talent as an *improvisatrice* is due not only to "her teeming wit" but to her "generous thoughts" (664). Sappho too is praised for her traits of generosity and interest in her friends: "she is loyal in her friendships; and she has a soul so tender, and a heart so passionate that it is a supreme joy to be loved by Sappho" (336).

Thus the portrait of Corinne, in her literary genius, her style of improvisation, and her personality traits, bears a close resemblance to the portrait of Sappho from *Cyrus.* Their charisma draws lovers to them, and their simplicity and generosity endears them to their friends. Their genius is marked by divine inspiration rather than mental concentration. Corinne's innate ability, her unlearned brilliance, parallel the effortless knowledge of Sappho that Molière mocked in his farce *Les Précieuses ridicules* with the comment: "People of quality know all without having learned anything."[17]

Mme. de Staël, who had acted in Molière's *Les Femmes savantes,* was well aware of the criticism leveled against pedantic *précieuses* by the playwright who claimed in his introduction to *Les Précieuses ridicules* that he had only satirized their imitators from the provinces. This disclaimer seems to have mollified the Parisian *précieuses,* and Mlle. de Scudéry's later mention of the performance of Molière's plays at Versailles indicates she bore him no ill will. Several modern scholars have suggested she shared with the playwright a distaste for the type of pedants he parodied.[18]

In constructing her self-portrait Mlle. de Scudéry had been careful to disassociate herself from those women in her circle who flaunted their learning. She blamed the public disapproval of her circle on the foolish behavior of her imitators. In order to set apart her own literary salon from those of her emulators, she created a fictional character, the false *précieuse,* Damophile, who, as Victor Cousin pointed out, may well have been a model for Molière of Philaminte in *Les Précieuses ridicules.*[19] Damophile, the provincial *précieuse,* surrounds herself with tutors and

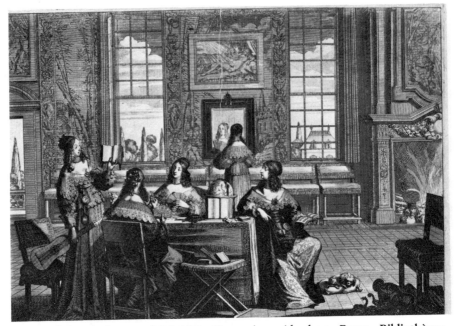

The Foolish Virgins ca. 1635–1641. Engraving. Abraham Bosse. Bibliothèque Nationale, Paris.

books in order to gain the reputation as a *savante.* Mlle. de Scudéry contrasts this pretentious behavior with the modest demeanor of Sappho: "there are more books in her [Damophile's] study than she has read, and there are fewer in Sappho's house than she has read." Thus Mlle. de Scudéry warns that the trappings of scholarships are often an uncertain measure of learning.

Another example of Damophile's pedantry is her commissioned portrait as a Muse. She poses "decked out the way Muses are painted" beside a table "laden with a quantity of books, paintbrushes, a lyre, mathematical instruments which would mark her learning."[20] Mlle. de Scudéry suggests here that to have oneself painted in the guise of a Muse is a display of unbridled vanity. Damophile's portrait beside a table piled with implements of music, mathematics, paintings, and literature also recalls the engraving by Abraham Bosse from *The Foolish Virgins* series (ca. 1635–41) in which the Foolish Virgins are depicted as Frenchwomen of the time of Louis XIII gathered around a table laden with globes, books, musical instruments, and geometrical devices. The gloss states that these women waste their time on music, dance, and books of love, an obvious gibe at the learned ladies of the artist's day.[21]

Mlle. de Scudéry created Damophile in an effort to blunt the force of antifeminist satire, as ten years earlier in *Famous Women or Heroic*

Addresses she had delineated an antiportrait of a pedant in Sappho's address to Erinne.[22] In *Cyrus,* she contrasted the ridiculous Damophile to her own self-portrait as Sappho, the unstudied and modest woman admired by all. The antithesis between the two portraits appears to have been consciously emphasized by Mlle. de Scudéry in order to disassociate her circle from the pretentious pedantry that contemporary detractors attributed to the *précieuses.*

Mme. de Staël took up the same emphasis on natural charm and spontaneity in painting her picture of Corinne. Additional support for the heroine's unstudied genius could be found in eighteenth-century literature, especially in the works of Rousseau. By the time Mme. de Staël was writing *Corinne,* the critics of literary women were even more outspoken than in Mlle. de Scudéry's day. Napoleon's antifeminism may have aroused Mme. de Staël's disdain, but Rousseau's writings on literary women probably caused her some concern, since the Swiss philosopher had been a household god of the Neckers, and her first published pamphlet was a defense of his writings.[23] Rousseau's attack on literary women as unworthy of love could scarcely have been ignored by the young Germaine who aspired to be a famous writer. Rousseau's description of the literary lady working at her disordered desk looked back to the satirists of the *précieuses* and anticipated M. Necker's nickname, "M. de Saint-Écritoire":

> Readers, I appeal to you on your honor—which gives you the better opinion of a woman as you enter her room, which makes you approach her with the greater respect: to see her occupied with the duties of her sex, with her household cares, the garments of her children lying around her; or, to find her writing verses on her dressing-table, surrounded with all sorts of pamphlets and sheets of notepaper in every variety of color? If all the men in the world were sensible, every girl of letters would remain unmarried all her life.[24]

Mme. de Staël herself must have borne a close resemblance to Rousseau's woman writer absorbed in putting down her thoughts at her dressing table, for she was remembered by friends with pen in hand even when her hair was being coiffed. However, in creating her heroine, Germaine was careful to paint a vision of grace and beauty in which the pen was exchanged for the lyre. An image from ancient Roman and Renaissance art and literature, the lady with the lyre was appropriated by the *précieuses* as an emblem of Italian Renaissance culture and revived in the nineteenth century under the influence of Neo-Classicism. As we shall see in chapter 3, the Muse with the lyre carved in antique marble could scarcely have been ignored by Mme. de Staël on her tour of Italy to gather material for her novel. At the time the book was published, the lady with the lyre was to become not only a popular

motif but also the emblem of many women writers among the French Romantics, who styled their salon recitations after *Corinne*.[25] Attributes of Muses, sibyls, and ancient poetesses were no longer clearly differentiated, and any woman with intellectual aspirations might don the sibyl's turban and strum the lyre-guitar in the manner of a Muse or poetess.

In *Corinne* the Muse with lyre becomes the living apotheosis of her own genius when, after the crowning at the Capitol, the heroine takes up her instrument and improvises poetry before the assembly. This scene was based on a real event on Mme. de Staël's trip to Italy when she was received by the Academy of Arcadia in Rome under the pseudonym of Telesilla, the fifth-century Greek poetess.[26] Such a triumph was a rare occasion for a literary woman, and Mme. de Staël was to treasure this moment and to create a permanent image of it in her book, an image that would kindle the aspirations of many nineteenth-century women authors. Though Mme. de Staël's triumph in Rome inspired the scene, it is my conjecture that Mlle. de Scudéry's *Cyrus* (pt. 8, bk. 2) provided some of the elaborate details of the crowning. In the homage paid to Cleonisbe, at the feast of the triumph of the sun, many elements of Corinne's crowning are anticipated. The gilded chariots, the ascent to the throne, the crowning with garlands, the music, the throngs of admirers are all described. Even the Prince of Phoceus who falls hopelessly in love with Cleonisbe on the spot anticipates the lovesick Oswald.[27]

The scene of Corinne's triumph closes with an allusion to honors accorded women of genius since the days of Sappho: "The same mythological images and allusions must have been addressed to such women of celebrated literary talents across the centuries from the time of Sappho to our own" (663). Mme. de Staël's interest in the homage paid to women writers over the centuries would probably have made her aware of the recognition accorded the seventeenth-century French Sappho in her day. The earliest instance of official recognition of a woman by the French Academy was the award of first prize in eloquence to Mlle. de Scudéry in 1671 for her *Discourse on Glory*. Later her fame spread beyond France, and she was recognized as an Italian Muse with her election to the academy at Padua. Recognition by the Italian academy was particularly appropriate, since the ideal of the educated gentlewoman that she personfied derived ultimately from Castiglione's *Courtier*. The honors accorded Mlle. de Scudéry were probably the grandest ever bestowed on a seventeenth-century French *femme auteur*. Though she originally published under her brother's name owing to prevailing notions of propriety among the nobility, still in her late years her fame had spread throughout Europe.[28] And after her

death she was memorialized in Mlle. L'H[éritier de Villandon]'s eulogy, *The Apotheosis of Mlle. de Scudéry* (1702). A sculptural tribute was paid her when she was included as a French genius in the form of a Grace on Titon de Tillet's monument *The French Parnassus.*[29]

Thus Sappho's acclaim would have served as historic precedent for the tributes paid Corinne. That Mlle. de Scudéry was the most appropriate model for the feminine literary genius available to Mme. de Staël seems to have been overlooked by modern critics.[30]

To Mme. de Staël, who longed for recognition of her literary genius, how fortunate must Madeleine de Scudéry have appeared, as the recipient of glory during her lifetime. No such possibility of official recognition seemed to exist for Mme. de Staël writing *Corinne* in exile from Napoleonic France. However, not only Classical echoes but also the memory of tribute paid to an earlier French woman may well have been in her mind when she related the scene of the crowning of Corinne to historic precedents "from the days of Sappho to our own."

In several ways Corinne embodied attributes of Mlle. de Scudéry. The name Corinne, which Mme. de Staël is said to have borrowed from Propertius, was also a reflection of the earlier author's Greek pseudonym.[31] In Mlle. de Scudéry's "History of Hesiod" in *Clélie*, Corinne is described pridefully as a woman poet who will triumph five times over Pindar and will teach him how to employ fiction in poetry.[32] In *Corinne*, Mme. de Staël had her heroine say: "I tell no one my true name. . . . I take only that of Corinne which the history of a Greek woman, friend of Pindar and poet, has made me love" (bk. 14, chap. 4, p. 788). In an accompanying footnote Mme. de Staël explained: "Corinne was a Greek woman, famous for lyric poetry; Pindar himself took lessons from her." Beyond the classical name, the association of Corinne with the Muse was also a seventeenth-century mode applied to literary women, like Mlle. de Scudéry, that suited the style of early nineteenth-century Neo-Classicism.

The sibylline quality of Corinne, brought out by Mme. de Staël through a comparison of her costume with that of the Sibyl in Domenichino's painting, had historic connections with Mlle. de Scudéry.[33] Visitors to the aged writer noted in their memoirs Mlle. de Scudéry's resemblance to an antique sibyl. Her oracular manner of speech as well as her aging face appeared sibylline to her respectful admirers.[34] Besides biographical links, Mlle. de Scudéry had introduced the prophetic power of the sibyl into the pages of her novels. In *Cyrus* the plot is often advanced through the words of prophesying sibyls. Though Sappho herself is too modest to recite her poetry in the course of the novel, the sibyls gave their pronouncements in poetic form.[35] Mlle. de Scudéry did not, however, endow Sappho with the prophetic

powers of a sibyl. Mme. de Staël, on the other hand, showed no such restraint. Corinne's improvisations, written in poetic form, were presented as "inspired" utterances.

Beyond its associations with Mlle. de Scudéry, the tradition of the sibylline woman genius (which still continues in twentieth-century interviews with *femme auteurs*[36]) was very much in vogue during the Neo-Classical period at the turn of the eighteenth century. Mme. de Staël and her portraitist Mme. Vigée-Le Brun were among the many women who liked to wear turbans as emblems of their genius. In describing the turban of Corinne as "twined around her lustrous black curls" the author was surely thinking of her own luxuriant tresses rather than of the smooth neatly parted hair of the Sibyl in Domenichino's painting.

Domenichino's painting of the Sibyl offered to Mme. de Staël a youthful image of inspired genius whose uplifted eyes could be neatly contrasted to the demure lowered gaze of Correggio's *Madonna de la Scala*, the emblem in the novel for Corinne's rival for Oswald's love, the conforming and domestic Lucile. Lucile prevailed over Corinne in winning the love of Oswald. But the Scottish lord was to suffer pangs of conscience. In Bologna he stood before Domenichino's *Sibyl* until his wife asked him nervously "if the Sibyl of Domenichino spoke more to his heart than the Madonna of Correggio." He replied tactfully, "The Sibyl no longer sends forth oracles; her genius, her talent are finished: but the angelic figure of the Correggio has never lost her charms" (bk. 19, chap. 7, p. 854). Thus motherhood won out over genius.

Mme. de Staël brought her characters into direct juxtaposition with works of art in several scenes in the book. When Oswald and Lucile stand before Correggio's painting the devoted husband marks the resemblance between his wife and the painted Madonna. Earlier Corinne takes him to visit Canova's studio where she and the famous sculptor concur on Oswald's resemblance to the figure of the genius of death from Canova's tomb for Pope Clement XIII.[37]

Mme. de Staël's use of famous paintings to symbolize the virtues or express the mood of her fictional character was a device that may have developed from the literary portraits of the *précieuses* with their frequent comparison of their subjects to mythological or literary heroines. Transposing legend into life, the *précieuses* enjoyed dressing up in the guise of mythological or literary characters for their entertainments and also for their portraits. In fact the frequenters of the *ruelles* revived the *portrait déguisé* as a fashion in art.[38] While Mme. de Staël merely analogized her characters to a painted or sculpted image of a Classical or religious figure, the *précieuses* often dressed for the stage or the atelier as the personnage with whom they chose to be identified. Popular classical goddesses were Minerva, Diana, and the Graces and

Muses. In a letter of 1646 Mlle. de Scudéry refers to the fashion for portraits as *Pallas armata*. The vogue of the allegorical portrait spread from the bourgeois *ruelles* to the court, when Giovanni Francesco Romanelli decorated the vaults of the *Galerie Mazarine* by painting the portraits of several salon ladies as Muses. Mazarin had close ties with the *précieuses*, and this decoration demonstrated official assimilation of their taste.[39]

The fondness of the *précieuses* for collecting portraits of their circle was exemplified by the taste setter the Marquise de Rambouillet in whose blue chamber hung likenesses of many friends; probably these were given as keepsakes. Portraits were presented as tokens for loyal service, as, for example, the Duchess of Longueville's gift to the Scudérys after the Fronde. A similar gift appears in *Clélie* when Princess Elismonde tries to win her subjects' loyalty by bestowing her portrait upon them. These portraits were often in Classical guise. Mme. De Longueville was drawn by Dumoustier as a warrior, and Mme. de Rambouillet was painted by Van Mol as Thetis grieving over Achilles after the death of her son at the battle of Nordlingen.[40] The *précieuses* did not limit themselves to figures from Classical mythology and history for their portraits. A literary heroine, Astrée, the chaste shepherdess from the romance by d'Urfé (who was probably a caller at *la chambre bleue*) set the vogue for using the shepherdess's attire in *portraits déguisés*. In *Cyrus*, Sappho decides on a ragged shepherdess's dress for her portrait, because, as she tells the painter, "Nelante" (Nanteuil), she does not want to resemble Damophile whose portrait as Muse with attributes he is also painting. The simple dress of the shepherdess points up Sappho's modesty. She is so pleased with the finished painting that she has it copied for her friends. In real life, after Nanteuil painted her portait (now lost), Mlle. de Scudéry sent him a quatrain in which she said, "I hate my eyes in my mirror/ I love them in his work of art." In answer the learned painter responded gallantly in rhyme that by painting her he would be rendered immortal through her writings.[41] Mlle. de Scudéry's mention of Sappho's portrait in *Cyrus* no doubt enhanced the popularity of the shepherdess portrait, a vogue that continued into the eighteenth century.[42] Sappho's choice was no doubt inspired by an actual portrait painted around 1645 by Claude Deruet of Mme. de Rambouillet's daughter, *Julie d'Angennes de Rambouillet as Astrée*. Julie's identification with Astrée drew attention to the sitter's reputation for chastity. The portrait was probably painted before her marriage following a fourteen-year engagement. With crook in hand, surrounded by lambs and flowers, Julie is seated before a Classical landscape, the temple of the Sibyl in Tivoli. Deruet may have chosen this background as an allusion to the Italian ancestry of Julie as well as to her reputation as a woman of Classical learning.[43]

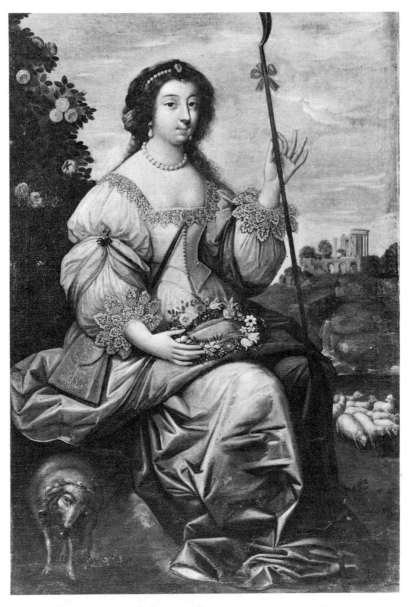

Portrait of Julie d'Angennes de Rambouillet as Astrée ca. 1645. Oil on canvas. Claude Deruet. Musée des Beaux-Arts de la ville de Strasbourg. This is an early example of a *précieuse* posing as a shepherdess for her portrait.

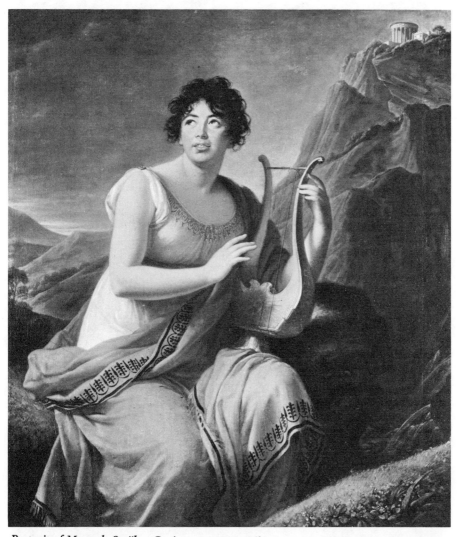

Portrait of Mme. de Staël as Corinne ca. 1808. Oil on canvas. Elisabeth-Louise Vigée-Lebrun. Musée d'art et d'histoire, Geneva. This is a replica of the original version which is in the Chateau de Coppet.

The temple of the Sibyl reappears in the famous portrait of *Mme. de Staël as Corinne* painted by Mme. Vigée-Lebrun (ca. 1808) shortly after the novel appeared. Mme. de Staël chose to follow the *précieux* mode of having herself painted in the disguise of a heroine from literature, in this case from her own novel. In a letter dated August 7, 1807, Mme. de Staël remarked to Henri Meister: "I do not know if I dare to have myself painted as Corinne by her [(Vigée-Lebrun)]."[44] Though the painting was

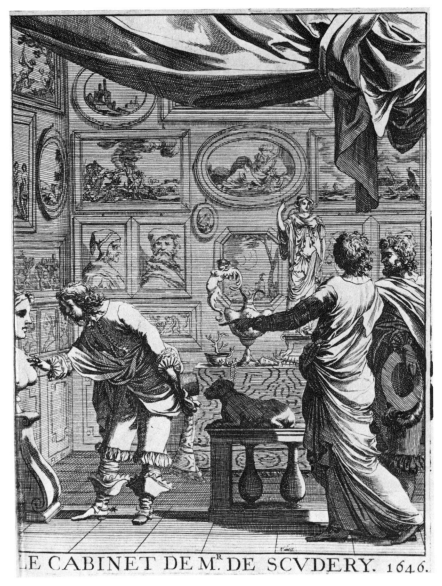

LE CABINET DE M.^R DE SCVDERY. 1646.

The Cabinet of M. de Scudéry 1646. Frontispiece engraving. The figure whose back is turned appears to be guiding two visitors through his collection.

started in Coppet, Mme. Vigée-Lebrun finished it in Paris. Writing to the sitter, the artist expressed her preference for a background of the Bay of Naples instead of the temple of Tivoli suggested by the author:

> Your steward, Madame, has informed me that your friends desire in the background of the painting the temple of Tivoli and the cascades instead of the gulf of Naples which I should wish to place in the distance. I am going to reflect on it. As I have done both of these [scenes] from nature, if this can be suited to the composition and the lines which give altitude I will follow your preference.[45]

Mme. de Staël got her wish. Posed seated with lyre in hand like an antique statue, she improvises her song against the mountainous background topped by the temple of Tivoli. We can only wonder whether Mme. de Staël was familiar with the background of the Deruet painting. Was the temple a link with *précieux* portraiture or merely a symbol for the intellectual woman?[46]

Mme Vigée-Lebrun appears to have solved her compositional problems with the background by looking at the self-portrait of Angelica Kauffmann choosing between the allegorical figures of Music and Painting, set before a rocky landscape topped by a circular Classical temple.[47] For portraits of women artists and writers, the temple of the Sibyl seemed to provide the appropriate Classical setting. The emblem is presented with full significance in *Corinne:*

> Corinne's house was constructed above the noisy waterfall of Teverone; at the peak of the mountain her garden was the temple of the Sibyl. . . . What spot could be more appropriate for the dwelling of Corinne, in Italy than the place consecrated to the Sibyl, to the memory of a woman animated by a divine inspiration! (bk. 8, chap. 4, p. 730).[48]

In the novel, the temple of the Sibyl houses Corinne's collection of paintings through which Lord Nelvil is guided by the *improvisatrice* who plays the role of *cicerone.* The description in *Corinne* of a tour of the heroine's imaginary private collection to point up the taste and the views of the collector was not an original device but had its source in *précieux* literature. Descriptions of paintings interrupted the plot in *L'Astrée. Le Cabinet de M. de Scudéry* (1646), a guide to an ideal collection written in verse by Madeleine's brother Georges, was an early example of such a tour published by a Frenchman. The *Cabinet,* a series of poems about pictures that the author owned or admired, was modeled after the *Galleria* of the Italian poet Marino, as de Scudéry announced in the introduction.[49]

Several parallels exist between the use of art in *Corinne* and in the literature of the *précieux:* not only are actual paintings referred to as

analogies or symbols of fictional characters in the mode of the *portrait déguisé,* but imaginary collections of art are described for the purpose of defining the taste of the collectors and expressing moral viewpoints. In the *Cabinet,* the author introduces himself as knowledgeable in art both of the ancient world and of his own time. Most of the works are mythological and their themes are love and courtship. The *précieux* point of view on courtship prevails, with paintings of faithful lovers like Orpheus and Eurydice, Pyramus and Thisbe, Venus and Adonis, favorite subjects. A recurrent theme is the punishment of the insistent lover depicted in paintings of the flight of Daphne, of Atalanta, of Europa, and of Syrinx. The fickle lover who causes pain is castigated in a poem on a painting of Dido committing suicide. Thus the etiquette of courtship, a central strand of *précieux* literature, is presented as a series of moral lessons illustrated in art.[50]

Though the perfect lover is expected to restrain his passion in order to win the ideal woman, passion itself was not rejected by the *précieuses.* Mlle. de Scudéry has been characterized by Antoine Adam as an "apologist of passion," who believed in directing passion not stifling it. Her concept of love derives from neo-Platonism and anticipates Romantic doctrine. Underlying her opposition to the arranged marriage was her disapproval of indifference.[51] Her novelistic portrayal of virtuous love based on respect was a civilizing ideal, far from the brutal realities facing Frenchwomen of her day. The ideal but often unattainable love between the *honnête homme* and the *précieuse* put forth in her novels was transposed into art in her brother's *Cabinet.*

Corinne's gallery is similar in some respects to the *Cabinet.* Like the *précieux* collector she has several paintings on literary love themes. Virgil's *Dido* by Rehberg, Tasso's *Clorinda* by an unidentified artist, and Racine's *Phaedra* by Guérin all illustrate the theme of tragic love. In this sense the paintings Corinne collects foretell her doom. But at the same time as they reflect the mood of the love story they also become the subject of Corinne's critical appraisal, based on Mme. de Staël's reading of Lessing, that painting is not as effective as literature in presenting narrative sequence or in expressing depth of emotion.[52]

In the tour of Corinne's gallery the paintings are interpreted as aesthetic analogies for many of Mme. de Staël's philosophical ideas. History paintings exemplify the undeserved suffering of the statesman whose loyalty brings him only sorrow. Corinne discusses three well-known paintings, David's *Brutus,* Drouais's *Marius,* and Gérard's *Belisarius.* All paintings of *exemplum virtutis,* they become illustrations of the tragic consequences of overwhelming love of country. As an exile whose outspoken opposition to Napoleon was well known, her interpretation of these paintings had special resonance. The moral lesson taught is: "in Brutus are virtues which resemble crime; in Marius,

glory, causing misfortune; in Belisarius, services requited by the blackest persecutions" (bk. 8, chap. 4, p. 731). The human misery brought about by political oppression is assuaged, according to Corinne, by religion. Thus she follows Schlegel and Chateaubriand in endorsing religious subject matter in painting.[53] In this area her taste differs from that of the *précieux* author whose interest in religious painting was minimal.

Corinne ends her tour with two landscape paintings that include allusions to history and fable, a literary requirement she demands of the genre. The paintings by George Augustus Wallis not only have literary or historic themes but are interpreted as visual evidence supporting the culture-climate theory on which the novel rests. A southern landscape of Cincinnatus exemplifies the culture of the South and is contrasted with a northern scene from Ossian. A contrast between the sunny, southern landscape of Italy and the northern vaporous landscape of Scotland serves to illustrate her own theory of the dichotomy between northern and southern culture. Like the paintings, the visitors to the gallery, Corinne and Oswald, stand for the southern Classical culture of Italy as opposed to the northern Ossianic literature of Scotland.

While the imaginary collections of Georges de Scudéry and Mme. de Staël both provide thematic interpretations of art, and both reveal the rather conservative taste of the collector, they also reflect the salon worlds whose taste they record. The *précieux* circle's concern with problems of amorous etiquette is apparent in the moral lessons drawn from the art in de Scudéry's *Cabinet*. Similarly Corinne's temple of Sibyl displays important history paintings in which conflicts between private conscience and public duty are held up to scrutiny. Mme. de Staël's choice of paintings and her comments reflect the upheavals in her native land and her status as an exile. Furthermore, the difference between the two collections indicates the change in function of the salon between the seventeenth and the eighteenth centuries. This change was noted by Mme. Necker who said: "Women speak of the constitution with the same warmth with which they analyzed sentiment at the hotel de Rambouillet."[54]

Though the conversation in her salon had broadened considerably since the time of the blue chamber, still Mme. Necker as salon hostess continued to play the role originally established by Mme. de Rambouillet as taste maker of her circle. Diderot, a frequent caller at her "Fridays," submitted to his hostess his art *Salons* before publication. This compliment to Mme. Necker's taste in the field of art may not have been entirely lost upon her daughter, who endowed Corinne with the expertise in art that had traditionally been associated with the *salonnière* since the seventeenth century.[55]

Perhaps in part inspired by the *Cabinet* of her brother, Madeleine de

Scudéry had included several descriptions and evaluations of paintings in her novels. However, her interest was aroused more often by architecture and gardens than by painting. The tasteful house and gardens of Mme. de Rambouillet were much admired by her circle of friends and were described in the *Grand Cyrus*.[56] But while Mlle. de Scudéry paid tribute to the refined taste of her friend as evidence of the sensibility of the educated woman, she seems to have believed that descriptions of the beauties of the wider world had educational value for her readers, and that, like travel, literary descriptions of foreign monuments were instructive.

In the *Promenade of Versailles* (1669) she showed the palace of Louis XIV to a visitor from abroad, "the beautiful foreigner." While the background material for her novels was generally derived from the writings of historians and travelers of the past,[57] in the *Promenade* she observed and recorded the palace firsthand. In the opening of the *Promenade*, as she took on the role of *cicerone* herself, she drew attention to the important function she was performing. Since the *Promenade* was the introduction to *Celinthe*, a novella, she felt called upon at the very outset to justify the lengthy description of a real place in imaginative literature. She pointed out that from Homer to Ariosto depiction of real monuments served to instruct the reader. Furthermore, real backgrounds lent an "air of truth" to the tale. But beyond the educational and literary value, she emphasized the importance of such documentation for posterity: "If someone who knows how to write describes Versailles well, have no doubt that this description will be useful to posterity in understanding the construction of this palace where so many great designs were conceived."[58]

Although the tour leader is anonymous, it is made clear that she is a fictional incarnation of Mlle. de Scudéry. She pauses on the walk to answer, in the mode of her *précieuse* creator, questions of courtship decorum addressed to her by two young cavaliers whose verses on the subject she reads, and she even refers to *Clélie* in the course of conversation. These hints as well as the use of the first person in the narration identify the author as the guide. Having attended a fête in July of 1668, Mlle. de Scudéry lets her readers know that she has been honored by an invitation to the king's new palace. By taking the role of the guide herself, she renders a modest thank-you to the king and at the same time sets the tradition for the *femme auteur* as *cicerone*.

The tour of Versailles presents Louis XIV's new palace as the embodiment of the king's genius, displaying at once his virtue as an *honnête homme* and his triumph at "embellishing nature with art." Tribute is paid to his support for the arts, his establishment of the academy, and his interest in natural science. One sight that arouses the astonishment and praise of "the beautiful foreign woman" is the "galerie

de Dames," a series of portraits ordered by the king shortly after 1660 and installed at Versailles at the time of the *Promenade.* Painted by the Beaubrun brothers, favorites of the *précieuses,* these portraits indicate continuation of the galleries of famous women so popular earlier in the century. The visitor admits that there is nothing like the "Gallery of Ladies" in her country.[59]

Like Mlle. de Scudéry's "beautiful foreigner," Corinne's tourist is a melancholy visitor, but in contrast to the visitor to Versailles who marvels at Louis XIV's grand conception, Oswald fails to respond to the monuments of ancient Rome. Governed by rigid moral principles, he denigrates the architectural ruins of Rome as reminders of ancient decadence. To the half-Italian Corinne, these remnants of the ancient world are emblems of the survival of artistic genius beyond the life span of temporal power. Though Corinne continually tries to communicate her belief in the triumph of genius in art through the masterpieces and monuments of Italy, Osward is incapable of sharing her enthusiasm. Her first *chant* celebrated the literary and artistic glories of Italy. In her final song, she bemoans having given up her genius for an unworthy love.

Though Oswald fails Corinne as both lover and pupil, he is still an attentive listener. Spellbound by her eloquence he follows her from Rome on sidetrips to Pompeii and Naples. Her lectures inspired by historic places reach beyond the landscape of Italy to treat a broad range of topics. Many of the subjects on which Corinne discourses recall themes from the writings of Mlle. de Scudéry. Both authors celebrated the capacity to understand the arts—literature, music, and the visual arts—as essential for the educated person. Since literature was their primary interest, they share a predilection for interrupting their narrative with literary criticism. Mlle. de Scudéry's "History of Hesiod" in *Clélie* anticipated the chapter on Italian literature in *Corinne.* As a well-educated woman, Mme. de Staël, as Mlle. de Scudéry before her, showed concern over the illiteracy of her sex and urged women to develop their intellectual potential. The two writers were united in expressing feminist scorn for husbands who prefer uneducated wives.[60] Their concern with feminine education may have been one of the reasons these authors chose the love novel format, which assured them a reading audience of women.

Since the seventeenth century, the *femme auteur* had used the love novel as her literary form. The concept of the love novel unfolding against the background of a grand and distant place, which we see in *Corinne,* began in the very early examples of the genre, *Cyrus* in Persia and *Clélie* in Rome. The unfamiliar settings of these novels supplied an element of exoticism demanded by Romantic taste, but in the hands of the two novelists exoticism came under a purposeful restraint. Even

before Mlle. de Scudéry wrote her famous novels she had already enunciated in her preface to *Ibrahim* (1641) the aesthetic of *la vraysemblance*. For the writer of imaginative literature Mlle. de Scudéry paraphrased Horace's rule of mixing the lie with the truth as the effective method of creating a believable story. She declared that in order to give her own works a believable setting, however outlandish the locale, she had observed the details of local color: "I have observed the customs, the costumes, the laws, the religions and the tastes of the population."[61] Mlle. de Scudéry's list of the elements that she had observed in order to give an authentic background to her novels closely parallels the local color in *Corinne*. Mme. de Staël described not only the monuments and landscape of Italy, but the customs, the religion, the dress, and the character of the Italians she observed. Thus Mme. de Staël included in her novels many of the elements of *vraysemblance* identified by Mlle. de Scudéry.

The opening scenes of *Corinne* also reflected the views of Mlle. de Scudéry. Although Mlle. de Scudéry criticized the excessive use of the miraculous in telling a story, an example of which was the device of numerous shipwrecks in Greek novels, still she used disaster scenes in moderation to establish at the outset the courage of her hero.[62] *Cyrus* begins with the taking of Sinope by Cyrus who then nobly helps the inhabitants to put out the fire that threatens to destroy the city. The blaze is followed by a tempest that destroys the ship on which Cyrus's beloved Mandane has been abducted. Mme. de Staël reverses the two disasters in book 1 of *Corinne*, entitled "Oswald." The hero makes his appearance in the novel as a man of action. He pilots his ship through a storm at sea and then on landing puts out a raging fire in Ancona. These episodes in *Corinne* have been puzzling to modern critics. Ellen Moers states, "For no apparent novelistic reason, Mme. de Staël sets fire to Ancona."[63] The explanation appears to be that Mme. de Staël was following the method of Mlle. de Scudéry in introducing her heroine's lover in a properly heroic fashion. Not only are the disasters Oswald survives similar to those of Cyrus, but he even manages to save a group of Jews from death just as Cyrus did. Thus both heroes are shown to have the virtue of religious tolerance. After his courageous exploits in book 1, Oswald lapses into passivity as *honnête homme mélancolique* to whom Corinne lectures on the wonders of Italy.[64]

Though the setting and plot of *Corinne*, as has been seen, owe much to the writings of Mlle. de Scudéry, Mme. de Staël never acknowledged her debt to the earlier *femme auteur*. Her reticence on this point is not surprising. The reputation of Mlle. de Scudéry had been badly damaged by Molière and was not to be refurbished until 1850 when Victor Cousin reexamined her *Cyrus*. Mme. de Staël may have been referring to Molière's treatment of the *précieuses* when she called attention in *On*

Literature to the problems facing talented women who are discouraged by accusations of pedantry or assailed by mockery.[65] She had acted in Molière's *Les Femmes savantes* and was likely aware of Beckford's sneering description of her mother as a *"précieuse-ridicule"*; her experience might have made her loath to admit the strong impact on *Corinne* of Mlle. de Scudéry's life and works.

Despite her reluctance to acknowledge her borrowings from Mlle. de Scudéry, it is evident that in both style and content her novel followed in the tradition of Mlle. de Scudéry's work. Both authors forced their philosophical thought into the format of the love novel that had served as the traditional literary form for women writers. In *On Literature* Mme. de Staël perceived the love novel as an expression of feminine sensibility. She traced the development of the love novel by women writers to the winning of social equality for their sex: "In reading books composed since the renaissance of letters, one should note on each page the ideas that would not have been expressed before women were accorded civil equality."[66] Her insistence on the close connection between the post-Renaissance love novel and women's literary ideas demonstrates her cognizance of the *précieuse* tradition. What could be more natural for her in seeking a model for *Corinne* than to look back to the love novels of the seventeenth century, especially those written by the preeminent woman writer of that age? There, I believe, she found an exemplar for the interweaving of fictional romance and moral instruction.

Sainte-Beuve in his essay on Mlle. de Scudéry recognized the stylistic problems of the interweaving of passion and precept in the format of the novel. He described Mlle. de Scudéry's method as transforming "the delicate" into "the didactic" through her penchant for analysis and classification and gave her the rather patronizing title of "governess" of society. Mme. de Staël in *Corinne* followed the tradition of Sappho. The lovers who caught the imagination of her readers probably interested the author less than the ideas she was able to expound through their dialogue. Their tour of Italy is accompanied by the lecture as well as the lyre. Sainte-Beuve's metaphor for Mlle. de Scudéry's pursuit of ideas in the course of her romantic novels might well describe Corinne's wanderings through the Italian landscape: "in the middle of the parks and gardens which she described, she took care to always place an *écritoire*."[67]

3

Terpsichore and Corinne
Two Nineteenth-Century Muse
Portraits

In the seventeenth century the *précieuses*'s taste for literary portraiture in the *romans à clef* of Mlle. de Scudéry paralleled the popularity of the *portrait déguisé* in art. Added to the artist's standard repertoire of goddesses for allegorical portraits were a variety of new figures: heroines from past French history and shepherdesses from pastoral romances. Later the salon game of composing literary portraits of intimate friends became a favorite pastime that continued into the eighteenth century, when the future author of *Corinne* was personified by an admirer as a "priestess of Apollo." As we have seen Mme. de Staël's literary self-portrait in her novel looked back to the tradition initiated by Mlle. de Scudéry of the *femme auteur*'s portrayal as an ancient poetess. This image of the literary woman was to have tremendous impact on both art and literature in the nineteenth century. *Corinne* reinforced the aspirations of young women writers in France and also set the style for portraits in painting and sculpture. These artistic images, which recalled antique statuary, were perfectly suited to the Neo-Classical style then in vogue.

One of the "ladies with the lyre" that appeared in the early nineteenth century was Canova's marble portrait of Lucien Bonaparte's wife Alexandrine as the Muse Terpsichore, an elegant emblem for an aspiring French poetess. The derivation of the pose from a Roman Muse sarcophagus suggests associations with pagan belief in the heroization of the contemplative life. In *Corinne* Mme. de Staël had emphasized the relationship between ancient images of death and philosophical ideas of the apotheosis of man, and she had related the pagan celebration of the

arts to the central theme of her novel: the triumph of genius over temporal power. This theme had special meaning for Lucien and Alexandrine Bonaparte, who, like the author, had been exiled from France by Napoleon.

Canova sent his statue of the Muse Terpsichore to be exhibited in Paris at the Salon of 1812; in 1816 he made a second version, now in The Cleveland Museum of Art, for the English collector Simon Clarke. When the original statue was first shown, it drew praise from art experts for the meticulous execution of the draperies. "The beautiful draperies . . . are the object of admiration of the connoisseurs," wrote the critic Henri de Latouche in his *Oeuvre de Canova.* He described the Muse as "a response from Canova to the critics who accused him of lacking nobility in the arrangement and the draperies of his figures. . . the draperies of the Terpsichore are refastened under the bosom by a picturesque knot; both the crossing of the legs and the raised left foot give to all the pleats a novelty and a grace that no one has ever rivalled."[1] Latouche writing in 1825 did not mention the origin of *Terpsichore* as a Muse portrait of Mme. Alexandrine Bonaparte.[2] However, in 1812 many of the Salon visitors who gathered around the statue were less interested in the marble's aesthetic qualities than in its model, for the *Terpsichore* was known to have originated in an allegorical portrait of the woman who had come between Napoleon and his brother Lucien Bonaparte.[3]

In 1803, while Napoleon was planning to arrange the marriage of the widower Lucien with the Spanish infanta and thereby establish a royal lineage, Lucien, against his brother's expressed wishes, secretly married Alexandrine Marie Laurence de Bleschamp, the divorced wife of a failed businessman, M. Jouberthon. The marriage aggravated an already strained relationship, and though it is uncertain whether Napoleon officially exiled Lucien, he was probably relieved when the couple retired to Italy. On hearing of the scandalous political murder of the Duke of Enghien, Lucien said to his wife in his customary theatrical style, "with the gesture of a togaed senator who braved Tiberius: 'Alexandrine, let us go away, he has tasted blood.' "[4]

In April 1804 they departed for Italy where Lucien occupied himself with writing and collecting art. From 1805 to 1807 Napoleon made several unsuccessful attempts to convince Lucien to annul his marriage and take an active role as prince of France. Napoleon's famous words, "Everything for Lucien divorced, nothing for *Lucien without divorce,*" fell on deaf ears. Lucien refused to give up Alexandrine for political reinstatement.[5] Lucien, an avid collector of antique marbles and "Etruscan" vases as well as of Renaissance paintings, found life in Rome to his taste. He purchased a country estate at Tusculum for his writing and his researches in archeology and astronomy, and a Roman palace for

Terpsichore 1816. Marble. Antonio Canova. The Cleveland Museum of Art, Purchase, Leonard C. Hanna Jr. Bequest. This is a later version of *Terpsichore* executed for Simon Clarke.

his amateur theatricals. Alexandrine, whose wit and beauty had drawn admiration in many Parisian salons,[6] now invited Roman aristocracy to her home where she performed on the stage with her husband to an audience of some two hundred people, who ranged from cardinals and princesses to such young artists of promise as Ingres.[7] Lucien delighted in the discomfiture of the diplomats in the audience when he played in Voltaire's tragedy *Zaïre*, the role of Orosmane to Alexandrine in the title role. Refusing the ransom asked for Zaïre, Lucien in the role of the sultan spoke Voltaire's words with a personal emphasis: "Her price is not within your power."[8] His undisguised declaration of loyalty to wife and defiance of his brother was greeted with applause from the audience—and later with consternation from the French legation in Rome.

During his stay in Rome Lucien devoted himself to the arts. A discriminating collector, Lucien managed to put together a remarkable collection of High Renaissance and Baroque paintings and antique statuary. Earlier, while still in favor as Napoleon's representative in Madrid, he had acquired important Spanish paintings. Now though estranged from Napoleon, he was able on his own, to garner some of the masterworks owned by the Giustiniani family, which had fallen on hard times.[9] At the same time he excavated on his property for fragments of ancient statuary and embellished his gardens with his finds. Perhaps in commemoration of the ancient resident of Tusculum, Cicero, as well as of his own literary aspirations, Lucien designed his garden as a shrine to poetry. A small hill became Mount Parnassus, crowned by statues of Apollo and the nine Muses copied in Carrara after the antique. Leading to Parnassus was a pathway lined with busts of poets arranged in ascending order as determined by Lucien's literary tastes.[10]

While creating a new Parnassus in his garden, Lucien, who later was given the papal title of prince of Canino, embarked on a career for which he was to be dubbed satirically by Henri de Latouche "the prince of poets," a reversal of Virgil's title "the poet of princes."[11]

In 1807 when Lucien began composing an epic poem of twenty-four cantos, *Charlemagne, or the Church Delivered*, he had the honor of reading the opening cantos to the pope. He recorded this experience in his *Memoirs*, noting that it reminded him of Virgil reading the *Aeneid* before Augustus and Livia.[12] With his enforced retirement from the stage of contemporary history, Lucien's penchant for self-dramatization led him to play roles inspired by Classical literature. Though his recitations in Rome met with polite applause, his finished poem was ignored in France. Napoleon in 1816 saw his brother's literary efforts as wasted and called his desire to write poetry "a forced vocation."[13]

It was also in 1807 that Alexandrine began a career as a poet. With

wifely modesty she composed her poem, *Batilda, Queen of France*, on a somewhat smaller format of twelve cantos.[14] A cousin of Lamartine, she now became a poet herself in addition to her duties as wife and mother. Curiously, her twelve cantos matched the number of children she was to produce during her lifetime, ten of the dozen belonging to Lucien.[15]

In 1807 or 1808 at the time of the debut of the couple as poets, Lucien paid tribute to his wife's literary talents by commissioning her portrait as a Muse by Canova. This portrait in which Alexandrine was to appear as the Muse Terpsichore belongs to the portrait motif discussed by Mario Praz in *On Neoclassicism*.[16] The popularity of this motif, which Praz called "the lady with the lyre," was enhanced by the immediate success of the novel *Corinne, or Italy*, in 1807. By 1808 Jane Austen was already telling her friends to read the English translation. *Corinne*, like Mme. de Staël's earlier novel *Delphine* of 1802, tells the story of an extraordinary woman who does not fit the submissive role convention had decreed for her. The heroines of both novels lose their lovers to more conforming women and die unhappily.

Although Corinne and Delphine lose their lovers in the end, thoughout the novel these extraordinary women exert a powerful attraction on the men they love. The central problem of the novel *Corinne* concerns the woman author's desire to be loved as well as admired. Corinne tells Oswald, Lord Nelvil, the man she loves: "Yet, in toiling for celebrity, I have ever wished that it might make me beloved."[17] The novel asks the question: Can a passionate poetess from Rome find happiness as a wife of a rich and melancholy Scottish lord? The answer is no: the Scottish lord, though spellbound by the dark Corinne, ends by marrying a blond. Lucile, the blond English girl, who represents Nordic culture in opposition to the Latin Corinne, wins the hero by her demure nature.[18]

Corinne, an idealized self-portrait of the author, is a passionate *improvisatrice* who sings her poetry to the chords of the lyre, and she dances as the ancient lyric poetesses did. Mme. de Staël relates Corinne's dance to Classical art: "Corinne was so well acquainted with antique painting and sculpture that her dance brought to mind the girls of Herculaneum." The dancing girls depicted in the frescoes of Herculaneum, unearthed some fifty years earlier, were favorites of Winckelmann, the German and art historian whose taste formed Mme. de Staël's.[19]

When Mme. de Staël had her own portrait painted by another famous woman, an artist and salonière of France, Mme. Elisabeth Vigée-Lebrun (herself a devotee of Classical dress and decor), she appeared as Corinne, looking heavenward for inspiration as she plucked the lyre.[20] Mario Praz calls this portrait of Mme. de Staël as her own heroine

the most significant, if not the first, representations of "the lady and the lyre." This Muse who, garbed in a tunic and a peplum adorned with a border of anthemions, raises her inspired eyes to heaven as she touches her lyre, while to her right rises a steep mountain crowned with a Greek temple, is Mme. de Staël.

The portrait set the vogue among women whom Praz describes as having "even the slightest talent as poetess or singer" to demand "the right to a portrait in the garb of a Muse with a red mantle, a laurel crown, and an elegant lyre . . . for her the appropriate background was not the anonymous garden, but the slopes of Parnassus."[21]

At the about the same time as Mme. de Staël was having her portrait painted as Corinne, Lucien Bonaparte decided to have Alexandrine sculpted as a marble Muse. Precedents existed in ancient statues dedicated to talented women like the Greek poetess Corinna, which Landon had mentioned in his *Annales du Musée* of 1802.[22] Madame de Staël, who had compared her heroine Corinne to a Grecian statue, was also to have her image rendered in marble by the German sculptor Christian Friedrich Tieck, brother of the poet Ludwig Tieck. During her stay in Rome in 1805 she had already commissioned him to make a bas relief for the tomb of her parents. In the autumn of 1808 Tieck made a marble bust of the author, with her hair drawn up in a ribbon à la Grecque. A second bust by an anonymous sculptor represented Mme. de Staël as a Muse.[23]

Such a portrait was Lucien's wish for Alexandrine. Having created the proper Parnassian setting for his wife-turned-Muse, Lucien now commissioned the full-length marble statue from Antonio Canova (1757–1822) in whose studio a few years earlier he had seen again his old friend Mme. de Staël.[24] In 1805 during her visit to Rome, a visit that formed the basis of the first part of *Corinne*, Mme. de Staël renewed her friendship with Lucien, a frequenter of her salon in Paris in happier days before both of them were exiled by Napoleon.[25] The scene of their meeting, Canova's studio, reappeared in the novel as one of the sights of Rome where "the statues gained much from being seen by torchlight."[26] The fictional Corinne's admiration for Canova's work is a reflection of Mme. de Staël's enthusiasm. In the novel Corinne detects a resemblance between Oswald, Lord Nelvil, and "an exquisite figure intended for a tomb." The resemblance between the statue and Oswald "with which the artist himself was struck" underlined the melancholy character of the Scottish lord at the same time as it pointed up Corinne's sensibility.[27]

Canova, who responded so agreeably to Corinne's fictional visit, was well liked by the French living in Rome. When Lucien brought Alexandrine to visit the studio and they looked at Canova's colossal

statue of Napoleon, the sculptor remarked with understanding on the harsh treatment Alexandrine had received from her brother-in-law.[28] Certainly Napoleon, who had been angered by Lucien's bestowal of the Bonaparte name on Mme. Jouberthon, would hardly have been pleased with his now calling on Canova to create a work that would elevate her for posterity to the status of an immortal.

Besides the presumption of choosing the favorite sculptor of the Bonaparte family to immortalize a woman still considered by the emperor as an unwelcome intruder, a further irritant would have been the literary source, a novel written by a *femme auteur* whom the emperor could not tolerate. Napoleon had justified his order to Mme. de Staël to stay forty leagues outside of Paris with the explanation that "he left the rest of the world to her, and only reserved Paris for himself."[29]

Mme. de Staël's Paris salon had been a center for the opposition, and she recorded Lucien's presence there on the eve of Benjamin Constant's warning of "the dawn of tyranny."[30] Lucien recalled in his *Memoirs* the discussion he and his brother Joseph had with Napoleon in 1803 on the subject of Mme. de Staël. Napoleon expressed his general antipathy to intellectual women and his particular annoyance at Mme. de Staël's salon repartee. He remembered with fury her retort to Talleyrand's warning to be discreet in her comments on Napoleon's government. Mme. de Staël had answered Talleyrand, one of her past admirers, with these defiant words: "Genius is also a power."[31]

It was this view, that genius equals or surpasses temporal power, that the outspoken author promulgated in her novel *Corinne*. The magnificient ruins of Rome commemorating the rulers of ancient times served as a foil to the triumph of genius. Thinking of the past when eloquence had outshone military power, Corinne pointed to the Aventine Hill with these words: "Thither the orators of Rome walked from the forum: there Caesar and Pompey met like simple citizens, and sought to conciliate Cicero, whose independent eloquence was of more weight than even the power of their armies."[32]

Corinne's view of the independence of genius and its power to rise above political tyranny reflected Mme. de Staël's resistance to Napoleon. Lucien, who had used his eloquence to bring his brother to power, now played the role of a modern Cicero. The novel enunciated a view of Rome that could be interpreted as justifying Lucien's abdication of temporal power in favor of a solitary life dedicated to the arts.

In Corinne's many hymns to liberty, Mme. de Staël veiled only slightly her denunciation of tyranny. Yet the political aspect of the novel was not generally acknowledged by her readers. The book was popular for its romance, and the tragic heroine drew the admiration even of

some of Napoleon's generals.[33] Mme. de Staël's ideas on the triumph of genius over tyranny were overshadowed by the passionate love story.

Napoleon, who predictably called the novel trash when it first appeared, may have understood its meaning. In 1808 he said to the statesman and man of letters, Fontanes, "There are only two powers in the world, the sword and the mind. . . . In the long run the sword is always defeated by the mind."[34] He was to revise his opinion of *Corinne* on St. Helena when he made another attempt to finish the book. But though he was more charitable on a second reading, his difficulty in reaching the end perhaps grew from the insistent presence of the author. Napoleon complained: "I see her, I hear her, I feel her, I wish to avoid her, and I throw away the book. . . . However, I shall persevere: I am determined to see the end of it; I still think that it was not destitute of some interest."[35]

Lucien and Napoleon had different tastes in both books and in women. In his *Memoirs* Lucien proudly recalled defending Mme. de Staël to Napoleon: "Permit me to say that Mme. de Staël in matters of intellect has no equal in her sex and scarcely in ours."[36] In his decision to immortalize his wife as a marble Muse Lucien demonstrated that he, unlike his brother, admired women of wit. Alexandrine's ability to combine literary talents with domestic ones recalled the fictional Corinne who was presented in the novel in this double aspect.[37] To Lucien, this description may have appeared appropriate for Alexandrine who was producing children at the same time as she was composing poetry.

In the novel Corinne appears for the first time on her way to her coronation at the Capitol. Mme. de Staël presents Corinne garlanded as a poetess of Rome in a scene based on the author's reception as an honorary member of the Academy of Arcadia in Rome. Mme. de Staël's description of the crowning as harking back to "the days of Sappho," served to draw the reader's attention to the high esteem of women writers in ancient days. Writers in the *Greek Anthology* had called Sappho the Tenth Muse, and it was this literary compliment that lay behind the recognition of women writers as "Muses" of the academy.[38]

Although the fictional Corinne receives her laurel wreath like "a priestess of Apollo," Mme. de Staël does not specify which of the nine sisters Corinne most closely resembled. However, Corinne's famous shawl dance in which she appears like "the girls of Herculaneum" suggests an association with Terpsichore, the Muse of lyric poetry associated with dance.

Besides these literary sources for connections between the fictional Corinne, the historical Corinna, and the Muse of lyric poetry, Terpsichore, Mme. Vigée-Lebrun's portrait of Mme. de Staël supports a

Study of the Side Relief from Louvre Sarcophagus, Showing "Socrates Seated and a Muse." Pencil. Antonio Canova. Museo Civico, Bassano del Grappa. Photograph courtesy of Cini Foundation, Venice.

Fragment of Roman Muse sarcophagus from the studio of Antonio Canova. Marble. Photograph courtesy of Deutsches Archaeologisches Institut, Rome.

visual association of Corinne with Terpsichore. In the painting Mme. de Staël plays on the small lyre that had been associated with Terpsichore since ancient times. A possible visual source for the painting is a seated Muse statue from Tivoli with a tortoise-shell horned lyre in the Louvre collection illustrated in Landon's *Annales du musée* of 1800. Landon identifies this Muse as Terpsichore and distinguishes her from Erato, the other Muse of lyric poetry. A lyre is a visual attribute of both of these Muses, but Landon associates the small tortoise-shell lyre with Terpsichore.[39] Mme. Vigée-Lebrun in giving *Mme. de Staël as Corinne* the small lyre to play was associating the heroine of the novel with Terpsichore, presumably with the understanding and approval of the author.

Canova, in choosing the subject of his statue *Terpsichore Lyrans*, the Muse of lyric poetry, probably referred to late Roman frescoes that identify Apollo and the nine Muses by inscription and attribute and support the association of Terpsichore as Muse of lyric poetry (dance) with the small lyre, in contrast to Erato, Muse of lyric poetry (choral hymns) with the large kithera. It is probable that Lucien knew of these frescoes also since Napoleon had offered them to his brother Joseph in 1802.[40]

The critic Quatremère de Quincy who first indicated the same wall paintings as a source for the title of *Terpsichore Lyrans* of Canova's statue also attempted with difficulty to find the source for the pose in ancient sculpture. Although he thought Canova was inspired by the Muses from Tivoli in the Vatican collection, he was puzzled by the lack of resemblance to pose, motif, and draperies between those statues and Canova's.[41] Some drawings by Canova of the Muses from the Louvre Muse sarcophagus indicate Canova's interest in relief sculpture on sarcophagi as a source for the *Terpsichore*.[42] Henry Hawley has pointed out the close relationship of the Muse with scroll in one of Canova's drawings of the Louvre sarcophagus to the *Terpsichore* in both the position of the legs and the arrangement of the draperies.[43] The pose with legs crossed appears also on the two end reliefs of the Louvre sarcophagus showing seated "Socrates" with Muse and seated "Plato" with Muse. These reliefs appear also to have been drawn by Canova.[44]

The pose of the upper portion of Canova's *Terpsichore* statue, with head turned away from the lyre, left hand on the instrument and right arm extended along her side, the plectrum (now lost) grasped in her hand, is found in modified form on several Muse sarcophagi, six of which were accessible to sculptor and patron in Roman collections.[45]

Canova not only drew Muses from sarcophagi as his drawings of the Louvre sarcophagus indicate, but he also collected fragments of Muse sarcophagi which he kept in his studio. One of these ancient fragments shows the sharp turn of the head to the right and the drapery rolled in a

band and knotted under the bosom as in the *Terpsichore*.[46] The choice of the pose of *Terpsichore* with her head turned away from the lyre as though listening rather than playing suggests poetic inspiration, an aspect of genius emphasized in the novel *Corinne*. Countess Albrizzi had described the pose in these words: "The turn of her head, and her look, expressed all that gentle ecstacy in which the mind is held, when under the enchanting influence of music."[47] Such a description would be appropriate to the portrayal of the inspired Corinne. Mme. de Staël emphasized the poetess's "enthusiasm" (possession by a god), and in Corinne's song at Capo Miseno she speaks of the power of genius to hear the harmony of the spheres, the celestial music made by the ancient Muses:

> Genius doth catch the music of the spheres,
> Which mortal ear was never meant to know.
> Genius can penetrate the mysteries
> Of feeling, all unknown to other hearts;
> A power hath entered in the inmost soul,
> Whose presence may not be contained.[48]

One of the reasons for the appearance of Muses on sarcophagi was this magical ability through the celestial music to provide a pathway to the stars, to offer immortality to the soul. The Muses not only presided over music, dance, and poetry, but also over the sciences, including mathematics and astronomy. According to Pythagorean doctrine, Apollo at the center of the universe drew souls toward him after death. His sacred animal, the winged gryphon, which appears at his feet on many Muse sarcophagi, carried the shade to the stars on a path through the planets indicated by the chorus of the Muses. Plato, who took up the Pythagorean doctrine of the musical structure of the universe, spoke in his *Timaeus* and *Phaedrus* of the philosopher's wisdom as allowing him to share in immortality.[49] The idea reappeared in Roman literature. Virgil in the sixth book of the *Aeneid* describes the Elysian fields as open to those who have dedicated themselves to culture and the arts. In the "Dream of Scipio" from Cicero's *Republic*, immortality is offered to men of learning and wise statesmen. After describing the harmony of the spheres, the shade of Scipio's grandfather, Africanus, tells him:

> Some men of skill by imitating the result [of the movement of the spheres] on the strings of the lyre or by means of the human voice have laid open for themselves a way of return to this place, just as other men of lofty souls have done the same by devoting themselves during their earthly life to the study of what is divine.[50]

In the third century, Plotinus, expounding the concept of the heroization of the contemplative life, spoke of immortality bestowed on

people dedicated to the liberal arts and culture. The appeal of Plotinus's philosophy during the political turmoil of the third century is demonstrated by the many images of elevation to a celestial life on Muse sarcophagi made during his lifetime. In these third-century sarcophagi the dead man, as a philosopher seated with a scroll as attribute of his learning or magistry, is coupled with a Muse symbolic of his particular interest in the arts. Eventually, according to Bieber, the Muse becomes a portrait of the dead man's wife.[51] The dead couple sometimes sit facing each other as on the Vatican sarcophagus dated A.D. 230 to A.D. 250, where the seated couple appear with eight Muses. Differentiated from them by her Roman hairstyle, the wife, who holds a lyre of the Terpsichorean type, would, if counted with the eight standing women, be assimilated to the ninth Muse. Numerous sarcophagi with seated couple and one or more Muse are extant.[52] Another example of a portrait of a Roman couple with eight Muses appears on the sarcophagus from Villa Torlonia dated A.D. 250 to A.D. 260, where the standing woman poses as Polyhymnia leaning on a plinth with a scroll in one hand and her legs crossed in the manner Canova used on his *Terpsichore*. She appears to be listening to her husband seated with a scroll open between his hands. They are clearly differentiated as portraits from the other figures. In addition to the couple, six Sages appear and eight Muses. In order to reach the traditional number of seven Sages and nine Muses, one would have to count the portraits of husband and wife, thereby elevating them both above their mortal status. Again this type of portrait couple appears on many other sarcophagi, although generally accompanied by only one or two Muses.[53]

Although some of the visual details of these sarcophagi can be related to Canova's *Terpsichore* (for example, the crossed legs of the standing Muse type and the small lyre held in the hands of the seated Muse type), more important for Lucien and Alexandrine is the pairing of the Muse portrait with the Sage-philosopher portrait and the elevation of both husband and wife as members of a literary or intellectual elite. The celebration of the learned couple on many extant Muse sarcophagi may have inspired Lucien to ask Canova to exalt Alexandrine from a Roman poetess to Muse.

These sarcophagi offered Lucien an archeologically accurate visual source for the Muse portrait of his wife à la Corinne. Perhaps, too, the cultivated brother of Napoleon thought of himself as a philosopher-magistrate in the pose of a seated Sage. In 1807–8 when the young Ingres drew the portrait of Lucien Bonaparte, one wonders whether the domineering sitter suggested the pose to the artist, a newcomer to Rome whose letters attest to his trepidation in dealing with one of the city's most influential patrons.[54] Seated on an ancient cinerarium with his legs crossed and his cloak draped behind him in the manner of the Sage on the right in the Torlonia relief (and reminiscent also of Canova's

Sarcophagus relief: *Seated Couple and Eight Muses.* Marble, Rome, ca. 230–250 A.D. Pio Clementino Museum, Vatican, Rome. Photograph courtesy of Deutsches Archaeologisches Institut, Rome.

Relief from sarcophagus of L. Lucius Peregrinus: *Couple with Six Sages and Eight Muses.* Marble. Rome. ca. 250–260 A.D. Villa Torlonia, Rome. Photograph courtesy of Deutsches Archaeologisches Institut, Rome.

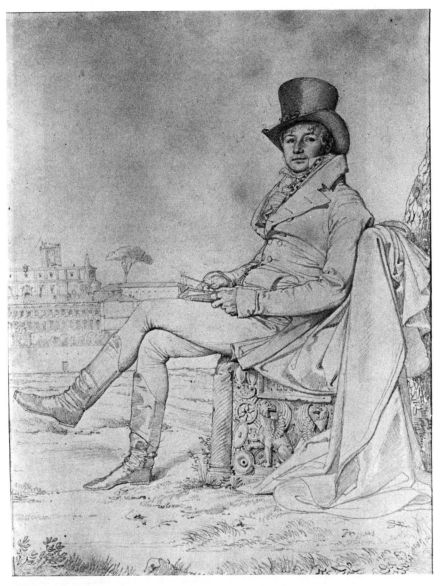

Portrait of Lucien Bonaparte, Later Prince of Canino. Graphite on white wove paper.
Jean Auguste Dominique Ingres. Private collection.

drawing), Lucien looks up from his book. With a thoughtful expression he appears ostensibly as a studious collector of antiquities seated in a Roman landscape. In 1807 in his *Memoirs* Lucien described himself as "exempt from all ambition, at least of the kind to which my brother Napoleon, in his munificence desires to associate me. . . . I wait no longer for anything from him if it is not the tranquility necessary for me to cultivate the literary laurel."[55]

Lucien may well have intended the portrait as an emblem of his new life. As an exiled statesman who tended Cicero's property and gave up political power for the contemplative life of an archeologist, an amateur astronomer, and poet, he may have imagined himself as a modern Scipio in the Ciceronian mode. Mme. de Staël had drawn a parallel between Cicero's time and Napoleon's when in Corinne's chant given at Capo Miseno she emphasized the Ciceronian dream of apotheosis of the persecuted statesman. Corinne celebrates the memory of three great men: Cicero, Scipio, and Marius. Fallen at the hand of the tyrant, these statesmen will be "consoled by apotheosis":

> Cicero 'neath the tyrant's dagger fell,
> But Scipio, more unhappy, was exiled
> With yet his country free. . . .
> Marius found a refuge in yon marsh,
> near to the Scipio's home. Thus in all time
> Have nations persecuted their great men.
> But they enskied them after death.[56]

The theme of apotheosis of man had been sounded earlier in the book when Corinne and Oswald wandering through the Vatican Museum came upon "the antique sarcophagi" that "teem, but with martial or joyous images." Corinne explained to Oswald that "emulation was the reigning principle in art as in policy; . . . and genius was worshipped even by those who could not aspire to its palm. Grecian religion . . . required glory and triumph; it formed the apotheosis of man."[57]

Mme. de Staël's thoughts on the apotheosis of great leaders were probably derived from Cicero's writings. However, her mention of artistic apotheosis on sarcophagi reliefs suggests that she was aware of the vision of immortality on many of the Muse sarcophagi excavated in Rome. Her crowning at the Capitol in *Corinne*, a literary record of her own "apotheosis," was perhaps not unlike Lucien's intention to glorify himself as a Sage in his portrait by Ingres.

In Ingres's drawing Lucien is seated on a Roman cinerarium from his collection on which are carved winged gryphons associated with Apollo, the giver of immortality and the leader of the Muses. The

gryphons resemble those seated at Apollo's feet on many Muse sarcophagi.[58] Not only does Lucien's pose with book in hand suggest his scholarly interests in archeology and his "throne" recall ancient funerary beliefs, but buildings of the Quirinale in the background are appropriate to Lucien's interest as an *antiquaire.* The solitary figure set against a background of ancient Roman architecture brings to mind Corinne's view of the ruins of Rome as a reminder in times of strife of the moral grandeur of republican Rome:

> but all at once some broken column, or half-effaced bas-relief, or a few stones, bound together by indestructible cement, will remind you that there is in man an eternal power. . . . When in the latter days of Rome, the world was subjected to inglorious rulers, centuries passed from which history could scarce extract a single feat, this forum, the heart of a circumscribed town . . . by the recollections it retraces has been the theme of genius in every age. Eternal honor to the brave and free, those who vanquish even the hearts of posterity.[59]

These associations with republican Rome that Mme. de Staël expressed so well would have been in keeping with Lucien's view of himself as he looks out at posterity. In his *Memoirs* Lucien wrote that some day it would be said of him, "He loved liberty as much as we, and his life was almost entirely an expiation of this sacred love."[60] In the Ingres portrait Lucien is "the image of the sovereign independence of genius," the phrase used by Sainte-Beuve to describe the theme of *Corinne.*[61] A year or so earlier Ingres had exhibited *Napoleon I on the Imperial Throne* at the Salon (1806). Now he took a portrait of the markedly different brother, the literary and theatrical younger brother who had turned away from public life to contemplate the past.

Lucien, who had declaimed his defiance of his brother on the stage of his Roman palace, now attempted through portraiture to dramatize his dedication to the arts. At the same time as he had himself portrayed seated before a view of ancient Rome, he commissioned a portrait of Alexandrine as marble Muse with lyre. Was his wife as Terpsichore a complement to himself as modern Sage?

The portrait of Alexandrine as Terpsichore was not to be completed. Landon refers in his review of the Salon of 1812 to the "particular circumstances" that necessitated a change of the statue from a Muse portrait to a symbolic figure. Probably the commission was canceled when, as a result of worsening relations with Napoleon, the Bonaparte family embarked from Rome in 1810.[62] The ever-growing family left Rome with some thirty servants and set sail for America. Captured at sea by a British ship, they were returned to England where they lived under surveillance until their return to Rome in 1814. Canova, who had

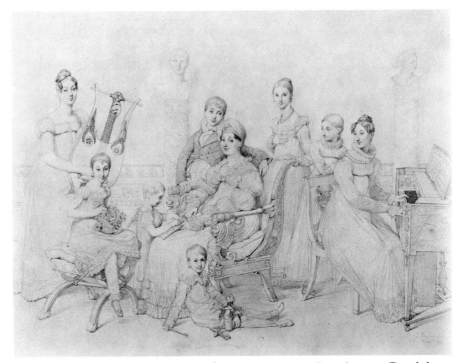

Family of Lucien Bonaparte 1815. Graphite on wove paper. Jean Auguste Dominique Ingres. Courtesy of the Fogg Art Museum, Harvard University, Bequest Grenville L. Winthrop.

earlier made a bust portrait of Alexandrine, now finished the full-length statue as the Muse *Terpsichore Lyrans* and sold it to Count Sommariva for his collection in Paris.

When the Bonaparte family returned to Rome in 1814, the *Terpsichore* was no longer there. Sommariva posed with it for his portrait by Prud'hon the following year.[63] Lucien had to be content with a French Muse in his own family. As we can see from Ingres's portrait of Alexandrine and the children in 1815, the role of the lady with the lyre was played by a daughter.[64] The young girl on the left rather awkwardly holds the lyre-guitar, which had become "indispensable to the empire drawing room."[65] Its popularity during the first quarter of the nineteenth century was probably due to associations with Mme. de Staël's heroine. Corinne had chosen the lyre, "more antique in form, and simpler in sound than the harp";[66] and many young women took to playing the lyre-guitar and reciting à la Corinne in the salons of Paris after the book appeared.

Delécluze the artist and writer, who astutely appraised Mme. de Staël's literary criticism above her skill as a novelist, complained of the

new fashion for recitation that was infecting the salons: "The reading of this work [*Corinne*] is like a poisoned drink for all the girls of wit who aspire to writing."[67] In his journal Delécluze recalled the recitations by Mlle. Delphine Gay, named after Mme. de Staël's first heroine Delphine. The young lady soon took on all the attributes of the second heroine Corinne. Thus life imitated art, and Delphine Gay improvised poetry to the sound of the lyre-guitar in Mme. Récamier's salon under the painting by François Gérard of *Corinne at Capo Miseno*.[68]

Delphine's mother, Sophie Gay, whom Delécluze nicknamed "Mnemosyne" (Memory, mother of the Muses) was a friend of Mme. de Staël and an active promoter of women writers.[69] She appears in turban à la Mme. de Staël in Hersent's portrait with his earlier portrait of Delphine just glimpsed behind a curtain in the background.[70] Sophie Gay helped to organize the journal *La Muse Française* (1823–24) in which her daughter published poetry. The cover of the journal showed a lady with a lyre, and the prospectus welcomed "young Corinnes." It gave the French Muse an audience beyond the private salon. Delphine, in keeping with her Staëlian image, wrote poetry on romantic heroines such as "Corinne Aimée," and "Magdeleine," inspired by Canova's statue. The journal also offered opportunity for appearing in print to that other Muse of love and childhood, Latouche's beloved Marceline Desbordes-Valmore.[71] Hailed by Barbey d'Aurevilly as "une Corinne simplifiée," this actress-turned-poet was admired also by Sainte-Beuve and Verlaine.[72] Both *femme auteurs* as Muses of lyric poetry appeared to be incarnations of the fictional Corinne.

Barbey d'Aurevilly recognized the talents of both women in poetry, but when Delphine Gay abandoned her lyre for the journalist's pen, the critic complained that her work deteriorated.[73] With her marriage to Émile de Girardin, the founder of *La Presse* (1836), Delphine began to write a weekly gossip column (one of the earliest known) and also to publish novels and comedies.[74] Her transformation from salon Muse to professional writer demonstrated the new power of women writers whom Barbey d'Aurevilly disdainfully now classed as bluestockings *(bas bleus)*. His outrage at the Muse turned journalist was a reflection of growing antifeminist feeling toward professional women writers that was reflected in contemporary caricatures.[75] Henri de Latouche, editor of *Le Figaro*, a supporter of both of these *femme auteurs*, asked pointedly: "Why does the best and most beautiful woman infallibly lose her charm if she dedicates herself to the career of an author?"[76] In 1830 when Latouche wrote these words, he had not yet met George Sand. When they met in January of 1831 he took her to Mme. Récamier's salon to hear Delphine Gay recite. By March he had given her a job as a journalist on his staff, and he was to pride himself on having convinced her to give up occasional watercolor painting for a career as a writer.[77]

George Sand, aware of the pitfalls of the Muse image, rejected the pose of the lady with the lyre in favor of a more feminist mode. With her rejection of the role of salon Muse, she became, in the eyes of the French, a bluestocking and a prime target for caricaturists. Yet George Sand, like the other women writers, had heard Corinne's lyre. She spoke of her "days of Corinne," and the spellbinding performances of her heroines Consuelo and Lelia recall those *chants* of Mme. de Staël's Roman poetess.[78] When in 1838 Sand wrote a poetic drama on the subject of the writer's dedication to her art she titled it the *Seven Strings of the Lyre* and seized on Corinne's instrument as the symbol of her creativity.[79]

For Sand as for many other aspiring women writers the image of the lady with the lyre was as compelling as it had been for Alexandrine and Lucien Bonaparte many years earlier. Balzac noted in *The Muse of the Department* that by 1830 "there arose in France a vast number of Tenth Muses, young girls or young wives tempted from a silent life by the bait of glory."[80] The "bait of glory" had been held out to them by Mme. de Staël. To these women authors of the 1830s *Corinne* was an emblem of a woman's triumph in man's world of letters, still more of a dream than a reality. A generation earlier Corinne's triumph had deeper political meaning to Mme. de Staël and her friends Lucien and Alexandrine. Beyond the triumph of a poetess, the crowning of Corinne in the novel represented homage paid to exiled genius in a period of political oppression. Thus, Lucien chose to crown his wife as a marble Muse just as Corinne was crowned—in Rome, the city where (as Sainte-Beuve remarked) "the conqueror who exiled her [Corinne] will not set foot."[81] Corinne's lyre had a special resonance for the exiled Bonaparte couple: its chords blended ancient Muse portraits with the contemporary theme of the triumph of genius over tyranny.

4
Critique and *Canard*
Henri de Latouche at the
Salon of 1817

The *précieux* novel that developed in the salon world of seventeenth-century Paris had addressed itself to an elite public of upper bourgeois and nobility. Indeed Molière had ridiculed the fact that its readership extended to provincial women who used it as a guide to city manners. By the nineteenth century, however, the public for *Corinne* was a broad one, an international audience from all levels of society. Mme. de Staël, who transmitted through her novels many of her ideas on art and literature, hoped to influence a vast reading public, for she believed it the duty of the best minds to elevate public taste. In her critical writings she played the role of taste maker by championing foreign literature in France. In her novel *Corinne* she expounded her concept of art as an expression of society in her heroine's discussion of both ancient statuary and contemporary painting.

In nineteenth-century Paris, the proliferation of journals offered new opportunities for the writer to reach a wider audience in his or her analysis of art and literary movements. Among the many novelists who wrote criticism for newspapers and periodicals was Henri de Latouche, an ardent admirer of Mme. de Staël. In his criticism Latouche popularized many of her ideas on art and literature.[1]

Art criticism, however, was only one strand in the literary career of Henri de Latouche. Editor of *Mercure du XIX siècle* and later of *Figaro*, his most important contribution to the Romantic movement was his publication for the first time in 1819 of the poetry of André Chénier. Gautier later proclaimed, "Modern poetry may be said to date from André Chénier, whose verse published by Latouche was a true

revelation."[2] Though often faulted for his own inadequacy as a writer of imaginative literature, Latouche's judgments of literary quality were sound enough to stand the test of time. In 1845 Latouche wrote to a friend: "My only pride in literature consists of two recollections: having edited André Chénier and having discouraged George Sand from occupying herself with watercolor portraits."[3]

As a writer of imaginative literature, he experienced both successes and failures. His plays received mixed reviews, and his poetry was never considered important. Perhaps his greatest successes were his novels, which tended in subject matter toward the bizarre. His first novel, *Olivier Brusson*, published in 1823, was a classic paraphrase of Hoffmann's *Mlle. de Scudéry*. Hoffmann had based his story on a supposedly historical account of the visit of a German, Wagenseil, to Paris in 1664. Wagenseil recorded the episode of a letter written to the king by the lovers of Paris protesting the activities of street robbers who interfered with their evening rendezvous. Mlle. de Scudéry, who responded in the name of the thieves, scolded the lovers: "A lover who fears thieves does not deserve a woman's favors." This anecdote inspired Hoffmann's tale and later Latouche's.[4] Frédéric Ségu points out that the strange tale of crime, love, and intrigue in which the character of Cardillac appears, had great appeal for Latouche who "lived really in this epoch, fertile in singular events, where the ardent *Chambre* [bleue] was instituted."[5] A scandal erupted, however, when Latouche was accused of plagiarizing the Hoffmann tale. He defended his work as "a kind of translation." It actually was the first French translation of a Hoffmann story, but the acknowledgment of it as such was too tardy to satisfy his enemies in the literary world.

The scandal did not, however, keep Latouche from writing novels. His most popular one, the story of a hermaphrodite, was published in 1829. *Fragoletta, Naples and Paris in 1799*[6] was modeled on *Corinne* in both its Italian setting and its use of a work of art as an emblem of the dual nature of its protagonist. Mme. de Staël appears in the novel as does a poetic *improvisatrice* and painter who resembles Corinne. Latouche describes the beauties of Italy, and, in the tradition of Mlle. de Scudéry's heroic novels, he devotes pages to graphic descriptions of disasters, including a horrendous earthquake. A great success, *Fragoletta* went into several editions; this, and his *romans reportages*, which will be discussed in the next chapter, made Latouche famous in his day. Yet this pioneer of Romanticism remains little known today, except as the mentor of Balzac and Sand and the editor of Chénier.

Though considered only a minor writer of the Romantic movement, Latouche had played an important role before 1830 as a journalist and critic who popularized many of the tenets of the early Romantics. Displaced by the younger Romantics of Hugo's *Cénacle,* Latouche

criticized the group harshly in an article entitled *On Literary Camaraderie* and published in *Revue de Paris* in 1829. The members of the Grand Cénacle, "a happy little world, sheltered and select" (like the *précieux*, to quote Sainte-Beuve's description)[7] helped to promote each other's work. Latouche denounced this literary log rolling in his article, where the word *camaraderie* was applied for the first time to the world of letters. Referring to Molière's character, the pedantic *précieux* poet Trissotin satirized in *Les Femmes savantes*, Latouche concluded the article with a scathing attack: "We would not like to see Romanticism, a useful reform to which we have made the first vows and which we will always love, change its name in the year 1829 and no longer call itself anything more than *Trissotinisme.*"[8]

Although Latouche continued to publish poetry and novels, his influence in the Romantic movement had already waned by the 1830s. In this chapter and the next I will examine his early art criticism, written as reviews of the Salons of 1817 and 1819 in which he applied the emerging Romantic literary tenets to the visual arts. Latouche's standards of judgment in painting and sculpture were in great part determined by his taste in literature. As an admirer of the first generation of Romantics, Chénier, Chateaubriand, Stendhal, and Mme. de Staël, Latouche's evaluations of art show strong affinities with the literary standards set by his predecessors.[9]

Mme. de Staël's book *On Germany* had appeared in France in 1814, just three years before Latouche's first Salon review. While traveling in Italy in 1813 Latouche had gained entree into the Récamier circle in Rome; and he was to maintain friendships with Récamier and Chateaubriand, who later became his neighbor at Aulnay.[10] He had also met Stendhal in Italy either in 1811 or in 1813. In 1817 Stendhal had published *History of Beaux-Arts* and *Rome, Naples and Florence in 1817.*[11]

As we shall see, Latouche's art criticism was imbued with many of the ideas expressed by the early Romantics; they also had a strong influence on his literary career. In 1802 in *The Genius of Christianity*, Chateaubriand had characterized Chénier as a genius lost to France. This early notice may have inspired Latouche's interest in Chénier.[12] Similarly, Mme. de Staël's *On Germany* turned Latouche's attention to German literature. In 1818, he collaborated with Émile Deschamps on *Le Tour de Faveur*, a one-act comedy in verse that satirized conservative journalists and theater critics.[13] The focus of the attack was the conservatives' insistence on maintaining the Classical unities. *Le Tour de Faveur* brought Mme. de Staël's demand for freedom from the Classical rules and her praise of Shakespeare and Schiller before the Parisian theater audiences.[14] From his early comedy of 1818 to his late poetry published in 1858, Latouche maintained a strong interest in German

literature and tried to bring to the stage works admired by Mme. de Staël. Though he complained that the glory of German literature was only perceived through the "grey glass of a feeble translator," Latouche himself was inspired to translate many of Mme. de Staël's favorite German works into French.[15] He contributed to *Lettres champenoises*, a free translation ("une imitation") of Goethe's *Roi des Aulnes*, which was hailed by the journal's editor as more natural than the original.[16]

Latouche's choice of the Goethe poem for translation followed Mme. de Staël's assertion that national legend could surpass Classical mythology as a subject for the poet. He also translated Schiller's dramas *Marie Stuart*, *Don Carlos*, and *William Tell*, works that Latouche believed to demonstrate that the modern dramatist could free himself from Classical rules and still produce great tragedy based on subjects from modern history. In Latouche's translations Schiller's characters expressed a republican point of view in accord with that of the translator.

Mme. de Staël had pointed out in *On Literature* (1800) that literature capable of "elevating the soul" had a moral function for society. Latouche in his translations of Schiller gave stronger emphasis to the political and social aspects of the historical dramas than had Schiller. Mme. de Staël, who analyzed German literature in philosophical terms, understood that Schiller was not concerned with politics. The ardent polemicist Latouche seized upon Schiller's modern tragedies as analogues to the political situation in France (with William Tell becoming a republican).

In his introduction to *Mary Stuart*, Latouche credited Mme. de Staël with revealing to him the marvels of foreign literature. Although he did not acknowledge the debt, the novels of Mme. de Staël also left their mark on Latouche's imaginative writing. Her use of the epistolary style ultimately derived from Marivaux in *Delphine* (1800) may have determined the format of Latouche's *Last Letters of Two Lovers from Barcelona* of 1821 and *Clement XIV et Carlo Bertinazzi, Unpublished Correspondence of 1827.*[17] As we shall see in chapter 5, this epistolary style also found its way into Latouche's critical writings; his Salon review of 1819 was presented as a series of letters to David.

Mme. de Staël, whose views on art were influenced by the Schlegel brothers, considered herself to have a well-developed artistic taste. Just as her novel *Corinne* unfolded against a background of ancient ruins, museums, and artists' studios in Rome, so the moment of revelation in Latouche's novel *Fragoletta* took place before an ancient statue of a sleeping hermaphrodite in the Naples museum. The legacy from *Corinne* of art performing a symbolic function in the novel was bequeathed by Latouche to Balzac whose *Sarrasine, The Unknown Masterpiece*, and *Séraphîta* all owe a debt to Latouche's *Fragoletta*.

Mme. de Staël, basing her ideas on Montesquieu's theory of the effect of climate on civilizations, presented in *On Literature* the notion of aesthetic relativity.[18] In her influential book later referred to by Sainte-Beuve as "the prospectus of future romanticism,"[19] she characterized northern literature springing from the songs of Ossian as mystical, imaginative, and melancholic in contrast to southern or Classical literature founded by Homer and dedicated to healthy images of reason and morality. Applying this theory of duality to art, she viewed sculpture as deriving from Classical civilization and painting from medieval Christianity. Though she criticized the Neo-Classicist Winckelmann for his overemphasis on sculpture, she retained a taste for Neo-Classical art. In *Corinne* her heroine gathered a gallery of her favorite painters, including David, Gérard, and Guérin, who were also to become favorites of Latouche. In her artistic taste, Mme. de Staël, like Latouche, was unable to resist the beauty of Classical forms. While they both championed a new aesthetic, they could not completely liberate themselves from the Classical ideal in the visual arts. The Romantic Classicism of Mme. de Staël was transposed into paint by Gérard, whose painting of her heroine in *Corinne at Capo Miseno* combined Classical style with the Romantic elements of passionate inspiration and wild setting.[20]

In *On Germany,* Mme. de Staël enunciated new aims for the modern artist.[21] Though the contemporary artist might not be able to surpass the ancient in beauty, he could progress in depth of emotional expression and vivid characterization. To accomplish this end, the artist must not be a servile imitator but an imaginative creator, free to develop his innate originality. Freedom in literature, the fine arts, and music was, according to her, dependent on political freedom. Central to the progress of the arts in Mme. de Staël's theory was political liberty.

The ardent republican Latouche adopted this view and applied it in his Salon criticism. His views on the art exhibited in the Salons were shaped in large part by his literary and political sympathies. Latouche, writing for the opposition journal, *Constitutionnel*[22] saw his role as both political and aesthetic. Thus, throughout his articles on the Salon of 1817 he took care to caution the public against the Bourbons' propagandist motives. With the censor looking over his shoulder, Latouche was adroit in mingling aesthetic assessments and political polemic.

Just as Latouche saw himself in the role of a translator as enlarging the horizons of the French public, so as a reviewer of the Salon of 1817 he may have taken on the duty (described by Mme. de Staël) of a republican who elevates the taste of the masses through his eloquence.[23] The aristocrat Latouche assumed the role of taste maker with a

somewhat more elitist attitude than Mme. de Staël. Though a republican, he was not a democrat and could not resist making caustic comments on the vulgarity of the Salon audience.[24]

In *On Germany* Mme. de Staël had characterized A. W. Schlegel's criticism as going beyond the narrow search for defects, to the discovery of genius worthy of admiration.[25] Latouche, as the defender of the younger Romantic painters, addressed himself to an appreciation of their genius and excused the faults that blinded the Classical critics to their art. Thus, in his opening remarks on the Salon he chided the detractors "full of eternal apprehensions on the decadence of art and of the national taste" (May 3), and in his second article he applauded the genius of the young French artists who have triumphed "in uncongenial circumstances" (May 8). Following Mme. de Staël's view on the interaction between the society and the artist, he asserted: "The heart of a painter is far from being inaccessible to calamities of his country; we are in mourning in our mobile imaginations; and when enthusiasm is extinguished, when all the Muses are discouraged, the studios alone are not deserted" (May 8). But despite the inauspicious environment for art in France, the young artists, according to Latouche, had repaid the hopes of both Frenchmen and foreigners.

The Salon of 1817, the first held after the Hundred Days, was preceded by several setbacks to the artistic community for which the Bourbons were responsible in the eyes of the republican Latouche. In 1815 Louis XVIII had ignored the request made by the Class of Fine Arts of the Institute for increased membership, a request that was subsequently granted by Napoleon during the Hundred Days. On their return to power in 1816 the Bourbons hastened to placate the Fine Arts Class of the Institute by confirming Napoleon's enlargement of its membership and allowing it to participate in the state's educational program under its restored name of "Academy."[26] However, although the Bourbons tried to placate the Institute, many artists felt that they had already suffered too much at the hands of the monarchy. Their grievances went beyond the Institute conflict. The artistic community resented the Bourbon decision to return some two thousand works of art taken to France as war booty during the Napoleonic conquests. Because the monarchy's ties with European royalty necessitated the return of these precious trophies to their original owners, the great monuments of antiquity were no longer available for young artists to copy. Later in 1825 Latouche still maintained in his book on Canova that the French were legitimate possessors of the masterpieces.[27] A further grievance was the exile of Neo-Classical painter Jacques-Louis David who had played such an important role during the Revolution and the Empire. Thus, by 1817 the young artists had been deprived of

their greatest teacher as well as of major works of antiquity from which to study. Though the Bourbons might try to mollify the artists by liberalizing educational policy and by generating an active program of commissioning works to decorate monuments of both church and state, still republican critics like Latouche would not let the problems of the artistic community go unheeded.[28]

In the *Salon de 1817* the governmental attempts at support of the artist through commissions were brushed aside by Latouche who announced that he would first discuss uncommissioned works "whose invention and execution belong exclusively to the genius of their authors" (May 8). Latouche presented himself as a disinterested critic concerned with "the progress of the arts" and with "spontaneous productions." At the same time as he encouraged the young artists to a freer expression, he denigrated the restrictions imposed on them by the more conservative critics of *Journal des Debats,* which in his eyes preached a cold pedantry. He encouraged the young artists to "meditate on the models and lessons of antiquity" and at the same time to avoid figures that are too academic, mannered poses, and twisted draperies (May 8). According to Latouche, the modern artists worthy of imitation were Gros for drawing, Guérin for composition, and Girodet and Gérard for innate qualities of genius.

Latouche's assumption that one might separate these elements from an artist's work and imitate them shows a lack of understanding of how visual artists work. These comments were probably based on inadequate understanding of the separation between the technical and the intuitive aspects of art, which had been the subject of a lecture by Girodet a few weeks earlier. On April 24, 1817, at the convocation of the four academies, Girodet had addressed the official art world on *L'Originalité dans les arts du dessin.*[29] In discussing the training of the artist, Girodet had emphasized that artistic originality was a natural gift from God enabling the artist to transform nature into his personal vision. According to Girodet it was the artist's originality visible in a work of genius that elicits an emotional response from the viewer. The previous year when Girodet had addressed the Academy at its annual meeting, he had warned aspiring artists against overconcentration on the technical aspects of art at the expense of judgment and sentiment, without which works of genius are impossible. In his comments to young artists, Latouche was reiterating with less clarity the ideas expressed earlier by Girodet.[30] Girodet and Latouche, as spokesmen for the Romantics against the Classicists, drew on these concepts in an effort to encourage more freedom in the academic training of the future artists of France. Though Girodet addressed the teachers and Latouche addressed the newspaper public, their words must have given encour-

agement to young artists inspired already by literary Romanticism. One of the young artists, Eugène Delacroix, noted Girodet's remarks at the 1817 Convocation in his diary.[31]

Inherent in Girodet's assertion that works of originality possessed the power to move the spectator was the notion that great art made its impact through feeling rather than through reason. This Romantic premise—going back to J. B. Dubos—had been applied by Mme. de Staël to the arts in general.[32] Several French critics took up this notion in relation to the visual arts in particular. The decorator Raymond in 1804 stated, "It is to sentiment their only supreme judge to which artistic productions must address themselves."[33] In 1815, Droz, who also believed that the mainspring of artistic judgment was sentiment rather than technical expertise, drew the conclusion that the professional artist was to be excluded from the role of critic. Droz pointed out that the most able man of taste in the judgment of art or music was one who was not initiated "in the mysteries of the arts." Thus, the man of sensibility—the amateur or dilettante—was likely to feel the effects of great art more directly than the expert, and it was the effects rather than the technique of art to which the critic must address himself.[34]

According to this criterion, Latouche the journalist-dilettante qualified well as a Salon critic. In his opening article Latouche introduced himself in this light to the reader; he announced that he would launch right into an examination of the works without bothering to discuss the qualities of a judge of the Salon or to specify "the superiority of judgments by sentiment over interested judgments of those whose profession hems them in with prejudices and prejudgments" (May 3). Thus, the journalist defended his critique against a comparison with that of technical experts like the artist Landon who were currently writing their impressions of the Salon.[35]

Latouche opened the Salon review with a discussion of *Aeneas Relating to Dido the Misfortunes of Troy* and *Clytemnestra* by Guérin, whom he characterized as a follower in the Classical tradition from Vien to David. In defense against the criticism that the face of Dido expressed too sensual a love, Latouche asserted first that ideal love did not have enough *caractère* for painting and, second, that for the ancients love was not modified by modern sentiments but existed on a level closer to nature.[36] Both of these defenses of the "Neoclassic Erotic" (to use Robert Rosenblum's term) recalled the writings on pagan love of Mme. de Staël whom Guérin had met in Naples in 1804. Guérin's painting was reminiscent also of the pagan vision of antique love in the poetry of André Chénier.[37] Latouche described Guérin's composition meticulously, and, although he complained of the loss of color since he had seen the painting in the artist's studio, he praised the work for its charming composition, simplicity of action, purity of taste, beauty of

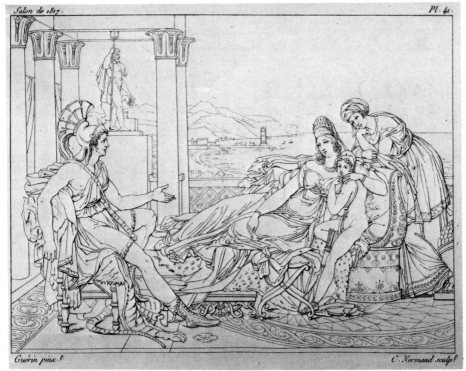

Salon de 1817. *Pl. 41.*

Guérin pinx. *C. Normand sculp.*

Aeneas Relating to Dido the Misfortunes of Troy. **Oil on canvas. Pierre-Narcisse Guérin. After engraving by C. Normand from Landon,** *Salon of 1817.*

form and drawing. The arch style of Guérin's *Aeneas and Dido* paralleled Girodet's manner in some of his mythological scenes. The languid poses attracted both Latouche and Balzac. It became Balzac's favorite painting and inspired his pen.[38]

Guérin's second painting, *Clytemnestra,* exemplified the intense expressiveness of the "Neoclassic Horrific" and also drew high praise from Latouche, who responded with the proper *emotion profonde* to the nocturnal murder scene based on the theater. Comparing it to Aeschylus and to Lemercier, Latouche, who first found himself speechless before the painted tragedy, finally launched into an evocative description. Following the Romantic taste for chiaroscuro, he appreciated the torchlight that shown on the murderess with an infernal gleam. Again Guérin was following in the footsteps of Latouche's and Balzac's favorite painter Girodet who had used such theatrical lighting in his powerful *Phèdre* illustrations (1799) and his painting *Scene of a Deluge* (1806).[39] Though Girodet had been reproached by David for his *Deluge,* by 1817 sensational representations were gaining acceptance even among orthodox critics.[40]

While both Guérin's erotic and horrific paintings on Classical literary themes received high praise from Latouche, Christian subjects, which made up a large share of the Salon entries, were less appealing to the anticlerical journalist.[41] Many of the historical subjects from the French past were associated with Christian piety through images of devout peasants and settings of gothic architecture. Religious ceremonies were given emphasis in the numerous deathbed scenes on view in the exhibition. This linking of historicizing subjects with Christianity could be traced to the influence of Chateaubriand's *The Genius of Christianity* of 1802.[42] Though this great Romantic had laid the groundwork for the exploration of such subjects, the Bourbons encouraged these themes in an effort to remind the public of the close ties between crown and the Catholic church in the past history of France. One of the most popular themes in the Salon of 1817 was Saint Louis on his deathbed.

The republican Latouche discussed these royal deathbed scenes with cool detachment.[43] His republican sensibility also led him to remark on the relationship between ruler and subject depicted in Bondel's *The Death of Louis XII* where the populace was shown entering the death chamber. Latouche applauded this ancient custom because it alerted the public "not to forget that our masters are men" (May 13).

Just as he analyzed royal deathbed scenes according to his republican views, so Latouche took exception to several paintings that paid tribute to royal benevolence. Ansiaux's *Cardinal Richelieu Presenting Poussin to Louis XIII* drew plaudits from Landon in the *Annales* and Boutard in the *Journal des Debats* for its depiction of royal patronage of the arts.[44] Latouche, however, took an opposing view. Echoing Stendhal's comments in his *History of Painting in Italy* (1817) on the detrimental effect of monarchic government on the artist, Latouche wrote a polemic on the injustice suffered by artists at court. He detailed the harsh treatment of Poussin by the French court and documented his comments by quoting from a letter written by Poussin to Desnoyers.[45] Thus, he effectively brought into question the royalist message of Ansiaux's painting, which had been commissioned by the minister of the interior (May 13).

Furthermore, Latouche stressed the uncertainty of royal favor and its corrupting effect on the artist. Following some negative remarks on Kinson's painting of *Belisarius* (which he found too reminiscent of Guérin's *Marcus Sextus*), he discussed a painting by Laurent showing Callot rejecting a commission from Richelieu to engrave the taking of Nancy. Latouche praised this scene in which an artist patriotically refused a royal commission rather than bring dishonor on his native Burgundy. Using the portrayals of Belisarius and Callot as examples of individuals in confrontation with state authority, Latouche emphasized the underlying uncertainty of royal patronage. He ended the article

with a tribute to Joan of Arc painted by Laurent. Mme. de Staël had pointed to Joan of Arc as a national heroine worthy of literary tribute, and Mlle. de Scudéry had defended her chastity in a series of letters. Latouche commended the courage and virtue of the romantic heroine from France's past whose exploits were a fitting subject for art and literature.

Clearly, subject matter was of central importance to Latouche in his Salon review. From the foregoing it is apparent that he took upon himself the task of refuting much of the royalist propaganda implicit in many of the commissioned works. On thinly disguised political grounds he even criticized a current work of one of his favorite painters, Gros. He judged *Louis XVIII Leaving the Tuileries on the Night of March 20,* ordered by the king, to be beneath Gros's talent. Latouche's criticism was directed against visual deficiencies such as disorganized composition, poor perspective, bad grouping, ineffective modeling of the figures, bizarre poses, ugly women, and trivial expressions. This kind of criticism would be viewed by the authorities as artistic rather

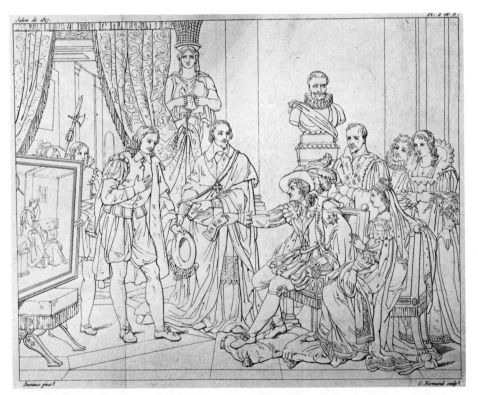

Cardinal Richelieu Presenting Poussin to Louis XIII. Oil on canvas. Antoine Ansiaux. After engraving by C. Normand from Landon, *Salon of 1817.*

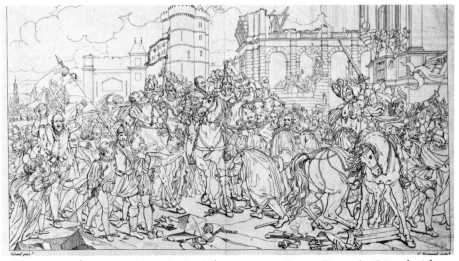

The Entry of Henry IV into Paris. Oil on canvas. Baron François Gérard. After engraving by C. Normand from Landon, *Salon of 1817.*

than political, and to further strengthen his stance as a disinterested critic, Latouche praised Gros's portraits of the Duchess of Angoulême and of the king. However, he evaluated the present painting as feeble by comparison with the Napoleonic paintings by Gros, which, he asserted, had made the artist's reputation. Thus, he established that the artist who had been inspired by Napoleon now failed in the service of the unheroic Louis XVIII (May 18).

In the seventh and last article (July 16), Latouche discussed the most impressive painting of the Salon, Gérard's gigantic *The Entry of Henry IV into Paris,* which had been commissioned by the Maison du Roi.[46] Latouche admired the severity of the drawing and the richness of color. Moreover, he congratulated the painter for eschewing allegorical aids.[47] The subject chosen by the king's minister had political implications that were apparent to all. The return of Henri IV, founder of the House of Bourbon, to Paris was a historical analogue to the restoration of Louis XVIII after the Hundred Days. In 1814 Chateaubriand had laid the grounds for the parallel by comparing Louis with Henry IV.[48] Latouche, well aware of the attempt to give historical precedents to the current royal return, stressed the power of the bourgeois vis-à-vis the constitutional monarch. Thus, he described the scene in terms of the reconciliation between Henry and the French people of all ages and classes. He also remarked on the informality of the king and the absence of the grandiose in his portrait. Furthermore, he emphasized the prominence of the bourgeois l'Huillier who shared the center of the

composition with the king. Gérard's placement of the two leaders together in this manner was probably a conscious attempt to create a visual emblem of constitutional monarchy. Its significance was not lost on Latouche who said: "The marshall of the merchants, L'Huillier, occupies on equal terms the center of the painting; he is in front of the monarch preceding the magistrates who come to present their homage" (July 16).

As a further sign of reconciliation, Gérard was careful to include a member of the Catholic League among figures representing the king's political opponents. Latouche, pointing to this figure, launched into a polemic against the church; he drew attention to the church's domination of Henry and the resultant legacy of Catholic terror during the reigns of Henry's descendants. In fact, he suggested that Gérard should have added a fanatical monk to the composition in order to bring out the historical fact of Spanish Catholic resistance with which Henry had had to contend. Unwilling to accept the rather cursory recognition of the Catholic opposition, Latouche demanded more attention directed to the uneasy truce between Henry and the church, a demand hardly in accord with the propagandistic motives of the ruling Bourbons.

Latouche spent most of his time on history paintings because, as he asserted in his last article, they were more susceptible to analysis than landscapes. He praised Lethière for historic landscape in the tradition of Claude and David. Balzac was later to compare Latouche's "roman historique" *Fragoletta* to a painting by Lethière, *Brutus Condemning His Son to Death*. Latouche's favorite landscape artists seem to be those who concentrated on scenes of Italy, like Bertin, whose work he likened to Poussin and Claude, or those who painted melancholy subjects. Of the latter, le Comte Turpin de Crissé's paintings of ruins were admired for their local color, one suggesting Greece to Latouche and the other "the cloudy sky of England."[49]

Like Dubos in the eighteenth century, Latouche had a preference for landscapes in which some human actions were introduced. A landscape that combined death and eroticism had particular appeal for Latouche's Romantic sensibility. Such a painting was Roumy's *View taken at Genesano, near the Lake of Nemi*, a dark and melancholy scene showing the burial of a young virgin. Latouche's evocative description recalled Chateaubriand's *Atala* as painted by Girodet.[50]

Latouche's scant treatment of landscape reveals his rather traditional evaluation of landscape as lower than history painting in the academic hierarchy. The discussion of subject matter having to do with religion, history, or literature was of greater import to Latouche than analysis of landscape that would bring him to a closer study of the visual aspects of painting. Although at this time the concept of landscape was being

expanded beyond the Classical historic landscape, Latouche's praise of the poetic qualities of landscape demonstrates his primary concern with literary aspects of art.

Despite the fact that in 1817 historical landscape had been recognized as important enough for a *prix de Rome,* Latouche's hurried remarks suggest that he was unaffected by attempts to elevate landscape in the academic hierarchy.[51] As a reviewer of the Salon, Latouche was drawn primarily to the paintings that reflected the political forces of this unsettled period. Landscapes could hardly compete with history painting as a subject for the popular journalist.

As a novelist, however, Latouche was to devote space to lengthy descriptions of landscape. In *Fragoletta* he described the beauties of the countryside around his native Berry. He also depicted the ruins at Herculaneum and the Neapolitan landscape. Sainte-Beuve, in his necrology on Latouche, quoted a passage from *Fragoletta* as a demonstration of Latouche's talent for recreating landscape. Sainte-Beuve regretted that Latouche failed to allow free rein to his genius for "natural impressions." Latouche may have set an example for Sand and Balzac in giving life to the settings of his novels through careful observation of nature.[52]

Portraits, too, received little attention from Latouche except for historic ones like Guérin's portrait of the Vendée hero Henri de la Rochejacquelein in a series of Vendean generals commissioned by the king. Latouche remarked on the difficulty of painting a hero in bourgeois clothing *en chapeau rond* (July 16). While he considered that Guérin had overcome this obstacle "with rare talent," he disdained everyday costumes and settings as beneath the dignity of the great artist.[53]

The opposition between the heroic and the bourgeois is perhaps the basis of Latouche's attack on genre painting. In his discussion of Drolling's interiors and *The Mistress of the Village School,* he complained that such paintings were admired by the crowd for their truth to reality but that they offered nothing of the noble and the ideal.[54] Everyday objects are unworthy models for the artist because in Latouche's mind art must have social value: "The goal of the arts must be to ennoble and elevate ideas" (June 6). Latouche the dramatist asserted that the genre scenes of Drolling were as far beneath history painting as vaudeville is beneath literature. The crowd admired this type of painting because the public lacked knowledge and was accustomed to "anti-poetic ideas." Though the ancients made art for the people, it was not degraded art: Homer, Phidias, and Sophocles all worked for a popular audience. In accordance with Neo-Classical doctrine, Latouche believed that the public's acceptance of genre painting signified a decline in popular taste.[55] This view was held even by eclectic critics like

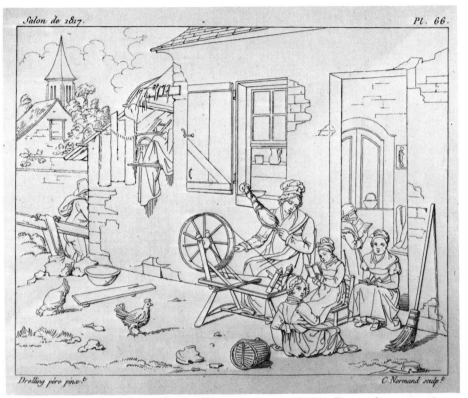

Salon de 1817. Pl. 66.

Drolling père pinx.t C. Normand sculp.t

The Mistress of the Village School. Oil on canvas. Martin Drolling. After engraving by C. Normand from Landon, *Salon of 1817.*

Taillasson who admired Dutch and Flemish genre painting. In the final analysis Realist subject matter was considered lacking in instructive value. Thus, a decade earlier Taillasson in his discussion of Gerard Dow expressed reservations about genre very similar to those Latouche was to articulate in 1817:

> Posterity in distributing its crowns puts a great distance between authors of a woman who holds a tankard of beer. . . and those of the testament of the Eudamidas. . . . She places in her esteem a just difference between talents which amuse. . . and those which move and instruct. . . retracing memorable deeds, examples of virtue and heroism enlarge the mind, elevate the soul and contribute to the support of noble and useful actions.[56]

Though a political republican, Latouche, fastidiously refined in manner, had little tolerance for the bourgeois level of taste. He saw himself as belonging to a literary elite whose mission it was to raise the level of public taste. The *vulgarité* that Mme. de Staël had noted among the masses was apparent to Latouche in the paintings favored by the

Salon crowds.[57] The public approval of genre painting like Drolling's had a pernicious effect, according to Latouche, on the painters of the school of David. The idealizing function of art was its central value for society, according to Latouche. Though he might emphasize his love of drama, animation, and color as important elements in painting, still, art without idealism, art as a mere reflection of the real world, was meaningless to him. His intense belief in the importance of art as a social force never allowed him to follow the doctrine of art for art's sake, soon initiated by Victor Cousin and taken up by many of the Romantics.[58] Latouche remained committed to the belief in the power of art to perfect man and nation.

Latouche's dedication to the social ideals of Romanticism led him to defend the young artist against the power of state patronage. He viewed the paintings of the *juste-milieu* with a cynical eye. In 1825 he was to write: "Painting has been religious or military following the princes who have paid for it."[59] According to Latouche, the committed artist through his originality could create a noble painting, but propaganda paintings paid for by the state were usually beneath the talent of the true artist.

When it came to particular works of art, Latouche's shortcomings as a critic reveal the inconsistency of the period. The visual vocabulary of Romantic painters was not yet determined by 1817. To Latouche the closest equivalent in painting to Romantic literature was the Romantic Classicism of the second generation of Davidians. Thus, he chose Guérin's paintings, be they "erotic" or "horrific," as his favorites. Latouche largely ignored the categories of landscape and genre that were later to play such important roles in the development of modern painting. Latouche's taste in painting was formulated during the height of David's career, and though theoretically he espoused the Romantic credo, he was still strongly drawn to Neo-Classical style and subject matter.

Although most of the Salon review was devoted to painting, Latouche confided in the sixth article (July 5) that he had a secret predilection for sculpture. His admiration for the sculptor Canova, on whom he was to write in 1825, influenced his evaluation of the sculpture on exhibition in the Salon of 1817. In his *Oeuvre de Canova* he traced the history of sculpture and credited Canova with having brought modern sculpture back to its dual origins, nature and the antique. He also linked Canova to the Davidians: "The school of David formed the taste, developed the talent of the Italian sculptor." Conversely, Latouche believed that Canova's achievement had left its mark on the French school that was now capable of the highest standard of sculptural work. "The flourishing school . . . only waits for the signal to distinguish itself. . . our marbles even begin to replace the marbles of Carrara; and if, with so many advantages we leave nothing to posterity,

one must recognize in all humility that we only lack heroes. "[60] The great accomplishments of Canova had produced among his French inheritors sculptors capable of leaving heroic monuments to posterity. But where, the Romantic republican asked, were appropriate sitters? Where were the new heroes of France?

By 1825 when he wrote these remarks, Latouche was more optimistic about the French school of sculptors than he had been in 1817 as he reviewed the entries in the Salon. In his opening remarks on the Salon sculpture, he complained (following Winckelmann) that although the pagans supported sculpture as central to their religious worship, in modern times sculpture was merely for funerary monuments. Thus, modern sculpture no longer served to ennoble man as did the cult statues of the Greeks.

In examining many of the works on exhibition, Latouche was critical of the sculptors' failure to modify ideal beauty with convincing realism. Most of the work was pedestrian: "One searches in vain for an artist's thought; one sees the work of an artisan" (July 5). Two exceptions to his negative criticism were the sculptors Bosio and David d'Angers.[61] In Latouche's eyes, Bosio's *Aristée* and *Hyacinthe* were among the most remarkable statues on exhibition, particularly Bosio's masterpiece, *Hyacinthe,* which in Latouche's judgment reached perfection in its grace and beauty. Even the color of the marble added to its charm. Latouche's unqualified admiration for this image of feminized male beauty

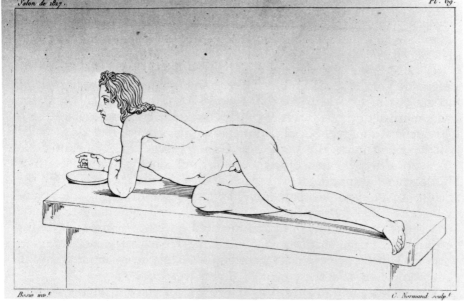

Hyacinthe. Marble. François-Joseph Bosio. After engraving by C. Normand from Landon, *Salon of 1817.*

paralleled the taste of many of David's painting students.[62] Its ultimate
art historical source was Winckelmann, who cited the hermaphrodite in
antique sculpture as a visual image of the Neo-Platonic notion of ideal
beauty embodying the most perfect combination of male and female
elements. The suggestion that ideal beauty of the ancients consisted of
"both sexes, blended with a mystic significance in one," was most
appealing to Latouche, who dabbled in Swedenborgian Neo-
Platonism.[63] To him the feminized male figure signified a Neo-Platonic
ideal of spiritual unity materialized in sculpture. The sensuous aspect of
the feminized male figure was to be later exploited by Latouche in his
novel *Fragoletta* (1829), the story of a living hermaphrodite linked to art
through a statue in the Naples museum. Latouche's fascination with
sexual ambiguity was shared with his contemporaries. *Fragoletta* went
into three editions by 1840 and was imitated on the vaudeville stage.
Latouche's novel anticipated Balzac's *Sarrasine* and *Séraphîta* and
Gautier's *Mademoiselle de Maupin*. In life as well as art Latouche
showed a strong interest in women who dressed as men. He, like other
Romantics, was an ardent admirer of Joan of Arc, the originator of this
mode in France. Latouche was to find a living heroine disguised as a
man in Mme. Manson, whose murder *Memoirs* he helped to write. As
the key witness at the 1818 Fualdès trial, she was known to don men's
clothes and, in fact, had disguised herself in this manner when she
allegedly observed the murder. A *femme savante* in men's clothes was
George Sand, whom Latouche hired to write for *Figaro*. Perhaps both
women were living prototypes of the fictional *Fragoletta*, since
Latouche had made the acquaintance of both women prior to creating
his heroine.

Bosio's *Hyacinthe* was appealing to Latouche both because of its
suggestion of the sexual ambiguity of antique statues and also because of
its grace, which harked back to the work of Canova. The other sculptor
who merited his praise was the young David d'Angers, who shared with
Latouche strong republican sentiments and was to become the medalist
of the Romantics. His statue, *Le Grand Condé*, for the Pont de la
Concorde, was his first official commission, inherited on the death of
his teacher Philippe-Laurent Roland. When the plaster appeared in the
Salon its modern costume caused consternation among the Neo-
Classicist critics.[64] Latouche took up its defense: he ignored the costume
and spoke of the noble head and the bold pose. He praised David for
creating an image that would remind the French of great actions in
history. David's achievement according to Latouche lay in his ability to
animate a figure in a moment of dramatic action.

Latouche's admiration for David d'Angers extended from his work to
his personality as a fellow Romantic and republican. David wrote in
regard to portraiture, "I have refused to do the statue of princes and

kings and I have been content to reproduce the image of the man of the
people who will consecrate the inspirations of his genius to the noble
cause of liberty."[65] Balzac, who, like Latouche, was one of David's
sitters, also admired the sculptor as much for his personality as for his
work and fictionalized him in the character of Chaudet in *La
Rabouilleuse.* As Laubriet has pointed out, Balzac's taste in sculpture
may have been formed in part by Latouche.[66] Balzac's choice of David
d'Angers as the prototype of a fictional character as well as his
admiration for Canova, whose works he referred to many times in his
novels, may have been generated by Latouche's predilection for their
sculpture.

In Latouche's last article on the Salon of 1817 the journalist went
beyond the role of art critic to play the part of political instigator. He
taunted the censor in a description of an Isabey drawing. In directing
attention to the image of a child holding a bouquet of red, white, and
blue roses, Latouche made the association with the tricolor and the king
of Rome, whom Isabey had painted several times.

> One notes among the prettiest drawings of M. Isabey, the standing figure
> of a child who carries in his hands an enormous bunch of *roses.* This
> association of spring colors and the graces of childhood recalls ideas of hope.
> In the middle of the bouquet the artist has thrown pretty blue flowers: the
> general effect of this composition has to be more propitious. These flowers
> are called, in German, *Vergiss mein nicht,* forget-me-not!" (July 16)

On its appearance, the article caused a sensation. The public quickly
caught the allusion to the king of Rome and the emblem of the tricolor,
and when the doors of the Salon opened the next morning, a crowd
gathered in front of the Isabey drawing of an unknown child and
chanted, "It is the King of Rome!" The following morning *Con-
stitutionnel* was suppressed.

That Latouche had intentionally thumbed his nose at the censor has
been suggested by Sainte-Beuve, who recorded the scandal as an
example of Latouche's waggishness.[67] Sainte-Beuve reported that after
the censor deleted the offending passage, Latouche managed to reinsert
it secretly the night before publication. This account is supported by
Ségu.[68] But another contemporary commentator claimed that the
passage was overlooked by the censor, the good Doctor Regnault, a
busy hospital administrator, who missed the point of Latouche's
malicious joke. At any rate, *Constitutionnel,* founded during the
Hundred Days as an active opposition paper, had already been
suspended three times before the final suppression of July 16.[69] Its
public, accustomed to reading between the lines, was quick to catch any
innuendo. Though both Latouche and his paper gained notoriety from
the incident, the suppression was only momentary: the journal reap-

peared under the name *Journal du Commerce* a few days later. According to Sainte-Beuve, "M. de Latouche had a good laugh and rubbed his hands together."[70]

Latouche's instigation of a political scandal at the Salon of 1817 exemplified the type of opposition journalism that Balzac was to describe in 1843 in his satire *La Monographie de la presse Parisienne*. According to Balzac, the opposition journalist, besides blaming, scolding, and advising the government, must be capable of thinking up hoaxes or *canards* that will embarrass those in power. Latouche's seventh article on the Salon followed this pattern of political journalism: his *canard* was not a fictitious news bulletin but, as was more appropriate to the art critic, an imaginative visual interpretation of a drawing. Perhaps Balzac was thinking of Latouche's *canard* when he said in his 1843 satire: "The *Constitutionnel*, under the Restoration, made of the *canard* a political weapon."[71]

The Man Who Wrote to David Henri de Latouche at the Salon of 1819

In covering the Salon of 1817, Latouche, writing for the opposition newspaper *Constitutionnel,* had dreamt up a *canard* that resulted in a demonstration at the Salon and simultaneously in the suppression of his newspaper—a triumph that delighted the republican journalist. By 1819 he had several other literary successes behind him. He had just returned to Paris after covering the sensational Fualdès murder trial. Both his 1818 publication of the account of the Fualdès murder, thought by many to have been a White Terror plot, and his *Memoirs of Madame Manson,* a private correspondence in which a key witness in the sensational murder trial "told all," had been great triumphs, with seven editions of the latter work appearing in the course of the year.[1] The *Memoirs* was one of the earliest examples of a documentary novel retelling a criminal trial and was a genre—*roman reportage*—that Latouche would later return to with great success. Although he disclaimed any involvement beyond editing the letters, actually the *Memoirs* were probably largely the work of Latouche. Consisting of letters penned by the highly emotional Clarisse Manson to her *maman,* the pseudodocumentary *Memoirs* recalled the genre that Mme. de Staël had used most effectively in *Delphine* and Richardson in *Clarissa.*[2]

The success of the *Memoirs of Mme. Manson* may have influenced Latouche's decision to publish his 1819 Salon criticism in epistolary form instead of presenting it as a series of reviews in the newspaper as he had done in 1817. Published with engravings by Ambroise Tardieu of twenty works from the Salon, the book entitled *Letters to David on the Salon of 1819, by some of the students of his school* appeared with a

frontispiece by Eugène Déveria, showing a portrait of David.[3] The correspondence of thirty-four letters, dating from August 1, 1819 to March 1, 1820, was signed by initials that failed to match the actual students from David's atelier. The first letter, however, was signed "N.," the initial Latouche had used in the *Salon of 1817*. Although Latouche may have had one or more collaborators in compiling the fictional letters,[4] it is my conjecture that he wrote most of the book himself, for it was as we have seen his custom to publish letters supposedly written by others. Another such faked correspondence, *Clement XIV and Carlo Bertinazzi: unpublished correspondence* (1827), was later published by Latouche as a series of secret letters between a pope and a harlequin—both historical figures. In 1821 his *Last Letters of Two Lovers from Barcelona* appeared as a "translation" of letters published originally in Madrid by "le chevalier Henares Y. de L.," a Spanish author whose name bore a close resemblance to Henri de Latouche. Finally, even his most popular novel, *Fragoletta*, appeared anonymously. Latouche's predilection for anonymous publication was noted by Henri Beyle (Stendhal), who retorted to Latouche's joking comments on Stendhal's partiality for pseudonyms: "Keep quiet, you are another one."[5]

That Latouche was the guiding force behind the *Letters to David* is implied not only by his penchant for anonymous publication but by the similarity of viewpoint between the "letters" and Latouche's earlier Salon critique, the *Salon of 1817*. The style of writing—provocative, witty, often malicious—was typical of his critical essays and included were many anecdotal pieces and dialogues that recall his imaginative writing.[6]

In August 1819, just at the time the Salon opened, Latouche had made his greatest literary coup for the Romantic movement by editing and publishing the poetry of André Chénier. When the Salon in which Géricault's painting *Raft of the Medusa* would have its first official exhibition opened, Latouche seized with enthusiasm another opportunity to strike a blow on behalf of the young Romantic painters. A parallel between the *causes célèbres* of the Fualdès case and the Medusa disaster had already been drawn in the press. The *Minerve française* had commented, "The Fualdès affair has Medusa'd everyone," indicating that the scandal of the *Medusa* shipwreck, like the Fualdès murder, had been an embarrassment to the government.[7] Madame Manson herself had made a donation to a fund for the *Medusa* survivors, and the "collaborator" of her *Memoirs*, the journalist Latouche, "un sténograph Parisien," with his strong antiroyalist feelings, would have found it difficult to resist writing on the Salon where Géricault's *Raft of the Medusa* was the center of attention.

Though the epistolary format had been used in art criticism ever since the eighteenth century, the idea of a private correspondence written by

David's students to the exiled artist had a flavor of the sensational and even the seditious. Signed by initial only, the letters gave the impression of a private and more outspoken critique of the Salon than those by newspapermen.

It is curious to note that the original idea of a correspondence with David may have stemmed from an actual letter written by David to his pupil Antoine Jean Gros in 1817. David, eager for reports from his friends on the current Salon, remarked that the journal reviews were of little value to him: "I wait for the arrival here of those who will have seen the Salon. I will not look at any newspaper, one knows how those articles are done. For us and our friends, I will leave it to M. Navez."[8] The last sentence suggested that David would rely on his pupil, whom he then described as talented and *juste* for an honest appraisal of the Salon. In his *Letters to David* Latouche followed David's view that the student-artist would render a more careful appraisal of the Salon than the newspaper critic. He denigrated the professional critic: "we will offer you today only a general and rapid survey; for we do not know how, in the manner of professional critics, to speak of an object without having examined it."[9]

Fear of an artistic decline hovered over the Salon. As early as 1807 Taillasson had predicted the eventual disappearance of the severe standards of French art established by the school of David, but it was not until a decade later with the Restoration and the exile of David that the prediction was taken seriously.[10] Even to the royalist critic Comte de Kératry, disturbing signs of the degeneration of French art were apparent in the 1819 Salon exhibition, and he wrote that he was very tempted to cry out, "David, where are you now?"[11] Similarly, Gros wrote to David: "Despite the renown that you left to the French school, I am beginning to see disorder menacing."[12] Latouche, by publishing the supposed correspondence of David's loyal followers in Paris, demonstrated that the Davidians, even without the presence of their master, were still a powerful force. Trained according to the strict discipline of David's atelier, his disciples were capable of evaluating the Salon according to aesthetic standards uninfluenced by the propagandistic purposes of Bourbon officialdom.

On August 25, the date of the Feast of Saint Louis, patron of the Bourbon family, the Salon of 1819 opened its doors to the public. The Salon was staged by the king's art officials to demonstrate to Frenchmen and foreigners what royal support could do for art and industry, and its walls were lined with a gigantic display of paintings, including many religious and historical works commissioned by the government. The ceilings above the stairway leading to the Salon were newly decorated with paintings in honor of the opening. The central painting, the *Rebirth of the Arts* by Abel de Pujol, was an allegorical tribute to the art

patronage of the Bourbons. A disconcerting detail among the figures rising in the clouds to the winged Genius of Art was an attribute of the allegorical figure of Engraving: tucked under her arm appeared an engraving plate of David's *Oath of the Horatii* noted by Latouche:

> We will only say a word about the ceiling of the grand stairway of the Museum, painted with talent by the same artist [Abel de Pujol]; the foreshortenings are indicated with art, and one is thankful to the artist for having, in his subject, which presents to us the regeneration of the fine arts in France, offered indirect homage to the head of the modern school, whose taste and talent have fixed in France love of the antique. The figure of Engraving carries on the plate, which is her attribute, the *Oath of the Horatii*, the most beautiful painting of the master.[13]

The "indirect homage offered to the chief of the modern school" in the very entrance to the exhibition hall supported Latouche's view that David, though not present at the Salon, was still a name to contend with in the art world of France.

The Salon was large, some 1,615 works were listed in the *livret*, about 30 percent more than appeared in 1817.[14] To many, the size of the Salon signified that art was thriving under the Bourbons. And no doubt the government mounted such a gigantic exhibition with this intention in mind. Kératry, who recognized in the exhibition the lowering of the standards set by David, still felt called upon to praise the Salon as a demonstration of the strong interest in art of the French people: "The love of the arts is not less familiar to the French than to the people of antique Athens."[15] Other critics, however, openly questioned the quality of the numerous works on exhibition. Latouche warned that "this great number of paintings, this crowd of statues" did not prove that art was flourishing but, rather, argued its impending decline. He attributed the lack of honest criticism to fear of authority, self-interest, or heedlessness:

> Let one make a scrupulous examination of the diverse kinds of merit of all these productions, and one will be convinced most unhappily that art is very close to degenerating; that it is following a bad path. . . . And that, whether through calculation, or in order to flatter the authorities, or through a very condemnable negligence, none of those who could direct it the best dares to point out its errors, or is willing to lead it back to the true path far from which it has strayed.[16]

At the same time as the letters warned of the decline of French art they bore witness to David's continued interest in the Salon during his exile. The letters may have been calculated to inspire a recall of the painter to his native land. David's former student, Comte de Forbin, who was in charge of the Salon as director of the museum, had

suggested to Gros that David's *Léonidas* be placed in a position of honor in the Salon of 1819 so that David's students might gather around it to petition for the recall of their master when the king visited the exhibition. David had refused his permission.[17] Thus, Latouche had seized upon an issue that was still very much in the air: the underlying motive of the *Letters to David* appeared to be a plea for the return of David, the only master capable of reversing what his students perceived to be the decline of French art. David was presented as a hero who had suffered at the hands of the Bourbons, and on the frontispiece his portrait by Déveria appeared between France and the Genius of Painting. Despite Forbin's covert support for David, Latouche, as we shall see, presented him as an adversary in an effort to heighten the sensational appeal of his book.

In opposition to the government's attempt to show the revitalization of French art under the Bourbons, the letters presented the public with an analysis of the reasons for the current degeneration of French art. The central problem in the eyes of David's "students" was that David's great works were no longer on display and his influence could no longer be felt by aspiring artists. Letter 2 traced the history of French art and compared David to Poussin. It stated that Poussin, exiled in Rome because of artistic rivalry, was never able to form a school of French followers. Formerly, David had been able to show a "new path" to the young French artists of his studio. With his exile, his school no longer existed and France was threatened with a decline of art.[18]

One solution to the current problem was to be found in the training of the artist, a subject that Latouche had already discussed in the second article of the 1817 Salon review. Currently, training for artists was hardly more than vocational: they were taught merely "the art of tracing lines," and they lacked the basic literary education necessary to the great artist.[19] A curriculum was suggested that would nourish the imagination of the young with treasures of ancient and modern literatures. Furthermore, since there was no living master in France whose example they could follow, the students must learn to discover for themselves the beauties of the works of antiquity, a process that would be aided by exposure to antique sculpture. Here Latouche's admiration for sculpture as the foundation of painting paralleled the beliefs of the conservatives, including Comte de Forbin, who at this time was making efforts to supply the Beaux-Arts with antique casts for study.[20]

Although in many ways Latouche's taste paralleled that of Forbin, the director of the royal museums became the object of attack throughout the *Letters*. A student of David's, Forbin was himself a painter *manqué* whose works on exhibit in the Salon Latouche mocked.[21] In his role as museum director, Forbin was faced with a difficult task as intermediary between the government and the artists in

a period of great political pressure and artistic uncertainty. His loyalty to his teacher was still apparent in his efforts to save David's Napoleonic paintings from destruction and to acquire them for the state.[22] However, while these negotiations were going forward and were recognized with gratitude by the exiled master, Latouche presented a portrait of Forbin as the lackey to the Bourbons and failed to credit his efforts in support of his master.

Latouche took Forbin to task for setting the opening date of the Salon on the Feast of Saint Louis. The official date should not depend on the whim of royalty, according to Latouche, who chided Forbin also for his royalist sympathies that kept him from exhibiting the great Napoleonic canvases of David and Gros. Although Latouche may have known through his friend Gros of the negotiations begun in January 1819 by Forbin to acquire for the state the *Sabines* and the *Léonidas*, he nevertheless portrayed Forbin as a puppet of the Bourbons who was unfair to David and his students. In Letter 9 he claimed that Forbin had rejected the works of David's students because of their loyalty to their master. One such rejected work, which did not appear in the Salon, was still the subject of an illustration and was discussed in Letter 11. The letter (a kind of literary *Salon des refusés*) argued that the painting *Alexander the Great Visiting Apelles* by Ponce-Camus was rejected because the royal officials who made up the jury believed the scene alluded to Napoleon's visit to David's studio during the Hundred Days. Latouche claimed that this subject was considered "very seditious" by an undistinguished jury made up of royal officials rather than artists or members of the Institute. To emphasize the propagandistic motives of the Salon jury, Latouche asserted, "The crime of Ponce-Camus is in the choice of this subject."[23]

In the second letter of the correspondence, Latouche had taken up the theme already dealt with in the *Salon of 1817*, the importance of artistic freedom. In 1819 he again urged young artists to free themselves from patronage and to work for themselves alone:

> let them flee with care all protection, all patronage. Otherwise they would not be free to direct their brushes. . . . Sweet liberty is favorable to great ideas, to beautiful execution! Of all artists, who more than the painter is in a position to enjoy it? . . . Who can stop him? If his work is good, soon they will dispute the honor of possessing it.[24]

While there were a few disagreements among the letters on particular works of art to lend an air of verisimilitude to the correspondence, the preferences generally accorded with Latouche's *Salon of 1817*. This similarity was true in the "students'" choice not only of painters, as we shall see, but also of sculptors. Letter 10, supposedly written by a

"student" of David who had given up painting in favor of sculpture, began with the remembered advice of David, "Love sculpture; she gives the idea of beautiful forms." The student went on to cite, as upholders of the glorious tradition of French sculpture, several artists whom Latouche had praised in 1817: Dupaty, Bosio, and Cortot among others. A second letter (31) on sculpture, appearing after the Salon was closed and covering the Luxembourg exposition, focused on Bosio's *Salmacis,* a pendant in the Salon of 1819 to his *Hyacinthe* so greatly admired by Latouche in the Salon of 1817. The *Salmacis,* too, drew praise for being "poetically conceived." Latouche's fascination with the feminized male as a sculptural type recalling antique hermaphrodites was as apparent in 1819, as it had been in 1817, with his high praise of the "delicious" *Narcisse* of Cortot.

Latouche's taste for sculpture in the tradition of Canova determined the preferences of both letters on sculpture. Similarly, his admiration in the Salons for the students and followers of David, the Romantic Classicists Guérin and Gérard in 1817 and Girodet in 1819, was reflected in the *Letters.*[25]

Girodet's suave mythological *Pymalion and Galatea* had brought forth many accolades from the critics. Letter 32 cited all the bad poems that were inspired by this beautiful painting. In his appreciation of Girodet's painting Latouche, like Kératry, gave unqualified praise to the figure of Galatea, which resembled Canova's version of the *Medici Venus.*[26] Changing from stone to flesh, her metamorphosis occurred under the strong chiaroscuro effects suggesting torchlight playing over sculpture. Girodet, in painting this work at night under lamplight in his studio, had been inspired most likely by the Roman custom (recorded in Mme. de Staël's novel *Corinne*) of viewing antique statuary at night.[27] Latouche, an admirer of Girodet's *Endymion* and *Atala* as "compositions vaporeuses, aériennes, *soufflées,*"[28] was pleased with the lighting. The atmospheric effects were enhanced by the smoke from burning incense that whirled around Cupid as he brought the lovers together.

Perhaps these misty effects in painting inspired Latouche's description of a girl in *Fragoletta.* The hero Hauteville, "often preoccupied with ideas from painting," imagined the young girl seen in a temple to be a marble statue under the last rays of the setting sun.[29] While Girodet's marble becomes a girl, Latouche's girl is transformed into marble.

Although Latouche admired the beauty of the Galatea, he criticized Girodet for not setting the scene in the sculptor's studio and for failing to represent Pygmalion as a genius in the throes of creative work: "Has not the expression of his enthusiasm for his work and of his profound passion escaped the brush of one who was capable of reproducing so well these beautiful effects?"[30] Latouche's disappointment was sharp-

CARL A. RUDISILL LIBRARY
LENOIR RHYNE COLLEGE

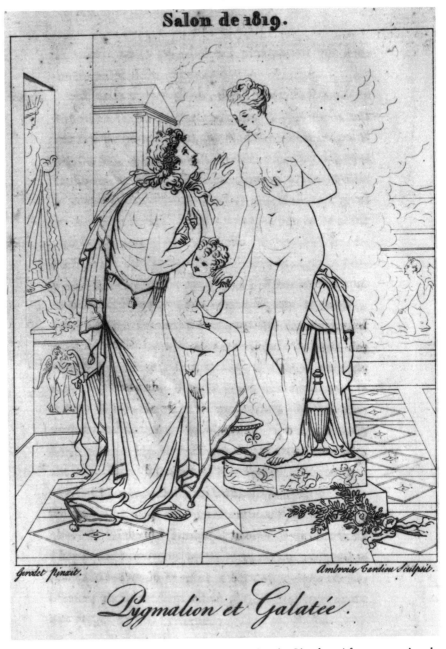

Girodet pinxit. Ambroise Tardieu sculpsit.

Pygmalion et Galatée.

Pygmalion and Galatea. Oil on canvas. Anne-Louis Girodet. After engraving by Ambroise Tardieu from *Letters to David.*

ened by his admiration for the mastery Girodet previously had shown in expression of the passions. Girodet's expertise as a painter of the passions had been demonstrated in his earlier paintings, and his interest in the creative frenzy of the artistic genius was recorded in his writings. The subject of Pygmalion offered him the opportunity to portray the passion of the artist in the moment of creation.

Girodet was one of the first French painters to apply Lavater's ideas to his work. It was not until 1804 that the full translation of the physiognomist's work was available in French, and yet by 1806 Girodet seems to have put Lavater's theory into practice in the intense expressions depicted in the people of his *Scene of a Deluge*.[31]

Girodet seems to have believed with the eighteenth-century theorist J. B. Dubos that there was a connection between the originality of an artist and his ability to express the passions in his work.[32] In a letter to Bernadin de Sainte-Pierre he even criticized his early *Endymion* for its failure to express the passions.[33] Girodet's belief that expression played an important part in an original creation was stated more generally in his poem *Le Peintre*. Here he spoke of Lavater as a guide to the painter in search of true feelings hidden beneath the human mask.[34]

Not only had Girodet's poetry supported his deep interest in study of expression as the foundation for works of genius, but also in his *Consideration on Genius in Painting and Poetry* he had discussed in detail the enthusiasm of the artist in the moment of creation, the very enthusiasm that Latouche felt he did not reveal in his painting of *Pygmalion:* "The excitement, which awakens in him the superabundance of creative powers. . . whose fury he cannot contain, agitates him in all his senses, finally concentrates and absorbs him entirely in profound meditations." Girodet went on to picture the soul of the artist engulfed as by a wave or a flame during the artistic process, a concept that accorded with Mme. de Staël's idea of the overwhelming enthusiasm of genius.[35]

To Latouche, a staunch defender of Girodet, the insufficiency of Pygmalion's expression was a serious flaw, especially in light of his own concern as a journalist with capturing fleeting expressions that might give a clue to character.[36] Latouche, as a reporter covering the Chamber of Deputies, prided himself on going beyond an analysis of political speeches to a penetrating psychological characterization of the speakers.[37] Marcel Dupeyré, in a necrology on Latouche, paid tribute to his having invented a new kind of journalism "which is called *la physionomie.*"[38]

Latouche's reservations about the insufficiency of expression in the Pygmalion grew out of his expectations of Girodet as well as from his own literary accomplishments in this area. He was aware of Girodet's

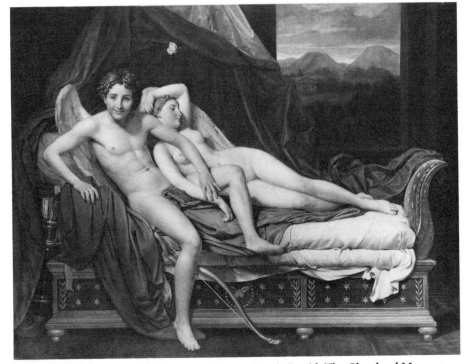

Cupid and Psyche 1817. Oil on canvas. Jacques-Louis David. The Cleveland Museum of Art, Purchase, Leonard C. Hanna Jr. Bequest.

turning away from forceful expression in favor of a more decorative mode related both to his recent paintings for the Chateau de Compiègne and to the suave Classicism of his youth.[39]

A similar sweetly decorative mythological painting, François-Edouard Picot's *Cupid Leaving Psyche*, received the highest number of votes (thirty-one) from the Academy judges who evaluated the Salon in October.[40] Latouche came out strongly against Picot's work as a mere pastiche of David's *Cupid and Psyche* (1817). Although not on exhibition in the Salon, David's painting was available to the amateurs of art in the private collection of the patron who had commissioned it, Comte de Sommariva.[41] The presence in Paris of a new work by France's most important living artist assured it critical attention.

David's controversial painting drew a negative response from the conservative critics who bestowed accolades on Picot's work, which was a more idealized rendering of the same scene. Critics who were shocked at David's realistic depiction of Cupid (in the pose of Caravaggio's *Love Triumphant*) were delighted to show through comparison with Picot, one of his own students, that David's brush was no longer supreme.[42]

Before being shipped to Paris for display at the Sommariva mansion, the painting had been exhibited in Brussels to raise funds for charity. That it caused some controversy there is suggested by articles that appeared in the Brussels press.[43]

The *Vrai Liberal*, a Brussels newspaper published by French refugees, defended the painting and published a poem dedicated to David by an admirer of the painting who bemoaned the fate of the artist rejected by France in this "day of ignorance." The last lines of the poem were ascribed to "righteous posterity" who would say: "Look at this work, which in days of sorrow, served humanity." Of the several poems dedicated to the Cupid and Psyche, the editors of this refugee newspaper printed the one that they thought "would give pleasure to the subscribers" probably because of its anti-Restoration point of view.[44]

How much news reached Paris of the reaction to the painting in Brussels is difficult to ascertain. The only published report of the exhibition in a French periodical appeared in the *Journal du Commerce,* the new name taken by the opposition journal *Constitutionnel* after its suppression on July 16, 1817, following Latouche's *canard.* On August 12, 1817, it announced the exhibition of the painting "which is already the talk of the town." Again on August 19 an announcement appeared that the queen had paid a visit to see "the charming painting of David."[5]

On its arrival in Paris, David's painting predictably drew negative criticism not only for its realistic treatment of a mythological theme but for its strong color. It was immediately apparent to the conservatives among the French critics that David, under the influence of Flemish art, was moving away from the subdued color of his Neo-Classical paintings. In a letter to Gros (September 1817), David described his belated desire to become a colorist: "If I had had the good fortune to come to this country earlier, I believe that I would have become a colorist. This country inclines towards it, all surroundings are of an admirable tone, and in this country those who exercise our art, without being great painters, have a color sense that Frenchmen are far from possessing."[46]

In the same letter, after asking for Gros's "indulgence for my painting which you are going to see at M. de Sommariva's," David requested an honest appraisal from his pupil. Gros, who did not answer until January, gave the painting a polite but mixed review. He praised it for its composition "worthy of the Greeks," and the warmth of its color, reminiscent of Titian and Giorgione. He went on, however, to comment negatively on the faunlike head of Cupid, his brownish and roughly painted hands, his elongated foot, and Psyche's projecting big toe. All in all, Gros's reservations appeared to outweigh his appreciation of David's new painting.[47]

Another former pupil, Delécluze, writing in 1855, recalled the impact of the painting on the Parisian art world:

> Sensitive to the reproach that had often been made against him of being only an imitator, only a copyist of the antique, David, mustering all the force of his instinct and his talent in order to imitate nature without seeking to modify and to embellish it, completed the painting of *Cupid and Psyche* and proved that he could represent the natural, unselectively copied immediately from the model. This work, when it was exposed in Paris, towards 1823 [*sic*] drew praise and attracted the most excessive criticisms against the painter, and one could regard it as the last of David's works which had any influence on the spirit of the young artists who at this moment were getting ready to make a revolution in the art of painting.[48]

Delécluze interpreted the reaction to David's painting in light of the rising interest in color and realism on the part of the young painters in Paris. David's painting appeared to support the new concerns of the Romantics. His realistic portrayal of Cupid pointed away from the Neo-Classical idealism of many of his earlier works to a more fleshly interpretation of a mythological theme. This unidealized rendering of a Classical scene appeared as an affront to decency in the view of the conservative critics, who, according to Delécluze, "could not pardon him for having represented indifferent nature in a subject belonging to the highest poetry."

The figure of Psyche, however, met with some praise from the upholders of the Neo-Classicist style. Psyche did not appear to be painted from a living model. Her languid pose and the sumptous draperies enfolding her recalled instead reclining nudes of David's pupil Ingres, in particular Ingres's *Grand Odalisque* of 1814, which was first exhibited in the Salon of 1819.[49] David may have been both consciously borrowing and reacting to Ingres's *Grand Odalisque* as he signed and dated his painting on the wooden frame of the couch as Ingres had on the *Odalisque*'s mattress. Though pose and setting are similar, Ingres's nude is composed of elongated abstract forms, while David's is closer to actual human anatomy. Furthermore, the *Odalisque*'s inviting glance contrasts with Psyche's innocent sleep. David used the pale, sleeping figure of Psyche as a foil for the lively and rugged Cupid. Such was the reaction of the Salon critic Miel, who praised the "ideal forms" of Psyche but compalined the Cupid "is not a god, not even a handsome adolescent: he is a model, a common model copied with a servile exactitude," and his expression of happiness "merely a cynical grimace."

Another conservative critic, Kératry, also reacted with distaste to Cupid's mischievous expression, which he interpreted as the triumph of "an ignoble nature." He complained that Cupid appeared too "earth-

bound" with a torso that looked like an anatomical study and pointedly ended his appraisal by saying that out of respect for David he would refrain from comparing the master's version of the mythological scene with that of his student Picot. Thus Picot's popularity among the academicians and the conservative critics was in part a repudiation of David.

Letters to David expressed an opposing view. Although Picot's work was given moderate praise for its seductive forms and its pure drawing, various faults were indicated in the background, the drapery, and the drawing of Psyche's arm. In comparison with the master's work, it was pronounced inadequate: "Happily for him [Picot] my dear Master, your painting on the same subject is not beside his; the vigor of your drawing, the natural tone of your Cupid, the forms of your Psyche have thrown light on the mistakes of the young artist, and his pleasant color has appeared too ideal and perhaps too feeble beside the vigor and the truth of your flesh-tints."[50]

To Latouche, Picot's idealized vision of the mythological love scene lacked the power and animation of David's more realistic depiction. David's image of Cupid as a rakish adolescent boy, proud of his conquest, appealed to Latouche, whose taste in Classical literature leaned toward the voluptuous. André Chénier's love poetry, Girodet's illustrations to *The Loves of the Gods,* and Canova's erotic nudes were all admired by Latouche, who enjoyed pagan sensuality in both art and literature. He mocked the prudery of the French public. In his article on Girodet's illustrations to *The Loves of the Gods,* he chided the French for following the dictates of the confessor and the censor.[51] His pride in tempting the censor and ignoring the restrictions of the Catholic church led him to seek subjects on the theme of unusual loves. *Fragoletta,* the story of a hermaphrodite's simultaneous love affair with a brother and a sister, was certainly an *outré* subject. Similarly, in his play *The Queen of Spain* (1829), he was to depict in salacious detail the sexual intrigues of the Bourbon court in seventeenth-century Spain.[52] The daring comedy, which inspired Hugo's *Ruy Blas,* went beyond acceptable limits of French taste, and Latouche found that not only did he tempt the censors, but his licentiousness drew outraged rejection from many Parisian critics. In both of these works Latouche's lascivious interest recalled the eighteenth-century writings of Crébillion *fils* and of Casanova, whose *Mémoires* had supplied him with Fragoletta's unusual name.[53]

Sainte-Beuve related Latouche's desire to write erotic poetry to his "ardent feeling for physical beauty." Unfortunately, according to Sainte-Beuve, Latouche pursued this interest "farther than is permitted, even to an artist, in some lascivious elegies." Thus, it appears Latouche's taste for the sensual in art matched his taste in literature.

The Assumption of the Virgin. Oil on canvas. Pierre-Paul Prud'hon. Musée du Louvre, Paris.

Sainte-Beuve noted Latouche's delectation for literary "paintings of a most exquisite aphrodisiac character."[54]

Latouche's predilection for sensual beauty may have determined his assessment of Ingres's work. Although Letter 32 ridiculed Ingres's mannered style in *Roger and Angelica* and accused him of forgetting the precepts he had studied in David's studio, Letter 11 compared his *Grand Odalisque* favorably to nudes by Titian. Latouche's admiration for the pure contours of Canova's sculpture may have prepared him to appreciate Ingres's paintings of the "Neoclassic Erotic" type.[55] Although he questioned Ingres's use of color, Latouche still asserted that as a draftsman Ingres had nothing to fear from the critics.

Of the nearly two hundred history paintings listed in the *livret*, half treated subjects from ancient times. The remaining included historical and literary subjects from the Middle Ages and the Renaissance. Many of the paintings of the French past were executed in the *style troubadour*, which aimed at an archeologically detailed recreation of medieval costume and setting. Latouche was interested in subjects from medieval history and legend as can be seen in many of his poems, in *Vallée au Loup* (1833), as well as by his appreciation of Charles Nodier's work in this field.[56] Yet, he seemed to have some reservations about the detailed *trompe l'oeil* style of the *troubadour* painters that caused him to question whether the exact imitator of nature deserved the title of painter. The work of the Lyonnais painter Genod recalled to Latouche the genre paintings of his bête noire Drolling, whom he had criticized so harshly in 1817. While he admired the technical skill of the *troubadour* works, he was concerned with their affinity for genre scenes and suggested that perhaps they should not be listed among history paintings but, rather, in a subheading called "anecdotal."

To Latouche the artist of genius had to rise above the servile imitation of nature. He had to create an image that would demonstrate his artistic originality. Such an artist was Prud'hon, whose ability to imitate nature was amply demonstrated according to Latouche in the accuracy of his portraits but whose other paintings revealed a poetic artist who viewed the world "across the prism of his imagination."[57] Prud'hon's *The Assumption of the Virgin* received high praise from Latouche, while more conservative critics like Coupin and Kératry gave it mixed reviews. Latouche declared at the outset that Prud'hon had suffered at the hands of the critics for the originality of his talent. This comment was no doubt a reference to Jal's harsh criticism of *Justice and Divine Vengeance Pursued by Crime* in his review of the Salon of 1817. Latouche ranked Prud'hon far above most artists in talent and in the possession of a natural charm and grace. As a religious painter, he was accorded high tribute from the Swedenborgian Latouche who perhaps saw in Prud'hon's *Assumption* metaphysical images of celestial beauty:

"If someone had dreamed of celestial beatitude, if he imagined the beauty of the angels, if his imagination transported him to the middle of the celestial spheres, he would believe his dream realized."[58]

Latouche's praise for Prud'hon's vaporous chiaroscuro and the suavity and charm of his images was in accord with his taste for the *sfumato* execution of Girodet's mythological paintings. Furthermore, his interest in the mysticism of Swedenborg made Prud'hon's suave execution of *The Assumption* "in celestial space" irresistible to Latouche, who, in general, did not have much patience with Christian subjects.[59]

Religious subjects abounded in the Salon of 1819. Some eighty-six religious paintings were listed in the *Livret* as opposed to only twenty-seven in 1817. Many of the critics expressed dissatisfaction with this revival of religious subject matter. Even Kératry, who commended the commissioning of works from young artists, was upset at the increase in religious paintings. As a Neo-Classicist, Kératry held to Winckelmann's prejudice against Christian subjects in art. Latouche, as an anticlerical republican, satirized the increasing number of religious paintings in the Salon and pointed out that David never painted religious scenes and never had to face the problem of the vogue for religious commissions during his career. Following these comments a dialogue between an Enthusiast, an Amateur, and a Student focuses on religious scenes as a subject for art. The Student expressed Latouche's cynical point of view when he said, "I strongly doubt that these mystical paintings bring about many conversions."[60]

Though religious paintings filled the Salon, it was a single painting of contemporary history that was to mark the Salon of 1819 as an important moment in the history of Romanticism. Géricault's *Raft of the Medusa* depicted a disaster at sea, the shipwreck of the French frigate *Medusa,* and the survival of only a few members of its crew who had been abandoned by their officers on a makeshift raft. The event had horrified the French public and become an antiroyalist rallying point, with blame laid on the government for the incompetence of naval officers chosen for their aristocratic lineage rather than their seamanship.

In view of the possibility of antiroyalist demonstrations in the Salon, le Comte de Forbin handled the situation with great tact. The immense painting was given a place of honor in the *Salon Carré* at the same time as its title was edited to "Scene of a Shipwreck" in the *livret.* Although the word *Medusa* was dropped and the title generalized, the public had no trouble in identifying the event, which they had followed in the press.[61]

By exhibiting the painting in the Salon, Forbin demonstrated to the public that the monarchy had nothing to hide. Furthermore, the king

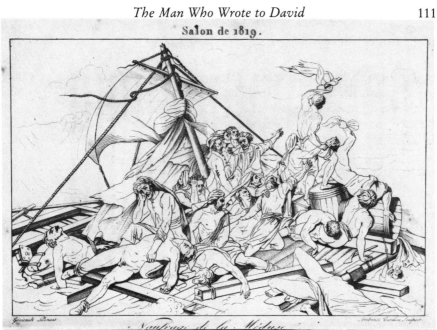

Raft of the Medusa. Oil on canvas. Théodore Géricault. After engraving by Ambroise Tardieu from *Letters to David.*

handled the situation with suavity, even complimenting Géricault in a jocular manner on his turning a disaster into a personal success: "Monsieur Géricault, you have just made a shipwreck which is not one for you."[62] This rather wry public statement on the part of the king may have served to deflect blame from the monarchy to the navy department. The minister of the navy, Dubouchage, seemed to react to the Salon with more discomfort than any of the other officials.[63] It was he who made a scene before Forbin for exhibiting the portrait by Legros of Corréard, the officer who had published his firsthand account of the disaster.

Critical reaction to the painting was fairly evenly divided. The conservative *Journal des Debats* gave it no notice, while many unfavorable critics took a patronizing tone, suggesting further study to the young artist. Kératry complained that Géricault had chosen the wrong moment in the narrative to portray, while Landon saw the work as a grouping of academic nudes. Other more liberal critics praised both the painting and the artist. Jal called Géricault "a courageous artist."

As a navy man himself, Jal wrote in detail about the naval and political aspects of the *cause célèbre.* He pointed out that most reviewers were motivated politically in their assessments of the painting: "Politics holds the pen of the critic. This conduct is justified because after all painting represents ideas." Jal himself was hardly immune to the political aspects

of the affair and admitted that his friendship with Corréard was based on common feelings of anger against Dubouchage. However, he pointed out that the account published in the *Mercure du XIX siècle* had aroused strong emotion in France and compared the scandal to the Fualdès trial. "Corréard's narrative had moved all France; and even in the prison at Rhodez where Mme. Manson of the Fualdès case was detained the victim of the shipwreck had found compassion."[64] Mme. Manson's donation to the subscription for the survivors of the *Medusa* had linked the two causes in the public eye.

Both the Fualdès murder and the *Medusa* affair could be used by antiroyalists as evidence of the corruption of the government. In fact, Géricault, in his search for a subject that would fulfill his urge "to shine, to enlighten, to astonish," had first studied the Fualdès murder and made a series of drawings showing successive episodes in the crime as it had been reported in the press.[65] In these studies, inspired partly by popular prints and partly by antique art, Géricault seemed to be working out the problem of choosing a single dramatic moment to use as a subject for a painting. Though the projected painting was never produced, the studies show Géricault's first plans for a history painting

The Murderers of M. Fualdès Carry his Body to the Aveyron River. Pencil, black chalk, and ink washes on yellow paper. Théodore Géricault. Musée des Beaux-Arts, Lille.

based on journalistic sources. The connection made between the Fualdès and the *Medusa* affairs may have inspired the young artist to turn his attention to the latter as a subject for his major Salon painting.

In his review of Géricault's painting, Latouche pointed out the figure of Corréard and paid tribute to him for publishing his eyewitness account. As a journalist, Latouche would have approved of Géricault's use in the *Medusa* of journalistic material similar to his own firsthand reports from the Fualdès murder trial. In the *Medusa*, as in his Fualdès drawings, the artist combined the literal journalistic record with a monumental vision derived from Baroque art. In a similar way, Latouche synthesized realistic detail and traditional Romantic elements in his *roman reportage*, the Manson *Memoirs*.

Perhaps closest to Géricault's *Raft of the Medusa* was Latouche's later work *Letters from Two Lovers of Barcelona* (1821).[66] In this pseudodocumentary epistolary novel set against the background of the plague in Barcelona in 1820, Latouche recounted the horrors undergone by the many Bonapartists who died in exile while their relatives and friends in France were helpless to save them. The appeal of the subject for French antiroyalists paralleled that of the *Medusa*. Just as Géricault studied the sick and dying to create his tortured nudes on the raft, so Latouche made a careful study of the plague. Letter 25 presented a detailed description of the symptoms of yellow fever, giving the impression of on-the-spot observation.[67]

In its depiction of man's reaction to imminent death and disaster, Géricault's *Medusa* had a recent precedent in Girodet's *Deluge* (1806). The *Deluge* drew negative reviews from conservative critics who viewed the work as more monstrous than tragic.[68] To the Classicists, history painting like Greek tragedy must produce a catharsis brought about through fear and pity. Aristotle himself had warned that "that which is merely monstrous and not productive of fear" was not true tragedy. Latouche, aware of the Classicist critic's demand for restraint in painting as on the stage, was quick to use the Aristotelian phrase "terror and pity" in connection with Géricault's painting. Aware that the Salon critics might attack the painting as they had the *Deluge* as mere melodrama, he insisted in his review that the work had reached the level of Aristotelian tragedy: "The general effect of this tragic composition inspires terror and pity."[69]

Not only did Latouche attempt to stem the Classicists' attack on the painting by describing it in Aristotelian terms, but he also tried to link it to the Davidian tradition. Though some critics like Delécluze viewed the work as a sign of Géricault's rebellion against David, Latouche was careful to indicate the similarities to a follower of David, Guérin; he observed that the figure of the "father" mourning his dying "son" had been derived from "Guérin's *Marcus Sextus*.[70] By mentioning that the

painting had "some reminiscences," Latouche established a link with the Davidian tradition at the same time as he noted Géricault's "originality," which customarily aroused the ire of the critics. He ended the review by drawing attention to the attacks on the painting motivated by "the conservatives and the jury who had removed the name of the *Medusa* from the *livret.*"

The deletion of the "Medusa" from the title in the *livret* irritated Latouche. After describing the agony of the suffering men on the raft, he asked ironically, "This man, who is he, in what country was he born?" and then answered, "these unfortunates are our brothers. Yes, they are our brothers. They are the shipwrecked of the *Medusa.* An understandable shame has wished to disguise from us this name which recalls so many misfortunes. But the laws have avenged these victims of a calculated infamy, and the nation has consecrated to them pious offerings in their friends who survived the shipwreck."[71]

Latouche's formal criticisms of the painting were similar to those of other contemporary reviewers: that the composition was too compressed and the color too uniform. He blamed the color on Géricault's quick method of execution and expressed the hope that the artist would no longer risk "improvising" a painting. Latouche may have learned from his artist friends of Géricault's piecemeal method of painting each figure from life directly on the canvas.[72] Though Latouche excused Géricault's unorthodox method because of a supposed lack of time, he indicated disapproval: "But time not permitting him to give to this part of his work [i.e., color] all the care that it demanded, he searched for a quicker manner; and what must appear to us a vice, is the effect of a system. Let us hope that the artist will no longer take a chance on improvising a painting, and that after having proved his talent in composition and drawing, he will wish to show that one can recognize him also as a colorist."[73]

As Eitner suggests, Géricault's method may have developed from his intense desire to retain the realistic immediacy of the contorted nude figures. Yet in composition the work was certainly clearly thought out in the tradition of Baroque painting. At the same time as Géricault was "improvising" certain figures directly from life, he took time to visit David's *Léonidas aux Thermopyles* and *Sabines* for artistic inspiration. He returned to his studio discouraged after viewing "the famous figures" of the *Léonidas* soldiers.[74]

Latouche, who had earlier stressed the importance of David's work for the young generation of artists, devoted Letter 33 (March 20, 1820) to a discussion of the *Léonidas aux Thermopyles.* Formerly on view only in David's studio, after its purchase by the state it was at last exhibited to the public at the Luxembourg. In a dialogue between an Amateur and

a Student, a format used in the eighteenth century by Diderot, the painting served as a model of modern artistic freedom in opposition to the restrictive observance of Classical rules.

The Amateur, a "grammarian of art," represented the eighteenth-century Classicist viewpoint founded on Winckelmann and Montfaucon. He cited Aristotle's insistence on the unities in art and literature and complained of David's license in the *Léonidas*. In response, the Student said of David: "He gives himself a new theory of art, for he is a creator." While the Amateur argued along philosophical lines, the Student praised David's artistic accomplishments, asserting "the connoisseurs are forced to agree that he has surpassed himself in color." To this the Amateur could not respond, for he turned out to be blind! Latouche twitted the critics of the *ancien régime* with the Amateur's response to the Student's expression of astonishment at finding a blind man visiting the exhibition: "It's an old habit; for more than a half century I have not missed an exhibition." The Amateur then proudly recalled that regardless of his blindness Diderot had consulted him, for art was basically a philosophical problem: "One could not render a greater service; also Diderot was a philosopher, and in art as in politics, it is demonstrable today that philosophy alone can work salutary reforms." The Student rejected the philosophical emphasis of eighteenth-century art criticism: "And what can philosophy do in this affair? The brush, the palette, talent and taste, those are the secret of art."[75] These words anticipated the comments of the artist Pourbus in Balzac's famous story on art, *The Unknown Masterpiece*, to be discussed in chapter 7: "Painters must meditate only with brushes in hand." In Latouche's view, as in Balzac's, philosophical thought was of little value to the creative artist. Rather, the painter must synthesize the real and the ideal in a uniquely imaginative way to communicate his sentiment to the beholder. The Student closed his defense of David with a definition of the artist that summarized Latouche's own views: "The artist, however, endowed with a feeling both profound and faithful, if he does not possess creative imagination, will be only a servile painter of a trivial and limited reality; he will only capture accidental visions and never the spirit of nature."[76]

In Latouche's view the true artist must find inspiration through his imagination. Looking beyond the material world for his ideal, he will reach the true spirit of nature. Thus, the artist was endowed with a tremendous power to reveal the mystery of nature through his artistic vision. By asserting the almost mystical power of the true artist to recreate the world in his works, Latouche mounted his attack on Classical rules. David's Student ended his account with these words: "It is thus, my dear Master, that I repulse these criticisms of a man who

would have had no arms against you if he could see your masterpiece."[77] In the last analysis the artist's chef-d'oeuvre would prove his superiority and defeat his critics.

In the dialogue between Student and Amateur, as in the individual letters to David, Latouche's use of supposed "students" of the painter as spokesmen for the Romantic aesthetic implied that the master was sympathetic to their cause. Thus, Latouche cleverly used the format of his Salon reviews to persuade the public that innovative artists, though rejected by the conservatives, had the support of the exiled leader, the "regenerator" of the French school. While the conservatives emphasized the break with tradition between the Classicists and the Romantics, *Letters to David* appeared to be documentary evidence to the continuity of the Davidian tradition in the paintings of the early Romantics.

6

Balzac's *Sarrasine*: The Sculptor as Narcissus

When Balzac met Latouche in 1824, the latter had already published his reviews of the Salons and was working on his book on Canova. He appeared to be an important figure in the literary and journalistic world as well as a knowledgeable critic of art. Balzac's early novella on art, *Sarrasine*, shows the impact of Latouche's artistic and literary taste.[1] This tale, like *The Unknown Masterpiece*, deals with the problems of artistic creation, and the protagonists of both stories, like the author, are young artists trying to determine which path is the proper one for them to follow.

Sarrasine, published in 1830, presents the problems facing a Neo-Classical sculptor, whose concentration on material reality leads him to copy nature rather than to recreate it. Balzac reiterated the theme of this novella in his preface to *Cabinet des antiques*, where he is concerned with literary creation: "Literature avails itself of the procedure painting employs, which, in order to create a beautiful figure, takes the hands of one model, the foot of another, the bosom of this one, the shoulders of that one. The work of the painter is to give life to these chosen members and to render it probable. If you copied a real woman, you would be led astray."[2] *The Unknown Masterpiece*, written in 1831, explores an opposing problem: the excessive spirituality of the Romantic painter, Frenhofer, who fails to strike a balance between his ideal conception and its technical execution. Frenhofer's failure is a lesson observed by the novice painter Poussin, who, like Sarrasine, is searching for his own direction. Written a year apart, these stories appear to be closely interrelated.

In 1832 Balzac told his editor that he intended to remove the novella *Sarrasine* from the next edition of the *Romans and Contes philoso-*

phiques. In Balzac's view the story was neither philosophical enough nor "of a theme easy to discover."[3] The theme of *Sarrasine* has indeed mystified many readers. Balzac's detailed setting of the story in Rome in 1758 has led some critics to look for sources in eighteenth-century memoirs. Reports of travelers provided Balzac with material on the papal court and the Italian musical stage.[4] The writings of Diderot yielded information on French artists working in Rome.[5] But at the same time as the particulars of place and period lent an aura of reality to the fantastic tale, they obscured the fact that its theme originated in the literature of antiquity. What has escaped the attention of the critics is that Balzac's tale of a naive young sculptor's deluded passion for a castrato singer is actually a retelling of an ancient myth. The theme of beauty and illusion that Balzac thought was "a theme not easy to discover" had its ultimate source in the Greek myth of Narcissus as told in Ovid's *Metamorphoses*. A more immediate source for the novella came from German Romantic interpretations of the Narcissus myth, particularly Hoffmann's *Der Sandmann,* a story of the artist and his relationship to his ideal.

Balzac described art as "nature concentrated",[6] and it is the process of turning nature into art that concerns him in his story of the sculptor Sarrasine. Jean Seznec has pointed out that the aesthetic philosophy enunciated in *Sarrasine* was drawn from Diderot's *Salon of 1767.*[7] In the *Salon* Diderot followed Plato's argument that ideal beauty exists only in the divine and not in the real world. Like Plato, Diderot rejected the eclectic system of attaining the ideal composite beauty through selection and imitation of the most beautiful features found separate in nature. The ideal is reached, according to Diderot, only through a process of continual corrections of imperfect models existing in the material world. Thus, Diderot follows Plato in giving more value to artistic imagination than to strict imitation of nature.[8] Seznec points out that Sarrasine's failure was the result of his search for ideal beauty in nature, whereas he should have created and refined it through his imagination. Because he thought he had found perfection incarnate in Zambinella, he merely copied the living model without bringing his imagination into play.

In another of Diderot's works, not mentioned by Seznec, the process of idealization of nature, first discussed in the *Salon of 1767,* is illustrated dramatically by means of sculpture. In his dialogue between two interlocutors, *Paradoxe sur le comédien,* the first interlocutor, using sculpture as an example, explains that the artist must begin with an ideal model as it appears to him in nature and improve upon it until little resemblance remains between the model and the work of art: "She [sculpture] copied the first model which presented itself. She soon saw that there were less imperfect models which she preferred. She corrected

the worst faults of these, then the lesser faults, until by a long process of work, she attained a figure which was no longer in nature."[9]

In Balzac's *Sarrasine,* the young sculptor does not follow this process of rarification of the natural model. He takes Zambinella's beauty as the already visible ideal, when it is actually an illusion that hides deformity, a chimera. Her resemblance to Greek sculpture seduces the artist's eye. He cannot correct the model, for his passion blinds him to imperfections. Sarrasine's needs as an artist are defeated by a symbiotic relationship between the sculptor and the model Zambinella that parallels the self-love of Narcissus. In Balzac's retelling of the Narcissus myth as an allegory of the artist's fixation on the model, both Sarrasine and Zambinella take on characteristics of Narcissus as though they are reflected images. In his recent analysis of the novella *S/Z,* Roland Barthes, who appears to be unaware of the Narcissus derivation of the story, nevertheless points up the linking of Sarrasine and Zambinella as mirror images, when he says: "S and Z are in a relation of graphological inversion: the same letter seen from the other side of the mirror."[10]

In the nineteenth century German Romantic writers, influenced by the Schlegel brothers, began to use the myth of Narcissus to illustrate the artist's relationships to his creation.[11] Beginning with Herder, the German Romantics accorded a new respect to ancient mythology. Friedrich Creuzer, a mythographer and student of Plotinus, believed that Classical mythology was a key to the wisdom of ancient religions. Many early Romantics were convinced that people of ancient times existed in harmony with God and nature. Balzac believed that a similar harmony governed the relationship of the artists of antiquity with their society. In his 1830 article *Des Artistes,* written the same year as *Sarrasine,* he expressed the view that ancient peoples had a greater understanding and respect for the geniuses who lived among them: "Savages and peoples who are closest to the state of nature live in greater harmony with superior men, than more civilized nations."[12] The profound understanding of the ancient artist by his society may have inspired Balzac to turn to mythology as a source for his stories about creative geniuses. Balzac wrote to Mms. Hanska: "It is deplorable, in the nineteenth century, to go in search of images from Greek mythology: but I have never been so struck as I am with the powerful truth of these myths."[13]

Balzac's Swedenborgianism made him particularly receptive to Creuzer's Neo-Platonic interpretation of the Narcissus myth. Creuzer explained the myth as an illustration of the fall of the soul from spiritual heights to earthly matter. To Creuzer Narcissus's pursuit of the visible world reflected in the water was analogous to the soul's attachment to beauty without substance, an attachment that lures the soul away from spiritual truth. Creuzer's mystical interpretation of the Narcissus myth,

destined to be popular among Scandinavian followers of Swedenborg, appeared for the first time in his introduction to a new edition of Plotinus's *On Beauty* in 1814.[14] Hoffmann's *Der Sandmann* appeared one year later.

Balzac gave a clue to his German source when he published an epigraph with the original version of *Sarrasine*. "Do you think that Germany alone has the privilege of being absurd and fantastic?" A further acknowledgment of his debt to Hoffmann was his dedication of *Sarrasine* in the 1844 edition to Charles de Bernard, who in an article on *La Peau de chagrin* in 1831 had pointed to the Hoffmannesque aura of that work. Balzac defended himself to Bernard by saying: "Modes belong to the whole world and the Germans do not have more right to use that of the moon than we that of the sun and Scotland that of the Ossianic mists. Who can flatter himself as being an inventer? I have not truly been inspired by Hoffmann whom I have only known after having thought out my work."[15] Balzac's denial of knowledge of Hoffmann's tales is difficult to accept in light of his friendship with Hoffmann's first translator, Henri de Latouche.

Balzac's equivocal response to Bernard's suggestion of Hoffmannesque influence may have been prompted by the criticism of Latouche as an unavowed imitator of Hoffmann. In 1823 a literary scandal erupted when Latouche was accused of plagiarizing Hoffmann's *Das Fräulein von Scudery* in his *Olivier Brusson*. As late as June 1830, *Figaro* was still discussing the issue, and Latouche continued to be branded as a plagiarist on the basis of this episode.[16]

It may, in fact, have been Latouche, the translator of much German Romantic literature into French, who first drew Balzac's attention to Hoffmann as a source for his stories about artists and their relation to their work. Both the theme of *Sarrasine*—the sculptor's obsession with the ideal woman—and the framing story of an evening party seen as a gothic dance of death, suggest derivation from the tales of Hoffmann.

The motif of the artist's difficulty in distinguishing between the real and the ideal was the central theme of several Hoffmann stories. In Hoffmann's *Der Sandmann* of 1814, the hero Nathanael, a student and poet, rejects a real woman, Clara, for his ideal, the automaton Olimpia. The story illustrates Hoffmann's belief that the artist's passion for material embodiments of his ideal will end in delusion. He must retain his love for the ideal as a spiritual inspiration, for he can never possess the ideal in the real world. The theme recurs in *Die Jesuiterkirche in G.* of 1815. In this tale the painter Berthold finds his true vocation as a painter of Madonnas when he takes as his model the beautiful Princess Angiola T. After rescuing her from a mob of angry revolutionaries, he wins her as a wife. As soon as he marries her, however, he loses his inspiration to paint her as a Madonna. Berthold denounces her: "She

was not the ideal which had appeared to me, but had only assumed the form and face of that heavenly visitant in order to destroy me."[17] Similarly Sarrasine accuses Zambinella of destroying all women for him after he discovers that the singer is actually a castrato: "Your feeble hand has destroyed my happiness. . . . I shall always have the memory of a celestial harpy who thrusts its talons into all my manly feelings, and who will stamp all other women with a seal of imperfection!" Both artists accuse their models of destroying their inspiration. For Berthold it was the physical possession of the woman that destroyed the illusion of perfection. Sarrasine's knowledge of Zambinella's physical and moral imperfection robbed him of his faith in the ideal. In both cases the artists failed to realize that the ideal is a spiritual inspiration that cannot be found in nature.

In Hoffmann's *Die Jesuiterkirche in G.* the spiritual aspect of the creative process is emphasized in these words addressed to Berthold:

> To seize nature in the most profound expression, in the most intimate sense, in that thought which raises all beings towards a more sublime life, is the holy mission of all the arts. Can a simple and exact copy of nature achieve this end? It is as miserable, awkward and forced as an inscription in a foreign language copied by a scribe who does not understand it and who laboriously imitates characters which are unintelligible to him. . . . The painter who is initiated in the divine secrets of art hears the voice of nature recounting its infinite mysteries through trees, plants, flowers, waters and mountains. The gift to transpose his emotions into works of art comes to him like the spirit of God.[18]

Balzac was in agreement with Hoffmann that the creative artist had special occult powers, a kind of second sight, which he must focus on the immaterial world in order to create great art. Hoffmann believed the artist must find the source of his creativity in his mystical search for the infinite. Balzac saw the artist as a man of genius with visionary powers that came into play only when he isolated himself from the material world: "Solitude is habitable only for the man of genius who fills it with his ideas, daughters of the spiritual world, or for the contemplator of divine works who finds it illuminated by the daylight of heavens, animated by the inspiration and the voice of God."[19] For Balzac the man of genius is a seer, and, like a religious mystic, he must lead a solitary and chaste existence. In *Sarrasine* the young sculptor shows promise of genius under the tutelage of Bouchardon, who controls him so that his life is devoted to sculpture: "For a long time, the lengthy and laborious studies demanded by sculpture tamed Sarrasine's impetuous nature and wild genius" (236). But at twenty-two he travels to Rome and falls under the spell, first of "the queen of ruins," and later of Zambinella's beauty. On seeing in Zambinella the ideal Grecian image of beauty,

Sarrasine turns his back on his training. Previously Sarrasine had followed the eclectic method of Zeuxis, the Greek sculptor who had created his image of Helen from many models. In Rome Sarrasine dares to turn away from the tradition of Zeuxis. The sight of Zambinella tempts him to copy ideal beauty from a single model:

> At that instant he marveled at the ideal beauty he had hitherto sought in life, seeking in one often unworthy model the roundness of a perfect leg; in another, the curve of a breast; in another, white shoulders; finally taking some girl's neck, some woman's hands, and some child's smooth knees, without ever having encountered under the cold Parisian sky the rich, sweet creations of ancient Greece. (237–38.)

It is curious to note that the sculptor Bouchardon, Sarrasine's master, had been noted for this innovative practice of working from a single model. Did Balzac read the commentary on Pliny by Diderot's friend Falconet? In his commentary, Falconet cited Bouchardon as being capable of working from a single model: "More than once, Bouchardon had studied only from a single model for works which are as important for him as the painting of Helen could have been for Zeuxis."[20] Falconet used Bouchardon as an example of the effectiveness of working from nature—a departure from tradition of the French Academy. Balzac sets Sarrasine on the same path, but the impetuous youth chooses a diabolical model who leads him to his doom.

Balzac describes Sarrasine devouring with his eyes the sight of Zambinella as "Pygmalion's statue, come down from its pedestal." Like Pygmalion, Sarrasine is a chaste genius who lived only for his Muse. His passion for beauty will be his undoing. Balzac's description of Zambinella in terms of Greek statuary recalls Ovid's description of Narcissus who sees his reflection in the pond as "cut from Parian marble." Narcissus's "ivory neck and shoulder" recur in the description the "dazzling white" of Zambinella's skin and the "marvelous roundness of her neck." Sarrasine is particularly vulnerable to her beauty because it combines "all the wonders of those images of Venus revered and rendered by the chisels of the Greeks" (238).

In the crowded theater, Sarrasine sees only the singer, as though they had become one being: "Moreover, the distance between himself and La Zambinella had ceased to exist, he possessed her, his eyes were riveted upon her, he took her for his own" (239). Similarly Ovid describes Narcissus's intoxication with his own image:

> Beauty caught his eye that trapped him;
> He loved the image that he thought was shadow,
> And looked amazed at what he saw—his face.[21]

The mesmerizing gaze that Sarrasine focuses on Zambinella is a recurring motif in the story. In fact, it is this gaze that causes the singer to falter and draws the attention of Cardinal Cicognara to the sculptor as a rival whom he will have destroyed.

Though Sarrasine's strong will exerts power over Zambinella through his obsessive gaze, his eyes do not see beyond the material world of the stage. He sketches her from memory in many imagined poses; as the fevered thoughts "went beyond drawing." Sarrasine used his imagination to live a life of passion with the singer. Caught up in his erotic dream, he fails to exert the genius's second sight. He fails to see beyond the physical beauty to the truth: his model is a deformed and immoral creature.

Balzac's description of Sarrasine's frenzied sketching as "a kind of *méditation matérielle*" is the key to Sarrasine's failure as an artist, for all his sketches are merely representations of matter, not of spirit. He uses his imagination to disrobe the singer, "to copy La Zambinella despite the veils, skirts, corsets and ribbons which concealed her from him" (240). But it is only her body that his passionate eyes see. Even when Zambinella asks, "If I were not a woman?" Sarrasine replies with the assurance of the artist: "Do you think you can deceive an artist's eye? Haven't I spent ten days devouring, scrutinizing, admiring your perfection? Only a woman could have this round, soft arm, these elegant curves" (247). Like Nathanael in *Der Sandmann* Sarrasine has been deceived by erotic passion.

Sarrasine's error occurs because he apprehends Zambinella only through his senses. As he listened to her sing, "His soul passed into his ears and eyes. He seemed to hear through every pore." He fell under the spell of her beauty: "With his eyes, Sarrasine devoured Pygmalion's statue, come down from its pedestal." Balzac's reference to Sarrasine's devouring gaze calls to mind the Ovidian Banquet of the Senses, a literary love theme developed from Classical sources during the Renaissance.[22] In opposition to the Platonic Banquet in which the senses are agents of the mind leading to the divine, the Ovidian Banquet is a feast of pleasure that will corrupt the soul. The Renaissance source for the opposition of the Platonic and Ovidian Banquets can be found in Ficino's Commentary on Plato's *Symposium*. According to Ficino, Reason, Sight, and Hearing nourish the soul; while the lower senses, Smell, Taste, and Touch, feed the body. Based ultimately on Aristotle's hierarchy of the senses, the descending order is followed in *Sarrasine*.[23]

Sarrasine's first experience of Zambinella is through the higher senses of Vision and Hearing. But the effect of sight and sound is so powerful that he loses his Reason, called by Ficino, the "sixth sense." "When La Zambinella sang, the effect was delirium." And as his pleasure increases,

the lower senses take control. He breathes "the smell of the scented powder covering her hair." He touches "her hand as he served her." And finally he tastes her lips: "Tell me you will cost my future, that I will die in two months, that I will be damned merely for having kissed you."

According to Ficino's interpretation of Plato's Banquet, the quest for the ideal beauty, first experienced through the senses, ascends through Reason to celestial love. In Ovid's Banquet, the voluptuous feast of the lower senses brings about the descent of the soul to bestial love. Thus, Sarrasine accuses Zambinella: "You have dragged me down to your level. *To love, to be loved!* are henceforth meaningless words for me, as they are for you." Sarrasine's gratification of his lower senses has destroyed his artist's soul: he has lost his creativity and has become as sterile as his model. Thus he accuses Zambinella: "Monster! You who can give life to nothing. For me, you have wiped women from the earth." Zambinella has turned out to be a "celestial harpy," the infernal *Doppelgänger* of the celestial angel she appeared to be.

Balzac was later to write a novel about a celestial angel, *Séraphîta* (1834), derived from the writings of Saint-Martin and Swedenborg. The protagonist, a mystical androgyne, ascends heavenward at the end of the book, like a Neo-Platonic soul returning to its divine origins. Although the creature has affinities with Latouche's *Fragoletta* in its double nature, Balzac did not emphasize the erotic aspects of the character, who instead suggests the pure idea of the artist's work. Like *Sarrasine*, the theme is linked with a work of sculpture, in this case a bronze angel designed for a tomb by Théophile Bra.[24]

In his article *Des Artistes* Balzac referred to the Platonic Banquet when he mentioned the presence "at the banquet" of artists in ancient times: "Among them the ancient beings *with a second sight,* bards, improvisators are looked on as privileged creatures. Their artists have a place at the banquet, are protected by all, their pleasures are respected, their sleep and their waking equally."[25] Plato's concept of eternal oneness with the divine wisdom of the universe attained through contemplation of ideal spiritual beauty was the source of the Swedenborgian concept of the celestial angel's ascent to the divine. To Balzac, who was reared on Swedenborgian literature, the visionary artist of Plato's Banquet appeared as a mediator between the sense and spirit. In order to serve this function, the artist, in Balzac's view, must distance himself from the sense experience that is his raw material. The separation between the life of the world and the monasticism of the artist was dramatized by Balzac's own peculiar writing habits. Like the narrator in *Sarrasine*, Balzac could view the life of the world with the detachment of a visionary. He wrote to Madame Hanska of his disciplined imagination: "an imagination which could conceive all and

remain virgin, like the mirror which is not soiled by any of its
reflections. The mirror is in my brain."[26] To Balzac the sculptor may
have seemed particularly vulnerable to experience of the material world
because of the tactile quality of marble forms. The imitation of life in
stone might lure him, as Pygmalion was lured, to fall in love with his
own creations. Sarrasine sees Zambinella as a living "masterpiece" and
does not heed her warnings. Zambinella tells of being forced to see
happiness "flee me continually," recalling Narcissus's plaint, "I am
entranced, enchanted by what I see, yet it eludes me." Her abhorrence
of both sexes recalls Narcissus's "little feeling for either boys or girls."
At the end of the story the image of Narcissus weeping into the pool is
called to mind as "two tears . . . burning" fall from Sarrasine's eyes. In
despair Sarrasine attempts to break his statue but is killed by Cardinal
Cicognara's men before he can destroy "this monument to his folly."

Not only are the verbal parallels with the Narcissus myth striking,
but Zambinella is described in botanical terms as though drooping with
weakness: "a sleepless night and I lose whatever bloom I have." This
image of the drooping narcissus flower is perhaps a prevision of death.
In Diderot's *Encyclopedia* the narcissus flower is dedicated to the gods
of the underworld "because of the misfortune of young Narcissus."[27]
Diderot also quotes the Pausanius version of the myth, which presents
Narcissus as haunted by the love of his dead twin sister. That Balzac was
aware of this version, popular in the eighteenth century, is demon-
strated by Sarrasine's question on discovering that Zambinella is a
castrato: "Have you any sisters which resemble you?" This strange
question links the allegorical tale of the sculptor to the framing story of
the Parisian ball. La Comtesse de Lanty, the hostess, is the niece of
Zambinella; the castrato's sibling has produced a line of descendants
who live in Paris from the wealth earned through Zambinella's
prostitution. In this way Balzac brings the corruption of the eighteenth-
century papal court to Paris of the 1830s.

In the mid-eighteenth century, with the revival of interest in
antiquity, several new translations of Ovid and other Classical authors
appeared in France. André Chénier, whom Balzac called "the greatest of
French poets,"[28] relied on Ovidian sources for much of his poetry.
Chénier's *Gallus*, which he admitted was partly inspired by Ovid, is the
image of Narcissus. Chénier believed that the writer should not imitate
the ancients but, rather, capture the spirit of the pagan mythology in
making his modern myths. Balzac was following this mode in con-
structing his story of a Neo-Classical sculptor along the lines of the
Narcissus myth.

Another eighteenth-century source for both Latouche and Balzac was
Jean-Jacques Rousseau's version of Narcissus.[29] In his comedy *Narcisse
ou L'Amant de lui-même*, Rousseau introduced an expansion of the

Pausanius version that included a sex change and a split identity. In *Narcisse* Lucinde tricks her brother Valère by placing a portrait of him dressed as a woman on his dressing table. The plot revolves around Valère's search for the unknown woman (himself) with whom he falls in love. Latouche's novel *Fragoletta* may have been partly inspired by Rousseau's *Narcisse*. The sex change of the portrait in *Narcisse* occurs also in *Sarrasine* when the sculptural portrait of Zambinella as a woman changes into a painting of the nude Adonis-Endymion, a perfect male. Balzac's narrator explains to Madame de Rochefide: "Madame, Cardinal Cicognara took possession of Zambinella's statue and had it executed in marble; today it is in the Albani Museum. There, in 1791, the Lanty family found it and asked Vien to copy it. The portrait in which you saw Zambinella at twenty, a second after having seen him at one hundred, later served for Girodet's *Endymion;* you will have recognized its type in the Adonis" (253).[30]

Vien's painting of Zambinella as Adonis supports the theme of the five senses as a path toward voluptuous love. Venus has many of the attributes of Voluptas, and her love for Adonis is characterized by Shakespeare as a banquet of sense:

> Had I no eyes but ears, my ears would love
> That inward beauty and invisible;
> Or were I deaf, thy outward parts would move
> Each part in me that were but sensible.
> Though neither eyes nor ears, to hear nor see,
> Yet should I be in love by touching thee.
>
> For from the stillitory of thy face excelling
> Comes breath perfum'd, that breedeth love by smelling.
> But O, what banquet wert thou to taste,
> Being nurse and feeder of the other four.[31]

The Venus and Adonis motif runs through *Sarrasine*. Zambinella's beauty appears first as a sculptured Venus, "all these wonders of those images of Venus revered and rendered by the chisels of the Greeks." At the end of the story Zambinella's beauty is captured as the painted image of the Adonis. Zambinella is transformed from Venus to Adonis in the course of the story, a symbolic metamorphosis from love to death.

In the first version of *Sarrasine* the painter of the Adonis was Girodet. Girodet was Balzac's favorite painter, and his *Sleep of Endymion* inspired the painting of Zambinella in the novel. According to Girodet's correspondence, published in 1829, the *Endymion* was begun in Rome in 1790 after a relief in the Villa Borghese and finished in 1791. As a painting of a Classical statue it was particularly appropriate

to the story of *Sarrasine,* and Balzac had admired it since at least 1819 when he first wrote a friend to get him a ticket to see it on exhibition in Paris. In his final revision of *Sarrasine* Balzac inserted Vien's name before Girodet's as the artist who copied Sarrasine's marble portrait of Zambinella,[32] but he failed to adjust the date (1791) to the time lag between Vien's fictional portrait of Zambinella and Girodet's "later" repetition of the Adonis type in his well-known *Endymion.* Perhaps Balzac inserted Vien in the story because Vien, Jacques-Louis David's master, would have been closer to Sarrasine's generation than Girodet, David's pupil.

In the framing story, the voluptuous image of the eternal sleep of beauty in art is contrasted with the grotesque "human wreckage" of the aged living figure of Zambinella at the ball. The old man resembles the medieval images of death as partner to a beautiful young woman in a dance of death. In contrast, the painting of him at twenty is a seductive image of a Classical love-death. Winckelmann's descriptions of an ancient tombstone where images of sleep and death appear as brothers inspired eighteenth-century Neo-Classical artists to idealize death in the form of a sleeping youth. These Classical images accorded with Balzac's

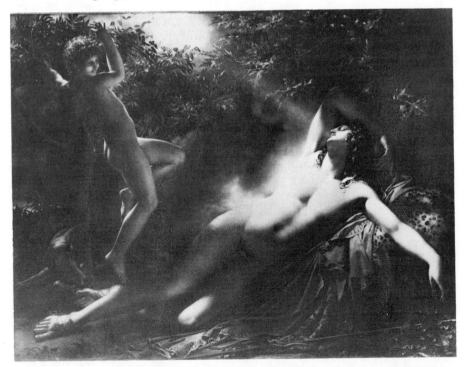

The Sleep of Endymion 1791. Oil on canvas. Anne-Louis Girodet. Musée du Louvre, Paris.

mystical beliefs on the kinship between sleep and death. In his *Letter to Charles Nodier* he said: "your article has considered sleep as a great goal, a pre-taste of the lazy delights of the idleness of the dead."[33] Symbolically the image of death as an eternal sleep suggested the immortality of art. The tension between art and life fascinated Balzac, who often compared his characters to statues. In *Sarrasine* Filippo de Lanty's beauty is "a living image of Antinous." At the same time as he imagined the animation of statues, he perceived a deathlike quality in marble forms: "Is the granite peace of marbles our omega or our alpha?"[34]

In *Sarrasine* the marble sculpture of Zambinella as a living woman is transformed by the great painter Vien (Girodet) into a painted image of death as a sleeping youth. In Ovidian fashion the statue of a woman has become a painting of a "too beautiful man." Although Vien (Girodet) "has never seen the original" and merely copied his painting of Adonis "after a statue of a woman," he succeeded in correcting Sarrasine's fatal error. In pointing out the great painter's distance from the original model, Balzac emphasizes the intuitive power of the great artist who is able to capture the inner truth hidden from those who train their attention too closely on materiality. In his preface to *La Peau de chagrin* Balzac describes the second sight of the great artist as making it possible for him to invent the truth by analogy.[35] In *Sarrasine* Vien (Girodet) has condensed the love-death theme of the story in the symbolic image of Zambinella as a sleeping Adonis. Like a great Balzacian artist he has painted the truth hidden behind the marble illusion.

To Balzac the great artist was a visionary who saw beneath the surface of the real world so that he did not need to copy nature: "He has actually seen the world, or his soul has revealed it to him intuitively. Thus, the most ardent, most precise painter of Florence has never been in Florence."[36] Sarrasine's belief that he would find ideal beauty in Rome was a chimera. To Balzac the true artist had to find his ideal in his own soul.

The ability of the true artist to penetrate beneath the surface of nature is a theme from Balzac's story that Proust was to echo in *Remembrance of Things Past.* When the narrator Marcel visits the studio of the fictional Impressionist Elstir and sees the watercolor portrait of Mme. Swann as a young girl on the stage, wearing boy's clothing, he is enthralled by "the ambiguous character of the person whose portrait now confronted me." This painting exuded "immoral suggestions" because of the uncertainty of the sitter's "latent sex" that "seemed to be on the point of confessing itself to be that of a somewhat boyish girl, then vanished and farther on reappeared with a suggestion rather of an effeminate youth, vicious and pensive, then fled once more to remain uncapturable."[37] Looking at the portrait of Odette in her youth, Marcel discovers

something vulgar in her character revealed to him for the first time through the art of the great painter. Elstir's eye, like that of Balzac's genius (Vien/Girodet), had seen through the facade of sexual coquetry to the real person. Proust describes Elstir's vision as a process of recomposition: "Artistic genius in its reactions is like those extremely high temperatures which have the power to disintegrate combinations of atoms which they proceed to combine afresh in a diametrically opposite order.[38] In Elstir's portrait of Odette, Marcel sees her face recomposed as it had appeared to the painter in the distant past. He sees at once both the early style of the artist and the unpolished image of the woman. "And this, Elstir's earliest manner was the most damaging of birth certificates for Odette because it not only established her, as did her photographs of the same period, as the younger sister of various time-honoured courtesans, but made her portrait contemporary with the countless portraits that Manet or Whistler had painted of all those vanished models, models who already belonged to oblivion or to history."[39]

In this passage Proust has created a confrontation between viewer and painting that is not unlike what Balzac had described in *Sarrasine*. When we see the old man Zambinella and later recognize the *Endymion* as a painting after his youthful marble portrait, we have a similar comparison between the beautiful and vicious early portrait and the aging sitter. Balzac's use of the feminized male image in the Girodet looks forward to Proust's description of the boyish girl or girlish boy painted by Elstir. Just as Elstir's portrait preserves on canvas the ambiguous sexual history of the sitter, so the Girodet is an unclear image of the castrato from whose prostitution the Lanty family received their wealth.

One wonders whether Proust had *Sarrasine* in mind when he conjured up the episode of Odette's portrait. In *Contre Sainte-Beuve* he mentioned "the fortune of the [Lanty] founded on the love of a cardinal for a castrato."[40] And in *Remembrance of Things Past* he again referred to *Sarrasine*, this time by title, when the Baron de Charlus praised Balzac for dealing in his novels with "passions the rest of the world ignores."[41] It would appear that this moment in *Remembrance* is a literary bow to Balzac's *Sarrasine* for having indicated to Proust a method—through comparison with a sexually ambiguous image in art— to bring into the novel the difficult theme of homosexuality.

7
Balzac's Unknown Masters

While *Sarrasine* was largely ignored until Roland Barthes turned his attention to it in his structuralist study *S/Z*, discussed in chapter 6, *The Unknown Masterpiece* has generated many critical inquiries in the past century. Scholars have speculated about a baffling central problem: how could Balzac, with his limited knowledge of art, have written with such expertise on the technical problems of painting that are expounded by his fictional painter Frenhofer? A secondary problem that has intrigued students of the story is the identity of Frenhofer. Is he purely fictional or does he have some model in a real person whom Balzac knew? I shall attempt to answer both of these questions in this chapter. In order to do so, however, I will rely on hints that are embedded in the earliest version of the story that appeared in *L'Artiste;* this first publication is, in my view, more revealing of sources than the later versions, which reflect considerable reworking. Furthermore, I will examine art and literary criticism of the period as a possible source of many of the ideas expressed by Frenhofer. As we have seen in chapter 6, Seznec has pointed out in relation to *Sarrasine* that Balzac was aware of Diderot's art theory. Balzac may well have also discussed current art and literary theory with critics he knew. Furthermore, he contributed to art and literary magazines like *L'Artiste* in which art criticism was featured. The idea put forth by many scholars that lengthy discussions with a painter or a writer provided Balzac with the material for this story seems to me less convincing, however, than the possibility that he had at hand published material in the form of current Salon reviews that he could draw on while working on *The Unknown Masterpiece.* In the underlying lesson of the story—that criticism impedes creativity, a theme exemplified by the fate of Frenhofer—Balzac gives us a clue that the sources of the tale itself may be found in art criticism. In his *Monographie de la presse Parisienne* Balzac stated his belief that the critic was an artist *manqué:* "The universal characteristics of the critic

are essentially remarkable in the sense that there is in every critic an impotent author."[1] In *The Unknown Masterpiece* the character of Frenhofer personifies such a hypercritical artist who has lost his creative ability. What could be a better proof of Balzac's belief in the interference of the critical intelligence with the spontaneity of the creative process than that he put into the mouth of such a failed artist words derived from current art criticism?

Since 1879 when Jules Claretie raised the question of whether Balzac had collaborated with Gautier on the reworking of *The Unknown Masterpiece* scholars have given more attention to the revisions of the story (in 1831 and again in 1837) than to the original version as it appeared in *L'Artiste* in the summer of 1831. The debate over the mysterious collaborator who helped Balzac revise the tale has reduced the original to a text for comparison with the two expanded versions. As I have stated, it is my purpose in this chapter to go back to the first version and examine some of the sources that the debate on collaboration has obscured.[2]

Scholarly agreement has been reached that the later versions of the story are richer than the original in Frenhofer's exposition of the technique of painting. The first version is superficial in its treatment of the technical aspects of art. Various people who were more knowledgeable than Balzac have been offered as the source for the elaborated technical passages. Charles Spoelberch de Lovenjoul upheld the view that Gautier inspired these passages.[3] François Fosca questioned Gautier's intervention and suggested instead that Delacroix was the source of Frenhofer's technical expertise.[4] Mary Wingfield Scott rejected both of these collaborators and instead conjectured that Balzac used ideas developed from conversations with an artist or art critic in his two revisions: "My own surmise is that the insertions and changes in the editions of 1831 and 1837 are not the connected work of Gautier or Delacroix or of any third person so far unsuspected, but that they are the outcome of conversation between Balzac and some critic or painter."[5] Scott's "surmise" and her further mention of the close ties between art and literary fields in Paris of the 1830s suggest that there may be neglected sources in critical writings for the original text and point to a broader interpretation of the novella to include the problem of literary as well as artistic creation. The first version of the story, so often faulted for its lack of concrete material on painting, may indeed be derived from theoretical writings on both art and literature. Much of the criticism during the early 1830s, even in the field of art, was written by literary men, who applied the same philosophical approach to literature as to art. The derivation of the story from critical and philosophical writings would account for the scant attention paid to painting technique in the original text. Only later did Balzac attempt to flesh out

the aesthetic discussions with a more detailed analysis of painting methods.

It is my thesis that the story in its initial conception was based on the aesthetics of three men who, while primarily concerned with literary ideas, also applied their theories to art. The ultimate source for the story was the philosophy of Victor Cousin, whose theory of Eclecticism offered a means of reconciling the Classicist and Romantic factions in France. The *spiritualiste* aesthetic of Frenhofer, the period setting of the tale, and the role played by Poussin were all derived from Cousin's lectures. Second, the critical writings of Cousin's follower and Balzac's friend, Gustave Planche, provided Balzac with many of Frenhofer's critical remarks on painting and on the methods of the artist. Finally, Henri de Latouche who, as we have seen, was Balzac's mentor in his early years as an unknown writer in Paris, was in many respects the prototype for Frenhofer as a failed artist. The contradiction between Frenhofer's supreme assurance as a critic and his failure as a creative artist had its parallel in Latouche's career. The relationship between the young Poussin and the older Maître Frenhofer in many ways mirrors Balzac's deteriorating relationship with Latouche at the time the story was written.

Before examining the influence of these three literary men, it is important to look at the journal in which *The Unknown Masterpiece* first appeared. *L'Artiste*, founded in 1831, was a journal with a bias in favor of Romanticism. Jules Janin, in his article *Être Artiste!* in the first issue emphasized the magazine's interdisciplinary point of view. The word *artiste* referred not only to the visual artist but to artists in many fields: "Really should one imagine that art consists only of painting and that it belongs only to the one who holds the brush and the pen?"[7] Janin, perhaps aiming for bourgeois support of the new journal, concluded that every man had something of the artist in him. The same idea was reiterated by Victor Schoelcher later in 1831, adding that there existed a "spiritual affinity," which allied the arts to one another.[8] The *fraternité* of all the arts was a battle cry in support of the artistic renewal after the revolution of 1830. According to Alexandre de Saint-Chéron, whose articles of 1832 dealt with poetry and art, the vitality of the arts in the past was a result of artists from many different fields working in unity.[9] The broad interpretations of the word *artiste* and the idea of the interdependence of the arts were central to the position of *L'Artiste* in its early years.

Balzac had already expressed similar views in print. In his article *Des Artistes*, which appeared in *La Silhouette* (February 25, 1830), he applied the word *artiste* to all creative people, even scientists and explorers: "Thus with Gutenberg, Columbus, . . . Descartes, Raphael,

Voltaire, David. All were artists, for they created, they applied thought to a new production of human forces, to a new combination of the elements of nature, both physical and moral."[10] In *Lettres sur Paris,* published in *Le Voleur* (January 9, 1831), Balzac pointed out reassuringly that though Claude was dead in 1730, Delacroix was still young in 1830.[11] Balzac's vision of the interdependence of all the arts of the same epoch, either flowering or fading together, was in accord with the view of the editors of *L'Artiste* in 1831. Although by 1835 the journal had narrowed its vision and begun to concentrate on the visual arts alone, in the year of its founding when Balzac's novella *Le Chef-d'oeuvre inconnu* appeared (in two parts) in its pages, its dedication to the unity of the arts lent an expanded interpretation to Balzac's story of three painters in the seventeenth century. The reader who was attuned to the policy of the magazine might well have interpreted such a story as a parable of all the arts in France in 1830, despite its being titled a *conte fantastique* (a tag dropped in later versions).

The similarity of the methods of writers and painters was to be stated in Balzac's preface to *Le Cabinet des antiques* (1839) and quoted in chapter 6: they both reassemble diverse elements in nature to achieve a composite image that appears to be natural. The most difficult problem for the artist after he has achieved his eclectic synthesis is the infusion of life into his creation. For the writer as for the painter the problem is "to give life" to the disparate elements joined together in his creation.[12]

In *The Unknown Masterpiece* the painters Frenhofer and Pourbus wrestle with the problem of creating a lifelike image of a woman, while the young Poussin listens. As Jerrold Lanes has indicated, the opposition of the two older painters, recalling the seventeenth-century dispute between Rubenists and Poussinists, may also be interpreted in terms of the Romantic-Classicist factionalism of Paris in 1831.

> Of the two principal schools of painting at the time—they were often described as the followers of Ingres on the one hand and of Delacroix on the other, but more usually they were called classicists and romantics or conservatives and progressives—Frenhofer is a militant partisan of the second faction. His is a style based on "color" rather than "contour" (the two basic categories of style since the quarrel between the Poussinists and the Rubenists).[13]

This artistic factionalism extended into the field of literature where, according to Balzac, the Eclectic school was rejected by France which "loves war in everything."[14] In his article *Étude sur M. Beyle* [*Study on Stendhal*], published in *Revue Parisienne* of September 25, 1840, Balzac indicated that the reconciliation of the two warring factions in literature through a third Eclectic school that drew from both the Classical and

Romantic would not be possible in France where the masses were not attracted to "composite things" (*Beyle*, 272). He described the literary situation in terms of three schools: the Literature of Ideas, the Literature of Images, and Eclecticism. The Literature of Ideas was conservative and Classical, stemming from the seventeenth and eighteenth century and particularly attuned to "le génie de la France" (*Beyle*, 373). This rational and factual school (represented in the novella by Pourbus) is described by Balzac as being characterized "by the abundance of facts, by its sobriety of images, by the concision, the lucidity, by the little phrase of Voltaire, by an eighteenth-century style of narration, by the sentiment of the comic, above all" (*Beyle*, 372).

Balzac also saw the emergence in the nineteenth century of a new school, the Literature of Images, a Romantic school that concerned itself with the lyrical, the elegiac, the meditative. This school is characterized "by the poetic amplitude of phrase, by richness of images, by its poetic language, by its intimate union with Nature. . . it tends to elevate itself through sentiment toward the very soul of Creation" (*Beyle*, 372–73). The Literature of Images in its Romantic and spiritual union with nature is represented in the novella by Maître Frenhofer.

In an attempt to reconcile these opposing schools Balzac pointed out that their methods are not mutually exclusive: "Thus I do not mean to say that a poet of the School of Images is without ideas and that another of the School of Ideas does not know how to invent beautiful images" (*Beyle*, 372). He then went on to demonstrate that painting, like literature, can be analyzed according to its formal means. Color and drawing he saw as corresponding elements to idea and image in literature. He illustrated the need for artists to use both means in a comparison of the art of Raphael and Rubens in terms of line and color: "In literature, the Image and the Idea correspond to what in painting is called Drawing and Color. Rubens and Raphael are two great painters; but one would be strangely mistaken if one believed that Raphael is not a colorist; and which of us would refuse to Rubens the title of draughtsman?" (*Beyle*, 372).

The correspondence that Balzac saw between the formal problems of the painter and the writer shows a broad vision about controversies in the art and literary worlds. In his discussion of the three literary schools existing in France in the 1830s he used analogies from the work of earlier painters. This interdisciplinary mode of thinking in his critical writing supports the interpretation of *The Unknown Masterpiece* as a parable of both the artistic and literary factionalism of Balzac's day. In the novella the neutral stance of the young artist Poussin corresponds to Balzac's personal position vis-à-vis rival literary schools. In his *Étude sur M. Beyle* Balzac holds himself apart from the opposing factions and espouses the third school, Eclecticism:

As for me, I rank myself under the banner of literary Eclecticism for the following reason: I do not believe it possible to paint modern society by the severe procedure of seventeenth-century literature. The introduction of the dramatic element, of the image, of painting, of description, of dialogue appears to me indispensable in modern literature. (*Beyle,* 373).

Balzac's position as a literary Eclectic derived ultimately from his familiarity with the philosophy of Eclecticism espoused by Victor Cousin in his famous lectures that Balzac attended in 1816.[15] When, after an eight-year political suppression, Cousin returned to lecture at the Faculté des Lettres from 1828 until 1830, he drew a following that Stendhal compared to Abélard's audience. Such interest was aroused that copies of his lectures were posted in the streets of Paris.[16] No wonder that Balzac, who had been stimulated as a youth by Cousin's lectures, should again turn his attention to Cousin's philosophy. Balzac's interest in Cousin's theories intensified during the 1830s. Yet as Andréoli points out, in 1831 when Balzac wrote his novella he still thought of Cousin's views as excessively metaphysical: "for Balzac, the name of Cousin evoked then [1831] a philosophy, spiritualist, nebulous and 'poetic.' "[17] In 1829 Balzac had burlesqued Cousin's jargon in several articles and he continued to spoof Cousin's vocabulary when he referred to the three schools of literature as "this *triplicité,* an expression forged by M. Cousin" in the opening of his *Étude sur M. Beyle* (*Beyle,* 371). Yet by 1840 when Balzac wrote his analysis of the literary situation in *Études sur M. Beyle* and placed himself among the Eclectics, he had certainly begun to give Cousin's system more credence than he may have liked to admit.[18]

Cousin's philosophy was a mixture of ideas derived from Plato, Plotinus, Scottish philosophers, German thinkers like Schelling, Hegel, and Kant, and the aesthetic writings of Winckelmann and Quatremère de Quincy.[19] There was something for everyone in Cousin's theories, and his impact on the Romantic generation was greater, according to several modern critics, than has previously been acknowledged. Cousin affirmed that his system of Eclecticism had gathered basic truths from the history of philosophy, and his follower Théodore Jouffroy asserted in an article published in the *Globe* in 1825 that Eclecticism was capable of bringing about a reconciliation between the Classicist and the Romantic factions in France.[20]

In the eyes of his contemporaries Cousin was viewed as allied to literary Romanticism. By his own avowal his philosophy expressed thoughts similar to the writings of Mme. de Staël and Chateaubriand.[21] As D. G. Charlton suggests, Cousin's philosophy "anticipates the Romantic aesthetic" in the following respects: his emphasis on the independence of the arts from the social utility, his evaluation of the

imagination as the prime faculty of poetic genius, and his belief that the expression of the invisible is the highest aim of art.[22] These views as well as the phrases used to express them—"true art," "the spirituality of the soul," "poetry and liberty"—were similar to the ideas and the vocabulary of the early literary Romantics.[23]

Yet in the field of art, Cousin had much in common with the Neo-Classicism of Winckelmann and Quatremère de Quincy. His preference was for French Classical art of the seventeenth century. Though Cousin spoke of the necessity of the fusion of the school of the real with the school of the ideal, his taste favored an art of ideal beauty. To him the aim of art was the expression of moral beauty through the physical ideal, a beauty derived from nature but corrected by the imagination of the artist who held an image of the ideal in his mind. His aesthetic theory called for the artist to recreate the spiritual ideal hidden beneath the surface of nature. Art became an improvement over visible nature. The imagination of genius saw beneath the real world to an eternal beauty. However, though art was more ideal than nature it had lost the vitality of nature, and Cousin urged the artist to strive to infuse his creation with life.

In his hierarchy of the arts Cousin ranked painting below the first art, poetry, but above sculpture and music, whose elements it combined: "Like sculpture, it [painting] marks the visible forms of objects, but at the same time adding life to them; like music, it expresses the most profound sentiments of the soul." The most important subject for the painter is "the whole face of man, and his gaze, this living mirror of what is happening in his soul." Painting is elevated above both sculpture and music because it expresses "the human soul in all the richness and variety of its sentiments" (Du Vrai, 202).

Cousin's interest in the expression of the soul in painting is similar to Maître Frenhofer's aims in art. Frenhofer speaks of his painting as having a soul: "the soul which I have bestowed upon it" (2:7). Frenhofer embodies Cousin's belief that art is "a sort of religion" (Du Vrai, 186). In the novella he represents the type of Cousin's spiritualiste artist, whose primary faculty is his imagination. Frenhofer speaks of his painting in Cousinian phrases. His portrait is not merely a painting "it is a sentiment, a passion" (2:8). Similarly Cousin sees the true artist as awakening in the viewer the sentiment of the beautiful. Cousin contrasts the man of imagination (the true artist) with the positive man who merely imitates reality without transforming it. The man of imagination delights in the world of his dreams. Like Frenhofer, who has the look of a man "established in his boredom" (2:7), the man of imagination is bored with the real world and "imagination becomes mistress to the tedium of real and present things" (Du Vrai, 149). Frenhofer is the fictional example of the artist of imagination whose

excessive involvement with his ideal leads him to produce "works which are inaccessible to our senses."[24] The compelling attraction of his *fantômes* interferes with his creative activity, and he becomes in Poussin's words "more poet than painter" (2:10).

Cousin's Eclecticism called for a fusion of imagination and reason. According to Cousin such a fusion existed among the French writers and painters of the seventeenth century. In Cousin's lecture, *On French Art in the Seventeenth Century,* he discussed the great French artists of the past as models for the nineteenth century: "they excel in composition, above all in expression. They always have a thought, a thought both moral and elevated. It is for this reason that they are dear to us, that their cause interests us." Cousin chided the eighteenth century for ignoring the great artists of the past. Among neglected French painters Cousin hailed Poussin as the archetype of the great French painter, "the philosopher of painting." To Cousin Poussin represented the eclectic genius of France: "Poussin draws like a Florentine, he composes like a Frenchman." He was capable of painting in all the genres and was also able to infuse life into his art ("all lives, all breathes"), for Cousin asserted time could not take away from his paintings "what will make them live forever, drawing, composition, expression." Cousin also compared Poussin to "the great and forgotten" seventeenth-century French sculptor Jacques Sarazin. This comparison may have inspired Balzac to use the name Sarrasine for his fictional character of a French sculptor working in eighteenth-century Rome. These two artists linked by Cousin would then be linked, somewhat more remotely to be sure, in Balzac's two novellas (*Du Vrai,* 225–26, 228–29, 242).

Appreciation of Poussin grew in the nineteenth century.[25] In 1810 J. F. Sobry had accorded new recognition to Poussin by equating him with Raphael in his *Poétique des Arts.* Balzac referred to the earlier neglect of Poussin when he dubbed the painter "the neglected Poussin" in *Des Artistes.* Balzac's choice of Poussin to play the role of the naive onlooker in the discussion between Frenhofer and Pourbus may have stemmed from the new image of Poussin emerging in the nineteenth century. Poussin became the type of the dedicated artist-thinker totally involved in his work and removed from the petty rivalries of his envious colleagues. In the *Life of Poussin* by Maria Graham, published in English in 1820 and translated into French the following year, his career is presented as a model to the young artist. Mrs. Graham praised him for keeping out of quarrels with rival artists and also for his constant quest for knowledge. Like Félibien, Poussin's contemporary biographer, she cited his eclectic method of learning: "he considered everything worth remarking, and gained something from every painter."[26] Though, as Laubriet has pointed out, Balzac's major source on Poussin was Félibien, his presentation of Poussin as eager to learn

from many painters while maintaining his critical independence may have been generated in part by Mrs. Graham's recent account.

Poussin's role as the neutral observer in the story accorded with the fact that he was the hero of both the Classicists and the Romantics. Not only were both Ingres and Delacroix to write tributes to him, but many painters depicted great moments in his exemplary life. In 1825 Balzac's friend Charles Nodier published a lithograph *The Childhood of Poussin* by Pierre-Noasque Bergeret showing the painter as the precocious artist Bellori had described him to be. Though little was known about Poussin's youth, his perseverance in art was a lesson many of these paintings taught. Balzac's favorite painter Girodet described in his *Mémoires* (published posthumously in 1829) a projected painting, *Poussin Meditating in the Ruins of Rome,* that was to have depicted Poussin painting under lamplight while Jealousy and Envy conspired to deprive him of Fame. At the same time as Girodet acknowledged the tradition of Poussin's mistreatment by his colleagues, he planned to portray him as following the work methods Girodet himself practiced.[27]

While Girodet would have stressed the Classical sources of Poussin's art, Balzac chose to emphasize Poussin's early training by Flemish artists. Félibien had documented Poussin's youthful studies with the Flemish artists Ferdinand Elle and L'Allemand and had recorded Poussin's interest in observation of nature and his empirical method of sketching on his walks around Rome. It was Poussin the thinking artist, the empiricist and Eclectic, who was depicted in the novella. Balzac, in showing Poussin's quest for the vitality and realism in Flemish art, may have been legitimizing his own interest at his time in Flemish art and literature as a mirror of reality.

Partly perhaps as a reaction to Romanticism, Flemish and Dutch art were much admired in Paris of the 1830s. The realistic qualities of Flemish painting were recognized by travelers who returned from Flanders struck by the resemblance of the natives to seventeenth-century paintings. Even in the eighteenth century Diderot had remarked: "Women, such as one sees in the paintings of Rubens, appear there in their houses."[28] Balzac, an ardent admirer of Dutch and Flemish art, eventually added many northern paintings to his collection. He owned a copy of J. B. Descamp's *The Life of the Flemish, German and Dutch Painters* from which he gathered information on Mabuse and Pourbus for the novella.[29]

The realistic portraiture of Flemish art was often compared to Balzac's portraits in words. Critics during the 1830s praised Balzac's ability to render lifelike portraits through observation of exterior detail and through psychological penetration. Bernard Weinberg points out: "In connection with Balzac as a descriptive artist and as a 'painter,' it is important to note that very early his style is assimilated to that of the

Flemish and Dutch masters."[30] In fact, according to Weinberg, the interest in Flemish painting during the 1830s contributed significantly to the reception of French Realism in both painting and literature.

The discussion in Balzac's novella centers on the problem of giving vitality to the painted human image, a key problem for the literary realists like Balzac. That he had succeeded as a literary portraitist was acknowledged by friends like Samuel-Henry Berthoud, the Flemish writer, with whom he became friendly in 1831. A decade later Berthoud, who had been his mentor in things Flemish, praised him as a northern painter: "Sometimes resplendent and impetuous like Rubens, mysterious and fantastic in the manner of Rembrandt, one must still compare him above all to Terburg."[31] Balzac, too, in his novella tried to give a sense of the many different aspects of northern painting at the same time as he emphasized its quest for vitality and psychological penetration. It was no mistake that Pourbus, whose work like Balzac's was admired for its accurate observation of detail, should be included in the story as a foil to the imaginative Frenhofer. Balzac was trying to show that great art consists of painting the inner man while still depicting the surface of nature. Although Pourbus's painting receives severe criticism from Frenhofer, the young Poussin calls the work "sublime." This difference of opinion suggests that Frenhofer's judgment may be too harsh. Frenhofer acknowledges his own severity as a critic when he warns Pourbus: "Let us not analyze anything, it will only put you in despair" (1:320).

It is my conjecture that Frenhofer's grave and hypercritical analysis of art finds its source in the rigorous critical writings of the young journalist Gustave Planche, whose *Salon of 1831* was causing a stir among Parisian art circles during the period when Balzac published *The Unknown Masterpiece.* Later in November of 1831 Planche, a fledgling member of Hugo's *Cénacle,* took it upon himself to avenge that coterie in print against the accusations made by Latouche's article of 1829, *On Literary Camaraderie.* Planche's response, entitled *Literary Hatred,* appeared in *Revue des Deux-Mondes* shortly after the failure of Latouche's play *The Queen of Spain* (which was to inspire Hugo's *Ruy Blas*) and dealt a terrible blow to the older author. Planche accused Latouche of plagiarizing not only Hoffmann, but the eighteenth-century correspondence of Abbé Galiani in his *Clement XIV and Carlo Bertinazzi.* Furthermore he attacked *Fragoletta* on grounds of obscenity. It was not until 1842 in his last novel *Adrienne* that Latouche retaliated (with little effect) by drawing a portrait of Planche in the character of the opportunist and vicious critic "M. Jouvellier."

While Planche had not yet published his attack on Latouche when he wrote his *Salon of 1831,* he was already a rising star among Hugo's circle. His Salon review was to bring him to the attention of a large

public. Planche began and ended his highly analytical critique with a cry of despair at the current situation of the arts. He saw art and poetry menaced by science and economics and insisted that the arts would continue to play their role only when the public had been properly educated, a difficult mission that he intended to undertake in his *Salon.*

Although the overall tone of Planche's *Salon of 1831* was one of contempt for the superficiality of the critics and the low level of public taste, Planche suggested in his introduction that more intelligent and serious criticism could elevate French taste in the future. He stated that with the establishment of democracy in July 1830, France would begin to look for something to fill its leisure hours and would become aware that "art alone can fill them."[32] France would recognize an aristocracy of genius when an ideal republic was established, but in the meantime, Planche asserted, "art is sick," and the mission of the conscientious critic was to cure it (5). Planche's declaration that "art is sick" is alluded to by Balzac in *The Unknown Masterpiece,* when in declining to give a verbal description of Pourbus's studio Balzac says, "but the arts are so sick, that it would be a crime to make paintings in literature" (1 : 320). This joking paraphrase of Planche's pessimistic statement appears only in the 1831 *L'Artiste* version of the novella. The reference to Planche's *Salon* introduction indicates that Balzac was familiar with the *Salon* while writing his novella.[33]

Frenhofer's warning to Pourbus that further analysis will lead to despair holds true in his own case, for his dissatisfaction with his "masterpiece" plunges him into one of his "profound and spontaneous depressions" in which the two younger painters find him (2 : 7). Balzac suggests two diagnoses of the depression: a medical one of bad digestion and a psychic one "following the spiritualists," stemming from "the imperfection of our moral nature." He goes on to say that "the pretentious jargon of our epoch" would lead "modern writers" to characterize Frenhofer's state as due to "a prodigious expenditure of soul" (2 : 7). Thus his *spiritualiste* diagnosis would follow Cousin's doctrine of the subordination of the senses to the spirit (*Du Vrai,* xliii). Was Balzac also thinking of Planche's despondent tone in his *Salon of 1831?* The *Salon* was to conclude with "a cry of torment and of agony" at the sterility and powerlessness of the critic (166). Later Balzac described the malaise of the critic in the character of Claude Vignon, the fictional journalist modeled in part on Gustave Planche. Vignon spoke of a malady similar to Frenhofer's when he said to Lucien de Rubempré, "Genius is a horrible sickness. Every writer carries in his heart a monster which, appearing like a tapeworm in the stomach, devours sentiment."[34] In both Vignon and Frenhofer the hypercritical obsession stifles creativity.

The preoccupation with ideas that Balzac noted in Frenhofer and

Vignon was part of the Cousinian baggage of Planche's writings on art. Planche as a student of Damiron, one of Cousin's disciples, inherited the Eclectic view of art as the painting of the soul and played the role of the critic as philosophical interpreter and judge. However, Cousin's emphasis on the idea behind the object was balanced in Planche by a taste for concrete analysis of the work itself derived from Condillac whose method of serious reflection on the object underlay Planche's writing. Planche's rather literary approach and his attempt to analyze works of art in relation to general philosophical ideas placed his *Salon* on a higher intellectual level than the writing of most Parisian journalists.[35] Although to artists his demands may have appeared implausible, to a literary man like Balzac, Planche with his rigorously analytical approach, appeared as an example of what the critic should be. He wrote to Mme. Hanska of Planche as "an immense and great critic."[36] Though Planche's *Salon of 1831* was not a commercial success, the year of its publication marked his admission to the staff of the *Revue des Deux-Mondes,* and at twenty-three Planche's future as a journalist was assured.

In the *Salon of 1831* Planche attacked the criticism that supported the intermediary school of painters, the popular painting of the *juste-milieu,* which, as Grate points out, had developed as a conservative compromise between the Classic and Romantic schools. Planche took an opposing view to Delécluze and denounced the paintings that had been praised by the established art critics. Clément de Ris recognized Planche's position vis-à-vis the critics of "the intermediary school" as the beginning of a new kind of criticism, the "spiritualist criticism," the "criticism of ideas," the "true criticism."[37]

Planche's criteria for evaluation of works of art stemmed from Cousin's doctrine of "true art." Planche called for the artist to imitate nature accurately and then to imbue his work with life. The artist must strive for "true reality, that is, poetically, vividly felt, closely and courageously studied; he wishes above all to translate his personal and intimate impressions" (95). To Planche the artistic process involved a struggle of the artist with nature in an effort to penetrate "the intimate character" of reality. In the "characteristic details" of nature is hidden "enduring truth" (129–30). Though Planche, like Cousin and Damiron, valued the spiritual truth hidden beneath the material surface of nature, he gave more weight than his masters to an accurate rendering of the real world as a foundation for art. In many respects his early critical writings anticipated Realist doctrine, though later he became a staunch opponent of Realists like Courbet. Thus Planche examined the paintings of the Salon of 1831 first for their accuracy in representation of reality before he went on to evaluate their "expression of soul," a vague concept difficult for the artist to translate into paint.

In his analysis of specific paintings, Planche took on the role of mentor to the artist as well as educator to the general public. Thus, it would not have been difficult for Balzac to transpose Planche's *Salon* criticism into the analysis of paintings offered by Frenhofer to Poussin and Pourbus. In the *Salon* Planche discussed the intentions and achievements of the artists' work hanging in the museum as Frenhofer was later to do of works hanging in the atelier. In fact, Planche described his *Salon* critique as conversational in style: "these free and familiar conversations" (18). At the same time he took pride in his method of close study of particular works, a dissection that penetrated "in the entrails of a work, in making the tour [of the gallery] to see it [the work] in all its aspects, to see not only what it is, but to wonder what it could be" (165). He engaged in this careful analysis for the benefit of the artist: "I have wished to make, on art, remarks from which the artists may profit" (171). Though Planche was to complain that he did not understand Balzac's *The Unknown Masterpiece*, his own *Salon of 1831* was probably the source for Frenhofer's critical language.[38]

Planche, in the Cousinian tradition, considered portraiture the true test of the artist: "No study perhaps is more profitable and matures the talent of artists more rapidly than the faithful and conscientious reproduction of the human mask in all its attitudes." He went on to describe the great artist's vision, which sees beyond visible nature: "the great artist . . . sees with other eyes than the vulgar person, seizes and guesses the subtleties that an ignorant curiosity would not even suspect" (33). Planche's expectations of the great artist's recreation of the human form accord with Frenhofer's demand of Pourbus for something more in his *Marie Egyptienne:* "But where is *the most?* You have *the least,* with which the vulgar person is content" (1:320). Frenhofer laments the loss, with the death of his master Mabuse, of the secret of imparting life to the painted figure. Yet in discussing the *Adam* of Mabuse, he gives it a mixed review: "There is life there. . . but truth is still lacking in the background of the canvas" (1:321). Similarly, Planche in the *Salon* praised Champmartin's portrait of Mme. de Mirbel for its lifelike quality: "The mask is of an exquisite subtlety, life is everywhere and mannerism nowhere. One discovers the flesh beneath the skin, and the structure beneath the flesh"; however, he went on to criticize the background as "flat and without depth" (36).

In a negative review Planche complained of the lifelessness of the heads of the young princes of Delaroche's *Edouard V et Richard d'York:* "the two heads lack life, so it is impossible to imagine the blood under their violet fleshtones" (23). Similarly, Frenhofer remonstrates with Pourbus that his woman "does not live. . . . I do not sense the warmth of this beautiful body and do not find blood in the veins" (1:320). For

both Planche and the fictional Frenhofer the artist must convince the viewer that blood flows in his painted image. Realistic color seems to be an effective means of animating the figure. Planche stressed fresh color (151) and circulation of air (156) as important elements in painting, and complained when life and air are lacking (17, 51). He praised the art of Rubens, Rembrandt, Velasquez, and Delacroix for its animation. In this regard Planche differentiated himself from Cousin's militantly national-istic views by urging young painters to look at the realistic art of the Dutch, the Flemish, and the Spanish as a source for vitality of their own work.[39]

Beyond the exterior reality of the figure, both Planche and Frenhofer looked for an understanding of the inner woman. Thus Planche praised Scheffer's *Marguerite* in terms of the expression of sentiment: "The tears which course down Marguerite's cheeks fall naturally. . . . One seems to hear the sobs which choke the heart of the cherished heroine of Wolfgang-Goethe" (31–32). Frenhofer's chef-d'oeuvre is also a woman of sentiment: "Here eyes seem humid to me, her flesh agitated, the tresses of her hair tousled. . . . She breathes." Later when he shows her to his friends, only he sees her as a living image: "There is so much depth on this canvas. . . the air there is so true. . . . I have seized color, life. . . . Flesh palpitates. She is going to rise, wait!" (2:9). Ironically, Poussin and Pourbus find that the only living part of the painted woman is the foot—hardly a part of the body capable of expressing the soul. Yet Frenhofer has spent endless effort on what he believes to be a masterpiece. Demonstrating that the years of work mean nothing to the truly dedicated artist, Frenhofer asks: "What are ten years in the struggle with nature?" (1:321). This question echoes one of Planche's characteristic phrases. Planche urged artists "to seek through coura-geous and incessantly renewed studies to struggle with nature." And when they succeeded as did Delacroix in his *Liberty Leading the People*, Planche praised the artist for having "struggled body to body with nature" (62).

Frenhofer's hypercritical judgments on art enunciated in the language of Gustave Planche transform him in the eyes of the neophyte Poussin into the embodiment of "art himself" (1:322). Yet Frenhofer is not merely "the spokesman of pictorial theories," as François Fosca has stated.[40] Though Frenhofer's critical comments reflect the *spiritualiste* aesthetics of Planche, his personality is drawn in part from life. The prototype of Frenhofer was the man who has been called Balzac's "unknown master," Henri de Latouche.[41] The relationship between Balzac and Latouche was similar to that between Poussin and Maître Frenhofer in the novella. Latouche recognized the talent of the young Balzac and helped to finance the publication of *Les Chouans.* Similarly, Frenhofer encourages the young Poussin by purchasing his sketch.

Balzac looked up to the older man as an established figure in the world he hoped to enter. Latouche, his senior by fourteen years, was already famous when Balzac met him in 1824. As we have seen in chapter 4, Latouche had made his name in journalistic circles, and although his "translation" in 1823 of *Olivier Brusson* may have damaged his reputation somewhat, he was still credited with having been the first editor of Chénier. His interest in Balzac must have been tremendously encouraging to the fledgling author, who was immediately impressed with Latouche's polished manners, elegant Rococo taste in decor, and witty conversational style. Yet although he had published two documentary novels, *The Memoirs of Mme. Manson,* and *Last Letters of Two Lovers from Barcelona,* he had not yet published the work that would bring him fame as a novelist, *Fragoletta.* An astute and often severe critic of his protegés, Latouche's ability as a writer of imaginative literature was as yet untested. His own uncertainty in this area was reflected in a letter of 1829 to his pupil in which he complained that Balzac had failed to help him in the polishing of *Fragoletta,* a debt Latouche felt Balzac owed him.[42] Though Balzac owed Latouche debts of money at this time also, it was probably the reversal of the master-apprenticeship relationship that was the chief cause of the rift between the two men.

Just as Poussin was impressed with Frenhofer's exposition on the aims of art, so Balzac admired the eloquent speech and manners of Latouche. Henry Monnier recalled the powerful influence of Latouche's style on the young Balzac: "Latouche always exercised a great influence on the men who surrounded him. Balzac imitated his manner of saying things and even the sound of his voice."[43] As an amateur art critic and the first biographer of Canova, Latouche was also Balzac's mentor in artistic taste. Latouche even set Balzac's style in house furnishings.

Latouche, as a pre-Romantic and follower of Madame de Staël and Chateaubriand, spoke of art with the fervor and passion of the fictional Frenhofer. A letter to George Sand captures his passion for his art: "Art must be treated as seriously as a political or religious faith. For the artist, it is the only concern of life."[44] Sand saw that Latouche's real talent lay not in writing but in poetic speech: "His spontaneity. . . was in the exchange of words, in the quick remark colored on the spot by the feature of apt observation or a poetic comparison."[45] Perhaps like Frenhofer he was "more poet than painter" (2:10), for he could not translate his critical insights into a masterpiece of fiction. The spontaneity of his speech was lost on the printed page. Sand said, "Judging from the numerous crossed-out words which covered his manuscripts he found writing painful, and if he composed with spontaneity, he only finished his works with great efforts and indecision."[46] Latouche's finished works often brought severe criticism. Perhaps the most unkind criticism he suffered was from Balzac. Their relationship worsened in

1829 when Balzac ended his review of *Fragoletta* with words that his friend regarded as tantamount to a betrayal: "An immense mist veils from one time to another certain parts of his paintings. . . . One needs to be told before hand what one reads in order to understand as if the author wishes to be mysterious."[47] The description of the book as a veiled and mysterious painting anticipates the appearance of Frenhofer's masterpiece as a chaos of color. In 1840 Balzac's review of Latouche's *Leo* was even more devastating. He ended the review with a personal attack on the man whose eloquence as a speaker he had once admired so much:

> *Leo* proves that M. de Latouche does not know how to distinguish what can be said among young men, after dinner, from what can be written; he does not even distinguish what can be written from what should be printed. The art of preparing scenes, of drawing characters, of forming contrasts, of sustaining interest is entirely unknown to him.[48]

Balzac showed less sympathy for his former master than Sainte-Beuve, who appraised Latouche's disappointing career in these words: "He was punished and his example is the most evident that one could cite of this torture of the chained Prometheus, intelligent, powerless in the literary line, a Prometheus who has not been able to transmit the spark and who has created nothing."[49] Latouche, when his hopes for literary immortality had vanished, assessed his own career in words of bitterness: "I have made, as they say, more authors than works."[50] He had made the reputations of André Chénier, George Sand, and Balzac. His primary ability was a critical sense that helped him to recognize, guide, and edit those with literary genius. Although like Maître Frenhofer, Latouche could describe his projected books with great enthusiasm, the finished work never equaled the conception. George Sand compared the talents of Balzac and Latouche in terms that could be applied to Poussin and Frenhofer:

> Latouche had a thousand times less talent for writing than Balzac; but as he had a thousand times more for suggesting his ideas through words, what he narrated admirably appeared admirable, while what Balzac related in an often impossible manner, often only represented an impossible work. But when Latouche's work was printed, one searched it in vain for the charm and beauty which one had listened to, and one was surprised on the contrary in reading Balzac.[51]

Sand's comparison of Balzac and Latouche as writers and raconteurs suggests that Latouche's lack of the power to transform his intentions into art undermined his apprentices' faith in the older man as their mentor. Balzac's disappointment with Latouche's novels is mirrored in

The Unknown Masterpiece by Poussin's reaction to Frenhofer's "finished" canvas as "colors massed as on a palette" (2 : 10), a phrase that expresses Frenhofer's inability to move from conception to creation. While Balzac drew Frenhofer's theory of art from the writings of Victor Cousin and Gustave Planche, Frehofer's failure to leap the gap between ideology and artistic performance was drawn from the career of Balzac's own "maître"—Henri de Latouche.

Visions of Moreau in
Huysmans and Proust

Balzac's *Sarrasine* anticipated Baudelaire's emphasis on sensory re-
sponse to painting and his concept of the artist's relation to his work. In
the theme of the Banquet of the Senses is the root of Baudelaire's
perception of painting through intense sense experience, a kind of
instinctive nervous reaction to color and form. Like Sarrasine mes-
merized by the beauty of Zambinella, Baudelaire is haunted by
paintings that "torment" him and "follow" him after he has seen them.
His theory of *correspondances* developed the symbolic relations be-
tween the different senses and substituted for the spiritual contempla-
tion of art advocated by Romantics like Latouche and Balzac, a nervous
or physical experience of synesthesia. In *Sarrasine* Balzac had warned
against the intrusion of the senses into the creative process. Baudelaire,
and the Symbolists who followed him, however, celebrated the sensory
perception of art as a mystical link between the viewer and the work.

Another theme of *Sarrasine* developed by Baudelaire was the
Narcissus myth. Baudelaire's retreat from the real world into the private
world of dream is both a rejection of society and a declaration of
narcissism. Thus he says in his *Poem of Hashish:* "Shall I add that
hashish, like all solitary joys, makes the individual useless to other men
and society superfluous to the individual, driving him to admire himself
ceaselessly and hurrying him day by day toward the luminous abyss in
which, Narcissuslike, he admires his face?"[1] Intoxicated, the poet
deciphers an invisible reality and translates it into poetic images. A
reader of Swedenborg, Baudelaire expressed his "religious" faith in art
and glorified the imagination of the godlike artist-creator in a character-
istically sensuous manner: "It is Imagination that first taught man the
moral meaning of colour, of contour, of sound and scent. In the

beginning of the world it created analogy and metaphor. It decomposes all creation . . . it creates a new world."[2] As we shall see, this notion of art as a new creation looks forward to Proust's description of the work of his Impressionist artist Elstir in *Remembrance of Things Past*.

Among painters, Baudelaire regarded Delacroix, the great Romantic colorist, as the presiding imaginative genius. In literature, he gave similar rank to Edgar Allan Poe, the American poet whose disorderly life resembled his own. As Shroder has pointed out: "The fascination Poe exercised on Baudelaire was the fascination the narcissist experiences before his own reflection."[3] Baudelaire described his artistic identification with Poe as a *déjà-vu* experience: "The first time that I opened one of his books, I saw with terror and delight, not only subjects I had dreamed of, but *sentences* I had thought, and which he had written twenty years before."[4]

The French Symbolist movement was given direction by the writings of Edgar Allan Poe. In 1847 when Baudelaire first read Poe, he "experienced a strange commotion."[5] In 1852 he published a French translation of Poe's tales, so that Poe's work became familiar to the poets and artists of the Symbolist movement. Later Mallarmé translated Poe's poetry, and it was these poems that were in the back of his mind when he was working on his own. In 1866 while composing *Hérodiade* he wrote to a friend: "I will have what I have always dreamed of: a poem worthy of Poe and just as good as his."[6]

Poe's aim in writing was to produce a spiritual effect through mystery: "I know that the indefiniteness is an element . . . of true musical expression . . . a suggestive indefiniteness of vague and therefore spiritual effect."[7] The indefiniteness was produced, according to Edmund Wilson, by two means, first by a "confusion between perceptions of different senses" similar to Baudelaire's "correspondences," and second by a confusion "between the imaginary world and the real."[8]

In des Esseintes, the decadent hero of Huysmans's *A Rebours* (1884), we can see both of these devices of confusion taken from art to become the central focus of life. The title of the book, *Against the Grain* (or, more recently, *Against Nature*) suggests a turning away from the natural to the artificial. Des Esseintes rejects the real world of nature in favor of an artificial life, a life based on an imitation of art. For artifice is to des Esseintes "the distinctive mark of human genius."[9] He constructs an exotic hermitage where he can stimulate his jaded senses. He plays a taste symphony with liqueurs, paints perfumed pictures in the air with an atomizer, and produces real flowers that look artificial in their horrible imitation of human diseases. The syphilitic plant is his parody of nature. Even in his art collection he turns away from real life: "Once he had cut himself off from contemporary life, he had resolved to allow

nothing to enter his hermitage which might breed repugnance or regret; and so he had set his heart on finding a few pictures of subtle, exquisite refinement, steeped in an atmosphere of ancient fantasy, wrapped in an aura of antique corruption, divorced from modern times and modern society" (63).

Thus des Esseintes rejects the real world for a sensual world of fantasy. The life of the senses takes away any interest in the active life. Contemplation of a trip to London is substituted for a real trip. The boundaries between the real and the imaginary are weakened. Examining his own response he remains insulated from the real world, like Proust in his cork-lined room. In fact Proust's fictional character, the aristocratic homosexual Baron de Charlus, shared a common prototype with des Esseintes, Count Robert de Montesquiou. Friendly with Moreau, Mallarmé, and Redon, painted by Whistler, Montesquiou epitomized the Decadent hero. A dandy and an aesthete, he was seen in the fashionable drawing rooms of Paris with his jeweled turtle tucked under his arm. Aloof and aristocratic, he reserved his admiration for two people, Louis II of Bavaria, an eccentric decadent who shared with Montesquiou the blood of royalty, and Sarah Bernhardt, who represented to him modern woman, emancipated and almost androgynous in her strength. Similarly des Esseintes admired Miss Urania, the American acrobat "with a supple figure, sinewy legs, muscles of steel, and arms of iron." Her muscularity, he hoped, would bring out his passive effeminacy, but the liaison ended in disappointment when he realized "that no transmutation of masculine ideas into her feminine person had occurred" (110, 112). The effeminate hero became the ideal of the Decadents who prophesized in 1886: "Man is growing more refined, more feminine, more divine."[10]

The power of modern woman that haunted the Decadent hero was epitomized in Salomé, the *femme fatale* whose story was retold by Wilde and Richard Strauss in their Salomés and by Flaubert and Massenet in their Hérodiades. Des Esseintes, contemplating his water color of Salomé by Gustave Moreau, recalls the lines of Mallarmé's poem *Hérodiade.* The poem, a mixture of symbolist metaphors, has been analyzed by struggling critics word for word in an attempt to capture its elusive meaning. Des Esseintes, after quoting the lines Hérodiade addresses to her mirror, describes Mallarmé's poetic technique: "Sensitive to the remotest affinities, he would often use a term that by analogy suggested at once form, scent, colour, quality, and brilliance, to indicate a creature or a thing" (196–97). Des Esseintes understood quite well the technique of the poet he admired. Mallarmé chose words not for their reportorial sense but for their Symbolist suggestive power in order to communicate a "state of soul" through deciphering the essence of the image.[11] Thus he substituted the name

Hérodiade for Salomé partly because it was associated in his mind with blood and passion. In Flaubert's novella and Massenet's opera, Hérodiade, the mother of Salomé, is the one who demands the head of John from her daughter who loves him. It is Hérodiade who is the incarnation of female cruelty and vice. According to Mallarmé, he chose to use the name Hérodiade because of the correspondence that he perceived in the sounds of "this word, sad and red like an opened fruit."[12] *Éros, rose, grenade* (fruit) are all sound analogies that suggested love and death to the poet, while the sound *diade* suggested the purity and hardness of gems through an association with the words *diamant* or *diadème*.[13] The ambivalence between her passion and her purity are caught within the sound of the name Hérodiade.

The poem is conceived in three parts: the "Overture," the "Scene," and the "Canticle of Saint John." The "Overture" is a prophecy by Hérodiade's nurse of the decapitation of John following his attempt to possess Hérodiade by his look. The "Scene" presents Hérodiade in a soliloquy with her mirror, almost a ritual incantation. It is this ceremonial quality that des Esseintes sees in another of Moreau's paintings of Salomé, an oil of her, dancing in a trance, her eyes lowered in introspection as she holds the lotus blossom like a mirror before her face: "Amid the heady odour of these perfumes, in the overheated atmosphere of the basilica, Salomé slowly glides forward on the points of her toes, her left arm stretched out in a commanding gesture, her right arm bent back and holding a great lotus-blossom beside her face" (64). Moreau's painting captures the hieratic aspect of Salomé as an occult, Astarte-like goddess. Moreau himself described the beauties he loved to paint as the epitome of evil: "Fatal lovers, condemned ones of titanic shames, what will become of you, what terrors, what pities you inspire."[14] Des Esseintes found Moreau's interpretation of Salomé akin to his own conception of the fatal woman: "In Gustave Moreau's work, which in conception went far beyond the data supplied by the New Testament, des Esseintes saw realized at long last the weird and superhuman Salomé of his dreams. . . . She had become, as it were, the symbolic incarnation of undying Lust, the Goddess of immortal Hysteria, . . . the monstrous Beast, indifferent, irresponsible, insensible, poisoning, like the Helen of ancient myth, everything that approaches her, everything that sees her, everything that she touches" (65–66).

The Salomé figure who is thus a lascivious goddess for Moreau and des Esseintes becomes a more ambiguous figure in Mallarmé's *Hérodiade*. The poet sees her as ambivalent: the conflict between her virginal frigidity and her growing passion is played out in the words she addresses to her mirror. These words quoted by Des Esseintes stress her purity and coldness in the water and ice images at the beginning, and

only at the end does the "nakedness of my scattered dreams" appear. But des Esseintes, though he understood the technique of the poet, ignored the ambivalence expressed in Mallarmé's frequent use of polarized images. Mallarmé resolves the conflict between passion and coldness in the final words of the "Scene" when Hérodiade inwardly becomes aware of her growing desire and cries out, "You lie; O naked flower of my lips!" as the "cold jewels" of her childhood begin to melt.[15] Thus her desire, which she denies throughout the "Scene," will in the "Canticle" result in the decapitation of the Saint.

In the final section of the poem, the "Canticle of Saint John," Mallarmé presents the apparition of the head of Saint John to Salomé as a confrontation of the sensual female with the male intellect, whose look she both desires and fears. Though Saint John dies, his head is a mystical spirit that rises above death. To the poet it may have represented the triumph of genius in its release from life into art.[16] Thus the whole drama may be read on a level other than the story of taboo and punishment, the *femme fatale* theme, emphasized by both Huysmans and Moreau. For Mallarmé the theme of Hérodiade and Saint John was perhaps the confrontation of the poet with his Muse at the moment of creation. This theme may be derived in part from Balzac's Séraphîta, the celestial angel with whom Hérodiade in her coldness and her immortal beauty has a strong affinity.[17] Such an understanding seems plausible when one considers Mallarmé's description in these terms of his personal spiritual crisis of 1866. Writing two years later to a friend, he described the experience in words suggesting the Hérodiade theme: "For these last two years, my sin has been that I have seen my Dream in Its perfect nakedness, when I should rather have veiled It over with mystery, music, and forgetfulness. And now that I have had the horrible vision of a pure work, my reason is almost lost and I have forgotten the meaning of even the commonest words."[18] Perhaps in Hérodiade he saw his own continuing struggle with his art that demanded agonizing sacrifices from the poet in the process of creating the "pure work." His obsession with Hérodiade remained with him from 1864 when he began the poem until his death. The unfinished manuscript was open on his desk when he died.

Moreau had no difficulty in completing many paintings of Salomé. Des Esseintes was lucky enough to own two: one an oil painting of her dance and the other a water color, *The Apparition*, depicting the final moment in the poem. The painter in his emphasis on the white body of Salomé bound in jeweled belts and bracelets and the head of the saint dripping blood, evokes the sensual theatrical aspect of the confrontation rather than its mystical quality. Salomé shrinks before the shining head of the saint suspended above her in the huge vaulted space of the palace. The glowing colors, the exotic background, and the brilliance of the

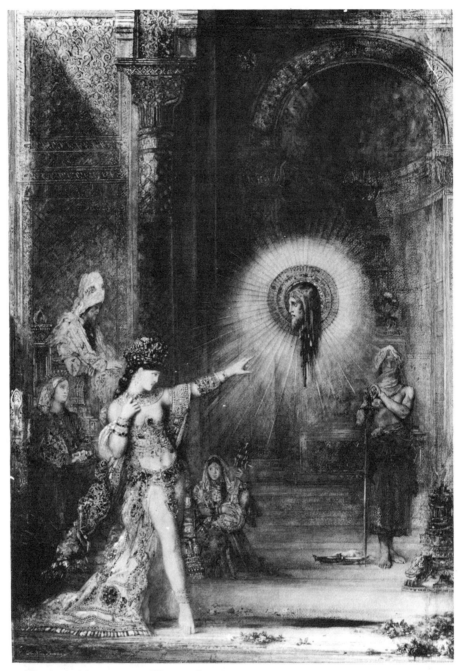

The Apparition ca. 1876. Water color. Gustave Moreau. Musée du Louvre, Paris.

gems are all admired by des Esseintes. He likens his reaction to that of the old king Herod who is "maddened by the sight and smell of the woman's naked body." The painting is so full of sensual evocations that des Esseintes "smells" the perfume of Salomé and "feels" the warmth of her jewels while he looks at the picture: "She is almost naked; in the heat of the dance her veils have fallen away and her brocade robes slipped to the floor, so that now she is clad only in wrought metals and translucent gems. . . . Under the brilliant rays emanating from the Precursor's head, every facet of every jewel catches fire; the stones burn brightly, outlining the woman's figure in flaming colours." To des Esseintes this image of Salomé is "less haughty, but more seductive than the Salomé of the oil painting." He turns to a discussion of Moreau's technical brilliance in producing the image. "It was des Esseintes' opinion that never before, in any period, had the art of water-colour produced such brilliant hues; never before had an aquarellist's wretched chemical pigments been able to make paper sparkle so brightly with precious stones, shine so colourfully with sunlight filtered through stained-glass windows, glitter so splendidly with sumptuous garments, glow so warmly with exquisite flesh-tints" (68–69).

Though the mysterious effects of the painter achieve a heightening of the senses on the part of des Esseintes who describes himself as "overwhelmed, subjugated, stunned," there is little evocation of confusion or ambiguity in the water color. Every detail is carefully indicated, great attention is lavished on costume and setting. The tie to the narrative is too close for our own symbolic perceptions to intrude. Thus while Mallarmé tried not to describe but to suggest, seeking a relationship between images that would produce "a third element, clear and fusible" that could be "distilled and caught by our imagination,"[19] Moreau, on the other hand, strove to catch the flicker of each jewel in its palpable material beauty.

The two paintings of Salomé by Moreau were favorites of des Esseintes. He hung them on specially constructed panels suspended between the shelves of his study. Fittingly, these literary paintings hung surrounded by books. He quoted Mallarmé while looking at the Moreau water color. He also likened Moreau's art to Baudelaire's poetry. To him part of the charm of Moreau's art was its literary quality. It was in his words "an art which crossed the frontiers of painting to borrow from the writer's art its most subtly evocative suggestions" (69–70).

It was for similar reasons that des Esseintes collected the works of a follower of Moreau, Odilon Redon. Redon's work produced in des Esseintes "the same sort of malaise he experienced when he looked at certain rather similar *Proverbs* by Goya or read some of Edgar Allan Poe's stories, whose terrifying or hallucinating effects Odilon Redon

Vision. Lithograph. Odilon Redon. Collection of The Art Institute of Chicago.

seemed to have transposed into a different art." Furthermore, to des Esseintes Redon's art had an "unhealthy" quality that was appealing to the Decadent aesthete. To him the drawings and lithographs recalled "feverish nights and frightful nightmares of childhood" or perhaps "the nightmares of science, to go back to prehistoric times." It was above all the unhealthiness of Redon's art to which des Esseintes seemed most attracted: "These drawings defied classification, most of them exceeding the bounds of pictorial art and creating a new type of fantasy, born of sickness and delirium" (73). Though this was an interpretation that clung to Redon's work and obscured its derivation from the unconscious, the then unknown artist was willing to forgive Huysmans his subjective analysis because of the attention the novel focused on his art. In 1882 Redon wrote to a friend: "I am singularly happy and proud of the chapter which Huysmans is devoting to me."[20]

In the novel des Esseintes described some of what Redon called his "blacks," his charcoals and lithographs. Des Esseintes emphasized their grotesque subject matter. One lithograph, *Sur La Coupe* (plate 10 from Redon's first lithographic series, *Dans le Rêve*, 1879), described by des Esseintes as "a Merovingian head balanced on a cup" (73), suggests the theme of John the Baptist. Another lithograph, *Vision*,[21] from the same series is also related to the Salomé theme. A charcoal drawing by Redon, *The Apparition*,[22] executed a few years later, bears a striking resemblance to *Vision*. The explanation for the resemblance has been offered by Sandstrom, who points out that both *Vision* and the charcoal *The Apparition* derive originally from the water color, *The Apparition*, by Moreau which hung in des Esseintes's study. Neither of these works, however, is mentioned in the novel. It is probable that Huysmans was familiar with *Vision*, which was in the same series as the other lithographs described in his novel. It is less likely that he knew the charcoal *The Apparition*, which is closer in subject matter to the Moreau and therefore could have acted as a visual link between *Vision* and the water color. Since the charcoal was probably not executed until 1883 when the novel was almost ready for publication, it is likely that Huysmans had not seen it. However, had he seen these works it is doubtful that he would have recognized their dependence on his favorite Moreau water color. His interpretation of Redon's art as deriving from a fevered brain would surely have made it difficult for him to trace the source of these works to the ever-popular Salomé theme.

Though their source was the same, a comparison of Redon's drawing and lithograph with Moreau's water color illuminates the profound difference between the two artists. The development of Redon's style from the early precise rendering of deep space in the lithograph to the later flattening and more amorphous sense of space in the charcoal

The Apparition. Charcoal drawing. Odilon Redon. Musée des Beaux-Arts, Bordeaux.

supports the dating of the charcoal as later than the lithograph even though the charcoal is iconographically closer to the Moreau water color.[23]

The floating head and the floating eye were recurring images in Redon's work. It is possible, as Sandstrom points out, that these visual images derived originally from Moreau's treatment of the Salomé story in his water color.[24] Thus Redon's enigmatic imagery may have derived in part from Moreau's precise and literal rendering of the apparition of Saint John's head to Salomé. While Moreau attempted to illustrate the dramatic climax of the story, Redon used the visual image of a suspended head and the power of John's look for his own personal vision.

Many explanations have been offered for the recurring image of the eye in Redon's work. Certainly like Poe he was hypnotized by the eye as a symbol. The look that he avoided in the charcoal was emphasized with great force in the lithograph as an enormous eye searching into space. It was no longer the look of John the Baptist that Redon portrayed. The eyeball staring into space had some private meaning for the artist. Though originally it was the Moreau water color that inspired him, how different were the resulting lithograph and the charcoal. Each poet and artist approached the Salomé theme in his own way. The only hint of a literary source in Redon's work was the menacing "look" abstracted from the Salomé story. In the lithograph the space the eye inhabits emerges, open and limitless, behind the precisely measured squares of the foreground. The world of the eye is not the world of the stage setting that Moreau sought to recapture in all its lavish detail: it is the endless world of the unconscious.

Redon described the process of creating a lithograph as the making of another world: "the whole thing is no more than a little oily black liquid, transmitted by crayon and stone to white paper, with the sole purpose of producing in the spectator a sort of diffuse but powerful attraction to the obscure world of the *indeterminate,* and to set him thinking."[25] Unlike Moreau he did not try to communicate a story but instead merely set down his inner vision for us to contemplate. "My drawings are not intended to define anything: they *inspire.* They make no statements and set no limits. They lead like music, into an ambiguous world where there is no cause and no effect."[26]

Redon, like des Esseintes, admired Moreau's art. "There are certain watercolours that are breathtaking for anyone who has ever handled a watercolour brush," he said after a visit to the Moreau Museum. Yet he was conscious of the vast difference between himself and the older artist who had been an early influence on his work: "But how different we are, Moreau and I. . . he did not penetrate into himself; we know

nothing of his mental life. It remains veiled beneath this essentially worldly art."[27]

While Moreau's emphasis on the symbolic object is similar to Baudelaire's in its evocation of sensual correspondences, Redon's was closer to the technique of Mallarmé. Mallarmé's use of symbolic language led to a delaying of the realization of the image so that the creative tension of the reader would extract the essence from the poet's suggestive words. Redon's lithographs and drawings moved from Moreau's sensual world and toward the ambiguity of the unconscious world in an effort to awaken the spectator's own "imaginative aptitude to enlarge things or diminish them."[28]

It was through Huysmans that Redon was introduced to Mallarmé. Later Huysmans on his conversion to Roman Catholicism turned away from his old friends, but Mallarmé and Redon remained close friends as well as admirers of each other's works. Redon wrote on hearing of Mallarmé's death: "the only cloud is that I have learned of the death of Mallarmé, which upset me profoundly and filled me with depression. After Huysmans's desertion, he was almost the only one left of my own generation, and I know that he never allowed anyone to smile about me; he was really an artistic ally upon whom I could rely absolutely."[29]

In 1898 when Redon wrote this note on the death of Mallarmé, Marcel Proust, after having paid a visit to Moreau's house-turned-museum, had begun to write his essay on the art of Moreau. This essay was one of five that Proust worked on during the decade from 1895 to 1905 when he decided to put aside his unfinished *Jean Santeuil* and immerse himself in the study of art.[30] Curiously this turning aside from the writing of fiction in order to formulate his ideas on art parallels a similar undertaking on the part of Huysmans, who spent three years between the publication of the Naturalist novel *En ménage* (1881) and his Symbolist *Against the Grain* (1884) writing mainly art criticism on the Salons and the Impressionists' exhibitions. Both novelists seemed to have needed time to reevaluate their ideas on the visual arts before embarking on novels that would rely heavily on art criticism.[31] It is significant also that Proust knew the work of Moreau mainly through his friend Robert de Montesquiou whose taste in art was the model for that of des Esseintes.[32]

Moreau figured in *Jean Santeuil* where Proust described Jean's room in which a *Salomé* painting by Bergotte hung. A prefiguration of Elstir, the character of the painter Bergotte in *Jean Santeuil* was (unlike the writer Bergotte in *Remembrance*), based largely on Gustave Moreau. In *Remembrance* the image of Moreau's fatal woman is called up when Swann perceives Odette as a kept woman: "an iridescent mixture of unknown and demoniacal qualities, embroidered, as in some apparition

of Gustave Moreau, with poison-dripping flowers, interwoven with precious jewels."[33]

In his essay on Moreau, entitled *Notes on the Mysterious World of Gustave Moreau,* Proust was concerned with describing Moreau's unique vision of the poet in his mythological paintings and with his own response to this image. For this undertaking Proust turned to art criticism, reading a series of recent articles on Moreau in the *Gazette des Beaux-Arts.* But before we trace these sources for the essay, let us place the essay in the context of Proust's other writings of 1898. Proust's article on Gustave Moreau was probably written in November 1898, at the same time as his essay on Rembrandt, since it ends with a reference to Proust's trip to Holland. Here as in the Rembrandt article Proust describes a confrontation between a viewer and a painting. The theme of the Rembrandt article, the communication between a modern viewer, Ruskin, and the work of a dead artist, Rembrandt, is changed only slightly here. The viewer is the young narrator himself and the work of art is Moreau's image of a Persian poet on horseback, singing, a youthful parallel perhaps to Rembrandt's painting of Homer reciting his poetry.[34]

After characterizing "the mysterious worlds" of Moreau's paintings by defining their recurring motifs, Proust recounts a personal encounter with the painter's work: his sudden recognition of Moreau's vision in a painting of the Persian poet hanging in a private home. Proust's unexpected glimpse on this occasion into the inner world of the artist, of which the painting is only a material souvenir, becomes for him a moment of inspiration. Through the image of the Persian poet on horseback, the thought of the artist is revealed to the viewer. Like the moments of involuntary memory in *Remembrance,* Proust, in the middle of a social conversation, catches sight on the wall of Moreau's "native clime," that part of his soul that he had transformed into a work of art. Though dead, Moreau still communicates through his art to those who share a poetic vision: "His vision is still to be seen, it is before us, that is all that matters."[35] The paintings of Moreau, like those of Rembrandt, attest to the immortality of the artist.

Although the confrontation between the viewer and the work of art parallels that in the Rembrandt article, the discussion of Moreau's art finds its source in articles published in the *Gazette des Beaux-Arts* by the secretary of the journal, Ary Renan, who was a friend and follower of Moreau. Proust was to express his admiration for Renan's writing on art in his second article on Ruskin (*G.B.A.,* August 1900, 137) and to assess Renan as equal to Fromentin as a writer on art. Renan published two articles on Moreau in 1886 (May and July), and, following the artist's death, a series of six in 1899 (January, March, April, July,

November, December). Whether the later series were available to Proust when he was working on his Moreau essay (probably in the late fall of 1898) is uncertain. However, several of the ideas Renan had expressed in his 1899 articles were cited by Proust in his second article on Ruskin. It is possible that Renan served as a guide to Proust when he visited Moreau's house in November 1898. Although Renan's later articles went into more detail in evoking the unique vision of Moreau, the 1886 articles, which have not been mentioned by Proust scholars, outlined similar ideas.[36]

In 1886 Renan emphasized Moreau's debt to primitive sources in art and literature, to fable, myth, and Classical art. In his second Ruskin article, Proust was to liken Moreau to Ruskin in this search for innocence in the distant past (*G.B.A.*, August 1900, 137). One of the paintings Renan discussed in his first 1886 article is Moreau's *Young Thracian Girl Carrying the Head of Orpheus*, for which he reproduced both a drawing and an engraving of the painting from the Luxembourg. He described the head of Orpheus in death as "incorruptible" with closed eyes that still appear to see (*G.B.A.*, May 1886, 387). In 1899 Renan placed the painting in the context of "the cycle of the poet" in Moreau's *oeuvre* and asserted that from the moment he had painted Orpheus "entering immortality Moreau professed the cult of the artist-creator and built a monument to him" (*G.B.A.*, November 1899, 426). Renan's Baudelairean interpretation of the painting as a symbol of the godlike power and the immortality of creative genius was taken up by Proust. In his Moreau essay, Proust tells of making a pilgrimage to the Luxembourg in honor of the artist's death, going there in the manner of the Thracian girl only to find that the artist's soul lived on in the painting: "in that head of Orpheus we see something that looks at us through those lovely sightless eyes that are the color of pansies" (*C.S.B.*, 350/671). Proust was to express similar ideas on the persistent life still visible in the paintings of the dead artist in a letter to Douglas Ainslee in which he likened the English writer, who had eulogized Moreau, to the Thracian girl who carried Orpheus's head.[37]

In his second 1886 article Renan discussed the serenity of Moreau's paintings, and the artist's decision, based on his knowledge of Classical art, to portray a moment of quiet in his mythological scenes. Renan traced Moreau's achievement to his understanding of the limitations in time and space that distinguish painting from poetry. Moreau, influenced by ancient art, sought to capture a single moment of great beauty, appropriate to the visual arts, and to ignore representation of violent activity that Renan viewed as belonging to the province of drama. Following Lessing, Renan stated that unlike the poet, the painter must limit himself to a single moment: "A painting can represent

only a *moment;* it is true that it must eternalize this moment" (*G.B.A.,* July 1886, 36). Proust began his essay with a description of Moreau's mythological landscapes as fixing time forever: "Moreau's landscape being as a rule contracted in a ravine, closed by a lake wherever and whenever an aspect of the divine manifests itself at some indefinite moment that the canvas perpetuates like a heroic myth" (*C.S.B.,* 346/668). He was to sound this theme again when in *Remembrance* he discussed the exact hour to the minute depicted in one of Elstir's early mythological paintings.

Renan also discussed in 1886 several paintings that Proust would later mention: the *Prometheus,* the *Young Man and Death,* and the *Salomé* series. Renan emphasized Moreau's ability to create a setting attuned to the legendary theme he chose to represent. In his power to conjure up a mythic vision, Renan likened Moreau to Baudelaire, a comparison that Proust would make in *Contre Sainte-Beuve* (135/255). Renan quoted from Baudelaire's *L'Art romantique* on the necessity for the artist-creator to discover and recreate in his work, be it poetry or the visual arts, the secret links between our state of soul and inanimate nature: "A painting faithful and equal to the dream which has inspired it must be produced like a world!" (*G.B.A.,* July 1886, 44). According to Renan, it is the ability to create such an imaginary world analogous to reality but dreamlike and in harmony with ancient legend that distinguishes Moreau's paintings: "These are, some say, landscapes of an exquisite improbability, too beautiful, fashioned in overly rich materials. . . . Must they not appear inaccessible to us in order to awaken in us the image of dream countries and to carry us back to the time when nature still scarcely peopled, but peopled with heroes, had the charm and the savagery of a new creation?" (*G.B.A.,* July 1886, 50). In *Remembrance* Marcel glimpses Moreau's mythological universe not only in Elstir's paintings but even occasionally in certain landscape settings. On horseback, riding along the cliffs above the sea on his way to the Verdurins, he finds himself in a place that recalls Elstir's mythological paintings:

> For a moment the barren rocks by which I was surrounded, the sea visible in their jagged intervals swam before my eyes, like fragments of another universe: I had recognized the mountainous and marine landscape which Elstir had made the scene of those two admirable water colours: "Poet Meeting a Muse," "Young Man Meeting a Centaur" which I had seen at the Duchesse de Guermantes's. The thought of them transported the place in which I was so far beyond the world of today that I should not have been surprised if, like the young man of the prehistoric age that Elstir painted, I had in the course of my ride come upon a mythological personage. (2:304/2:1028–29)

This horseback ride into the primeval world of Elstir's imagination in *Remembrance* brings to mind the painting by Moreau of the poet on horseback that appears in the drawing room in Proust's essay on Moreau.

The studio in which Moreau invented this new creation of the world was likened by Renan to a laboratory: "Thus, in entering this atelier, in this laboratory where he practices true transmutations, one notices certain controlling themes have haunted him" (*G.B.A.*, January 1899, 11). Renan's response to Moreau's studio looks forward to Marcel's visit to Elstir's studio at Balbec: "And Elstir's studio appeared to me as the laboratory of a sort of new creation of the world in which, from the chaos that is all the things we see, he had extracted, by painting them on various rectangles of canvas that were hung everywhere about the room, here a wave of the sea crushing angrily on the sand its lilac foam, there a young man in a suit of white linen, leaning upon the rail of a vessel" (1:628/1:834). The concept of Elstir's fragmentation of his imagined world into many paintings may have been inspired in part by Renan's emphasis on recurring motifs in the paintings of Moreau that he saw as "sisters" animated by the same spirit (*G.B.A.*, May 1886, 379). This idea was developed by Proust in his Moreau essay when he defined a picture as "a sort of apparition of a corner of a mysterious world of which we know some other fragments, which are canvases by the same artist" (*C.S.B.*, 347/669). Finally, the narrator's comment that Elstir's power of creation parallels that of God—"If God the Father had created things by naming them, it is by taking away their names or by giving them other names that Elstir created them anew" (1:628/1:835)—may find one of its sources in Renan's description of Moreau's house as filling one with a feeling of religious awe. Shortly after the death of the artist, Renan opened his 1899 series with these words: "The work of Gustave Moreau is a monument of pure art which no one will ever explore without a sort of sacred fear," and he urged the reader to visit the studio now transformed into a museum. Proust, who had made a visit to the Moreau Museum, spoke of it in his essay as half-museum, half-church in which the priestlike artist dedicated himself to his creative work.

It is significant that Proust places his contemplation of a Moreau painting in a private home rather than in a museum. Renan stated in his opening 1899 article that many of Moreau's most characteristic paintings were owned by twenty or so private collectors in Paris and affirmed that Moreau's work was venerated by "refined collectors" (*G.B.A.*, January 1899, 7). Proust knew many of Moreau's patrons, and in *Jean Santeuil* he referred to the popularity of Moreau's works among fashionable *amateurs*. That Moreau's painting of a poet that inspires the narrator in Proust's essay was a composite of several paintings by Moreau that Proust may have seen on visiting Parisian salons is

suggested by his referring to it once as *The Persian Singer* and another time as *Indian Singer*. Charles Ephrussi owned a water color, *The Indian Poet* of 1886. The closest work to the painting that Proust described is *The Persian Poet*, which was bought from the artist in 1893 by Baron Edmond de Rothschild, entered the Straus collection where it remained until 1899, and was reproduced by Ary Renan in his fifth 1899 article (*G.B.A.*, November 1899, 451).[38] Proust's description in his essay of the moment of epiphany before the Moreau painting when his own inner voice is revealed to him is perhaps the first study for the episode when Marcel holds up the serving of dinner at the Guermantes because he becomes so engrossed before their collection of paintings by Elstir. Looking at Elstir's early "mythological paintings of poets and Muses" (probably inspired chiefly by Moreau's *Dead Poet Carried by a Centaur*), the narrator notes the strange sexual ambiguity of the poet:

> Here and there a poet, of a race that had also a peculiar interest for the zoologist (characterized by a certain sexlessness) strolled with a Muse, as one sees in nature creatures of different but of kindred species consort together. In one of these water-colours one saw a poet wearied by long wanderings on the mountains, whom a Centaur, meeting him and moved to pity by his weakness, had taken on his back and was carrying home. (1:1019/2:1029)

The androgynous poets, whom the narrator notes in Elstir's paintings, recall earlier such images in French literature: Huysmans's passive and weak des Esseintes, Balzac's celestial androgyne in *Séraphîta*. For Proust perhaps these images signified the importance of a feminine sensibility for the poet, a sensitivity he may have believed was part of his own personality.[39] In addition to observing Elstir's poets, the narrator marvels at the painter's ability to give a scene from fable "a sort of historical reality" by setting it "at a definite point in the past" and capturing through light "the very minute what time of day it was" (1:1020/2:1310). As he stood before the painting, the dinner bell rang and he is awakened "from my dream." The moment of reverie, like that in the Moreau essay, demonstrates the power of art to communicate, even after the death of the artist, and even to a viewer who encounters the painting on his way to dinner. Thus in the midst of the social world, art draws Proust's narrator toward his true vocation. Moreau's vision of the mythic poet was to become for the narrator an inspiration and a proof of the enduring power of art.

Like this episode, many of the encounters with art in Proust's novel appeared first in his essays on painters. Proust developed in these studies ideas on art that had been suggested, in part, from his reading in art criticism. In his Rembrandt essay Proust stated that the only thing of interest to a thinking man in a picture gallery was the sudden

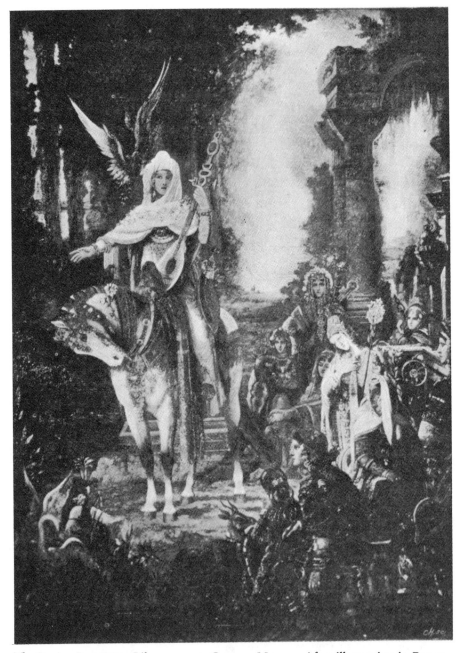

The Persian Poet 1893. Oil on canvas. Gustave Moreau. After illustration in Renan article, *Gazette des Beaux-Arts,* 1899. Proust knew this painting from Mme. Émile Straus's collection.

confrontation with an idea that might engender a host of other ideas in his mind. This search for ideas from paintings led Proust from the gallery to the library, where he deepened his knowledge of favorite artists by reading art criticism. By tracing Proust's essay on Moreau to its original source in *Gazette des Beaux-Arts,* we have seen how Proust was indebted not only to Huysmans and Montesquiou but also to Renan for an articulation of the vision of the artist. Proust found in Renan's articles on Moreau the germ of a fictional episode that he sketched first in his essay and later developed much more elaborately in his novel. The importance of criticism as a foundation of Proust's novel was apparent to the English critic Ralph Wright, who said: "Actually his books are filled from end to end with criticisms of music, of painting, of literature, not in the way that is unfortunately familiar in this country, as unassimilated chunks in the main stream of the narrative, but as expressions of the opinions of different characters."[40]

9

The Watteau and Chardin of Marcel Proust

The formation of artistic taste is an important theme in the fiction of Marcel Proust, just as it was in Proust's own life.[1] In his youth Proust haunted the galleries of the Louvre and contemplated a career as a museum curator.[2] His early interest in art is reflected in his first novel, the unfinished *Jean Santeuil,* in which the protagonist has a talent for drawing. While he was at work on *Jean Santeuil,* Proust also tried his hand at art criticism, writing five essays on artists whom he particularly admired.[3]

Though unpublished during his lifetime, Proust's essays on painters give us important insights into the way he extracted from works of art both visual images and theoretical concepts. Perhaps stimulated by his reading of John Ruskin's art criticism, Proust asserted his belief that the novelist could derive philosophical principles from works of art.[4] His admiration for Balzac was enhanced by what he described as Balzac's ability "to see in a pictorial effect a fine idea."[5] Perhaps Proust, in his essays on artists, was attempting to do what he observed in Balzac's novels: to find in images from favorite paintings ideas that might give coherence to the scattered impressions that were only loosely linked together in *Jean Santeuil.* In search of a theoretical framework to shape this novel (which a modern critic has called a "collection of genre paintings")[6] Proust turned, in the 1890s, to the study of art and, in his essays on painters, tried to formulate his own philosophy of art derived from the painter's vision. Thus he wrote in a letter of 1895 that in his essay on Chardin, which he called "a little study of the philosophy of art," he had tried to show how "great painters initiate us in the understanding and love of the exterior world."[7]

In 1899 Proust put aside *Jean Santeuil* and threw himself into the work of translating and annotating Ruskin's *Bible of Amiens* and

Sesame and Lilies. In 1909, after the completion of his work on Ruskin, Proust began writing his masterpiece, *Remembrance of Things Past,* the novel cycle in which he tells the story of the narrator Marcel's discovery of his vocation as a writer. The transformation of Marcel from frivolous youth to serious artist is accomplished in part through the lessons he learns from his mentor, the fictional Impressionist painter Elstir.[8] Elstir's discussions with Marcel on the relationship between art and nature give him a new appreciation of the world around him, and through observing Elstir and other artists (Bergotte, the writer and Vinteuil, the composer) Marcel eventually comes to realize that great art transcends time and that art, in fact, surpasses life. Thus he decides at the end of the book to dedicate himself to transforming into a literary work of art his own unique experience of life. In tracing Marcel's movement from the contemplation of works of art to the creation of his own masterpiece, the novel demonstrates Proust's belief that art can not only teach us new ways of looking at the world but that it can also act as a guide to life.

Proust's earliest writings on art, composed while still a schoolboy, were four poems on favorite paintings in the Louvre by Aelbert Cuyp, Anthony Van Dyck, Paulus Potter, and Antoine Watteau. These evocative poems, which were set to music by his friend Reynaldo Hahn, imitated Symbolist works by Leconte de Lisle, Verlaine, Nerval, and Baudelaire that attempted to transpose the spirit of art works into language.[9] Unlike the poems, the essays are concerned with the vision of the artist rather than with individual paintings and find their source in Proust's background in art criticism. Always an indefatigable researcher, Proust conscientiously read what critics had written on his favorite artists. Through his friendship with Charles Ephrussi, editor of *Gazette des Beaux-Arts,* he had access to the journal's library, and Proust was to culminate his art critical writing with several publications on Ruskin, including two articles in *Gazette.*[10] Proust's careful grounding in art critical writing deepened his understanding of his favorite works in the Louvre and lent enduring value to his essays. That his studies on artists are held in high esteem by today's art historians is demonstrated by the extensive quotations from Proust included by Pierre Rosenberg in his catalogue for the Chardin exhibition.[11]

The art critic Jean-Louis Vaudoyer, who often escorted Proust to the Louvre in the last decade of his life, recalled that "most often, Proust wanted to see or see again a certain painting, or the works of a certain painter. His preferences were for Dutch and French painters."[12] In answer to a questionnaire from Vaudoyer in 1920 Proust wrote a list of his eight favorite works in the Louvre, of which four were by the French artists Watteau and Chardin. He chose as favorite works one of Chardin's pastel self-portraits, the portrait of his wife, and an

Embarkation for Cythera. Oil on canvas. Antoine Watteau. Musée du Louvre, Paris.

unidentified still life. He listed two favorites by Watteau, between which he could not bring himself to choose, *The Indifferent One* or *Embarkation for Cythera.*[13]

In the opening sentence of his essay on Watteau Proust delineated the ambiguous relationship between the painter's works and the circumstances of his life. Proust believed that though love was the subject of Watteau's art, the painter's health was too delicate to allow him to partake of its pleasures. In his opening remarks Proust evoked with deep personal understanding the melancholy situation of the sickly artist: "I often think with a mixture of fellow-feeling and pity about the life of the painter Watteau, whose work lives on as the portrayal, the allegory, the apotheosis of love and pleasure, and who was, by the report of all his biographers, physically such a weakling that he could never, or rarely, taste the sweets of love" (319/665).[14]

The kinship that Proust felt for the consumptive Watteau may have stemmed from his own illness, an asthma that since 1893 had been a chronic problem. Not only did Proust sympathize with the sickness of the artist, but he felt compassion for Watteau's fickle personality, his indifference, and his moodiness. Proust excused Watteau's "change-ableness" as "a physical condition," arising from his illness. Yet despite his difficult personal relationships, the inconstant Watteau is thought of,

according to Proust, as "the first to have painted modern love." Here Proust relied on the Goncourts' *Art of the Eighteenth Century* where they described the love evoked in *Cythera* as "poetic love, love which dreams and thinks, modern love with its aspirations and its crown of melancholy." The Goncourts portrayed Watteau as "thin and nervous," growing thinner and more melancholy from portrait to portrait.[15] However, as J. Theodore Johnson, Jr., has pointed out, the Goncourts did not speculate as to whether Watteau's illness rendered him unable to pursue the amorous pleasures he painted.[16]

It is my conjecture that Proust's notion that Watteau's constitution incapacitated him for love developed in part from Proust's personal experience as a chronic invalid and in part from the writings on Watteau by Paul Mantz. Mantz's series of articles on the painter in *Gazette des Beaux-arts* (1889 and 1890) and his *Gazette* article (1870) on the Watteaus in the La Caze Collection at the Louvre, though apparently overlooked by Proust scholars, are, I believe important sources for Proust's interpretation of Watteau's personal life.[17] In all his critical appraisals Mantz went out of his way to refute the "modern legend" that Watteau was a frivolous hanger-on at the theater who enjoyed the amorous pastimes he made the subject of his art. Mantz maintained that despite the libertine wit evident in Watteau's paintings, "the purity of his behavior" was attested to by his biographers. He asserted that Watteau's illness precluded a life of amorous dalliance with actresses and that his penchant for painting his friends in theatrical costume merely reflected his fascination with the transitory vision of people on the stage. The reason he painted theater scenes was not because of his intemperate life, Mantz stated, for "in this ailing man who at the same time is an unceasing worker, the explanation [for such paintings] cannot be found in the propensity and need for forbidden loves." Here Mantz made the connection between illness and inability to enjoy love's pleasures that Proust was to expand in his essay.[18] Furthermore, Mantz rejected fictional accounts of Watteau's character: "How many novelists have spoiled this young man for us. They have made him into an adventurer, a tasteless hero of novels. There is no more ardent worker than Watteau. He knew how to make good use of a short life."[19]

Mantz's insistence on Watteau's dedication to his craft and his isolation from the public who failed to understand his temperament accorded with Proust's view of the artist's need to separate himself from daily social activities in order to devote himself to his work. As evidence of Watteau's absorption in his art, Mantz, as had the Goncourts, noted the artist's devotion to his pupil Pater, whom he called to his deathbed so that he might impart to him the secrets of his art. Proust cites the painter's "sincerity and goodness of heart" when he retells the story in his essay.

The Indifferent One. Oil on wood. Antoine Watteau. Musée du Louvre, Paris.

Proust's essay appears to imply a veiled comparison of his own temperament with that of Watteau. His admiration for Watteau's paintings in the Louvre inspired him to study the life of the artist, and he came away from his reading with a strong feeling of affinity for the man.

The dichotomy between Watteau's character and his art was evidence to Proust of the separation of the great artist's personal life from his creative work. The detachment of the artist as creator was later to be explored in his critical essay *Contre Sainte-Beuve* (1909) in which he rejected Sainte-Beuve's method of trying to understand the work of the artist by observing his behavior as a social and as a sexual being. In his essay on Watteau Proust searched for material on the life of the artist to prove the lack of connection between biography and creative expression. And he was to state in *Contre Sainte-Beuve* that conduct toward women was one of those points "where the poet's true self is not involved" (107/225).[20] It seems likely that a very intimate thought process of Proust's can be observed at work here, in germination in the Watteau essay and fully matured in *Contre Sainte-Beuve:* a critical justification of the proposition that Proust's private life as a homosexual, like Watteau's supposed sexual abstinence, would not preclude his portraying in fiction the joys and despairs of heterosexual love.

While in the essay on Watteau Proust is concerned with the distinction between the social and the creative sides of the artist's life, in his fiction he ignored Watteau's biography in favor of his work, using imagery derived from Watteau's art to enhance his own fictional themes of love. His favorite paintings, *The Indifferent One* and *Embarkation for Cythera,* illustrate two different aspects of love. *The Indifferent One* appears to have symbolized for Proust the compelling power of a loved one's indifference to arouse through jealousy an agonizing obsessive love. *Cythera,* on the other hand, was to Proust the visualization of a longed-for fantasy of ideal love existing in a remote time and place and never to be realized in life.

In his first published work, *Les Plaisirs et les jours* (1896), in which his poems on painters appeared, Proust treated themes of love, emphasizing disappointments, indifference, and remorse. The titles of these short prose impressions such as "Fragments of Italian Comedy," "Regrets, Reveries, Color of Time," "The End of Jealousy," suggest imagery similar to Watteau's paintings and the mood of the book is languorous, and nostalgic like Watteau's canvases of *fêtes galantes.* Motifs of the disappointed dream of love and the indifference of the loved one run through the short prose sketches. One story originally planned for the book but published instead in the magazine *La Vie contemporaine* (1896) even drew its title from Watteau's painting, *L'Indifférent.* The novella *L'Indifférent,* discovered and republished by

Phillip Kolb in 1978, appears to be a first sketch of the story of Swann's love for Odette in *Remembrance of Things Past*. In *L'Indifférent* a prominent and beautiful woman falls in love with a man socially much beneath her because of her attraction to his indifference. In *Remembrance* the socially sought-after stockbroker and connoisseur of art Charles Swann is similarly attracted to a vulgar courtesan Odette de Crécy because of her coldness to him. In both works Proust uses imagery derived from Watteau to characterize the indifference of the loved one. In the novella the heroine Madeleine admires her lover Lepré for his "Louis XIII face, delicate and noble," and by having a photograph of a portrait from this period sent to her, she brings her love for him "into the system of her artistic taste."[21] The Louis XIII type that Lepré resembles suggests Watteau's revival of the elegant sixteenth-century figure style (derived from artists like Callot and Van Dyck) in his paintings as, for example, *The Indifferent One*.[22] Like her lover, Madeleine evokes the artistic taste of an earlier time in her elaborate coiffure, the pale colors of her clothes, and her faded flowers, symbolizing unrequited love. The wistful ambiance of the story enhances the theme of hopeless love. In his introduction, Kolb relates "this languishing sadness" of the novella to "the melancholy atmosphere of Watteau's paintings."[23]

The comparison, in this early novella, of a loved one to an image from art anticipates similar comparisons in *Remembrance*. When Swann, thinking of Odette's past as a kept woman, a cocotte, becomes suspicious about her activities when they were apart, he conjures up an image of her derived from sketches by Watteau: "and the life of Odette at all other times, since he knew nothing of it, appeared to him upon a neutral and colourless background, like those sheets of sketches by Watteau upon which one sees, here and there, in every corner and in all directions, traced in three colours upon the buff paper, innumerable smiles."[24] Odette's indifference is visualized as "innumerable smiles" for other people, smiles sketched lightly "on a neutral background" that Swann admires for their resemblance to Watteau's drawings. However, as time goes on he becomes absorbed with jealousy and he realizes that Odette's indifference is evidence of the existence of rivals.

The Watteau drawing of a woman's head in several different aspects, which Proust uses as an aesthetic analogy for Odette's inconstancy, may have been suggested to Proust by many such drawings available to him in the Louvre and in private collections. The Goncourts, avid collectors of Watteau's drawings, spoke of the three-color drawings in their book as "painted drawings" and singled out one of women's heads in the Louvre "on old tinted paper, called *papier chamois*" as astonishing for its amber light similar to a Rubens canvas. They also reproduced a sheet of similar studies from their own collection and discussed the important

Study. Three crayons. Antoine Watteau. Calouste Gulbenkian Foundation Museum, Lisbon. The Comte de Greffulhe, a model for the Duke de Guermantes, acquired this sketch in 1894.

collections of Watteau drawings.[25] Another Watteau sketch of three heads of women that Proust may have known was acquired by the Comte de Greffulhe in 1894, the year when Proust first met the Comtesse de Greffulhe whom he was to memorialize as the Duchess de Guermantes in *Remembrance*.[26] In the novel the Guermantes represent rich collectors who failed to appreciate the art they owned. A forerunner of this characterization appears in *Jean Santeuil* where Proust constrasts the collector who "because she is rich . . . searches for the drawings of Watteau" with the connoisseur like "an Edmond de Goncourt, an Anatole France, a Robert de Montesquiou," who make "long pilgrimages" to find "a drawing of Watteau, a statuette of Clodion, a print of Hokusai."[27]

A serious collector of Watteau, whose collection was available to Proust and who served as one of the prototypes for Proust's fictional painter Elstir, was Paul-César Helleu. An artist as well as a connoisseur, Helleu was strongly influenced by Watteau's drawings. Robert de Montesquiou, in a monograph on Helleu, linked his drawings to the sanguines of Watteau, and the Goncourts admired his drypoints, particularly his *Woman before the Three-Crayon Drawings of Watteau*

at the Louvre. To these critics, Helleu's images of women, in their private world, dreaming, reading, in relaxed poses, made up "a sort of monograph of woman."[28] Helleu did several studies of women's heads in three crayons in the manner of Watteau and earned from Léon Daudet the epithet "Watteau à vapeur," which Proust had one of his characters apply to Elstir in *Remembrance.*[29]

Thus among Proust's friends there were many who admired and collected the type of Watteau drawing that Proust has Swann compare to Odette. Watteau's studies showing different views of women's heads with their characteristic half-smile, the eyes either lowered coquettishly or looking off into some distant place might well suggest the ambiguity of love. The danger of betrayal was a central theme in *Remembrance* whether the lovers are Swann and Odette, Marcel and Albertine, or Robert de Saint-Loup and Rachel. While Swann attempts to aestheticize his jealousy over Odette's liaisons by imagining her hidden smiles as sketches by Watteau, Saint-Loup becomes infuriated by the actress Rachel's admiring glance directed at a male dancer with "cheeks chalked in red like a page from a Watteau album" who dances past her during a rehearsal, "pursuing like a madman the course of his ecstatic dream"

Woman before the Three-Crayon Drawings of Watteau at the Louvre. Drypoint. Paul-César Helleu. After Montesquiou, *Paul Helleu, peintre et graveur.* Helleu, a model for Elstir, collected Watteau.

A Dancing Mezzetin. **Three crayons on chamois paper. Antoine Watteau. After** *Collection des Goncourt* **(Paris, 1897).**

(1:842/2:, 177). This dancer may be inspired by a sheet of four sepia studies of male figures from the Goncourt's collection, entitled *A Dancing Mezzetin,* in which the second figure from the left takes the pose of *The Indifferent One.* The series of figures seen together on one sheet suggests the dynamic movement of the dancer across the stage, "his eyes raised to the ceiling, as he sprang lightly into the air." Watteau's emphasis on the movement of the dancer's hands is brought out when Rachel exclaims: "Do watch those little hands of his dancing away by themselves like his whole body." Studies of single figures or faces shown in different aspects make up the bulk of Watteau drawings, and it was this type of drawing that Proust chose when he wanted to link images by Watteau to themes of indifference or jealousy.

When he chose to evoke a vision of ideal love, however, Proust derived his imagery from paintings by Watteau like the *Cythera* where lovers are shown dallying together in a pastoral dreamlike setting. In the Cleveland Museum of Art collection is a drawing for such a painting by Watteau, *The Romancer.* Made as a compositional study, the drawing focuses on the placement of the three main figures of the painting, a woman holding a guitar, a standing figure in the costume of a Pierrot bending over her and a kneeling figure (a storyteller) in the foreground.[30] The costumed men hovering around the musician represent

Study for "The Romancer." Red and black chalk. Antoine Watteau. The Cleveland Museum of Art, Dudley P. Allen Fund.

one of the recurring themes of both Watteau and Proust, the rivalry of love. At the same time the three figures exemplify the representation of love themes in a pastoral setting, embellished with music and archaizing costume that can be seen both in Watteau's art and Proust's novel.

Watteau's scene of a woman attracting lovers through music was probably derived in part, as Mirimonde has pointed out, from images in engravings by the French artist Abraham Bosse (1602–76).[31] In Bosse's *The Foolish Virgins,* for example, a woman playing a guitar signifies that music endangers virtue. This engraving was a cautionary image, as its gloss states, against the secular activities of the *précieuse* women, those learned ladies of seventeenth-century literary salons, who, as we have seen in chapter 2, developed a mode of courtship styled after the pastoral novels of the day. That this style of courtship, ornamented by music, poetry, and flowers was an important source for Watteau's scenes of pastoral love was recognized in the eighteenth century by Horace Walpole.[32] As Mirimonde points out, the love scene in *The Romancer* takes place at the moment when music has incited the kneeling lover to passion. That the scene depicts "the end of resistance" is symbolized according to Mirimonde by the roses "abandoned in the sun" at the feet of the lovers, an emblem easily understood by Watteau's eighteenth-century audience.[33] Proust too was to use flowers as symbols of love. In *L'Indifférent* Madeline's fading flowers reflect feelings of sadness at unrequited love, and in *Remembrance* Odette's Cattleya orchids become a floral code word for love making. Proust also interweaves music with love, as in "the little phrase" from the Vinteuil sonata, which becomes the "anthem" of Swann and Odette's romance. Furthermore, Swann costumes Odette in archaizing clothes that bring out her resemblance to Botticellian beauties admired by John Ruskin, through whose writings Proust learned about Renaissance art. Swann gives Odette a shawl like the one worn by *The Madonna of the Magnificat* or a dress ornamented with the floral print on the gown of *Primavera.* Odette reflects the vogue for Watteau gowns in fashion by giving up Japanese kimonos in favor of peignoirs in pale pleated silks like those Watteau sketched and painted.[34] Marcel, like Swann, buys his mistress Albertine a gown that reminds him of one he admired in a Carpaccio painting in Venice. Thus Proust has his lovers costume their mistresses in clothes from Renaissance art, just as Watteau dressed his pastoral lovers in theatrical costumes that harked back to the reign of Louis XIII and the art of Van Dyck.

This courtly style of love that Proust imitated from Watteau's art and that he described in his early poem on Watteau as "learnedly, wittingly, knowingly ornamented" was something Proust would yearn for in life and portray in literature. At twenty-two, in joking fashion he acted the role of a Watteau lover to the young ladies who made up his youthful

Marcel Proust at the Feet of Jeanne Pouquet with Some Friends 1892. Photograph. Bibliothèque Nationale, Paris.

"Court of Love." Strumming his tennis racket à la Watteau, the young Proust in a photo from 1892 knelt at the feet of a young lady in mocking imitation of images like the Cleveland drawing. In society he would take on the role of "the eternal Pierrot."[35]

In his essay Proust described Watteau's depiction of "modern love" in words that might apply to his own evocations of ideal love in *Remembrance:* "It has been said that he [Watteau] was the first to have painted modern love, implying by this, no doubt, a love in which conversation, the pleasures of the table, strolling in parks, the sadness of masquerading, of water flowing and time fleeting, are more to the fore than actual pleasure—a sort of garlanded impotence" (319/665).

It was a "garlanded impotence," inspired by paintings like *Cythera,* that Proust described in the narrator Marcel's courtship of the aloof, aristocratic, and highly educated Mlle. de Stermaria in *Remembrance.* Marcel first imagines courting the beautiful Breton girl on an isle in Brittany: "And for a whole month during which she would be left alone, without her parents, in her romantic Breton castle, we should perhaps have been able to wander by ourselves at evening, she and I together in the dusk which would shew in a softer light above the darkening water pink briar roses, beneath oak trees beaten and stunted by the hammering of the waves" (1:523/1:689). The soft light, the roses, the water all hark back to the settings on enchanted isles of Watteau's landscapes. This dream of romance on an isle in Brittany almost becomes a reality when Marcel invites Mlle. de Stermaria to dine with him on an isle in the Bois Boulogne, hoping to win her love in this place "especially designed for pleasure." When Marcel describes the isle as existing in "that romantic world of chance encounters and lover's melancholy . . . situated outside the universe" (1:993–4/2:384), it takes on an imaginary quality that removes it from Paris to a land of dreams. It recalls the land of *Tendre,* which had been charted on the allegorical map of the *précieuse* author Mlle. de Scudéry.[36] Her famous *carte de Tendre,* a psychological map of the lovers' emotions, with its lake of indifference and its city of esteem, was a forerunner of Watteau's *Cythera* and of Proust's isles of love.[37] Marcel's dream of love on an isle in the Bois is never realized in the novel, for the unapproachable Mlle. de Stermaria refuses his invitation.[38] Thus ideal love remains only an illusion seen through art or literature.

At the end of *Remembrance,* the narrator explains that love to him is merely a subjective vision and must always end in disillusionment, fading away like a painted mirage when he awakens from his dreams:

The amorous suggestion which they [dreams] impressed on us is dispersed and not only does the nocturnal mistress cease to exist for us as such and become again the ugly woman we know so well, but sometimes there is

dispersed also something more precious, a fascinating composite of feelings, affection, voluptuous delight, dimly outlined regrets, a whole *Embarquement pour Cythère* of passion, whose delicate shadings of a delicious accuracy we would fain note for our awakening but which disappears from sight like a canvas too faded to be restored (2:1024/3:911)

Though he awakens from his dream of Cythera, the narrator points out that throughout life, in yearning for the magic world of ideal love, he repeats the same love scene again and again finding different girls to fill "the empty space in our picture" (2:1028/3:916–17). Thus, according to Proust, love is an insistent fantasy in the mind of the lover, a subjective vision that is painted and repainted like the recurring themes of Watteau's art.

Proust's essay on Chardin, like his Watteau essay, relied on the Goncourts' *Art of the Eighteenth Century.* Following their lead Proust wrote on the kitchen still lifes, the depiction of old age in the pastel portraits, the relationship between everyday objects and people in the genre scenes and Chardin's use of light.[39] However, Proust did not concern himself with Chardin's technique as had the Goncourts but, rather, with the artist's vision of the world around him. He did not attempt, as they had, to give a historical account of Chardin's career or to discuss the artist's temperament as he had in the Watteau article.

The Goncourts had linked Chardin and Watteau as artists whose work had fallen into neglect during the ascendancy of David and his school.[40] They quoted at length Diderot's admiring comments on Chardin in support of their own efforts to rehabilitate the painter's reputation. The rediscovery of Chardin and Watteau paintings long after the death of the artists gave support to Proust's conviction, which he expressed in *Remembrance,* that a great work of art exists outside of time and will survive not only its creator but also ephemeral changes of taste. Perhaps because of this faith in the timeless quality of great art, Proust eschewed the Goncourts' evaluation of Chardin's art as a record of eighteenth-century bourgeois life in France. Taking Chardin's paintings outside of the life span of the artist, Proust related them to life in his own time as seen through the eyes of visitors to the Louvre. By structuring his essay as a tour of museum galleries, Proust gave an ahistorical setting to Chardin's works. His preference for viewing art in a museum setting rather than in the period decor so much in vogue among private collectors at the beginning of the century was stated in *Remembrance:* "A picture is nowadays 'presented' in the midst of furniture, ornaments, hangings of the same period . . . and among these the masterpiece at which we glance up from the table while we dine does not give us that exhilarating delight which we can expect from it only in a public gallery, which symbolizes far better by its bareness, . . . those

innermost spaces into which the artist withdrew to create it" (1 :490/ 1 :645).

The theme of Proust's essay on Chardin is that even a century after the death of the artist an encounter with his paintings in a museum produces an epiphany in the eyes of a young visitor and has a lasting effect on his enjoyment of his own everyday world.

While Proust, in the first person, discusses the personality of Watteau, for whom he feels a sympathy born of shared infirmities, in the Chardin essay he uses the second person and plays the role of the museum docent who teaches "the lesson of Chardin" to a young man of aesthetic taste. Proust creates a fictional encounter between this young man and the Chardins at the Louvre.[41] He opens the essay with the following sentence:

> Take a young man of modest fortune, of artistic taste, seated in the dining room at that dreary daily moment when the midday meal has been eaten but is still not completely cleared away. His imagination is full of the splendours of art collections and cathedrals, seas and mountains, and he eyes with discomfort and boredom, with a sensation approaching nausea, feelings akin to black despair, the pushed-back tablecloth dangling on the floor and a knife still lying beside the remains of an oozing unappetising cutlet. On the sideboard a ray of sunlight, glinting on a tumbler of water that a quenched thirst has left almost full, accentuates as cruelly as a sarcastic laugh the dreary familiarity of this inartistic spectacle. At the further end of the room he sees his mother who with the tranquility of everyday habit has already settled down to her work and is slowly winding off a skein of red wool. And behind her, perched on a cupboard beside a piece of biscuit-china that is only used on "special occasions," a stout squat cat seems the puny evil genius of this middleclass home. (323/372).[42]

The "inartistic spectacle" that Proust describes is actually based on details from several of Chardin's still lifes. Even the mother with her ball of red wool suggests Chardin's many paintings of women at domestic tasks. Having set the scene in the manner of Chardin, Proust then describes the young man's attempt to escape from everyday life by going to the Louvre "to feed his eyes" on paintings of elegant subjects, "palaces by Veronese, princes by Van Dyck, harbour scenes by Claude." He then projects himself into the scene: "If I knew that young man, I would not deter him from visiting the Louvre, I would be more inclined to go with him. But leading him into the La Caze Room and the Room of the eighteenth-century French School, or the Rubens Room, or some other room of the French School, I would halt him before the Chardins." (324/373)

The idea of a fictional trip to the museum was, I believe, derived from an article in the 1888 *Gazette de Beaux-Arts* by Henry de Chennevières

Still Life with Herrings. Oil on canvas. Jean Siméon Chardin. The Cleveland Museum of Art, Purchase, Leonard C. Hanna Jr. Bequest.

entitled "Chardin au musée du Louvre." Even using the same phrase, as Proust was to do, "Prenez un jeune homme," Chennevières suggests a similar situation in the following sentences:

> Take a young man, indifferent or even hostile to painting, make him look over, in the La Caze gallery, the collection of Chardin and leave him to the effects of this confrontation. You will surprise him the next morning on the way to the Louvre, and he will not be ashamed to tell you the reason for his unlikely return. Chardin will have touched him, will have opened his eyes, in the manner of a revelation, without his being able to keep up his last bourgeois defenses.[43]

Proust builds his essay upon the hypothetical situation sketched by Chennevières. The confrontation between a young man and the Chardins at the Louvre may have struck a personal note, for Proust was later to write in a letter to a friend: "Before having seen some Chardins, I had never realized what was beautiful, in my parents' home, the table disarrayed, a corner of a napkin turned back, a knife against an empty oyster shell. . . . Chardin has shown me how to enjoy the everyday life of all still-lifes."[44]

In the essay Proust described several of the Chardin genre paintings (*The Diligent Mother, Saying Grace, The Return from Market*) as well as still lifes (*The Rayfish, The Buffet,* among others). Proust points out to the young man that he has been charmed by the very things he had considered ugliest: "a shiny saucepan lid, crocks of all sorts and sizes . . . sights you shudder at, like raw fish lying about on a table." These words recall Chardin's many still lifes on the theme of the preparation for the meal. The Cleveland Museum's *Still Life with Herrings* is an example of the small-scale kitchen still lifes that Chardin began to execute in the 1730s.[45] These table-top groupings of fish with vegetables, crocks, and seasonings await the hand of the cook to prepare the fast-day meal. It was this type of kitchen still life that Proust was to portray in *Remembrance.*

In his essay, Proust invites the young man to enter his own kitchen after having seen Chardin's kitchen still lifes: "Now come into the kitchen, where the entrance is strictly guarded by a feudality of crocks of all sizes, faithful hardworking servants, a handsome industrious race." Years later Proust was to portray the kitchen in Combray in similar fashion when Marcel recalls going there before dinner to watch the cook Françoise, "finishing over the fire those culinary masterpieces which had been first got ready in some of the great array of vessels. . . . which ranged from tubs and boilers and cauldrons and fish kettles . . . and included an entire collection of pots and pans of every shape and size" (1:92/1:120). Marcel would admire food being prepared for the meal: the "platoons" of peas lying on the kitchen table and the

Bundle of Asparagus. Oil on canvas. Edouard Manet. Wallraf-Richartz Museum, Cologne, Germany. Proust knew this painting which belonged to Charles Ephrussi, Editor of *Gazette des Beaux-Arts* and a model for Charles Swann.

asparagus in a basket beside the kitchen maid. He describes the color of the asparagus as though he were painting them: "What fascinated me would be the asparagus, tinged with ultramarine and rosy pink which ran from their heads, finely stippled in mauve and azure, through a series of imperceptible changes to their white feet, still stained a little by the soil of their garden bed." In their "celestial rainbow hue," the asparagus shoots capped with sharply pointed "light crowns of azure" remind Marcel of the clearly outlined flowers that decorate a basket in Giotto's frescoes in the Arena Chapel at Padua (1:93/1:121). This striking likeness that Marcel sees between a vegetable and a Giotto fresco is perhaps inspired by his mentor Swann's joking comparison of Giotto's *Charity* with the pregnant kitchen maid. This type of comparison between the humble and the sublime suggests, early in the novel, a truth that Marcel will later understand: the artist through his unique vision can transform concrete objects from daily life into symbolic images of great power.

Later in the novel, Proust uses a painting of asparagus to illustrate a rich collector's insensitivity to art. The Duke de Guermantes turns down Elstir's still-life painting *Bundle of Asparagus* because of its lowly subject matter. Though urged by Swann to purchase the painting, the Duke protests to Marcel: "There was nothing else in the picture. A bundle of asparagus exactly like what you're eating now. But I must say I declined to swallow Monsieur Elstir's asparagus. He asked three hundred francs for them. Three hundred francs for a bundle of asparagus. A louis, that's as much as they're worth, even if they are out of season. I thought it a bit stiff" (1:1074/2:501). The episode refers to Manet's actual experience of painting his *Bundle of Asparagus* for Charles Ephrussi. In real life Ephrussi was a supportive patron who paid Manet so well for his painting that the artist, in appreciation, presented him with another painting of a single stalk of asparagus, "missing from his bundle."[46] Proust had no doubt transformed the discerning Ephrussi into the narrow-minded Guermantes, who ignored Swann's advice to buy the still life. Proust's use of a still life by Elstir to distinguish the philistine from the true connoisseur of art was a device Balzac had employed when the de Marvilles failed to appreciate the fan painted by Watteau in the collection of Cousin Pons.[47]

Proust further demonstrated the Duc de Guermantes's lack of serious interest in art when, in response to Marcel's query as to whether he had seen Vermeer's *View of Delft* when he visited The Hague, the Duc de Guermantes "contented himself with replying in a tone of sufficiency, as was his habit whenever anyone spoke to him of a picture in a gallery, or in the Salon, which he did not remember having seen 'If it's to be seen, I saw it'" (1:1090/2:523–24). Marcel's conversations with the Guermantes about art "shock" him into a realization that the owners of many of Elstir's paintings have no conception "of the way in which artistic impressions are formed in our minds." Thus they will later sell their Elstirs for mediocre ancestral portraits.

Marcel, on the other hand, though not a collector, is acquiring an understanding of Elstir's paintings.[48] His appreciation of Elstir's art begins when he visits the artist's studio. There he sees seascapes, portraits, and still lifes. It is only after this visit that Marcel understands "the poetry of still life" that he has seen in Elstir's paintings. Marcel's description of his new appreciation of still life recalls the reaction of the imaginary young man after he has seen the Chardins in the Louvre. Reading a letter at the luncheon table Marcel muses:

> I would now gladly remain at the table while it was being cleared. . . . Since I had seen such things depicted in water-colours by Elstir, I sought to find again in reality, I cherished as though for their poetic beauty, the broken gestures of the knives still lying across one another, the swollen convexity of

a discarded napkin upon which the sun would patch a scrap of yellow velvet, the half-empty glass which thus shewed to greater advantage the noble sweep of its curved sides, and, in the heart of its translucent crystal, clear as frozen daylight, a dreg of wine, dusky but sparkling with reflected light, . . . I tried to find beauty there where I had never imagined before that it could exist, in the most ordinary things, in the profundities of "still life." (1:653/1:869)

Elstir's still lifes are Impressionist paintings in the tradition of Chardin. Proust was aware that many Realist and Impressionist artists were influenced by Chardin's work. In *Remembrance* he points out the paradox that the same people who dislike the Impressionists admire Chardin and do not understand the link between the eighteenth-century artist and their own contemporaries:

> These people who detested these "horrors" were astonished to find that Elstir admired Chardin, a painter whom the ordinary men and women of society liked. They did not take into account that Elstir had had to make, for his own part, in striving to reproduce reality . . . the same effort as a Chardin . . . and that consequently . . . he admired [in Chardin's paintings] attempts of the same order, fragments anticipatory, so to speak, of works of his own. Nor did these society people include in their conception of Elstir's work that temporal perspective which enabled them to like, or at least to look without discomfort at Chardin's painting. And yet the older among them might have reminded themselves that in the course of their lives they had seen gradually, as the years bore them away from it, the unbridgeable gulf between what they considered a masterpiece by Ingres and what, they had supposed, must remain forever a "horror" (Manet's *Olympia*, for example) shrink until the two canvases seemed like twins. (1:1018/2:419–20)[49]

Proust, in these observations, points out that Manet's debt to Chardin was unrecognized by the foes of Impressionism. After Manet had seen the Chardins exhibited at the gallery Martinet in 1860, he made several copies of genre scenes by Chardin in the Louvre, and his still lifes of the sixties, such as *Still Life with Carp* (Chicago Art Institute) bring to mind Chardin's still lifes of fast-day meals.[50] Significantly it was Manet's *Bundle of Asparagus* that was singled out by Proust's friend, the painter Jacques-Émile Blanche for praise for its Chardin-like touch.[51]

Though Elstir's art is a synthesis of the paintings by many artists whom Proust admired besides Manet, Proust's insistence on the relationship between Elstir and Chardin is important, for it delineates the relationship between the great "modern" artist and tradition.[52] Although Proust regarded himself as an innovator in the novel, he was aware of his own debt to the past. At the very end of the novel when Marcel contemplates creating his own book, different and yet related to favorite books he has read, Proust again links the names of Elstir and

Chardin to emphasize the relationship of the innovative artist to tradition: "Not that I intended to reproduce in any respect the *Arabian Nights,* any more than the *Mémoires* of Saint-Simon, which likewise were written at night, any more than any of the books I had loved so deeply that, superstitiously devoted to them as to the women I loved, I could not, in my childish *naïveté* imagine without horror a book that might be different from them. But like Elstir and Chardin, one cannot reproduce what one loves without abandoning it" (2:1120/3:1034).

In Proust's essay on Chardin, he points out that not only the still lifes but the genre scenes have a lesson to teach. This lesson has to do with the relationship between people and things. Speaking of Chardin's genre scenes, Proust notes how "Chardin goes further by combining things and people in those rooms which are more than a thing and perhaps even more than a person, rooms which are the scene of their joint lives, the law of their affinities or contrarieties, the pervasive secreted scent of their charm, the taciturn yet indiscreet confidant of their soul, the shrine of their past."[53] In this very significant passage Proust envisions the relationships between people and inanimate objects as somehow having a hidden meaning related to a common past. He goes on to describe "friendship" in *Saying Grace* between the mother who lays the table and "the still unchipped plates whose gentle tenacity she has felt for so many years."

The sense of familiarity of the objects is particularly strong in Chardin's paintings because of the way the artist used the same objects from his household again and again.[54] A similar repetition of familiar domestic objects is seen in the paintings of Vermeer whom Proust was later to name as his favorite artist.[55] Proust in his novels likes to evoke the feeling of comfort he himself associated with the familiar objects in his room. In *Jean Santeuil* he describes Jean's room filled with belongings that become an extension of their owner: "When Jean was there the latent life of all these things seemed to show a rich display of bud and blossom."[56]

The response of the narrator to his surroundings is a recurring motif in *Remembrance,* which opens with the awakening of the boy Marcel in his room at Combray followed by memories of awakenings in other rooms. Later the familiarity of his room at Combray seems far away when Marcel stays at a hotel room in Balbec "full of things that did not know me, which flung back at me the distrustful look that I had cast at them, and, without taking any heed of my existence, showed that I was interrupting the course of theirs" (1:506/1:666). On a trip to Venice Marcel describes the impressions of this city as "analogous to those I had felt so often in the past at Combray." As he compares his experience of Venice with Combray he discovers that "there may be beauty in the most precious as well as the humblest things." Thus he adds the

"lesson" of Veronese "to the valuable instruction in the art of Chardin acquired long ago" (2:821–23/3:623–26).

While Marcel in Venice compares Chardin to Veronese, Proust, at the end of the Chardin essay, compares Chardin to Virgil as a guide to experience: "Here we reach the end of this journey of initiation into the unnoticed life of inanimate objects that any one of us can accomplish who takes Chardin for his guide, as Dante let himself be guided by Virgil" (334/380). Chardin has revealed to us, "the expression of what had lain nearest to him in his life and of what lies deepest in things, it is our life that it appeals to, it is our life that it makes contact with, and gradually disposes toward things, and acclimatises to the heart of things" (336/381). To Proust Chardin's art centers on things and people's sensitivity to things and the mysteries hidden "in the heart of things." This lesson of Chardin revealed to Proust that associations with familiar inanimate objects might be the basis for his own literary art. It is only when Marcel is stunned into intense moments of involuntary memory that he will realize that chance encounters with the inanimate will lead him to his own vocation as a writer.[57] It is through reviving these intense but forgotten moments that he will recreate his inner life in a novel. The series of "privileged moments" in which he experiences sensations lost in the past are triggered through Marcel's associations with the inanimate: the taste of the madeleine dipped in tea, the sound of a spoon striking a saucer, the touch of a starched napkin. These humble objects unlock the key to the distant past: "The past is hidden somewhere outside the realm, beyond the reach of intellect, in some material object (in the sensation which that material object will give us) which we do not suspect. And as for that object, it depends on chance whether we come upon it or not before we ourselves die" (1:34/1:44). In these sentences that appear in the novel just before the first involuntary memory evoked by the madeleine dipped in tea, Proust explains his faith in the power of the inanimate, which he had seen expressed in the paintings of Chardin.

For Proust the choice of Watteau and Chardin as subjects for his early essays prefigures the basic philosophical concepts of the masterpiece he would begin to write over a decade later. In Watteau's drawings and *fêtes galantes* Proust visualized the dream of love for which Marcel searches in his youth. Only toward the end of the novel does Marcel realize that this dream will always end for him in disillusionment. It is not through relations with people but through chance encounters with objects that he will be able to recapture the past. Thus it is "the hidden life of the inanimate," visible in the paintings by Chardin, that will communicate to him a means of bringing his own "lost time" into the realm of art.[58]

10
Conclusion

After three centuries of influence on writers of Romantic allegiances, the visual arts have left a significant imprint on French literature that may be regarded as a permanent legacy. Having examined in detail some of the crucial episodes in the interchange between the sister arts, I can now summarize the principal respects in which the visual arts modified and enriched the resources of French fiction.

One of the earliest contributions of art to French fiction was to permit the intensification of human images and emotions by literary renderings of portraiture, as well as the establishment of evocative *mises en scène* through description of architectural and sculptural monuments and of landscape paintings. Second, the power of the cunning artist to trick the fallible perception of the viewer provided images of duality that served as metaphors for new literary themes of ambiguity. Finally, the Romantic faith in art was embraced by French writers as a form of idealism (alternative to religion) investing the world, creativity, and even the inanimate with transcendental value.

From Madeleine de Scudéry to Marcel Proust all the writers discussed have used the painted portrait to reinforce their depiction of character. In *précieux* fiction the portrait served to link a character with heroes and heroines of history and romance and to draw a parallel between ideal comportment and *précieux* values. Mme. de Staël borrowed the *précieux* use of allegorical portraiture in her literary Muse portrait of Corinne, thereby placing her heroine in a line of descent from ancient art and literature. Her use of a Roman setting, however, contrasted with Mlle. de Scudéry's interpretation of the antique. While the Roman setting of *Clélie* lent to Mlle. de Scudéry's novel an aura of romance and historical verisimilitude, for Mme. de Staël the ruins of ancient Rome evoked a historical perspective against which to measure the corruption of the French state under Napoleon. Furthermore, landscape painting presented Mme. de Staël with visual images in support of her theories of the relation of the arts to culture and climate. To Proust, landscape painting

offered a corroboration of his own perceptions of places in a vision of nature seen through art. Paintings of Venice by Veronese and port scenes by Claude reflected his narrator's experience of travel and contrasted with his vision of Combray suggested by the genre scenes of Chardin. In a similar way, Watteau's paintings by Cythera served Marcel as a *Carte de Tendre* for his pursuit of love.

In addition, the self-deceptive sensory mechanisms on which art relies in order to achieve some of its most striking effects and the visual artist's ability to combine in one image unreal and often opposing aspects of nature provide French novelists with both precedent and technique for elaborating the portrayal of ambiguity in fiction. The tension between art and life is suggested by the animation of statuary: Corinne sees in Canova's marble tomb figure of the genius of death under torchlight her own melancholy lover Lord Nelvil. Another type of ambiguity appearing in Girodet's *Endymion*, with its mysteriously shadowed body contours, provided Balzac an image of indeterminate sexuality. The theme of sexual ambiguity, which Latouche also sounded in his comparison of Fragoletta to an antique statue of a hermaphrodite, developed into a central motif in Huysmans's and Proust's interpretation of Moreau's mythological paintings. Proust emphasized the major role of the passage of time in the creation of opposing facets of personality; for example, he contrasted the mature Odette to an early portrait of her by Elstir as a vulgar young actress in men's clothes, much as Balzac juxtaposed the aged Zambinella to his much earlier portrait as Girodet's *Endymion*. In addition to supplying the novelist with images of sexual ambiguity visionary art works, by their powerful suggestiveness, have enhanced the literary depiction of sensations of synesthesia. Like Balzac's Sarrasine, Huysmans's des Esseintes reacts to visual beauty with all his senses. Sound, scent, taste, and touch as well as vision are aroused by a compelling visual image. Furthermore, the indefiniteness of the Symbolist painting heightened the confusion of sensory perceptions and at the same time brought the world of the imagination into the realm of reality. In Proust's view, Moreau's precise rendering of myth gave the invisible a "historical" reality. And Proust saw in the ambiguity of Impressionist landscape paintings the confusing illusionism of nature. Elstir's paintings, which merge sea in land and land in sea, represent a metaphor for the uncertainty of our perceptions of the visible world. Like these visual illusions in Elstir's landscapes, the narrator's childhood view of the separate walks in Combray—the Méséglise way and the Guermantes way—turn out to be in reality a single circular path. Sharing the experience of Joyce's hero Bloom, Proust's narrator discovers eventually that the longest way round is the shortest way home.[1]

Finally, the French novelists' adoption of the Romantic belief in art as "religious faith," to use Latouche's term, places literary creation on a

level above reality and even above life itself. Latouche expressed this belief when he wrote to Sand: "For the artist, it [art] is the only concern of life," and Proust lived by this faith when he retired from life into the cork-lined room to compose his literary masterpiece. Balzac's view that the artist was a "seer" endowed with "second sight" looked forward to Baudelaire's perception of the artist as a mystical creator who in his artifice rivaled God's creation of nature. Proust's novel was, as Shroder observed, one of the last statements of this Romantic faith in art.

Still-life paintings by Elstir revealed to Proust's narrator the prehensive relationships we have with the inanimate objects with which we live. It is through his sensitivity to these silent "things," endowed by art with metaphysical meaning, that Proust's narrator experiences those "privileged moments" that bring back to him sensations lost in the past. Thus Elstir's still lifes lead the narrator to new perceptions of his own experience. To the narrator, Elstir is a creator who rivals nature in his "laboratory of a sort of new creation of the world" where he "extracts" from "chaos" his own unique vision of reality that will survive long after his death. Art recomposes life in a way that reveals to us the timeless truths that we ignore in our everyday existence. In contemplating the writing of his own novel, the narrator wonders if his sensations of involuntary memory are not similar to the inspirations of other writers like Chateaubriand, Nerval, and Baudelaire. In order to reassure himself that "the work I was now about to undertake without any further hesitation was worth the effort I was going to devote to it," he recalls "the poems of Baudelaire which are based in a similar manner on transferred sensation."[2] Just as Proust himself learned about life from literature and from paintings, so future readers will see the world through his eyes by reading his book: "for style is for the writer, as for the painter, a question not of technique but of vision. It is the revelation—impossible by direct and conscious means—of the qualitative differences in the way the world appears to us, differences which, but for art, would remain the eternal secret of each of us. Only by art can we get outside of ourselves, know what another sees of his universe."[3]

Thus to Proust art appears as a way of expanding our narrow vision of the world. At the same time he sees it as a means of escaping from time, from the confines of mortality. In words that recall the pagan belief in the apotheosis of the cultivated life, Proust describes his faith in art's power to transcend life itself: "The only true voyage of discovery, the only fountain of Eternal Youth, would be not to visit strange lands but to possess other eyes, to behold the universe through the eyes of another, of a hundred others, to behold the hundred universes that each of them beholds, that each of them is; and this we can contrive with an Elstir, with a Vinteuil; with men like these we do really fly from star to star."[4]

Notes

Chapter 1. Art in French Literature

1. As quoted in *Artists on Art,* ed. Robert Goldwater and Marco Treves (New York: Pantheon, 1945), p. 161. On the sister arts in the eighteenth century see Rensselaer W. Lee, *Ut Pictura Poesis: The Humanistic Theory of Painting* (New York: W. W. Norton, 1967), esp. pp. 18–23.

2. Théophile Gautier, "Eugène Devéria," in "Romanticist Studies", *The Works of Théophile Gautier,* trans. and ed. F. C. de Sumichrast, 12 vols. (New York: George D. Sproul, 1902), pp. 167–68.

3. As quoted in Jean Seznec and Jean Adhémar, *Diderot Salons,* 4 vols. (Oxford: Clarendon Press, 1957–67), 1:15.

4. *L'Artiste* (1831; reprint, Geneva: Slatkine Reprints, 1972), 1:121, n. 1.

5. Denis Diderot, "Pensées detachées sur la peinture," in *Diderot Oeuvres esthétique,* ed. Paul Vernière (Paris: Garnier, n.d.), p. 749.

6. As quoted in Jean Seznec, *Literature and the Visual Arts in Nineteenth-Century France* (Hull, England: Hull University Press, 1963), pp. 3–4. I am indebted to Professor Theodore Reff for drawing my attention to this lecture.

7. Gautier, *History of Romanticism, Works,* p. 35.

8. Peter J. Edwards, "*L'Artiste* (1831–1861): The Literary Role of an Artistic Review" (Ph.D. diss., Fordham University, 1973), p. 50.

9. Gautier, *History of Romanticism, Works,* p. 18.

10. As quoted in Prosper Dorbec, *Les Lettres Françaises dan leur contacts avec l'atelier de l'artiste* (Paris: Presses Universitaires de France, 1929), p. 85. Author's translation.

11. As quoted in Malcolm Easton, *Artists and Writers in Paris: The Bohemian Idea, 1803–1867* (London: Edward Arnold, 1964), p. 62.

12. Marcel Proust, *Remembrance of Things Past,* trans. C. K. Scott Moncrieff and Frederick A. Blossom, 2 vols. (New York: Random House, 1934), 1:628. Volume and page numbers of this translation will be cited before the slash, after which will appear volume and page numbers of the French edition: Marcel Proust, *A la recherche du temps perdu,* 3 vols. (Paris: Gallimard, Pléiade, 1954), 1:834.

13. Easton, *Artists and Writers,* p. 35.

14. Theodore Robert Bowie, *The Painter in French Fiction* (Chapel Hill: University of North Carolina Press, 1950), p. 9.

15. Proust, *Remembrance,* 2:509/3:187.

16. Madeleine de Scudéry, *La Promenade de Versailles* (1669; reprint, Paris: Devambez, 1920), p. 5. Author's translation.

17. [Henri de Latouche], *Lettres à David sur le salon de 1819 de quelques élèves de*

son école, ouvrage orné de vingt gravures (Paris: Pillet, 1819), Letter 19, October 15, 1819, p. 134. Author's translation. Later Zola claimed the artist's right to individual interpretation of reality in similar words: "A work of art is a corner of creation seen through a temperament."

18. As quoted in Michael Clifford Spencer, *The Art Criticism of Théophile Gautier* (Geneva: Droz, 1969), p. 111. See pages 109–12 for Spencer's comparison between Gautier's "microcosm" theory and Balzac's theory of genius.

19. Proust, *Remembrance,* 2 : 1009/3 : 885. See also in French edition 3 : 890, 1137 for double use of this passage.

20. Émile Zola, "Salon of 1866," *Salons,* ed. F. W. J. Hemmings and Robert J. Niess (Geneva: Droz, 1959), p. 73.

21. On the aristocratic sentiments of the Romantics see Carol Duncan, *The Pursuit of Pleasure: The Rococo Revival in French Romantic Art* (New York and London: Garland Publishing, 1976), pp. 64–73; Albert Cassagne *La Théorie de l'art pour l'art en France chez les derniers romantiques et les premiers réalistes* (1906; reprint, Paris: Lucien Dorbon, 1959), pp. 183, 193–95.

22. Esther Ellie Nower, "The Artist as Politician: The Relationship between the Art and the Politics of the French Romantic Literary and Artistic Figures" (Ph.D. diss., University of California, Berkeley, 1975).

23. Tallemant des Réaux, *Historiettes,* ed. Antoine Adam, 2 vols. (Paris: Pléiade, 1961), 2 : 685, as quoted in Nicole Aronson, *Mademoiselle de Scudéry,* trans. Stuart R. Aronson (Boston: Twayne, 1978), p. 17.

24. Antoine Adam, *Grandeur and Illusion: French Literature and Society 1600–1715,* trans. Herbert Tint (New York: Basic Books, 1972), p. 70.

25. Mme. de Sévigné, *Lettres,* ed. Gérard-Gailly, 3 vols. (Paris: Pléiade, 1960), 2 : 929 (March 5, 1683), as quoted in Aronson, *Scudéry,* p. 50.

26. Henri Peyre, *What Is Romanticism?,* trans. Roda Roberts (Tuscaloosa: University of Alabama Press, 1977), p. 40.

27. Henri de Latouche, *Oeuvre de Canova* (Paris: Audot, 1825), p. 19.

28. Frédéric Ségu, *Un Romantique républicain, H. de Latouche 1785–1851* (Paris: Société d'Édition "Les Belles Lettres," 1931), pp. 4–5. For Deschamps's quotation see pp. 206–7.

29. As quoted in Gretchen R. Besser, *Balzac's Concept of Genius: The Theme of Superiority in the "Comédie humaine"* (Geneva: Droz, 1969), p. 31. Author's translation. Besser notes the importance of Mme. de Staël's views on genius for Balzac.

30. As quoted in ibid., p. 107. Author's translation.

31. As quoted in Maurice Z. Shroder, *Icarus: The Image of the Artist in French Romanticism* (Cambridge, Mass.: Harvard University Press, 1961), p. 211.

32. As stated by Paul Alexis in 1882, quoted in Robert J. Niess, *Zola Cezanne and Manet: A Study of L'Oeuvre* (Ann Arbor: University of Michigan Press, 1968), p. 3.

33. Proust, *Remembrance,* 2 : 1010/3 : 891–92.

34. Marcel Proust, *Contre Sainte-Beuve précédé de Pastiches et mélanges et suivi de Essais et articles,* ed. Pierre Clarac and Yves Sandre (Paris: Gallimard, Pléiade, 1971), p. 276. Author's translation. For the relationship between Proust's literary Impressionism and critical writings on Monet see Helen O. Borowitz, "The Rembrandt and Monet of Marcel Proust," *Cleveland Museum of Art Bulletin* 70 (February 1983): 73–95.

35. Proust, *Remembrance,* 1 : 496/1 : 653.

36. As quoted in Anthony R. Pugh, *Balzac's Recurring Characters* (Toronto and Buffalo: University of Toronto Press, 1974), p. 471. Author's translation.

37. As quoted in ibid., p. 474.

38. Shroder, *Icarus,* p. 238.

39. Seznec, "Literature and the Visual Arts," p. 15.

Chapter 2. The Unconfessed *Précieuse*

1. Ian MacLean, *Woman Triumphant: Feminism in French Literature 1610–1652* (Oxford: Clarendon Press, 1977), pp. 209–12. Deborah Marrow, *The Art Patronage of Maria de' Medici* (Ann Arbor: UMI Research Press, 1982), pp. 65–70.

2. Rebecca Tingle Keating, "The Literary Portraits in the Novels of Mlle. de Scudéry" (Ph.D. diss., Yale University, 1970), p. 71.

3. Ibid., pp. 17–65, on antecedents to Mlle. de Scudéry's novels.

4. As quoted in Nicole Aronson, *Mademoiselle de Scudéry,* trans. Stuart R. Aronson (Boston: Twayne, 1978), p. 56. This is an excellent modern source for background on Mlle. de Scudéry's life and works. Other important books are Rathery and Boutron, *Mademoiselle de Scudéry; Sa vie et sa correspondance* (Paris: Techener, 1873); Georges Mongrédien, *Madeleine de Scudéry et son salon* (Paris: Tallendier, 1946); André Bellessort, *Heures de parole* (Paris: Perrin, 1929); René Godenne, *Les Romans de Mademoiselle de Scudéry* (Geneva: Droz, 1980); and, in English, Dorothy McDougall, *Madeleine de Scudéry, Her Romantic Life and Death* (London: Methuen, 1938). For Mlle. de Scudéry and the *préciosité* movement see Roger Lathuillière, *La Préciosité, étude historique et linguistique* (Geneva: Droz, 1966).

5. As quoted in Alain Niderst, *Madeleine de Scudéry, Paul Pellison et leur monde* (Paris: Presses Universitaires de France, 1976), p. 419. This study concentrates on the keys to the novels.

6. As quoted in J. W. Oliver, *The Life of William Beckford* (London: Oxford, 1932), p. 189. For background on Mme. Necker's salon see Gabriel-Paul-Othenin de Cléon, Comte d'Haussonville, *The Salon of Madame Necker,* trans. Henry M. Trollope, 2 vols. (London: Chapman and Hall, 1882). On Mme. de Staël's salon experience as a girl see Catherine Rilliet Huber, "Notes sur l'enfance de Mme. de Staël," *Occident et cahiers staëliens* 2, no. 2 (1932): 41–47.

7. Comte d'Haussonville, *Madame Necker,* 1 : 18, 27–30. On seventeenth-century salons see Jacques Wilhelm, *Le Vie quotidienne au marais au XVII siècle* (Paris: Hachette, 1966), pp. 197–223. For the popularity of Mlle. de Scudéry's novels in the eighteenth century see Daniel Mornet, *J. J. Rousseau La Nouvelle Héloïse,* Les Grands Ecrivains de la France, ed. Gustave Lanson (Paris: Hachette, 1925), p. 10.

8. As quoted in Béatrice d'Andlau, *La Jeunesse de Madame de Staël (de 1766 à 1786) avec des documents inédits* (Geneva: Droz, 1970), pp. 109–10. Author's translation. A good biography of Mme. de Staël is Christopher J. Herold, *Mistress to an Age: A Life of Mme. de Staël* (Indianapolis and New York: Bobbs-Merrill, 1958). See also Gabriel-Paul-Othenin de Cléon, Comte d'Haussonville, *Madame de Staël et M. Necker d'après leur correspondance inédite* (Paris: Calmann-Lévy, 1925). For an example of M. Necker's novel writing see Baroness de Staël-Holstein, "The Fatal Consequences of a Single Fault," *Memoirs of the Private Life of My Father to Which are Added Miscellanies by M. Necker* (London: Henry Colburn, 1818), pp. 354–416.

9. Mme. Necker de Saussure, "Notice sur le caractère et les écrits de Mme. de Staël," *Oeuvres complètes de Mme la baronne de Staël-Holstein,* 2 vols. (Paris: Firmin Didot, 1838), 2 : 47. Madelyn Gutwirth, "Mme. de Staël, Rousseau, and the Woman Question," *PMLA* 86, no. 1 (January 1971): 103.

10. On Guibert see Pierre de Ségur, "Un grand homme de Salons," *Gens d'autrefois* (Paris: Calmann-Lévy, 1812), pp. 195–270. See also Anne-Louise-Germaine Necker de Staël, "L'éloge de M. de Guibert," *Oeuvres complètes,* 2 : 412–22.

11. As quoted in Mme. Necker de Saussure, "Notice sur le caractère et les écrits de Madame de Staël," *Oeuvres complètes,* 2 : 7–8. Author's translation.

12. Mme. de Staël, *Corinne, ou l'Italie,* bk. 2, chap. 1, *Oeuvres complètes,* 1 : 663. Subsequent citations in the text refer to this edition (n. 9 above). English translations are

taken from *Corinne, or Italy*, trans. Isabel Hill, with metrical versions of the odes by L. E. Landon (New York: Derby and Jackson, 1857).

13. Michel Abbé de Pure, *La Prétieuse, ou le mystère des ruelles*, ed. Émile Magne, 2 vols. (Geneva: Droz, 1939), 1:143. See Germaine Brée, *Women Writers in France: Variations on a Theme* (New Brunswick: Rutgers University Press, 1973), pp. 37–38, on Madeleine de Scudéry as a model for French women novelists.

14. For her juvenalia see d'Andlau, *La Jeunesse*, pp. 125, 129, 130; and David Glass Larg, *Mme. de Staël, Her Life as Revealed in Her Work, 1766–1800*, trans. Veronica Lucas (New York: Knopf, 1926). Mme. de Staël many years later was to write a drama *Sapho et Phaon* in 1811. See *Oeuvres complètes*, 2:491–509.

15. These first exercises in character study followed the mode practiced by the *précieuses* and probably developed from her mother's suggestion of their pen portraits of M. Necker. See d'Andlau, *La Jeunesse*, p. 106, for influence on Mme. de Staël's writing as a girl of "une préciosité due à l'exemple maternel."

16. Madeleine de Scudéry, *Artamène ou Le Grand Cyrus*, 10 vols. (1649–53; reprint Geneva: Slatkine Reprints, 1972), 10:pt. 10, bk. 2, p. 332. Subsequent quotation from portrait of Sappho will be cited to this edition parenthetically in the text. Author's translations.

17. Molière, *Les Précieuses ridicules*, scene 9, as quoted in *Les Précieux et les Précieuses*, ed. Georges Mongrédien (Paris: Mercure de France, 1963), p. 125, n. 1.

18. For Molière's debt to Mlle. de Scudéry see Henri Cottez, "Sur Molière et Mademoiselle de Scudéry," *Revue de Sciences humaines* (1942), pp. 340–64; J.H. Whitfield, "A Note on Molière and Mlle. de Scudéry," *Le Parole e le Idee* 5 (1963): 175–87.

19. Victor Cousin, *La Société françaî au XVII siècle d'après Le Grand Cyrus*, 2 vols. (Paris: Perrin, 1886), 2:141, 277–82. See also Gustave Charlier, "La fin de l'Hotel de Rambouillet," *Revue Belge de Philosophie et d'Histoire* 18 (1939): 409–25, which proves the Rambouillet salon, run by the marquise's daughter Julie, lasted through the 1660s, longer than Cousin (following Roederer) realized. See Lathuillière, *La Préciosité*, pp. 130ff on Damophile and Molière.

20. As quoted from Cousin, *La Société*, pp. 141–44. On Damophile as model for Molière's Philaminte, see Armand Gaste, *Madeleine de Scudéry et le "Dialogue des Heros de Roman" de Boileau* (Rouen: Cagniard, 1902), p. 33.

21. See André Blum, *L'Oeuvre gravé d'Abraham Bosse* (Paris: Morance, 1924), pp. 9, 48; plate 20. See also "La Querelle, le mouvement populaire anti-feministe," in *Les Salons littéraires au XVII siècle*, exhib. cat. (Paris: Bibliothèque Nationale, 1968), sec. IX, for popular engravings against the *précieuses*, including several engravings by Bosse.

22. MacLean, *Woman Triumphant*, p. 153.

23. Madelyn Gutwirth, "Mme. de Staël, Rousseau," pp. 100–109. See also Jane Abray, "Feminism and the French Revolution," *American Historical Review* 80 (February 1975):43–62 for a description of the antifeminist climate that may explain Mme. de Staël's reticence on feminist issues.

24. *Rousseau's Émile*, ed. W. H. Payne (New York: D. Appleton, 1895), p. 303.

25. Mario Praz, "The Lady with the Lyre," in *On Neoclassicism*, trans. Angus Davidson (Evanston: Northwestern University Press, 1969), pp. 255–67.

26. Anne-Louise-Germaine Necker de Staël, *Les Carnets de voyage de Madame de Staël*, ed. Simone Balayé (Geneva: Droz, 1971), pp. 178–81, hereafter cited as *Carnets*. Geneviève Gennari, *Le Premier Voyage de Madame de Staël en Italie et la genèse de Corinne* (Paris: Boivin, 1947), pp. 72–77. For Mme. de Staël and A. W. Schlegel, her *cicerone* in Italy, see Comtesse Jean de Pange (née Broglie), *Auguste-Guillaume Schlegel et Madame de Staël, d'après des documents inédits* (Paris: Albert, 1938).

27. Madelyn Gutwirth, *Madame de Staël, Novelist: The Emergence of the Artist as*

Woman (Urbana, Chicago, London: University of Illinois Press, 1978), p. 175, asserts: "But even after we have assayed all these sources and echoes, biographical or literary, for the light they shed on the origin of this work [*Corinne*], we have still failed to account for the very extravagance of this vision of the priestess of Apollo *cum* sibyl we find at the outset of the novel, borne in on a chariot led by white horses." Gutwirth failed to consult *Cyrus* as a source for *Corinne* or to associate Mme. de Staël with Mlle. de Scudéry (see n. 30).

28. Bellessort, *Heures de Parole*, p. 176, credits Mlle. de Scudéry with "Europeanizing" the French genius. For the many translations of her books made during her lifetime see Georges Mongrédien, "Bibliographie des oeuvres de Georges et Madeleine de Scudéry," *Revue d'Histoire Littéraire de la France* 40 (1933): 224–36, 413–25, 538–65. For the impact of her novels on Richardson and other English readers see McDougall, *Romantic Life and Death*, pp. 119–32. On Mlle. de Scudéry's modernity see Antoine Adam, *Histoire de la littérature française au XVII siècle*, 5 vols. (Paris: Mondiales, 1962), 2:138–40.

29. Judith Colton, *The Parnasse François: Titon du Tillet and the Origins of the Monument to Genius* (London and New Haven: Yale University Press, 1979), pp. 22, 57–58, 98.

30. Gutwirth, who recognizes in *Mme. de Staël, Novelist*, p. 204, "learned or literary ladies like Heloïse, Louise Labé, Pernette du Guillet, Marguerite de Navarre," asks, "but where had there been one who, like Corinne, was the glory of her nation and her age?" The historic model for Corinne as literary woman is, I believe, Madeleine de Scudéry, called by her contemporaries "the Muse of our century" but disregarded by Gutwirth, who describes her merely as a "publicist of Preciosity" and, mistakenly, as "author of *Astrée*." That Mlle. de Scudéry's honors were known among nineteenth-century literary women is demonstrated in Stephanie Félicité Ducrest de Genlis, *De L'Influence des femmes sur la littérature française* (Paris: Mardan, 1811), pp. 95, 112–13, which records her honors and quotes from an elegy on her death by Mme. de la Roque-Montroune: "Le Ciel dut Aristote au siècle d'Alexandre;/ Il ne donna Sapho qu'au siècle de Louis."

31. Necker de Staël, *Carnets*, pp. 105, 215; Gutwirth, *Mme. de Staël, Novelist*, p. 174; Propertius's poem praises the young Cynthia's verses as rivaling those of "Antique Corinna." The comparison of a living woman to a famous poet of the past accords with the relationship of Mme. de Staël to Mlle. de Scudéry.

32. Madeleine de Scudéry, *Clélie, Histoire romaine*, 10 vols. (1654–60; reprint, Geneva: Slatkine Reprints, 1973), 8:pt. 4, bk. 2, p. 809. See also Lawrence A. Wilson, "The *Cyrus* and the *Clélie* of Mademoiselle de Scudéry as Reflections of XVIII Century Life, Ideas and Manners" (Ph.D. diss., University of Minnesota, 1941), pp. 65–71.

33. On the Domenichino painting see Esther Renfrew and Simone Balayé, "Madame de Staël et la Sibylle du Dominiquin," *Cahiers staëliens* (January 1964), pp. 34–36. Necker de Staël, *Carnets*, pp. 184f.

34. For accounts of visitors Martin Lister, Mme. du Noyer, Leibnitz see Claude Aragonnes, *Madeleine de Scudéry, reine de Tendre* (Paris: Colin, 1934), pp. 237–45; Georges Mongrédien, *Madeleine de Scudéry et son salon*, pp. 206–9. See also "Les Précieuses, leur modèles, le mouvement précieux," no. 193, in *Les Salons littéraires*, sec. IX, for several engravings of sibyls by Abraham Bosse.

35. Wilson, "The *Cyrus* and the *Clélie*" p. 170.

36. Interview with Marguerite Yourcenar, *New York Times*, December 3, 1979, p. D9. Speaks of her "face of a sibyl."

37. See Necker de Staël, *Carnets*, pp. 248–49.

38. See Émile Magne, *Voiture et l'Hotel de Rambouillet*, 2 vols. (Paris: Émile-Paul, 1929–30), 2:183–86 for *divertissements* at l'Hotel de Rambouillet that involved disguised portraits in literature: the *jeu de metamorphoses* and the *gazette allégorique*.

On the revival of the *portrait déguisé* and the Mannerist taste of the *précieux* circle in art see Anthony F. Blunt, "The *Précieux* and French Art," in *Fritz Saxl, 1890–1948: A Volume of Memorial Essays from His friends in England,* ed. D. J. Gordon (London: Thomas Nelson, 1957), pp. 326–38.

39. See "Les Précieuses, leurs modèles, le mouvement précieux," no. 194, in *Les Salons Littéraires,* sec. IX, on Romanelli's fresco decorations (reproduced).

40. Georges de Scudéry, *Le Cabinet de M. de Scudéry* (Paris: Courbé, 1646), p. 95, describes a painting by Van Mol of Mme. de Rambouillet as Thetis weeping over Achilles. This personification through a mythological subject of her grief after the death of her son at battle of Nordlingen looks forward to Corinne's identification of the mourning Oswald with Canova's genius of death.

41. Niderst, *Madeleine de Scudéry* p. 364.

42. Myra Nan Rosenfeld, "Nicolas de Largillièrre's Portrait of the marquise de Dreux-Brézé," *Apollo* 109 (March 1979): 202–07.

43. F. Ed. Schnéegans, "Note sur un portrait de Claude Deruet au Musée des Beaux-Arts de Strasbourg," *Archives Alsacienne d'histoire de l'art* 6 (1927): 60, points out that Deruet could have painted the Tivoli landscape from nature when he visited Rome in his youth. On dating of the portrait see Blunt, "*Précieux* and French Art," p. 335.

44. Anne-Louise-Germaine Necker de Stael, *Lettres inédites de Mme. de Staël à Henri Meister,* ed. Paul Usteri and Eugene Ritter (Paris: Hachette, 1903), p. 193.

45. As quoted in Yvonne Bezard, *Mme. de Staël d'après ses Portraits* Paris: Victor Attinger, 1938), p. 17.

46. According to response of Christine Speroni, documentaliste, Musée de Ville de Strasbourg, to my query on provenance, the Deruet portrait was acquired by the museum in Paris in 1926. Since I have not yet succeeded in obtaining more detailed provenance, it is still impossible to ascertain whether Mme. de Staël could have known the portrait. See Magne, *Voiture,* 2:305 for a list of writings by Julie d'Angennes.

47. Reproduced in Eleanor Tufts, *Our Hidden Heritage: Five Centuries of Women Artists* (New York: Paddington Press, 1974), fig. 63, p. 116, See Lady Victoria Manners and Dr. G. C. Williamson, *Angelica Kauffmann, R.A.* (London: John Lane, 1924), pp. 13, 206–7 for description of painting dated Rome, 1794. See also Bezard, *Mme. de Staël d'après,* p. 14, for mention of Angelica Kauffmann's drawing (now lost) of Mme. de Staël executed in Italy in 1805.

48. Necker de Staël, *Carnets,* p. 252–54. See Simone Belayé, "La Génie et la gloire dans l'oeuvre de Mme. de Staël," *Rivista de Letterature Moderne e Comparate* (December 1967), pp. 202–14, on Mme. de Staël's idea on Italy as a refuge for Corinne's genius.

49. Georges de Scudéry, *Le Cabinet de M. de Scudéry* "au lecteur." See Aronson, *Mademoiselle de Scudéry,* p. 21, for Scudéry's ownership of works by Durer, Bruegel, and Callot; and Blunt, "*Précieux* and French Art," p. 334, for his admiration of Callot.

50. In her novels Mlle. de Scudéry warns her readers of the dangers of inconstant lovers, who will destroy a woman's reputation *(gloire)*. This warning is reiterated in the *Cabinet* when Dido is told: "Ce n'est qu'en l'aimant encore,/ Que vous offendez la gloire." For discussion of woman's *gloire* in *Cyrus* see Lucien Arthur Aube, "Aspects of Reality in the *Grand Cyrus* of Madeleine de Scudéry" (Ph.D. diss., Case Western Reserve University, 1970), pp. 184–209.

51. Adam, *Histoire de la littérature,* 2:138–39.

52. Necker de Staël, *Carnets,* pp. 103–5, 245–49.

53. Jean Ménard, "Mme. de Staël et la peinture," in *Colloque de Coppet, Mme. de Staël et l'Europe* (Paris: Klincksieck, 1970), pp. 253–62.

54. Suzanne Curchod de Nasse Necker, *Nouveaux mélanges extraits des manuscrits de Mme. Necker,* 3 vols. (Paris: Pougens, 1801), 2:26.

55. On Diderot see *Madame de Staël et l'Europe*, exhib. cat. (Paris: Bibliothèque Nationale, 1966), p. 10, no. 42. On the salon tradition see Roger Picard, *Les Salons littéraires et la société française, 1610–1789* (New York: Brentano's, 1943), esp. pp. 339–47.

56. On the Rambouillet art collection and decor see *Inventaires de l'Hotel de Rambouillet, à Paris en 1652, 1666, 1671 et des Chateaux d'Angoulême et de Montausier 1671*, publiés par Charles Sauze pour la Société Archéologique de Rambouillet (Tours: Deslis, 1894), pp. 39–41, 74–76, for list of contents of *la chambre bleue*.

57. See Nicole Aronson, "Mlle. de Scudéry et l'histoire romaine dans *Clélie*," *Romanische Forschungen* 88 (1976): 183–94, for historical sources used by Mlle. de Scudéry for *Clélie*.

58. Madeleine de Scudéry, *La Promenade de Versailles* (1669; reprint, Paris: Devambez, 1920), p. 7. In *Clélie* Mlle. de Scudéry had included a description of another contemporary marvel of architecture, Foucquet's chateau de Vaux (Valterre). See René Godenne, "Les Nouvelles de Mlle. de Scudéry, *Revue des Sciences Humaines* 37, no. 148 (October–December 1972): 508–11 for the late *nouvelles* as a response to taste for shorter novels. See Robert M. Isherwood, *Music in the Service of the King* (Ithaca, London: Cornell University Press, 1973), esp. chap. 6 for the promenade as a *divertissement*.

59. De Scudéry, *Promenade*, pp. 29–30. See also *Les Salons littéraires*, XII, "Le cabinet de dames de Louis XIV," nos. 269–91.

60. Mme. de Staël discussed several other topics that had already been treated by Mlle. de Scudéry: monarchal versus republican government, the relation of climate to culture, and the conflict between love and ambition.

61. As quoted in Arpad Steiner, "Les Idées esthétiques de Mlle. de Scudéry," *Romanic Review* 16 (1925): 175. Steiner points out that nineteen years later the same conception of the novel was put forth by the character Anacreon in "History of Hesiod," in *Clélie*, and extracted from *Clélie* to be republished in 1680 in *Conversations sur divers Sujets*.

62. "Ce n'est pas que je prétende bannir les naufrages des Romans . . . mais comme tout exces est vicieux, je ne m'en servis que modérément pour conserver la vraysembl-ance," as quoted in Steiner, "Les Idēes esthétiques," p. 176, with spelling modernized by the author.

63. Ellen Moers, *Literary Women* (New York: Anchor Press, 1977), p. 272.

64. Oswald is the typical melancholy lover of Mlle. de Scudéry's novels. Cf. Victor Cherbuliez, *L'Idéal romanesque en France de 1610 à 1816* (Paris: Hachette, 1911), pp. 61–63. See also Lathuillère, *La Préciosité*, pp. 587–91 for Mlle. de Scudéry's conception of the *honnête homme*.

65. Anne-Louise-Germaine Necker de Staël, "Des Femmes qui cultivent les Lettres," *De la littérature*, ed. Paul van Tieghem, 2 vols. (Geneva: Droz; Paris: Minard, 1959), 2:334–39.

66. Anne-Louise-Germaine Necker de Staël, "De l'Esprit général de la Littérature chez les Modernes," *De la Littérature*, 1:151. Author's translations.

67. C. A. Sainte-Beuve, "Mademoiselle de Scudéry," in *Causeries du lundi*, 15 vols. 3d ed. (Paris: Garnier, n.d.), 4:141. Author's translation.

Chapter 3. Terpsichore and Corinne

1. Henri de Latouche, *Oeuvre de Canova* (Paris: Audot, 1825), p. 51.

2. Antoine Chrysostome Quatremère de Quincy, *Canova et ses ouvrages* (Paris: Adrien Le Clere, 1834), pp. 367–69, quotes from a letter by Canova of 1809 mentioning the Muse as a portrait of Mme. Lucien Bonaparte, as cited by Henry Hawley, "Antonio

Canova, *Terpsichore*," Cleveland Museum of Art *Bulletin* 56 (October 1969):290. Hawley, p. 302, establishes the identity between the Simon Clarke version and the *Terpsichore* in the Cleveland Museum of Art. See also Henry Hawley, "Additions and Corrections, Canova's *Terpsichore*," Cleveland Museum of Art *Bulletin* 57 (March 1970): 103.

3. Gerard Hubert, *Les Sculpteurs Italiens en France sous la Revolution, L'Empire et La Restauration, 1790–1830* (Paris: de Boccard, 1964), p. 52, n. 4. See also Vittorio Malamani, *Canova* (Milan: Hoepli, s.d. [1911]), pp. 174ff.

4. Fleuriot de Langle, *Alexandrine Lucien-Bonaparte, Princesse de Canino (1778–1855)* (Paris: Plon, 1939), p. 54. See chapter 2 on the marriage. See also Th. Iung, *Lucien Bonaparte et ses Mémoires 1775–1840*, 3 vols. (Paris: G. Charpentier, 1882), 2 : chap. 19, esp. 432–34.

5. Iung, *Lucien Bonaparte*, 3 : 117.

6. Étienne-Jean Delécluze, *Souvenirs de soixante années* (Paris: Michel Lévy, 1862), p. 51, called Alexandrine an enchantress whose conversation was animated and witty, when he met her at a soirée in 1799 while she was still Mme. Jouberthon. See also Mme. Elisabeth Vigée-Lebrun, *Mémoires*, trans. Lionel Strachey (London: Grant Richards, 1904), p. 174, for the artist's comment on first seeing Mme. Jouberthon: "She was so exquisite that I could not help exclaiming, 'Oh, how beautiful you are!' "

7. Iung, *Lucien Bonaparte*, 3 : 71–73. See also letter from Ingres to the family of Julie Forestier, May 29, 1807, mentioning his attendance at a performance by Lucien "et sa belle épouse," as quoted in Hans Naef, *Die Bildniszeichnungen von J. -A. -D. Ingres*, 5 vols. (Bern: Bentelie, 1977–80), 1 : 504. See also La Duchesse d'Abrantès, "Salon de Lucien Bonaparte," *Histoire des Salons de Paris* (Paris: Ladvocat, 1836–38), pp. 373–426, for a description of Lucien's Paris Salon of 1798 in which he featured amateur theatricals.

8. Iung, *Lucien Bonaparte*, 3 : 74.

9. Francis Haskell, *Rediscoveries in Art, Some Aspects of Taste Fashion and Collecting in England and France* (Ithaca: Cornell University Press, 1976), pp. 33–35. On Lucien's collecting see François Piétri, *Lucien Bonaparte* (Paris: Plon, 1939), pp. 180f.

10. Iung, *Lucien Bonaparte*, 3 : 59–62. See also *Memoires of the Private and Political Life of Lucien Bonaparte, Prince of Canino* (London: Henry Colburn, 1818), pp. 239, 255, for Lucien's decision to change the name of the estate from "La Ruffinella" to "Tusculum" as it was known in Cicero's day. He also placed a bust of Cicero in the ruins of the Orator's house.

11. Henri de Latouche, *Canova*, pp. 66–67.

12. Iung, *Lucien Bonaparte*, 3 : 62–65, 69–71. See also pp. 469f. for a list of Lucien's published works including his writings on "Etruscan" vases in his collection. Cf. Langle, *Alexandrine*, pp. 125–26, 149.

13. Napoleon's comments to Las Cases September 13, 1816, as quoted in Naef, *Ingres*, 1 : 515. See Iung, *Lucien Bonaparte*, 3 : 473–85 for reviews of the poem. For English reviews see *Memoires of the Private and Political Life of Lucien Bonaparte*, 2 : 253–90. Piétri, *Lucien Bonaparte*, p. 274, for Byron's complimentary remarks.

14. Langle, *Alexandrine*, pp. 126–29.

15. Iung, *Lucien Bonaparte*, 3 : 271–72, for genealogy of the family of Lucien Bonaparte. See p. 435 for Iung's conjecture that the childless Napoleon's jealousy of Alexandrine stemmed from her being in Iung's words, "si belle, si adroite, et surtout si féconde?"

16. Mario Praz, in *On Neoclassicism*, trans. Angus Davidson (Evanston: Northwestern University Press, 1969), "The Lady with the Lyre," pp. 255–67.

17. Mme. de Staël, *Corinne*, bk. 4, chap. 3, p. 680. French quotations are from *Corinne, ou l'Italie, Oeuvres complètes de Mme. la baronne de Staël*, 2 vols. (Paris: Firmin, Didot, 1838) 1 : 680. Page numbers refer to this edition. English translations are

taken from *Corinne, or Italy,* trans. Isabel Hill with metrical versions of the odes by L. E. Landon (New York: Derby and Jackson, 1857). This standard translation had many later editions.

18. Mme. de Staël compares the two characters to famous paintings; see chapter 2. For a discussion of these images see Esther Renfrew and Simone Balayé, "Madame de Staël et la Sibylle du Dominiquin," *Cahiers staëliens* (January 1964), pp. 34–36. See also Annie Corbeau, "Deux Aspects de l'Esthétique des Romans de Mme. de Staël," *Colloque de Coppet, Mme. de Staël et l'Europe* (Paris: Klincksieck, 1970), pp. 333–40.

19. Mme. de Staël, *Corinne,* bk. 6, chap. 1, pp. 698–99. Mme. de Staël's knowledge of ancient art came from Winckelmann as interpreted to her by the Schlegel brothers. See Comtesse Jean de Pange (née Broglie), *Auguste-Guillaume Schlegel et Madame de Staël* (Paris: Albert, 1938), pp. 186–92. See also Appendix 1, for catalogues of Coppet library with French translations of Winckelmann, Lessing, and a German collection of Schlegel brothers.

20. Cf. Yvonne Bezard, *Madame de Staël d'après ses Portraits* (Paris: Victor Attinger, 1938), pp. 15ff, establishes convincingly the date of September 1807, as the time when Mme. Vigée-Lebrun visited Mme. de Staël at Coppet in order to paint her portrait. Bezard quotes a letter from Mme. de Staël to Henri Meister of September 18, 1807, which informs him that the portrait is being finished in Paris. Bezard notes the incorrect date (September 1808) of the visit can be traced to Pierre de Nolhac, *Mme. Vigée-Lebrun, peintre de Marie Antoinette* (Paris: Goupil, 1912), pp. 222f.

21. Praz, *Neoclassicism,* p. 258f.

22. C. P. Landon, *Annales du Musée* (Paris: Migneret, 1802), 3:64: "Anithe, Glycère, Corinne eurent aussi leur statues des mains d'Euthycrate, Ctésiphon et Harpalus, dont les talens étaient renommés." The date of the commission of Alexandrine's Muse portrait is not known. Elena Bassi, *La Gipsoteca di Possagno* (Venice: Neri Pozza, 1957), p. 39, places it very early when she says that the plaster was completed in December 1807. Hubert, *La Sculpture dans l'Italie Napoléonienne,* p. 137, n. 2, questions this early date because of the signed and dated plaster with points for transfer in the Villa Carlotta. This plaster is dated 1811 and therefore accords better with Canova's letter of January 21, 1809 to Quatremère de Quincy, *Canova,* pp. 367–69, cf. n. 2 above. According to Canova's list of 1816 *Catalogo Cronologico Delle Sculture di Antonio Canova* (Rome, 1817), p. 14, as cited in Hawley, *Antonio Canova,* n. 10, 37, the *Terpsichore* is listed as 1808. Perhaps the statue as portrait was completed in 1808, and the symbolic figure of Terpsichore was completed in 1811, the year following the departure of the Bonapartes. The novel *Corinne, ou l'Italie* was published on May 1, 1807 and was an immediate success.

23. Cf. Bezard, *Mme. de Staël d'après,* pp. 22–24, on Tieck's bust, reproduced in Pierre Cordey, *Mme. de Staël et Benjamin Constant sur les Bords du Leman* (Lausanne: Payot, 1966), p. 209. Cf. Bezard, p. 24, on anonymous bust.

24. Iung, *Lucien Bonaparte,* 3:55. See also *Madame de Staël et L'Europe,* exhib. cat. (Paris: Bibliothèque Nationale, 1966), p. 49, no. 195. Christopher Herold, *Mistress to an Age: A Life of Madame de Staël* (Indianapolis and New York: Bobbs-Merrill, 1958), p. 306, for Mme. de Staël's letter of August 8, 1804 to Claude Hochet in which she stated, "I shall write a novel about my Italian journey." While collecting material in Rome she may already have been conversing about the book with her friends as was typical of her before publication.

25. Sophie Gay, *Salons Célèbres* (Brussels and Leipzig: C. Hochausen, 1837), p. 18.

26. Mme. de Staël, *Corinne,* bk. 8, chap. 2, p. 726. This practice was related to the notion that the ancients exhibited statuary under torchlight to create a sense of life. Cf. Latouche, *Canova,* p. 19, on relationship of Canova's bust of the Greek poetess Corinna to Mme. de Staël's heroine.

27. Mme. de Staël, *Corinne*, bk. 8, chap. 2, p. 726. The statue is the genius of death from tomb of Pope Clement XIII.

28. Iung, *Lucien Bonaparte*, 3:59.

29. Emmanuel, Comte de Las Cases, *Memoirs of the Life, Exile, and Conversations of the Emperor Napoleon*, 4 vols. (New York: Redfield, 1855), 3:121.

30. Gay, *Salons célèbres*, p. 18, cf. pp. 7–36 on Mme. de Staël's salon. Later at St. Helena Napoleon recalled that her salon at Coppet has been "a veritable arsenal against me," as quoted in Peter Gay. Introduction to Mme. de Staël, *Ten Years of Exile*, trans. Doris Beik (New York: Saturday Review Press, 1972), p. xxiv. See also Paul Gautier, *Madame de Staël et Napoléon* (Paris: Plon, 1933). On Mme. de Staël's salon see Duchesse d'Abrantès.

31. Iung, *Lucien Bonaparte*, 2:41.

32. Mme. de Staël, *Corinne*, bk. 4, chap. 5, p. 688.

33. Herold, *Mistress to an Age*, p. 344.

34. As quoted in Gautier, *de Staël et Napoléon*, p. 302.

35. As quoted in Las Cases, *Memoirs*, 3:119.

36. Iung, *Lucien Bonaparte*, 2:239.

37. Mme. de Staël, *Corinne*, bk. 2, chap. 1, p. 663.

38. Ibid. The full quotation generalizes the tribute to all women of genius. Cf. Simone Balayé, "Le Génie et la Gloire dans l'oeuvre de Mme. de Staël," *Rivista di Letterature Moderne e Comparate* (December 1967), pp. 202–14. Cf. Henry Thornton Wharton, *Sappho* (London: Simpkin, Marshall, Hamilton, Kent, 1885), esp. pp. 28–33.

39. C. P. Landon, *Annales du Musée* (Paris: Didot jeune, 1800), 1:135f., plate 66. Cf. "Muses," *The Oxford Classical Dictionary*, s.v. "Muses," for differentiation of Muses according to function from *Anthologia Palatina 9*, pp. 504, 505. Cf. Max Wegner, *Die Musensarkophage* (Berlin: Gebr. Mann, 1966), pp. 97, 101f., on Erato's large kithera suitable to her role of Muse of lyric poetry for festal choral hymns in opposition to Terpsichore's smaller tortoise-shell lyre appropriate to her small-scale lyric poems. Wegner cautions against the concept of a rigid system of identification of the Muses. Contradictions existed in the *Greek Anthology*, and even the Romans were not always consistent.

40. The relationship between the subject of the statue and the Roman wall paintings was first pointed out by Quatremère de Quincy, p. 161. Cf. Hawley, "Antonio Canova," p. 293, fig. 6, n. 17. See also Tran Tam Tinh, *Catalogue des peintures romaines (Latium et Campanie) du musée du Louvre* (Paris: Éditions des Musées Nationaux, 1974), pp. 29–31, fig. 4, Erato (with kithera) and fig. 5, Terpsichore (with lyre). See also pp. 22f., "Questions de provenance" for the assertion that the frescoes are from Pompeii rather than Herculaneum. On Napoleon's offer of the paintings to Joseph, see p. 25, n. 1.

41. Quatremère de Quincy, *Canova*, p. 162. Cf. Malamani, *Canova*, p. 313, for *Terpsichore* as one of Canova's imitations of antique style.

42. Hawley, "Additions and Corrections," and Hawley, "Antonio Canova," fig. 8. For the drawings cf. Elena Bassi, *Il Museo Civico di Bassano, I Disegni di Antonio Canova* (Venice: Neri Pozza, 1959), p. 121, nos. E. b. −5.1016., −6.1017., −7.1018., −8.1019.

43. Cf. Hawley, "Antonio Canova," fig. 8. Margarete Beiber, *Ancient Copies, Contributions to the History of Greek and Roman Art* (New York: New York University Press, 1977), p. 249, fig. 883, has identified the Muse on the far left that Hawley compares to Canova's *Terpsichore* as a likeness of the deceased woman in the guise of Clio. This appears to be an early example (dated A.D. 160) of a Muse portrait of the deceased. Cf. Cornelius Vermeule, "Roman Sarcophagi in America: A Short Inventory," *Festschrift für Friedrich Matz* (Mainz: Philipp von Zabern, 1962), p. 103,

plate 29, fig. 1, on the Kansas City William Rockhill Nelson Gallery of Art sarcophagus for a similar Muse, on the far left of which is a portrait of the deceased as the "Tenth Muse" amid the nine Muses. This visual image parallels the compliment paid to Sappho as the Tenth Muse.

44. Cf. Bassi, *Il Museo Civico di Bassano*, p. 121, no. E. b. −9.1020, "Socrate seduto" ed una "Musa," and −10.1021, "Platone" ed una "Musa." Cf. Henri-Irenée Marrou, *Mousikos aner, Étude sur les scènes de la vie intellectuelle figurant sur les monuments funéraires Romains* (Grenoble: Didier and Richard, 1938), pp. 91–92.

45. For Muses in which the pose of the upper part of the body is close to Canova's *Terpsichore*, cf. Wegner, nos. 2, 24, 131, 137, 170, 183, 188, 212, 231. Six of the above sarcophagi are still in Rome. The Woburn Abbey sarcophagus (no. 231) was originally part of the Giustiniani collection. Among modern scholars there is uncertainty as to the identification of the Muse in this pose. An example is the Muse on the Woburn Abbey sarcophagus who is identified by Wegner as Erato and by A. H. Smith, *A catalogue of Sculpture at Woburn Abbey* (London, 1900), pp. 59–61, as Terpsichore.

46. Cf. Wegner, *Die Musensarkophage*, no. 189. This fragment resembles no. 188. A second Muse fragment from Canova's studio is no. 190.

47. Isabella Albrizzi, *The Works of Antonio Canova* (London: 1824), 1:146 as quoted in Hawley, "Antonio Canova," p. 290.

48. Mme. de Staël, *Corinne*, bk. 8 chap. 4, p. 776.

49. Franz Cumont, *After Life in Roman Paganism* (New Haven: Yale University Press, 1923), chaps. 3 and 4, esp. pp. 101, 115, 212. Franz Cumont, *Recherches sur le Symbolisme Funéraire des Romains* (Paris: Paul Geuthner, 1942), chap. 4, esp. pp. 250–88. Pierre Boyancé, *Le Culte des Muses chez les Philosophes Grecs* (Paris: de Boccard, 1937), esp. pp. 236ff. Cf. Marrou, *Mousikos aner*, chap. 4, "L'Héroisation par la Culture," pp. 231–57. Ernst Robert Curtius, *European Literature and the Latin Middle Ages*, trans. Willard R. Trask, Bollingen Series 36 (New York: Pantheon, 1952), pp. 228–35.

50. Cicero, "Dream of Scipio," *The Republic* 6. 18–22. *Greek and Latin Classics in Translation*, ed. Charles Theophilis Murphy, Kevin Guinagh, and Whitney Jennings Oates (New York: Longmans Green, 1947), pp. 808–9. Cicero's belief in immortality for the statesman and man of learning is enunciated in his late writings after his retirement from public life. Beginning with his *On Consolation*, written after the death of his daughter and again in his *Tusculan Disputations*, Cicero discusses the idea of the soul's pathway to heaven, an idea that reaches fullest expression in the mystical ending of "The Dream of Scipio." Cf. Pierre Boyancé, *Études sur le Songe de Scipion, thèse complémentaire* (Limoges: A. Bontemps, 1936), esp. pp. 97–114, on cosmic harmony.

51. Beiber, *Ancient Copies*, p. 250. Note the wife as Muse generally lacks the siren feathers worn in the hair of the Muses as token of their triumph in music over the sirens.

52. On sarcophagus, Sala del Meleagro 13, Cortile del Belvedere, Museo Vaticano, see Walther Amelung, *Die Sculpturen des Vaticanischen Museums* (Berlin: Georg Reimer, 1908), 2:40–43, Sala del Meleagro no. 13, plate 5. Cumont, *Recherches sur le symbolisme funéraire des Romains*, 301f., plate 28, top. Wegner, *Die Musen sarkophage*, p. 57, no. 138, plate 68; Beiber, *Ancient Copies*, p. 250, plate 888. Other examples of Sage and Muse with lyre sitting facing each other on the sarcophagus illustrated in Wegner are nos. 25, 47, 48, 83, 134, 135, 160, 162, 188, 193. Cf. Marrou, *Mousikos aner*, 102–13.

53. On Sarcophagus 424 Museo Torlonia, see Marrou, *Mousikos aner*, pp. 101–3, 209–20, 246–49. Beiber, *Ancient Copies*, p. 250, fig. 889. Wegner, *Die Musensarkophage*, pp. 53–55, plates 60, 61, 62, 64a, 73a. Other examples of seated Sage and standing Muse illustrated in Wegner are nos. 31, 39, 53, 79, 81, 111, 118, 121, 129, 175.

54. On the drawing see Naef, *Ingres*, 1:511–14. Naef, who discovered the identity of the sitter (the drawing was earlier published as a portrait of Isabey), also reproduces

(p. 512, fig. 2) a portrait of Lucien at the Villa Ruffinella by his artist-in-residence, Marquis de Chatillon, in which the pose is quite similar to the Ingres drawing, except that Lucien has doffed his hat and is reading a somewhat larger book. For excerpts referring to Lucien from Ingres's letters from the Villa Medici to the family of his bride Julia Forestier in Paris (January 17, February 21, May 29, August 8, 1807) see Naef, 1 : 504f.

55. Iung, *Lucien Bonaparte,* 3 : 65.

56. Mme. de Staël, *Corinne,* bk. 8, chap. 4, p. 775.

57. *Ibid.,* bk. 8, chap. 2, p. 725. Mme. de Staël's preoccupation with images of death in the novel may have been related to her marking the first anniversary of her father's death during her stay in Rome in 1805.

58. For Muse sarcophagi with Apollo and a gryphon see the following plates in Wegner, *Die Musensarkophage:* 12, 22, 25, 26a, 27a, 28, 30, 31a, 33b, 35, 36b, 37b, 41b, 42a and b, 45b, 104b, 184a (showing a gryphon next to a seated Muse with lyre), 140a, b, c, d (showing gryphons alone).

59. Mme. de Staël, *Corinne,* bk. 4, chap. 4, p. 685. See also Cornelius Vermeule, *European Art and the Classical Past* (Cambridge, Mass.: Harvard University Press, 1964), p. 192, n. 21.

60. Lucien Bonaparte "Revolution de Brumaire," in M. de Lescure, *Bibliothèque des Mémoirs,* n. s., vol. 30 (Paris: Firmin-Didot, 1875): 186.

61. Charles-Augustin Sainte-Beuve, "Madame de Staël," *Critiqués et portraits littéraires,* 3 vols. (Paris: Eugène Renduel, 1832), 3 : 353.

62. See Piétri, *Lucien Bonaparte,* pp. 453–56, and Iung, *Lucien Bonaparte,* 3 : 160ff., for Lucien's decision on leaving Rome to raise cash by leaving behind as security some of his collection with Torlonia and other Roman bankers. The departure and the financial problems Lucien faced may have necessitated the cancellation of the Muse portrait of Alexandrine. For Canova's bust portrait of Alexandrine see Bassi, *La Gipsoteca,* pp. 187f., plates 193, 194.

63. See Francis Haskell, *An Italian Patron of French Neo-Classic Art* (Oxford: Clarendon Press, 1972), on Sommariva's collection.

64. Naef, *Ingres,* 1 : 504–38, esp. pp. 517–22, for the identity of the daughter with the lyre.

65. Praz, *On Neoclassicism,* p. 260. Cf. Henry Hawley, *Neo-classicism: Style and Motif,* exhib. cat. (Cleveland: Cleveland Museum of Art, 1964), no. 148. See also Emanuel Winternitz, *Musical Instruments and their Symbolism in Western Art* (New York: W. W. Norton, 1967), pp. 172f., on the development of the lyre-guitar from a misinterpretation of ancient reliefs by Renaissance artists who copied the strings as bands. The instrument is played like a guitar by stopping the strings against the fingerboard.

66. Mme. de Staël, *Corinne,* bk. 2, chap. 3, p. 665.

67. Étienne-Jean Delécluze, *Journal de Delécluze, 1824–1828,* ed. Robert Baschet (Paris: Bernard Grasset, 1948), pp. 372, 246f., 250.

68. Delécluze, *Journal,* pp. 331–35, describes Delphine's performance at Gérard's salon-atelier. Gérard, who had already painted a portrait of Mme. de Staël, depicted a moment of poetic inspiration from the novel. The patron, the Prussian Prince Augustus appears in Corinne's audience. See also Henri Malo, *Une Muse et sa mère, Delphine Gay de Girardin* (Paris: Émile-Paul, 1924), pp. 124f., on the commissioning of the painting.

69. Delécluze, *Journal,* p. 250. See Malo, *Une Muse et sa mère,* p. 62, for Sophie Gay's defense of *Delphine* in "Lettre d'une mère à sa fille," *Journal de Paris,* January 23, 1803. Mme. de Staël died in Sophie Gay's house.

70. Hersent's portrait of Delphine, barely visible behind the curtain, presents the French Muse in appropriate white dress with uplifted eyes. See Malo, *Une Muse et sa*

mere, pp. 202f. for Delécluze's comparison of Delphine with her portrait, which he felt failed to do justice to her striking appearance. On the Gays see also Daniel Stern (Marie Catherine Sophie Agoult) *Mes Souvenirs, 1806–1855* (Paris: Calmann-Lévy, 1877), pp. 305–13.

71. On *La Muse Française* see Malo, *Une Muse et sa mère*, pp. 186–191. See also Ch. M.M. des Granges, *La Presse littéraire sous la Restauration, 1815–1830* (Paris: Mercure de France, 1907), pp. 102–13.

72. Jules Amédée Barbey d'Aurevilly, "Mme. Desbordes-Valmore," in *Les Poètes*, in *Les Oeuvres et Les Hommes Series*, pt. 3 (Paris: Amyot, 1862), pp. 145–58. See also Lucien Descaves, *La Vie douloureuse de Marceline Desbordes-Valmore* (Paris: Éditions d'Art et de Littérature 1910), with a bibliography of her writings in the appendix. See also Eliane Jasenas, *Marceline Desbordes-Valmore devant la critique* (Geneva: Droz, 1962).

73. Barbey d'Aurevilly, "Mme. de Girardin," *Les Bas-Bleus* in *Les Oeuvres et Les Hommes* Series, pt. 5 (Paris: Palmé, 1878), pp. 33–43.

74. The gossip column published between 1836 and 1848 in *La Presse* under the pseudonym "Le Vicomte de Launay" was later collected and published in three volumes as *Lettres Parisiennes* (Paris: Librairie Nouvelle, 1856). Delphine Gay de Girardin and Marceline Desbordes-Valmore were active on the *Journal des Femmes* that appeared between 1840–51. Cf. Eveyne Sullerot, *Histoire de la presse feminine en France des origines à 1848* (Paris: Armand Colin, 1966), pp. 174–76.

75. See Germaine Brée, *Women Writers in France* (New Brunswick: Rutgers University Press, 1973), esp. chap. 2.

76. Henri de Latouche, "Des Femmes et des Arts," *Revue de Paris* 18 (September 1830): 144–59. On Latouche and Desbordes-Valmore see Frédéric Ségu, *Un Romantique républicain, H. de Latouche (1785–1851)* (Paris: Société d'Édition "Les Belles Lettres," 1931), pp. 368–76. Latouche was probably aware of the famous verse by the poet Ponce-Denis Écouchard Lebrun, cautioning French Muses: "Voulez-vous ressembler aux Muses?/Inspirez, mais n'écrivez pas," as quoted in Malo, *Une Muse et sa mère*, p. 50.

77. On Latouche and Sand see Ségu, *Un Romantique républicain*, pp. 437–60, esp. pp. 437ff.

78. For the influence of *Corinne* on Sand and other nineteenth-century women authors see Ellen Moers, *Literary Women* (New York: Anchor Press, 1977), pp. 263–320, esp. pp. 287–89.

79. George Sand, *Les Sept cordes de la lyre* (Paris: Flammarion, 1973). The poem ends with the Muse and the spirit of the lyre acending to the celestial light. On one level it celebrates the love between Chopin and Sand, while on another it has to do with the artist's dedication to art. See introduction by René Bourgeois, esp. p. 33, for influences of Mme. de Staël on this poem.

80. Honoré de Balzac, *La Muse du Departement, Oeuvres complètes*, ed. Marcel Bouteron and Henri Longnon, 40 vols. (Paris: Conard, 1912–40), 10:92.

81. Sainte-Beuve, "Madame de Staël," p. 353.

Chapter 4. Critique and *Canard*

1. For background on Latouche, see Frédéric Ségu, *Un Romantique républicain, H. de Latouche (1785–1851)* (Paris: Société d'Édition "Les Belles Lettres," 1931) and *Un Journaliste diléttante, H. de Latouche et son intervention dans les arts* (Paris: Société d'Édition "Les Belles Lettres," 1931). For background on Latouche's part in the battle of the Romantics against the Classicists, see Ségu, *Un Romantique républicain*, pp. 285–361.

2. Théophile Gautier, *Progress of French Poetry, The Works of Théophile Gautier*, trans. and ed. F. C. de Sumichrast, 12 vols. (New York: George D. Sproul, 1902), p. 235. For the importance of André Chénier to Balzac, see Geneviève Delattre, *Les Opinions littéraires de Balzac* (Paris: Presses Universitaires de France, 1961), pp. 190–91, for Latouche's influence on Balzac, pp. 331–34.

3. As quoted in Ségu, *Un Romantique républicain*, p. 99.

4. Nicole Aronson, *Mademoiselle de Scudéry*, trans. Stuart R. Aronson (Boston: Twayne, 1978), pp. 154–55.

5. Ségu, *Un Romantique républicain*, p. 122.

6. [Henri de Latouche], *Fragoletta, Naples et Paris en 1799* (Paris: Levavasseur et Canel, 1829).

7. As quoted in Ségu, *Un Romantique républicain*, p. 344.

8. Ibid., p. 352.

9. Ibid. esp. pp. 85–107, 165–85. On Romanticism, see Paul Van Tieghem, *Le Mouvement romantique* (Paris: Librairie Vuibert, 1923), and Pierre Martino, *L'Époque romantique en France 1815–1830* (Paris: Boivin, 1944).

10. Ségu, *Un Romantique républicain*, pp. 166–68. See also Alice Poirier, *Les Idées artistiques de Chateaubriand* (Paris: Presses Universitaires de France, 1930).

11. On Latouche and Stendhal, see Ségu, *Un Romantique républicain*, pp. 258–72. On Stendhal and art, see David Wakefield, *Stendhal and the Arts* (London: Phaidon Press, 1973); Jean Seznec, "Stendhal et les Peintres Bolonais," *Gazette des Beaux-Arts* 56 (December 1957): 167–78; and Pierre Martino, *Stendhal* (Paris: Boivin, 1934), pp. 72–113. For an excellent discussion of Stendhal as a critic, see David Wakefield, "Stendhal and Delécluze at the Salon of 1824," in *The Artist and Writer in France: Essays in Honor of Jean Seznec*, ed. Francis Haskell, Anthony Levi, and Robert Shackleton (Oxford: Clarendon Press, 1974), pp. 76–85.

12. Ségu, *Un Romantique républicain*, pp. 87–91. Latouche cited Chateaubriand in his introduction to Chénier's poetry; see André Chénier, *Poésies précédées d'une notice par H. de Latouche* (Paris: Charpentier, 1888), p. xix. On Chénier, see also Edmond Estève, *Études de Littérature Préromantique* (Paris: Champion, 1923), pp. 1–37.

13. On *Le Tour de Faveur* and Latouche's collaboration with Deschamps, see Ségu, *Un Romantique républicain*, pp. 51–63. See also Henri Girard, *Un Bourgeois dilettante à l'Époque romantique, Émile Deschamps, 1791–1871* (Paris: Champion, 1921), esp. pp. 63–76.

14. In scene 2 of *"Le Tour de Faveur"* mention is made of the genius of Shakespeare and Schiller, as quoted in Ségu, *Un Romantique républicain*, p. 59.

15. In a poem "Le Muse Allemande," Latouche spoke of the revelation of German literature:

> Gloire à vos novateurs, pensive Germanie
> De vos rhythms nombreux j'ignore l'harmonie
> Je n'aperçoise souvent tel barde créateur
> Que sous les verres gris d'un faible traducteur[,]

as quoted in Ségu, *Un Romantique républicain*, p. 145.

16. The ballad about the phantoms of tree shadows appealed to the Romantics' interest in mystery and popular folktales. While Goethe emphasized the simplicity of the dialogue between father and child as they ride through the night, Latouche added many descriptive embellishments that appealed to the French audience.

17. [Henri de Latouche], *Dernières lettres de deux amans de Barcelone, publiées à Madrid par le Chevalier Hénarès Y. de L., traduites de l'espagnol* (Paris: Ambroise Tardieu, 1821). [Henri de Latouche], *Clement XIV et Carlo Bertinazzi, correspondance inédite* (Paris: P. Mongie aîné, Baudouin, 1827). Cf. Georges Vrancken, "Un roman

politique sous la Restauration, *Clement XIV et Carlo Bertinazzi* par H. de Latouche," *Annales romantiques* 8, no. 1 (1911): 10–25 on Latouche's eighteenth-century sources for the correspondence between the pope who suppressed the power of the Jesuits and the harlequin of the *commedia del arte*. The frontispiece of the book was an illustration of Canova's tomb of Clement XIV, which Latouche had praised highly in his book on Canova. The anticlerical Latouche aimed the correspondence against the Jesuits who had supposedly poisoned the pope.

18. Mme. de Staël's reliance on Montesquieu's *L'Esprit des lois* (1748) is discussed in F. J. W. Harding, "Notes on Aesthetic Theory in France," *British Journal of Aesthetics* 13 (Summer 1973): 261–62. For Montesquieu's sources in J. B. Dubos's climate theory, cf. T. M. Mustoxidi, *Histoire de l'esthétique française 1700–1900* (1920; reprint, New York: Burt Franklin, 1968), pp. 25–26. Cf. Paul van Tieghem, Introduction, in Mme. de Staël, *De la littérature*, ed. Paul van Tieghem (Geneva: Droz, Paris: Minard, 1959), 1:vii–lxiv, for an excellent discussion of sources of and critical reactions to the work.

19. C.-A. Sainte-Beuve, *Chateaubriand et son groupe littéraire sous l'empire*, 2 vols. (Paris: Garnier, 1861), 1:67.

20. Léon Rosenthal, *Le Peinture romantique, essai sur l'évolution de la peinture française de 1815 à 1830* (Paris: Thorin, 1900), pp. 59–62. Pierre Moreau, *Le Classicisme des Romantiques* (Paris: Plon, 1931), pp. 57–110. Balzac refers to Gérard's *Corinne* in *Louis Lambert*, *Oeuvres complètes*, 40 vols. (Paris: Conard, 1912–40), 31:59–60.

21. See Ian Allan Henning, *L'Allemagne de Mme. de Staël et la polémique romantique, première fortune de l'ouvrage en France et en Allemagne 1814–1830* (Paris: Champion, 1929) for a discussion of the French reaction to the publication.

22. On the press during the Restoration, see Eugene Hatin, *Histoire politique et littéraire de la presse en France* (Paris: Poulet-Malassis et de Broise, 1864) and Ch.-M. des Granges, *La Presse littéraire sous la Restauration, 1815–1830* (Paris: Mercure de France, 1907).

23. Latouche's seven reviews of the Salon appeared in *Constitutionnel* of 1817 on the following dates: May 3, May 8, May 13, May 18, June 6, July 5, and July 16. Each article was entitled "Beaux-Arts" with the subtitle "Salon de 1817" and a listing of the serial position of the article with the final one as "septième et dernier article." Latouche signed each article "N." Hereafter articles will be cited by date in the text.

24. *Constitutionnel*, July 16, 1817, includes a diatribe against the bad taste of the nouveau riche. Balzac in "Des Artistes," *Oeuvres*, 38:351, asserts that few who visit museum exhibitions have any feeling for art. Because of this lack, he suggests, the public relies on the newspapers to judge art.

25. Mme. de Staël, *De l'Allemagne* (Paris: Garnier, 1866), p. 386.

26. Albert Boime, *The Academy and French Painting in the Nineteenth Century* (London and New York: Phaidon, 1971), esp. pp. 1–21. Francois Benoit, *L'Art Français sous la revolution et l'empire* (1897; reprint, Geneva: Slatkine Reprints, 1975), esp. pp. 178–96. Henri Delaborde, *L'Académie des Beaux-Arts depuis la fondation de l'Institut de France* (Paris: Plon, 1891), esp. pp. 158–201.

27. Henri de Latouche, *Oeuvre de Canova* (Paris: Audot, 1825), p. 11.

28. Léon Rosenthal, *La Peinture romantique*, pp. 74–80. See also Robert Rosenblum, "Painting During the Bourbon Restoration," in *French Painting 1774–1830: The Age of Revolution*, exhib. cat. (Detroit: Wayne State University Press, 1975), pp. 231–44.

29. Anne-Louis Girodet-Trioson, *Oeuvres posthumes*, ed. P. A. Coupin, 2 vols. (Paris: Jules Renouard, 1829), 2:187–204. The speech was reprinted a few days after the convocation in the *Moniteur*.

30. Girodet-Trioson, "Rapport sur les ouvrages de peinture, architecture et gravure, en pierre et en medaille; lu à la séance publique de l'Académie des Beaux-Arts du 5 Octobre 1816," *Oeuvres posthumes*, 2:247. The ultimate source of Girodet's ideas on

education of the genius may have been J. B. Dubos, the eighteenth-century theorist who described genius as a gift of nature in his *Réflexions critiques sur la poésie et sur la peinture*, 2 vols. (Utrecht: Etienne Neaulme, 1732), 2:30. Dubos stated: "la nature et non pas l'education fait les poëtes."

31. René Huyghe, *Delacroix* (London: Thames and Hudson, 1963), pp. 81–82.

32. J. B. Dubos in his *Réflexions* 2:177, stressed the role in criticism of sentiment over reason: "Or le sentiment enseigne bien mieux si l'ouvrage touche et s'il fait sur nous l'impression que doit faire un ouvrage que toute les dissertations composées par les critiques pour expliquer le mérite et pour calculer les perfections et les defauts."

33. George-Marie Raymond, *De la peinture considerée dans ses effets sur les hommes de toutes les classes, et de son influence sur les moeurs et le gouvernement des peuples* (Paris: Pougens, 1804), pp. 158–59.

34. Joseph Droz, *Études sur le beau dans les arts* (1815), *Oeuvres*, 2 vols. (Paris: Jules Renouard, 1826), 2:520. Latouche in his introduction to *Oeuvre de Canova*, p. 2, used similar language in discussing evaluation of art by sentiment.

35. Maurice Tourneux, *Salons et Expositions d'art à Paris (1801–1870) essai bibliographique* (Paris: Jean Schemit, 1919), pp. 38–41, lists the reviews for 1817. C. -P. Landon, *Salon de 1817* (Paris: Chaigneau, 1817), offers on the art works "quelques observations sur le mérite de leur exécution." The author's credentials as a student at l'École de Rome, a "peintre," and a "conservateur des tableaux des Musées royeaux" were noted.

36. Mme. de Staël, *De la littérature*, 1:chap. 1, describes love in ancient Greece as purely sensual. Stendhal seemed to view Guérin's *Aeneas and Dido* as exemplifying sensuality, for in *The Red and the Black*, chapter 9, in which Julien attempts to win Mme. de Renal, the subtitle reads "M. Guérin's *Dido*, a charming sketch," and the three characters are arranged as in the painting. Cf. David Wakefield, *Stendhal and the Arts*, p. 28.

37. Robert Rosenblum, *Transformations in Late Eighteenth-Century Art* (Princeton: University Press, 1967), pp. 20ff., 180, on the "Neoclassic Erotic" mode.

38. See Jean Adhémar, "Balzac et les Images," *Arts* (January 26, 1951) on the importance of this painting for Balzac. Cf. Jean Adhémar, "Balzac et la Peinture," *Revue des Sciences Humaines* (April–June 1953), p. 151. See Jean Seznec, *Literature and the Visual Arts in Nineteenth-Century France* (Hull: University Press, 1963), p. 5, for reference from Balzac's *La Princesse de Cadignan*: "The Princess de Cadignan remained in the languid, nonchalant attitude which Guérin has given to his Dido." For poses of other Balzac women inspired by this painting, see Scott, *Art and Artists in Balzac's "Comédie humaine"* (Chicago: University of Chicago Libraries, 1937), p. 24. See Henri Focillon, *La peinture au XIX siècle* (Paris: Renouard, 1927), pp. 50–51, for quotation from Baudelaire on analogy between Dido and Balzac's heroines.

39. Rosenblum, *Transformations*, pp. 11, 18. Adhémar, "Balzac et la Peinture," p. 151, points out Balzac's attraction to Girodet's paintings: "Il aime sa sensualité, ses clairs-obscurs, ses passages de l'ombre à la lumière." See Scott, *Balzac's "Comédie Humaine*," pp. 25–26, for mention of Girodet's *Deluge* in *Cadignan*.

40. J. L. Jules David, *Le peintre Louis David 1748–1825, souvenir et documents inédits*, 2 vols. (Paris: Victor Havard, 1880), 1:503.

41. Latouche's anticlerical feelings may have motivated him to cover the Fualdès case, which at first was thought by some to involve the Jesuits. See Henry Monnier, *Mémoires de Monsieur Joseph Prudhomme*, 2 vols. (Paris: Librairie Nouvelle, 1857), 2:88, for the belief that "the knife that murdered Fualdès had its handle in Rome." Another supposed victim of the Jesuits was Pope Clement XIV, who was the hero of the documentary epistolary novel by Latouche entitled *Clement XIV et Carlo Bertinazzi: Correspondance inédite* (1827). See n.17 above.

42. François-René Chateaubriand, *Le Génie du christianisme*, bk. 5, chap. 5. See also

Poirier, *Les idées artistiques de Chateaubriand*, esp. pp. 67–140. Focillon, *La peinture au XIX siècle*, pp. 58–59. Louis Hautecoeur, *Littérature et peinture en France du XVII au XX siècle* (Paris: Armand Colin, 1942), pp. 34–41.

43. Of the several versions of Saint Louis on his deathbed that Latouche discussed, he liked the work of Guérin's student Ary Scheffer better than Rouget's painting, which he criticized as a cold copy of a model. He also preferred Scheffer's paintings to the version by Meynier in which he criticized the portrayal of the king as "un obscur pénitant" (May 8).

44. Cf. Landon, *Salon de 1817*, pp. 9–11. Latouche mockingly quotes Boutard's defense of the French court's treatment of Poussin.

45. For nineteenth-century views of Poussin as a Romantic hero, ignored in his own time, see Richard Verdi, "Poussin's Life in Nineteenth-Century Pictures," *Burlington Magazine* 111 (December 1969): 741–50. See also Klaus Berger, "Poussin's Style and the XIXth Century," *Gazette des Beaux-Arts* 45 (March 1955): 161–70. André Chastel, "Poussin et la Postérité," *Actes du Colloque International Nicolas Poussin* 1(1960): 297–310. In his article "Des Artistes" (1830), Balzac was to describe Poussin as "le Poussin ignoré" and use him as a character in *Le Chef-d'oeuvre inconnu* (1831). See chapter 7.

46. For an excellent discussion of this painting, see Ruth Kaufmann, "François Gérard's 'Entry of Henry IV into Paris': The Iconography of Constitutional Monarchy," *Burlington Magazine* 117 (December 1975): 790–802.

47. Cf. Hautecoeur, *Littérature et peinture en France*, pp. 13–21, 31, on the role of allegory in painting from the seventeenth to the nineteenth century. Latouche's aversion to allegory was probably related to its use in the seventeenth century to glorify royalty.

48. Chateaubriand said of Gérard's painting: "Henri IV est une seconde fois devenu immortel sous le pinceau de M. Gérard"; as quoted in Poirier, *Les idées artistiques de Chateaubriand*, p. 398.

49. Cf. André Monglond, *Le Préromantisme français*, 2 vols. (Grenoble: - B. Arthaud, 1930), 1:124–70, esp. pp. 164–67, on tombs and ruins in landscape art and literature. See Jean Adhémar, "L'Enseignement académique en 1820, Girodet et son atelier," *Bulletin de la Société de l'Histoire de l'Art Français* (1933), p. 273, on Girodet's little-known interest in landscape and his collection of landscape lithographs.

50. Dubos, *Reflexions*, 1:52. Cf. David Wakefield, "Chateaubriand's 'Atala' as a Source of Inspiration in Nineteenth-Century Art," *Burlington Magazine* 120 (January 1978): 13–22.

51. P. H. Valenciennes in his *Elements de perspective practique* (1800) had argued for the importance of landscape, both historical and rural, and it was his student Michallon who won the first contest for historic landscapists that had taken place on February 15, 1817. Delaborde, *L'Académie*, pp. 185–91. Benoit, *L'Art Français*, pp. 412–18. Leonce Bénédite, *Histoire des Beaux-Arts 1800–1900* (Paris: Ernest Flammarion, n.d.), pp. 75–95. *Le Paysage Français de Poussin à Corot études et catalogue* (Paris: Gazette des Beaux-Arts, 1926), esp. pp. 76–86. Rosenthal, *La Peinture romantique*, pp. 184–201.

52. C. -A. Sainte-Beuve, "M. de Latouche," in *Causeries du lundi*, 15 vols., 3d ed. (Paris: Garnier, n.d.), 3:493–94. Ségu, *Un Romantique républicain*, p. 435, for Latouche's advice to his protegés, "grouiller tout çela."

53. On portraits, see Benoit, *L'Art Francais*, pp. 377–80.

54. Latouche's remarks in 1817 anticipated Landon's comments on Genod and Drolling in *Salon de 1819*, 2 vols. (Paris: Chaigneau, 1819), 2:51. See also Lorenz Eitner, "The Open Window and the Storm-Tossed Boat: An Essay in the Iconography of Romanticism," *Art Bulletin* 37 (December 1955): 281–90, for a discussion of Drolling's interiors.

55. The taste for genre painting accompanied a growing interest in Dutch and Flemish painting. Cf. H. van der Tuin, *Les vieux peintres des Pays-Bas et la critique*

artistique en France de la première moitié du XIX siècle (Lille: Publications de la Faculté des Lettres, 1948), pp. 24–32, for exhibitions and sales of Dutch and Flemish painting at this time.

56. Jean-Joseph Taillasson, *Observations sur quelques grands peintres* (Paris: Duminil-Lesueur, 1807), p. 168. On genre painting, see also Benoit, *L'Art Français*, pp. 389–94, and Rosenthal, *La Peinture romantique*, pp. 80, 90.

57. Cf. Benoit, *L'Art Français*, pp. 141–42, on the popularity of portraits, genre, and landscapes with the bourgeois public.

58. Louis Blanc, "L'Avenir littéraire," *Revue du progres politique, social et littéraire* 15 (February 1839): 139, places Latouche among dramatists committed to "la littérature sociale et democratique." See also Albert Cassagne, *La théorie de l'art pour l'art en France chez les derniers romantiques et les premiers réalistes* (Paris: Lucien Dorbon, 1906), esp. pp. 351–73, on the plastic arts.

59. Henri de Latouche, "Des Artistes," *Mercure du XIX siècle* 10 (1825): 37. On criticism of this period, see Pontus Grate, *Deux critiques d'art de l'époque romantique, Gustave Planche et Théophile Thoré* (Stockholm: Almqvist and Wiksell, 1959), esp. pp. 1–47.

60. Latouche, *Oeuvre de Canova*, pp. 15, 20. The influence actually worked both ways, with David often showing his awareness of Canova's sculpture and his pupil Girodet sometimes apparently quoting elements from Canova's works. Cf. Rosenblum, *Transformations*, p. 45, n. 142, and Hugh Honour, "Canova and David," *Apollo* 96 (October 1972): 312–17.

61. Chaudet's *Amour* and Dupaty's *Ajax* were also favored, although not with as much enthusiasm.

62. Cf. Rosenblum, in *Age of Revolution*, p. 234. For the connection between the feminized male image in the work of David's pupils (the Méditateurs) and Plato's theory of the androgyne, see James Henry Rubin, "New Documents on the Méditateurs: Baron Gérard, Mantegna, and French Romanticism circa 1800," *Burlington Magazine* 97 (December 1975): 789–90.

63. Winckelmann, *History of Ancient Art* (1764), as quoted in David Irwin in *Winckelmann, Writings on Art* (London: Phaidon, 1972), pp. 121–22. See A. J. L. Busst, "The Image of the Androgyne in the Nineteenth Century," in *Romantic Mythologies*, ed. Ian Fletcher (New York: Barnes and Noble, 1967), esp. pp. 1–41.

64. On modern costume in art, see Benoit, *L'Art Français*, pp. 41–44.

65. As quoted in Henry de Morant, *David d'Angers et son temps* (Angers: H. Siraudeau, 1956), p. 26.

66. Pierre Laubriet, "Balzac et la sculpture," *Gazette des Beaux-Arts* 57 (May–June 1961): 336–37.

67. Sainte-Beuve, "Monsieur H. de Latouche," pp. 487–88.

68. Ségu, *Un Romantique républicain*, pp. 78–79.

69. Hatin, *Histoire politique et littéraire*, pp. 174–75.

70. Sainte-Beuve, "Monsieur H. de Latouche," p. 488. After the scandal at the Salon, Isabey, who had previously made many portraits of the king of Rome, was accused of circulating caricatures against the Bourbons. The police searched his home, destroyed the plates of his king of Rome portraits, and confiscated many of his drawings. See Mme. de Basily-Callimaki, *J.-B. Isabey sa vie-son temps 1767–1855* (Paris: Frazier-Soye, 1909), p. 274.

71. Balzac, "La Monographie de la presse Parisienne," *Oeuvres*, 40:564. See also W. M. Thackeray, "Balzac on the Newspapers of Paris," *The New Sketch Book*, ed. Robert S. Garnett (London: Alston Rivers, 1906), pp. 130–38.

Chapter 5. The Man Who Wrote to David

1. [Henri de Latouche], *Histoire et procès complets des assassins de M. Fualdès, par le sténographe parisien,* 2 vols. (Paris: Pillet, 1818). [Henri de Latouche], *Mémoires de Madame Manson, explicatifs de sa conduite dans le procès de l'assasinat de M. Fualdès, écrits par elle-même et addressés à Madame Enjalran sa mère* (Paris: Pillet, 1818). After Mme. Manson's attack on Latouche for having harmed her reputation by publishing the *Mémoires,* Latouche responded with still another publication; see [Henri de Latouche], *Response du Sténographe parisien à une note de Mme. Manson, insérée dans son "Plan de défense" adressé à tous les coeurs sensibles* (Paris: Pillet, 1818). On the Fualdès case, see Frédéric Ségu, *Un Romantique républicain, H. de Latouche (1785–1815)* (Paris: Société d'Édition "Les Belles Lettres," 1931), pp. 64–73.

2. For Richardsonian elements in the Manson *Mémoires,* see Albert Borowitz, "Henri de Latouche and the Murder Memoirs of Clarisse Manson," in his *Innocence and Arsenic* (New York: Harper and Row, 1977), pp. 132–62.

3. [Henri de Latouche], *Lettres à David sur le salon de 1819, par quelques élèves de son école* (Paris: Pillet, 1819).

4. Three possible collaborators have been put forward: L.-F. L'Héritier, Èmile Deschamps, and Antoine Béraud. On L'Héritier see L.-F. Hoffman, Introduction, in H. de Latouche and L.-F. L'Héritier, *Dernières lettres de deux amans de Barcelone* (Paris: Presses Universitaires de France, 1966), p. xvi. On all three men see Henri Girard, *Émile Deschamps diléttante* (Paris: Champion, 1921), pp. 1–4, for the support only of Deschamps as a collaborator in the *Lettres à David.* Frédéric Ségu, *Un Journaliste diléttante, H. de Latouche et son intervention dans les arts* (Paris: Société d'Édition "Les Belles Lettres," 1931), pp. 22–23, believes Latouche to be the only author but will accept the possibility of limited collaboration with Deschamps. It seems possible to me that Deschamps may have collaborated on the dialogues and the Forbin-Genlis correspondence, but with the destruction of Latouche's papers during the Franco-Prussian War, final proof of sole or multiple authorship is impossible.

5. As quoted in Henry Monnier, *Mémoires de Monsieur Joseph Prudhomme,* 2 vols. (Paris: Librairie Nouvelle, 1857), 2:108.

6. As in the *Salon de 1817,* Latouche ridiculed the Salon audience. In Letter 29 he said: "les spectateurs ne sont pas la partie la moins divertissante de nos spectacles" (p. 125). Latouche's flair as a raconteur enlivened the *Lettres.* In Letter 14 he told an anecdote about Marin's statue *Telemachus,* mistaken for a Canova by foreign connoisseurs and almost taken back to Italy with the return of Napolean's art trophies. This humorous anecdote paralleled his more serious complaint on the dispersion of the art booty in his book on Canova.

7. As quoted in Frédéric Segu, *Un Journaliste diléttante,* p. 17. This book is the major source for Latouche's writings on art.

8. Letter to Gros from David, delivered by his student Navez who went to Paris to see the Salon, dated May 13, 1817, as quoted in J. L. Jules David, *Le peintre Louis David 1748–1825, souvenir et documents inédits,* 2 vols. (Paris: Victor Havard, 1880), 1:537–38. See Georges Wildenstein, "The Davidians à Paris sous la Restauration," *Gazette des Beaux-Arts* 53 (April 1959): 239–42, for a letter from Poisson to Navez giving a review of the Salon of 1822.

9. *Lettres à David,* Letter 1, August 25, 1819, p. 2.

10. Jean-Joseph Taillasson, *Observations sur quelques grands peintres* (Paris: Duminil-Lesueur, 1807), p. 184. See also Léon Rosenthal, *Louis David* (Paris: Librairie de l'art ancien et moderne, n.d.), pp. 143–50.

11. A.-H. de Kératry, *Annuaire de l'école française de peinture ou Lettres sur le Salon de 1819* (Paris: Maradan, 1820), p. 68.

12. As quoted in Rosenthal, *David,* p. 150.

13. *Lettres à David,* Letter 29, December 19, 1819, p. 211.

14. Pierre Angrand, *Le comte de Forbin et le Louvre en 1819* (Lausanne, Paris: La Bibliotèque des Arts, 1972), pp. 165–70.

15. Kératry, Introduction to *Annuaire 1819,* p. xv.

16. *Lettres à David,* Letter 2, August 25, 1819, pp. 7–8.

17. Louis Hautecoeur, *Louis David* (Paris: La Table Ronde, 1954), pp. 261–62.

18. See Robert Baschet, *E.-J. Delécluze, témoin de son temps 1781–1863* (Paris: Boivin, 1942), pp. 56–57, for Delécluze's debut as a Salon reviewer in 1819 with an article in *Le Lycée française* warning of the decline of the school of David.

19. Latouche may have been aware of David's criticism of the educational methods at the Académie du Louvre. For David's comments to his students ("à l'Académie on fait un métier de la peinture . . . ici on fait la peinture"), see E.-J. Delécluze, *Louis David, son école et son temps* (Paris: Didier, 1855), p. 47.

20. Angrand, *Forbin,* pp. 65–66.

21. See Letter 6 for an imaginary correspondence between M. le Comte de F*** (Forbin) and Madame la Comtesse de G*** (Genlis) on the subject of *Inez de Castro,* a painting by Forbin in the Salon of 1819. She complains that he did not consult her about changes he made in the painting; and therefore her writings on his paintings are no longer accurate. Latouche was disdainful of promotional efforts among friends in the arts. See chapter 4 on his article "De la Camaraderie littéraire" in the *Revue de Paris.*

22. Angrand, *Forbin,* pp. 110–25.

23. *Lettres à David,* Letter 11, September 15, 1819, p. 66.

24. *Lettres à David,* Letter 2, August 25, 1819, p. 16.

25. Latouche's taste in art paralleled that of several patrons of the period, such as Comte de Sommariva and Prince Yusupoff. Sommariva was the owner of both David's *Amour et Psyche* and of Girodet's *Pygmalion et Galatée.* On the similarity of artists and subject matter in the two collections, see Francis Haskell, *An Italian Patron of French Neoclassic Art* (Oxford: Clarendon Press, 1972), esp. pp. 20–23.

26. Henri de Latouche, "Les Graces," *Oeuvre de Canova,* unpaginated, described Canova's talent: "Le talent de Phidias est partout mêlé à l'esprit voluptueux d'Anacréon."

27. J. J. L. Whiteley, "Light and Shade in French Neo-Classicism," *Burlington Magazine* 117 (December 1975): 768–73.

28. As quoted in Henri de Latouche, "Les Amours des Dieux," *Mercure du XIX siècle* 10 (1825): 467. Latouche gave high praise to Girodet's illustrations.

29. [Henri de Latouche], *Fragoletta, Naples et Paris en 1799,* 2 vols. (Paris: Levavasseur et Canel, 1829), 1:121.

30. *Lettres à David,* Letter 25, November 22, 1819, p. 179.

31. On Lavater, see F. Baldensperger, "Les Théories de Lavater dans la littérature française," *Études d'histoire littéraire* (Paris: Hachette, 1910), pp. 51–89. George Levitine, "The Influence of Lavater and Girodet's *Expression des Sentiments de l'Ame,*" *Art Bulletin* 36 (March 1954): 33–44. James H. Rubin, "An Early Romantic Polemic: Girodet and Milton," *Art Quarterly* 35 (Autumn 1972):210–38.

32. J. B. Dubos, *Réflexions critiques sur la poésie et sur la peinture,* 2 vols. (Utrecht: Étienne Neaulme, 1732), 1:11–12, 26. On the possibility that Girodet depicted Canova's features in Pygmalion's face, see Haskell, *An Italian Patron,* p. 14.

33. Anne-Louis Girodet-Trioson, *Oeuvres posthumes,* ed. P. A. Coupin, 2 vols. (Paris: Jules Renouard, 1829), 2:275.

34. Girodet compared the "savant Lavater" with the painter who also observed the face:

Il soulève des coeurs le voile impénétrable,
Lit son arrêt écrit sur le front du coupable,
Et découvre bientot, sous un masque trompeur,
Les travers de l'esprit, les faiblesses du coeur.

35. Girodet, "Considerations sur le génie," *Oeuvres Posthumes,* 2:117.

36. Delécluze, *David,* p. 272, suggests that Girodet's promotional efforts on behalf of his *Pygmalion* stemmed from his awareness of the painting's weakness.

37. [Henri de Latouche], *Biographie pittoresque des députés; portraits, moeurs et costumes, avec quinze portraits et un plan de la salle des séances* (Paris: Delaunay, 1820).

38. Maurel Dupeyré, "Henri de Latouche," *La Politique nouvelle,* March 30, 1851, p. 364. Depeyré also recorded that Latouche was offered shares in *Constitutionnel* "pour sa part de collaboration et son invention de la physionomie," but he turned down what would have been a financial opportunity.

39. Girodet's *Pygmalion* has much in common with the *Pygmalion and Galatea* (1797) by a fellow student in Rome, Louis Gauffier. See Benedict Nicolson, "France from 1789 to 1847," exhib. review, *Burlington Magazine* 120 (May 1978): 334–35, fig. 110, for similarity in pose, costume, and composition. Girodet's painting was a return to this late Rococo type of mythological painting.

40. Angrand, *Forbin,* p. 200.

41. Because many critics discussed the painting in the course of their reviews of the Salon, it has often been assumed that the work was part of either the 1817 or 1819 Salon. However, the fact that it was not listed in the Salon *livrets,* coupled with the remark in Edmé F. A. M. Miel, *Essai sur les beaux-arts et particulièrement sur le Salon de 1817* (Paris: Didot, 1817, 1818), p. 236, n. 2, that he would discuss the painting that "almost all had seen" exhibited at Sommariva's gallery, makes it clear that David's painting was never a part of the official Salon.

42. H. S. Francis, "Jacques Louis David *Cupid and Psyche,*" Cleveland Museum of Art *Bulletin* 50 (February 1963): 29–34. Hautecoeur, *Louis David,* pp. 242, 268, 273, 306, for reactions to the painting.

43. For a summary of the reactions of the Brussels press see Helen O. Borowitz, "The Man Who Wrote to David," Cleveland Museum of Art *Bulletin* 67 (October 1980): 263.

44. *Le Vrai Liberal,* August 25, 1817, p. 3.

45. *Journal du Commerce,* August 12, 1817, p. 2; August 19, 1817, p. 1.

46. As quoted in Jules David, *David,* 1:543.

47. Jules David, *David,* 1:545–47. On the possibility that David intended a fleshy interpretation of the myth in contrast to the more ethereal renderings of Canova, see Hugh Honour, "Canova and David," *Apollo* 96 (October 1972): 316.

48. Delécluze, *Louis David,* pp. 368–70.

49. Robert Rosenblum, *Ingres* (New York: Abrams, 1967), p. 104, traces the *Grande Odalisque* to Michelangelo's tomb of Guiliano de Medici and to a female nude by David, perhaps a study for *Mme. Juliette Récamier* (fig. 100). See also Daniel Ternois, *Ingres et ses Maitres de Roque à David,* exhib. cat. (Montauban, 1955), p. 17.

50. *Lettres à David,* Letter 12, September 23, 1819, p. 82.

51. De Latouche "Les amours des dieux," p. 463.

52. The play closed almost immediately. See George Vranken, "Une Comédie de Henri de Latouche, La Reine d'Espagne," *Annales romantiques* 7, no. 1 (1910): 56–64.

53. See E. Girard and P. Roux, "Sainte-Beuve et H. de Latouche," *Revue d'Histoire littéraire de la France* (July–August 1934), p. 428. See Giacomo Casanova, *History of My Life,* trans. Willard R. Trask, 24 vols. (New York: Harcourt Brace and World, 1966), 1:42, 325, n. 16, for mention of an actress named Fragoletta, the diminutive of "strawberry."

54. C.-A. Sainte-Beuve, "M. de Latouche" *Causeries du Lundi,* 15 vols. (Paris: Garnier, n.d.), 3:486–87.

55. See Robert Rosenblum, *Transformations in Late Eighteenth-Century Art* (Princeton: University Press, 1967), pp. 20ff., 102f., on the "Neoclassical Erotic" mode.

56. Henri de Latouche, *Vallée aux Loups, souvenirs et fantaisies,* 3d ed. (Paris: Michel Lévy, 1875). On Latouche and popular traditions, see Ségu, *Un Romantiques républicain,* pp. 149–52. On the *style troubadour* in literature, see Fernand Baldensperger, "Le 'genre troubadour.'" *Études d'Histoire littéraire,* 1st ser. (Paris: Hachette, 1907).

57. *Lettres à David,* Letter 19, October 15, 1819, p. 134.

58. *Lettres à David,* Letter 19, October 15, 1819, p. 133. Angrand, *Forbin,* pp. 178–79, for reactions of critics to the *Assumption.* On Prud'hon, see also Henri Focillon, *La peinture au XIX siècle* (Paris: Renouard, 1927), pp. 60–79.

59. For Latouche's Swedenborgianism and its influence on Balzac, see Ségu *Un Romantique républicain,* pp. 432–35.

60. *Lettres à David,* Letter 13, September 23, 1819, pp. 84–85. See Lorenz Eitner, *Gericault's Raft of Medusa,* (London: Phaidon, 1972), p. 3, n. 4, for religious works in the Salon. Angrand, *Forbin,* p. 176, records remarks very similar to Latouche's in *Minerve française.*

61. See Auguste Jal, *Souvenirs d'un homme de lettres* (Paris: Techener, 1877), pp. 405–19, on the *Medusa* scandal and its repercussions in the Salon. Jal mentions a play entitled *Radeau de la Meduse* staged in 1840.

62. As quoted in Eitner, *Géricault's Raft of Medusa,* p. 6.

63. Eitner, *Géricault's Raft of Medusa,* pp. 5, 10–11. Jal, *Souvenirs,* pp. 412–15. Angrand, *Forbin,* p. 172.

64. Jal, *Souvenirs,* pp. 414, 418, 412.

65. As quoted in Lorenz Eitner, Introduction, Charles Clement, *Géricault de 1879* (reprint; Paris: Léonce Lager, 1973), p. 249. On the Fualdès drawings, see pp. 19–21. See Duc de Trévise, "Géricault peintre d'actualités," *Revue de l'art ancien et moderne* 45(1924): 300–301 for Géricault's detailed knowledge of Mme. Manson's testimony. The series of Fualdès drawings are illustrated in Klaus Berger, *Géricault and His Work,* trans. Winslow Ames (Lawrence: University of Kansas Press, 1955), plates 54–59.

66. [Henri de Latouche], *Dernières lettres de deux amans de Barcelone; publiées à Madrid par le chevalier Henares Y. de L., traduites de l'espagnol,* 2d ed. (Paris: Ambroise Tardieu, 1822). Reprint cited under n. 4 above.

67. This intense interest on the part of both men in capturing the details of illness and death may have had its ultimate source in the writings of Lavater, who had advocated the instructive value of observing the dying. More recently, Girodet in his poem *Le Peintre* urged artists to visit hospitals in order to watch the dying and had even made a sketch of his stepfather on his deathbed in 1815. Girodet's letter describing the death from dropsey of Doctor Trioson was only slightly less detailed than Latouche's plague letters. See Levitine, "The Influence of Lavater and Girodet's *Expression des sentiments de l'âme,*" pp. 35–36.

68. James H. Rubin, "An Early Romantic Polemic: Girodet and Milton," *Art Quarterly* 35 (Autumn 1972): 210–38.

69. Aristotle *Poetics* 14. *Lettres à David,* Letter 8, September 8, 1819, p. 51.

70. Latouche differentiated Géricault's permissible "reminiscences" of his master Guérin's painting from the "véritables *pastiches,* où les plagiates ne sont pas même déguisés" of many other paintings.

71. *Lettres à David,* Letter 8, September 8, 1819, p. 50.

72. For Géricault's methods of execution, see Eitner, *Géricault's Raft of Medusa,* pp. 31–36, and Eitner, *Clement: Géricault,* pp. 136–45.

73. *Lettres à David*, Letter 8, September 8, 1819, p. 51.

74. On Gericault's visit to the *Léonidas*, see Eitner, *Géricault's Raft of Medusa*, p. 34. Further proof of his admiration for David was the visit he made to David in Belgium in November 1820.

75. *Lettres à David*, Letter 33, March 20, 1820, pp. 244–51.

76. *Lettres à David*, Letter 33, March 20, 1820, p. 253. The influence of Girodet's public pronouncements in 1816 and 1817 (later published posthumously in 1829) on the importance of genius and of originality may have been a source for some of Latouche's ideas about the power of the visual artist. An earlier source may be J. B. Dubos, *Réflexions*, 1719.

77. *Lettres à David*, Letter 33, March 1, 1820.

Chapter 6. Balzac's *Sarrasine*

1. On the influence of Latouche's artistic taste on Balzac see Pierre Laubriet, *L'Intelligence de l'art chez Balzac* (Paris: Didier, 1958), p. 398, and Pierre Laubriet, "Balzac et la Sculpture," *Gazette des Beaux-Arts* 57 (May–June 1961): 336. On the visual arts in Balzac's writing, see Mary Wingfield Scott, *Art and Artists in Balzac's "Comédie Humaine"* (Chicago: University of Chicago Libraries, 1937), and Jean Adhémar, "Balzac et la peinture," *Revue des Sciences Humaines*, (April–June 1953), pp. 149–62. On Balzac's taste in furnishings, see Paul Jarry, "Le véritable 'Cousin Pons,' Honoré de Balzac, amateur d'Antiquités," *Le Figaro Artistique*, pt. 1 : December 24, 1924, pp. 167–169; pt. 2 : January 1, 1925, pp. 183–85.

2. Preface to the first edition of *Le Cabinet des antiques*, *L'Oeuvre de Balzac* 16 vols., eds. A. Béguin and J. A. Ducourneau (Paris: Club Français du Livre, 1950–1955), 15 : 298.

3. As quoted in Honoré de Balzac, *Le Chef-d'oeuvre inconnu suivi de Pierre Grassou, Sarrasine, Gambara et Massimilla Doni* (Éditions Gallimard et Librairie Générale Française, 1970), p. 361.

4. Cf. Henri David, "Balzac Italianisant autour de Sarrasine," *Revue de Littérature comparée* (1933), pp. 457–68, for sources in *Mémoires* of Casanova. Cf. Jean Seznec, "Diderot et Sarrasine," *Diderot Studies* 4 (1963): 238–39, for *Lettres familières* of President du Brosses as a source on Italian theater available to Balzac. Seznec points out that Montesquieu's *Voyages*, suggested by Pierre Laubriet, "Balzac et la Sculpture," pp. 351–54, as a source, was unavailable to Balzac in 1830.

5. Seznec, "Diderot et Sarrasine," pp. 239–42.

6. Honoré de Balzac, *Illusions perdues*, *Oeuvres complètes*, ed. M. Bouteron and H. Longnon, 40 vols. (Paris: Conard, 1912–40), 12 : 70. Quotations from Balzac novels and criticism will be from this edition unless otherwise noted.

7. Seznec, "Diderot et Sarrasine," pp. 243–45.

8. Denis Diderot, *Salons*, ed. Jean Seznec and Jean Adhémar, 4 vols. (Oxford: Clarendon Press, 1957–67), 3 : 57–58. Cf. Plato *Republic* 598b.

9. Diderot, "Paradoxe sur le comédien," *Oeuvres esthétiques*, ed. Paul Vernière (Paris: Garnier, 1959), p. 339.

10. Roland Barthes, *S/Z*, trans. Richard Miller, preface by Richard Howard (New York: Hill and Wang, 1974), p. 107. Quotations from this translation of *Sarrasine* will be cited in the text.

11. Louise Vinge, *The Narcissus Theme in Western European Literature up to the Early 19th Century* (Lund: Gleerups, 1967), pp. 297–314. This book was the major source for material on the Narcissus theme.

12. Balzac, "Des Artistes," *Oeuvres complètes*, 38 : 360.

13. Honoré de Balzac, *Lettres à l'Étrangère*, 2 vols. (Paris: Calmann-Lévy, 1899), 1:203.

14. Vinge, *Narcissus Theme*, pp. 315–26.

15. As quoted in Lucie Wanuffel, "Présence d'Hoffmann dans les Oeuvres de Balzac (1829–1835)," *L'Année Balzacienne* (1970), p. 45. Author's translation.

16. See chapter 4 above and Frédéric Ségu, *Un Romantique républicain Henri de Latouche (1785–1851)* (Paris: Société d'Édition "Les Belles Lettres," 1931), pp. 122–25.

17. E. T. A. Hoffmann, *Die Jesuiterkirche in G.*, translated as *Berthold the Madman, Tales of Hoffmann*, ed. Christopher Lazare (New York: Grove Press, 1946), p. 345.

18. As quoted in Hugh Honour, *Romanticism* (New York, Harper, 1979), p. 118.

19. *Splendeurs et misères des courtisanes*, as quoted in Gretchen R. Besser, *Balzac's Concept of Genius: The Theme of Superiority in the "Comédie humaine"* (Geneva: Droz, 1969), p. 37. Author's translation.

20. Étienne-Maurice Falconet, *Oeuvres*, 4 vols. (Lausanne: Chez la Société Typographique, 1781), 4:32.

21. Ovid, *The Metamorphoses*, trans. Horace Gregory (New York: Viking Press, 1958), bk. 3, p. 98.

22. Frank Kermode, "The Banquet of Sense," *Shakespeare, Spenser, Donne* (London: Routledge and Kegan Paul, 1971), pp. 84–115. See also Douglas Bush, *Mythology and the Renaissance Tradition in English Poetry* (New York: Pageant Book, 1957), pp. 203f.

23. Kermode, in *Shakespeare, Spenser, Donne*, points out (p. 94, n. 18): "Aristotle (*De Anima II*. vi-xii) establishes the order Vision-Hearing-Smell-Taste-Touch; in *De Sensu* (441a) he calls taste a form of touch, which may explain why in literary treatment the order of these two is sometimes reversed." Note the reversal in *Sarrasine*.

24. On *Séraphîta* see Jacques Borel, *Sériphîta et le mysticisme Balzacien* (Paris: José Corti, 1967).

25. *Oeuvres complètes*, 38:360. On the second sight of artists see Suzanne J. Bernard, "Une énigme balzacienne: la spécialité," *L'Année Balzacienne* (1965), pp. 61–82.

26. *Lettres à l'Étrangère*, 1:6. Author's translation. For Balzac's view of himself as an artist see Pierre Laubriet, *L'Intelligence de l'art chez Balzac* (Paris: Didier, 1958), pp. 231–49.

27. Quoted in Vinge, *Narcissus Theme*, p. 266.

28. *Lettres à l'Étrangère*, 1:40.

29. Vinge, *Narciussus Theme*, pp. 277–81.

30. The voluptuous cardinal recalls characters in Latouche's *Clement XIII and Carlo Bertinazzi, unpublished correspondence* of 1827.

31. Shakespeare, *Venus and Adonis*, lines 433–38, 443–46. For sources of *Venus and Adonis* in Ovid and possibly Ronsard see Bush, *Mythology*, p. 140.

32. Cf. Henri David, p. 464.

33. Balzac, "Lettre à Charles Nodier," *Oeuvres complètes*, 39:560.

34. Ibid. Cf. Mario Praz, *On Neoclassicism*, trans. Angus Davidson (Evanston: Northwestern University Press, 1969), pp. 50–51, for Winckelmann's emphasis on the placid, frozen quality of Greek sculpture. Praz points to the suggestion, in Winckelmann's writings on the Greek ideal of beauty, of "the image of Narcissus gazing at his reflection in the pool" to express the serenity and harmony of beautiful forms.

35. Balzac Preface to the first edition of *La Peau de chagrin*, *L'Oeuvre de Balzac*, 15:71.

36. Ibid., p. 72.

37. Marcel Proust, *Remembrance of Things Past*, 2 vols., trans. C. K. Scott Moncrieff and Frederick A. Blossom (New York: Random House, 1934), 1:638. Volume and page numbers of this translation will be cited before the slash, after which will appear volume and page numbers of the French edition: Marcel Proust, *A la recherche du temps perdu*, 3 vols. (Paris: Gallimard, Pléiade, 1954), 1:849.

38. Ibid., 1:647/ 1:861.

39. Ibid., 1:648/ 1:863.

40. Marcel Proust, *Contre Sainte-Beuve précédé de Pastiches et mélanges et suivi de Essais et articles,* ed. Pierre Clarac and Yves Sandre (Paris: Gallimard, Pléiade, 1971), p. 277.

41. Proust, *Remembrance,* 2:321/ 2:1052.

Chapter 7. Balzac's Unknown Masters

1. Honoré de Balzac, *Oeuvres complètes,* ed. M. Bouteron and H. Longnon, 40 vols. (Paris: Conard, 1912–40), 40:577.

2. Jules Claretie, *L'Independance belge,* January 5, 1879. The *Chef-d'oeuvre inconnu* appeared in two parts in *L'Artiste, Journal de la Littérature et des Beaux-Arts:* pt. 1, "Maître Frenhofer," 1 (July 31, 1831): 319–23; pt. 2, "Catherine Lescaut," 2 (August 4, 1831): 7–10. Further references to the novella will be cited in the text. Reference will be to *L'Artiste, première série,* 1–2 (1831; reprint, Geneva: Slatkine Reprints, 1972). For the importance of using the original text see Ch.-M des Granges, *La Presse littéraire sous la Restauration 1815–1830* (Paris: Société du Mercure de France, 1970), p. 28.

3. Charles Spoelberch de Lovenjoul, "Honoré de Balzac et Théophile Gautier," in *Études Balzaciennes: Autour de Honoré de Balzac* (Paris: Calmann-Lévy, 1897), pp. 1–88.

4. François Fosca, *De Diderot à Valéry: les écrivains et les arts visuels* (Paris: Édition Albin Michel, 1960), pp. 65–67.

5. Mary Wingfield Scott, *Art and Artists in Balzac's "Comédie Humaine"* (Chicago: University of Chicago Libraries, 1937), p. 41. See also p. 43, on "the community of ideas between the fields of literary and plastic art."

6. For my discussion of *L'Artiste* I have relied heavily on A. R. W. James "La 'Fraternité des Arts' et La Revue 'L'Artiste,'" *Gazette des Beaux-Arts* 65 (March 1965): 169–80. See also Suzanne Damiron, "La Revue *L'Artiste* Sa fondation, son époque, ses animateurs," *Gazette des Beaux-Arts* 44 (October, 1954): 191–202. An excellent study is Peter J. Edwards, "*L'Artiste* (1831–1861): The Literary Role of an Artistic Review" (Ph. D. diss., Fordham University, 1973).

7. Jules Janin, "Être Artiste!" *L'Artiste* 1 (1831): 11.

8. Victor Schoelcher, "Salon de 1831," *L'Artiste* 2 (1831): 280.

9. Alexandre de Saint-Chéron, "La Poésie et les beaux-arts à notre époque," *L'Artiste* 4 (1832): 165–67, 177–79. See also James, "La 'Fraternité,'" p. 171.

10. Balzac, "Des Artistes," *Oeuvres complètes,* 38:351.

11. Balzac, "Lettres sur Paris," *ibid.,* 38:114.

12. Preface to the first edition of *Le Cabinet des antiques, L'Oeuvre de Balzac,* 16 vols., ed. A Béguin and J. A. Ducourneau (Paris: Club Français du Livre, 1950–1955) 15:298. See full quotation in chap. 6, p. 117.

13. Jerrold Lanes, "Art Criticism and the Authorship of the *Chef-d'oeuvre inconnu:* A Preliminary Study," in *The Artist and the Writer in France: Essays in Honor of Jean Seznec,* ed. Francis Haskell, Anthony Levi, and Robert Shackleton (Oxford: Clarendon Press, 1974), p. 89. Lanes, after showing Balzac's limitations as a writer on art, calls for further study of possible sources for *Chef-d'oeuvre inconnu.*

14. Balzac, "Études sur M. Beyle," *Oeuvres complètes,* 40:373. Further references to this essay will appear in the text as "Beyle." Author's translation.

15. Laure Surville, *Balzac, sa vie et ses oeuvres* (Paris: Librairie Nouvelle, 1858), p. 28.

16. D. G. Charlton, "Victor Cousin and the French Romantics," *French Studies* 17

(October, 1963): 313–14. This is an excellent article on the impact of Cousin on the Romantics.

17. Max Andréoli, "Balzac, Cousin et L'Éclecticisme," *L'Année Balzacienne* (1971), p. 75. For Balzac's humorous allusions to Cousin, see pp. 59–64.

18. Ibid., pp. 79–81. See also D. G. Charlton, "The personal and general in French Romantic literary theory," in *Balzac and the Nineteenth Century: Studies in French Literature presented to Herbert J. Hunt*, ed. D. G. Charlton, J. Gaudon, and Anthony R. Pugh (Leicester University Press, 1972), pp. 279–81.

19. Frederick Will, *Flumen Historicum: Victor Cousin's Aesthetic and Its Sources* (Chapel Hill: University of North Carolina Press, 1965), provides an excellent analysis of Cousin's many sources. On Cousin see also Jules Simon, *Victor Cousin*, in Great French Writer series (London: George Routledge and Sons, 1888).

20. George Boas, *French Philosophies of the Romantic Period* (Baltimore: Johns Hopkins University Press, 1925), p. 230, esp. chap. 5, "The Rise of Eclecticism."

21. Victor Cousin, *Du Vrai, du beau et du bien*, 21st ed. (Paris: Didier, 1879), p. xliii. Further references will be cited in the text as *Du Vrai*. This book is an expanded version of Cousin's lectures first published in 1818 as an article entitled "Du beau réel et du beau idéal," in *Archives philosophiques* and reprinted in 1826 in *Fragments philosophiques*. The expanded version appeared as a book first in 1836.

22. D. G. Charlton, "Victor Cousin and the French Romantics," in *Balzac and the Nineteenth Century*, pp. 318–19.

23. Boas, *French Philosophies*, p. 233.

24. Cousin, as quoted in Andréoli, "L'Éclecticisme," p. 45.

25. For the following discussion of nineteenth-century evaluations of Poussin I rely on Richard Verdi, "Poussin's Life in Nineteenth-Century Pictures," *Burlington Magazine* 111 (December 1969): 741–50. See also Klaus Berger, "Poussin's Style and the XIXth Century," *Gazette des Beaux-Arts* 45 (March 1955): 161–70. André Chastel, "Poussin et la Postérité," *Actes du Colloque International Nicolas Poussin*1 (1960), pp. 297–310.

26. Maria Graham, *Memoirs of the Life of Nicholas Poussin* (London: Longman, Hurst, Rees, Orme, and Brown, 1820), p. 48.

27. Anne Louis Girodet-Trioson, *Oeuvres posthumes*, ed. P. A. Coupin, 2 vols. (Paris: Jules Renouard, 1829), 2:265. On Girodet's painting under lamplight see J. J. L. Whiteley, "Light and Shade in French Neo-Classicism," *Burlington Magazine* 117 (December 1975): 771–73 and fig. 1: F. L. Deguinne, *Girodet dans son atelier*.

28. As quoted in Madeleine Fargeaud, *Balzac et La Recherche de l'Absolu* (Paris: Librairie Hachette, 1968), p. 250. Diderot's comment comes from his *Voyage de Hollande*, written in 1772 and not published until 1819. On Balzac and Flanders see Fargeaud, chaps. 7 and 8, pp. 249–81. See also Lanes, "Art Criticism and Authorship," p. 96.

29. Pierre Laubriet, *Un Catéchisme esthétique: le Chef-d'oeuvre inconnu de Balzac* (Paris: Didier, 1961), pp. 44, n. 139, and 45.

30. Bernard Weinberg, *French Realism: The Critical Reaction, 1830–1870* (1937; reprint, New York: Modern Language Association of America, 1971), p. 55.

31. As quoted in Madeleine Fargeaud, "Dans le sillage des grands Romantiques: Samuel-Henry Berthoud," *L'Anné Balzacienne* (1962), p. 237.

32. Gustave Planche, "Salon de 1831," *Études sur l'École Française (1831–1852)* (Paris: Michel Lévy, 1855), p. 4. Further references to this work will appear in the text.

33. This quotation from Planche was pointed out by Maurice Regard in his review of Pierre Laubriet, *Un Catéchisme esthétique*, in *L'Année Balzacienne* (1962), p. 376. The introduction to the *Salon de 1831* was dated May 15, 1831, giving Balzac ample time to read it before writing his novella. The conclusion of the *Salon* was dated August 17. For

dates of the ten books that comprised the *Salon* see Maurice Regard, *L'Adversaire des romantiques, Gustave Planche 1808–1857,* 2 vols. (Paris: Nouvelles Editions Latines, 1955), 2:273–74. Regard's work on Planche is an excellent source on his life and work.

34. As quoted in Regard, *Planche,* 1:249.

35. Ibid., 1:30–33. Planche seemed to fulfill the role of the ideal critic as described by Jouffroy in two articles that appeared in the *Globe* (1826–27) on Walter Scott. Jouffroy asserted that criticism was a science. See *L'Artiste,* 1:95, for a bad review given to Planche's *Salon:* "C'est une énorme et diffuse conversation de 300 pages, ou il n'est question que de peinture, de sculpture, de gravure, sans un mot de digression." See Prosper Dorbec, "La Peinture au temps du Romantisme jugée par le factum, la chanson et la caricature," *Gazette des Beaux-Arts* 14 (July–September 1918): 281, n. 1, 282–85, for material on a comedy at the Palais-Royal by Brazier, Varner, and Bayard entitled *Le Salon de 1831* that satirized the avant-garde Romantic painters.

36. Honoré de Balzac, *Lettres à l'Étrangère,* 2 vols. (Paris: Calmann-Lévy, 1899), 1:313, 2:141. On Claude Vignon see Pierre Laubriet, *L'Intelligence de l'art chez Balzac* (Paris: Didier, 1958), pp. 455–46, and Regard, Planche, 1:244–50.

37. Pontus Grate, *Deux critiques d'art de l'époque romantique: Gustave Planche et Théophile Thoré* (Stockholm: Almqvist and Wiksell, 1959), p. 80. Laubriet, *Un Catéchisme esthétique,* p. 56, compares Frenhofer's criticism to that of Parisian journalists but fails to pursue Salon criticism as a source for Balzac.

38. See Regard, *Planche,* 2:39, for Planche's letter to *L'Artiste* editor, Achille Ricourt, August 8, 1831 in which he comments on the *Chef-d'oeuvre inconnu* as follows: "Je n'ai rien compris au conte fantastique de Balzac. Mais comme spéculateur vous avez raison de prendre sa marchandise." See also p. 204 for Planche's favorable mention of *Sarrasine.*

39. Grate, *Deux critiques,* pp. 112–15.

40. Fosca, *De Diderot à Valery,* p. 60.

41. Frédéric Ségu, *Un maître de Balzac méconnu, H. de Latouche* (Paris: Société d'Édition "Les Belles Lettres," 1928). For background on Latouche see also by Ségu, *Un Romantique républicain, H. de Latouche* (Paris: Société d'Édition "Les Belles Lettres," 1931) and *Un Journaliste diléttante, H. de Latouche et son intervention dans les arts* (Paris: Société d'Édition "Les Belles Lettres," 1931). In discussing the relationship between Balzac and Latouche, Ségu is biased in favor of Latouche. On Latouche and Balzac see also Herbert J. Hunt, *Honoré de Balzac* (University of London, 1957), pp. 23–25, 67.

42. Ségu, *Un maître de Balzac meconnu,* p. 74.

43. Henry Monnier, *Mémoires de Monsieur Joseph Prudhomme,* 2 vols. (Paris: Librairie Nouvelle, 1857), 2:108.

44. As quoted in George Sand, *Autour de la table, Oeuvres complètes,* (Paris: Calmann-Lévy, 1882), p. 253.

45. Ibid., p. 240.

46. Ibid.

47. "Fragoletta ou Naples et Paris en 1799," *Oeuvres complètes,* 38:205. This article appeared in *Mercure de XIX siècle,* June 1829. Balzac wrote a second more flattering article (signed Felix D.) that appeared in the same periodical in January 1831: "Du Roman Historique et de *Fragoletta,*" *Oeuvres complètes,* 38:205–7, in which he compares *Fragoletta* as a "roman historique" to a history painting by Lethière.

48. Balzac, "Lettres sur la littérature," *Oeuvres complètes,* 40:27, published originally in *Revue parisienne,* July 25, 1840.

49. As quoted in Henri Girard et Pierre Poux, "Apologie pour Sainte-Beuve: "Sainte-Beuve et H. de Latouche," *Revue d'Histoire littéraire de la France* (July–September 1934), p. 440.

50. As quoted in Ségu, *Un romantique républicain, H. de Latouche,* title page.

51. George Sand, *Histoire de ma vie,* ed. Noelle Roubaud (Paris: Éditions Stock, 1949), p. 298.

Chapter 8. Visions of Moreau in Huysmans and Proust

1. As quoted in Maurice Z. Shroder, *Icarus: The Image of the Artist in French Romanticism* (Cambridge, Mass.: Harvard University Press, 1961), p. 193.

2. Charles Baudelaire, *Salon of 1859,* as quoted in Anita Brookner, *The Genius of the Future—Studies in French Art Criticism: Diderot, Stendhal, Baudelaire, Zola, Brothers Goncourt, Huysmans* (London and New York: Phaidon, 1971), p. 69.

3. Shroder, *Icarus,* p. 201.

4. Ibid.

5. Edmund Wilson, *Axel's Castle* (New York: Charles Scribner's, 1947), p. 12.

6. Stephane Mallarmé, letter to Cazalis, March 1866, in *Mallarmé, Selected Prose, Poems, Essays and Letters,* trans. Bradford Cook (Baltimore: Johns Hopkins University Press, 1956). This edition will be cited hereafter as *Mallarmé.*

7. Edgar Allan Poe, as quoted in Wilson, *Axel's Castle,* p. 13.

8. Ibid., p. 13.

9. J[oris]-K[arl] Huysmans, *Against Nature (A rebours),* trans. Robert Baldick (Baltimore: Penguin, 1966). Quotations from this edition will be cited hereafter in the text.

10. As quoted from *Le Decadent* (1886), in Philippe Jullian, *Dreamers of Decadence,* trans. Robert Baldick (New York: Praeger, 1971), p. 46.

11. Mallarmé, "The Evolution of Literature," in *Mallarmé,* p. 21.

12. Mallarmé, letter to Lefèbure as quoted in Robert Greer Cohn, *Toward the Poems of Mallarmé* (Berkeley: University of California Press, 1965), p. 53. Author's translation.

13. Cohn, *Poems of Mallarmé,* p. 54.

14. Moreau as quoted in *Odilon Redon, Gustave Moreau, Rodolphe Bresdin,* exhib. cat. (New York: Museum of Modern Art, 1961), p. 119.

15. Translation of lines from *Hérodiade,* taken from Cohn, *Poems of Mallarmé,* pp. 72, 80.

16. Ibid., pp. 82–83.

17. Jacques Borel, *Séraphîta et le Balzacien mysticisme* (Paris: José Corti, 1967), p. 311.

18. Mallarmé, letter to Coppée, April 20, 1868, in *Mallarmé,* p. 97.

19. Mallarmé, "Crisis in Poetry," in *Mallarmé,* p. 40.

20. Odilon Redon, letter to Hennequin, August 25, 1982, as quoted in Rosaline Bacou, *Odilon Redon,* 2 vols. (Geneva: Pierre Cailler, 1956), 1:83. Author's translation.

21. Redon, *Vision,* lithograph, Mellerio no. 34, plate 8, in *Dans le Rêve* (1879).

22. Redon, *Apparition,* charcoal drawing, dated by Klaus Berger, 1883; by Sven Sandstrom, 1876–79.

23. Klaus Berger, in a letter to the author, April 19, 1970, points out that his dating of *Apparition* is based on "stylistic and visual arguments" while Sandstrom's dating is based on "iconographical and psychological considerations." Rosaline Bacou, *Odilon Redon,* exhib. cat. (Paris: L'Orangerie, 1956), pp. 3, 20, gives support to the 1883 date. According to this catalogue, no. 34, *Apparition* has been dated 1883 as verified by unpublished notes of Odilon Redon, lent by his son Ari Redon.

24. Sven Sandström, *Le Monde imaginaire d'Odilon Redon* (Lund: CWK Gleerup; New York: G. Wittenborn, 1955), pp. 48–52.

25. Redon, Letter to Mellerio, July 21, 1898 in Klaus Berger, *Odilon Redon, Fantasy and Colour,* trans. Michael Bullock (New York: McGraw Hill, n.d.).

26. Odilon Redon, "To Myself," trans. Richard Howard, *Portfolio,* no. 8 (Spring 1964), p. 108. Cf. Odilon Redon, p. 28.

27. Redon, letter to Madame de Holstein, January 29, 1900, in Berger, *Odilon Redon,* p. 134.

28. Redon, "To Myself," p. 106.

29. Redon, letter to Mellerio, October 2, 1898, in Berger, *Odilon Redon,* p. 132.

30. The five essays deal with the following painters: Watteau, Chardin, Rembrandt, Gustave Moreau, and Monet. First published by Bernard de Fallois in 1954 they are available in French in Marcel Proust, *Contre Sainte-Beuve précédé de Pastiches et mélanges et suivi de Essais et articles,* ed. Pierre Clarac and Yves Sandre (Paris: Gallimard, Pléiade, 1971), hereafter cited as C. S. B. For discussion of dating of essays see J. Theodore Johnson, Jr., "The Painter and His Art in the Works of Marcel Proust" (Ph.D. diss., University of Wisconsin, 1964), pp. 174–75, where the decade 1895–1905 is suggested as the period in which the essays were written.

31. Yves Clogenson, "Proust et Huysmans," *Revue de Paris* 70 (September 1963): 57.

32. Patrick Gauthier, "Proust et Gustave Moreau," *Europe* (August–September 1970), p. 237. See also J. Theodore Johnson, Jr., "Marcel Proust et Gustave Moreau," Société des Amis de Marcel Proust et des Amis de Combray *Bulletin* 28 (1978): 614–39.

33. Marcel Proust, *Remembrance of Things Past,* trans. C. K. Scott Moncrieff and Frederick A. Blossom, 2 vols. (New York: Random House, 1934), 1:205–6. Hereafter volume and page numbers of this translation will be cited in the text before the slash, after which will appear volume and page numbers of the French edition: Marcel Proust, *A la Recherche du temps perdu,* 3 vols. (Paris: Gallimard, Pléiade, 1954), 1:267. In the translation I have substituted Proust's word *apparition* for Moncrieff's *fantasy* (also used in the Kilmartin translation) since *The Apparition* is the tile of Moreau's Salomé painting that Proust had in mind.

34. See Helen O. Borowitz, "The Rembrandt and Monet of Marcel Proust," *Cleveland Museum of Art Bulletin* 70 (February 1983): 73–95.

35. *Marcel Proust on Art and Literature 1896–1919,* trans. Sylvia Townsend Warner (New York: Meridian Books. 1958; Delta paperback, 1964), p. 350; C. S. B., p. 671. Page numbers from this translation are cited before the slash, after which appear page numbers from the French edition cited in n. 30. Hereafter citations will appear in the text.

36. See Johnson, Jr., "Marcel Proust et Gustave Moreau," pp. 618–19, for the conjecture that either Ary Renan or Henri Ruppe guided Proust through the Moreau house and also for the citation of Renan's 1899 articles. This article dates the Moreau essay to November 1898 (pp. 623–24) and traces the Moreau themes from Proust's essay to *Jean Santeuil* and *A la recherche.* See Johnson, Jr., "The Painter and His Art," pp. 178–79, for citation of Renan's 1899 articles as sources for the Moreau essay.

37. Marcel Proust, *Correspondance, II, 1896–1901,* ed. Philip Kolb (Paris: Plon, 1976), Letter 244, p. 392; cited in Johnson, Jr., "Marcel Proust et Gustave Moreau," p. 628.

38. For provenance on these paintings see Pierre-Louis Mathieu, *Gustave Moreau,* trans. James Emmons (Oxford: Phaidon-Oxford, 1977), nos. 317, 347, 403.

39. Johnson, Jr., "Marcel Proust et Gustave Moreau," p. 634.

40. Ralph Wright, "A Sensitive Petronius," in *Marcel Proust: An English Tribute,* comp. C. K. Scott Moncrieff (New York: Thomas Seltzer, 1923), pp. 40–41.

Chapter 9. The Watteau and Chardin of Marcel Proust

1. Important studies on the formation of Proust's taste in art and his use of painting in his fiction are Maurice E. Chernowitz, *Proust and Painting* (New York: International University Press, 1945); Juliette Monnin-Hornung, *Proust et la peinture* (Geneva: Droz, 1951); J. Theodore Johnson, Jr., "The Painter and His Art in the Works of Marcel Proust" (Ph.D. diss., University of Wisconsin, 1964). An excellent biography and key to characters in *Remembrance* is George D. Painter, *Proust, the Early Years,* vol. 1; *Proust, the Later Years,* vol. 2 (Boston: Little Brown, 1959–65).

2. André Ferré, *Les Années de collège de Marcel Proust* (Paris: Gallimard, 1951), p. 259. Robert de Billy, *Marcel Proust: lettres et conversations* (Paris: Éditions des Portiques, 1930), describes Proust and his friends in the Louvre. For some of Proust's drawings see Marcel Proust, *Le Balzac de Monsieur de Guermantes* (Paris: Ides et Calendes, 1950), and Marcel Proust, *Lettres à Reynaldo Hahn,* ed. Philip Kolb (Paris: Gallimard, 1956). The title of this chapter is a pastiche on Proust's *Le Balzac de Monsieur de Guermantes.* A similar title appears in a fragment from *Jean Santeuil:* "Les Monet du Marquis de Reveillon."

3. The five essays deal with the following painters: Watteau, Chardin, Rembrandt, Gustave Moreau (discussed in chapter 8), and Monet. First published by Bernard de Fallois in 1954, they are available in French in Marcel Proust, *Contre Sainte-Beuve précédé de Pastiches et mélanges et suivi de Essais et articles,* ed. Pierre Clarac and Yves Sandre (Paris: Gallimard, Pléiade, 1971).

4. For the influence of Ruskin on Proust see Jean Autret, *L'Influence de Ruskin sur la vie, les idées et l'oeuvre de Marcel Proust* (Geneva: Droz, 1955). For an insightful discussion on biographical affinities between Proust and Ruskin see André Maurois, "Proust et Ruskin," *Essays and Studies by Members of the English Association* (Oxford: Clarendon Press, 1932), pp. 25–32.

5. Marcel Proust, "Sainte-Beuve et Balzac," *Contre Sainte-Beuve,* p. 276. Author's translation unless otherwise noted. An excellent discussion of Proust's chapters on Balzac in *Contre Sainte-Beuve* (published originally as *Le Balzac de Monsieur de Guermantes,* mentioned in note 2 above) appears in Walter A. Strauss, *Proust and Literature: The Novelist as Critic* (Cambridge, Mass.: Harvard University Press, 1957), pp. 85–105.

6. Georges Cattaui, *Marcel Proust,* trans. Ruth Hall (New York: Funk and Wagnalls, 1968), p. 26.

7. Marcel Proust, *Correspondance, I, 1880–1895,* ed. Philip Kolb (Paris: Plon, 1970), pp. 444–45, letter to Pierre Mainguet, editor of *Revue hebdomadaire,* probably written at the end of November 1895.

8. On the role of Elstir in the novel see Charles Newell Clark, "Elstir: The Role of the Painter in Proust's 'A la Recherche du temps perdu'" (Ph.D. diss., Yale University, 1952). Elstir's art is a synthesis of the work of many Impressionist artists: Monet, Manet, Renoir, Degas, among others. His speech is modeled after Vuillard's slangy conversational style. His name is an anagram for two other models, Paul-César Helleu and Whistler. There are also works by him that suggest Gustave Moreau and Turner.

9. J. Theodore Johnson, Jr., "Proust's Early *Portraits de peintres,*" *Comparative Literature Studies* 4, no. 4 (1967): 401. Simone Kadi, *La Peinture chez Proust et Baudelaire* (Paris: la pensée universelle, 1973), pp. 207–15. Margaret Mein, *A Foretaste of Proust: A Study of Proust and His Precursors* (London: Saxon House, 1974).

10. Proust acknowledged the use of the *Gazette* library in his preface to John Ruskin, *La Bible d'Amiens,* trans. Marcel Proust (Paris: Mercure de France, 1926), p. 14. Chernowitz, *Proust and Painting,* p. 14, cites *Gazette des Beaux-Arts, Les Arts de la Vie,* and *La Revue Blanche* as journals Proust read and published in. For Proust's source for

Vermeer in contemporary French criticism see Hélène Adhémar, "La vision de Vermeer par Proust à travers Vaudoyer," *Gazette des Beaux-Arts* 68 (November 1966): 291–94.

11. Pierre Rosenberg, *Chardin 1699–1779* (Cleveland: Cleveland Museum of Art, 1979).

12. As quoted in Monnin-Hornung, *Proust et la peinture,* p. 12.

13. Marcel Proust, *Correspondance générale de Marcel Proust,* ed. Robert Proust and Paul Brach (Paris: Plon, 1933), 4:80–82. See p. 86 for Proust's compliments to Vaudoyer on his article on Watteau. Vaudoyer's articles on Vermeer, Watteau, and other artists are available in Jean-Louis Vaudoyer, *L'Art est delectation* (Paris: Hachette, 1968).

14. Quotations from the English translation of the essays are taken from *Marcel Proust on Art and Literature 1896–1919,* trans. Sylvia Townsend Warner (New York: Meridian Books, 1958; Delta paperback, 1964). Page numbers of this translation are cited before the slash, after which appear page numbers of the French Pléiade edition of the essays in *Contre Saint-Beuve,* cited in n. 3.

15. Edmond and Jules de Goncourt, *L'Art du XVIII siècle,* 2 vols. (Paris: A. Quantin, 1880–82), 1, plate 6.

16. Johnson, Jr., "The Painter and His Art," p. 176: "And yet nowhere in the biographical material of the Goncourt's essay on Watteau can one find an allusion to a characteristic that Proust emphasizes: Watteau's failure to enjoy the pleasures of love because of his physical constitution."

17. Paul Mantz, "Watteau," *Gazette des Beaux-Arts,* 3d ser., 1 (1889): January, 5–29; March, 177–95; June, 455–72; 3d. ser., 2 (1890): January, 5–29; February, 129–47; March, 222–38. Paul Mantz, "La Collection La Caze au musée du Louvre," pt. 2, *Gazette des Beaux-Arts,* 2d. ser., 2 (July 1870): 5–25.

18. Mantz, "Watteau," *Gazette des Beaux-Arts* (June 1889), p. 466.

19. Mantz "La collection La Caze," p. 9.

20. J. Theodore Johnson, Jr., "Against 'Saint' Proust," *The Art of the Proustian Novel Reconsidered,* ed. Lawrence D. Joiner, Winthrop Studies on Major Modern Writers (Rockhill, S.C.: Winthrop College, 1979), pp. 108–18.

21. Marcel Proust, *L'Indifférent* (Paris: Gallimard, 1978), p. 53.

22. Réné Huyghe, "L'Univers de Watteau," in Hélène Adhémar, *Watteau, sa vie, son oeuvre* (Paris: Pierre Tisné, 1950), pp. 4–6.

23. Philip Kolb, Introduction to Proust, *L'Indifférent,* p. 27.

24. Marcel Proust, *Remembrance of Things Past,* trans. C. K. Scott Moncrieff and Frederick A. Blossom, 2 vols. (New York: Random House, 1934), 1:184. Hereafter volume and page numbers of this translation will be cited in the text before the slash, after which will appear volume and page numbers of the French edition: Marcel Proust, *A la Recherche du temps perdu,* 3 vols. (Paris: Gallimard, Pléiade, 1954), 1:240.

25. Goncourts, 1:42–45. Figures 3, 4, and 5 are catalogued in K. T. Parker and J. Mathey, *Antoine Watteau catalogue complet de son oeuvre dessiné* (Paris: F. de Nobele, 1957), 2, nos. 741, 744, and 777.

26. *Marcel Proust,* exhib. cat. (Paris: Bibliothèque Nationale, 1965), nos. 165 and 171 describe Proust first meeting with the Comtesse Greffulhe on May 30, 1894, at the matinee musicale at the home of Robert de Montesquiou. For Proust's article on the event published in the *Gaulois,* May 31, see "Une fete littéraire à Versailles," *Contre Sainte-Beuve,* pp. 360–65.

27. Marcel Proust, *Jean Santeuil précédé de Les Plaisirs et les jours,* ed. Pierre Clarac and Yves Sandre (Paris: Gallimard, Pléiade, 1971), pp. 435–36.

28. Edmond de Goncourt quoted in Robert de Montesquiou, *Paul Helleu, Peintre et Graveur* (Paris: H. Floury, 1913), p. 47.

29. Paulette Howard-Johnston, "Bonjour M. Elstir," *Gazette des Beaux-Arts* 69

(April 1967): 248, points out that the phrase *Watteau à vapeur* was applied to her father, Helleu, by Léon Daudet, not by Degas as others have written.

30. On *The Romancer* see Hélène Adhémar, *Watteau*, no. 168; Jean Ferré and Raoul Brie, *Watteau*, 4 vols. (Madrid: Athena, 1972), 3, no. B31. On the drawing see Henry S. Francis, " 'The Romancer'; A Drawing by Jean Antoine Watteau," Cleveland Museum of Art *Bulletin* 16 (December 1929): 179–81.

31. A.-P. de Mirimonde, "Les Sujets musicaux chez Antoine Watteau," *Gazette des Beaux-Arts* 58 (November 1961): 260.

32. René Huyghe, *Art and the Spirit of Man* (New York: Abrams, 1962), p. 419.

33. Mirimonde, "Les Sujets musicaux," pp. 269–70. On the rose as a symbol of love in Proust, see Clark, "Elstir," p. 404.

34. On the popularity of fashions à la Watteau from the 1860s to the end of the century see Christine Garnier, "La Mode Watteau," *Pèlerinage à Watteau*, 4 vols. (Paris: Hôtel de la Monnai, 1977), 1:169–72; 2:396–404. For Swann's love as a Baudelairean voyage see William S. Bell, "Proust's *Un Amour de Swann:* A Voyage to Cythera," *L'Esprit créateur* 5 (Spring 1965): 26–37.

35. Johnson, Jr., "Against Saint-Proust," p. 110. See also "Fragments de la Comédie Italienne," from *Les Plaisirs and les jours* in *Jean Santeuil*, p. 56, where Proust suggests the role he played in society as depicted in the photo was a role of the male ingénu: "It should be added that sometimes a man will appear in society for whom it has no ready-made character or at least none that is not being used at the moment by somebody else. First they give him one that doesn't suit him at all. If he is a man of real originality and there is nothing his size in stock, incapable of trying to understand him and for lack of a character to fit him, society ostracizes him; unless, of course he can gracefully play the young juvenile who is always in demand" (Marcel Proust, *Pleasures and Regrets*, trans. Louise Varese [New York: Crown, 1948], p. 86).

36. Evidence of Proust's familiarity with Madeleine de Scudéry's writings appears in his citation of some of her verses in a letter to Robert de Montesquiou of June 16, 1897 in Marcel Proust, *Correspondance, II, 1896–1901*, ed. Philip Kolb (Paris: Plon, 1976), p. 194. Frances Virginia Fardwell, *Landscape in the Works of Marcel Proust* (Washington: Catholic University of America Press, 1948), p. 165.

37. On sources in *précieux* literature for the theme of Cythera see René Huyghe, *Art and the Spirit of Man*, pp. 420–22, and Robert Tomlinson, *La Fête Galante: Watteau and Marivaux* (Geneva: Droz, 1981), pp. 111–16. On the *carte de Tendre* see Claude Aragonnès, *Madeleine de Scudéry, reine du Tendre* (Paris: Armand Colin, 1934), pp. 136–47.

38. For a study of the various manuscript versions of the Mlle. de Stermaria theme see Georgette Tupinier, "Autour de cinq ébauches de Mlle. de Stermaria," *Études Proustiennes*, no. 1, Cahiers Marcel Proust, n.s., no. 6 (Paris: Gallimard, 1973), pp. 211–75.

39. For a comparison of passages of Proust's essay on Chardin with the Goncourts' chapter on Chardin in *L'Art du XVIII siècle*, see Kyuichero Inoue, "Proust et Chardin," *Etudes de Langue et Littérature françaises* (Bulletin de la Société Japonaise de Langue et Littérature française) no. 1 (1962). For comparisons with Diderot see Gita May, "Chardin vu par Diderot et par Proust," *PMLA* 72 (June 1957): 403–18.

40. See *A la Recherche du temps perdu*, 3:779, 888, for Proust's mention of Watteau's art falling out of favor during the Revolution and being reinstated by critics like the Goncourts in the nineteenth century. See also Philippe Burty, "Watteau et David," *La Chronique des Arts et la Curiosité* 2 (1864–65): 52–53.

41. On Proust's use of the "vous" and its sources in the art criticism of Diderot, the Goncourts, and Ruskin see Johnson, Jr., "The Painter and His Art," p. 171.

42. The first sentence has been altered by the author from the Warner translation to accord more closely with the French.

43. Henry de Chennevières, "Chardin au musée du Louvre," *Gazette des Beaux-Arts* 2d ser., 38 (July 1888): 55. This is the first of two articles on the La Caze Chardins, the second appeared in *Gazette* 3d. ser., 1 (February 1889): 121–30.

44. Proust, *Correspondance générale* (1935), 5:39–40, Letter 18 to Walter Berry.

45. See Carol C. Clark, "Jean-Baptiste Siméon Chardin: Still Life with Herring," *Cleveland Museum of Art Bulletin* 61 (November 1974): 309–13.

46. See Denis Rouart and Daniel Wildenstein, *Edouard Manet, catalogue raisonné* (Paris: La Bibliothèque des Arts, 1975), 1, no. 358, for Manet's note to Ephrussi with the painting of a single stalk of asparagus: "Il en manquait à votre botte." See John Cocking, "Proust and Painting," in *French 19th-Century Painting and Literature*, ed. Ulrich Finke (Manchester: Manchester University Press, 1972), pp. 305–8, on Manet's asparagus as a model for Proust's literary still life in François's kitchen.

47. Honoré de Balzac, *Le Cousin Pons, Oeuvres complètes*, ed. M. Bouteron and H. Longnon, 40 vols. (Paris: Conard, 1912–40), 18:41–42.

48. Proust, too, was never a collector. See Monnin-Hornung, *Proust et la peinture*, pp. 19–22, for his letter on the decor of his apartment, in which a few family portraits and inherited paintings decorated the drawing room leaving his bedroom bare, and his comments that any painting that had not been "desired, bought with pain and love, is atrocious in an apartment."

49. A further connection between Manet and Elstir is made when the Duchesse de Guermantes mentions that Zola has written an article on Elstir (1:1073/2:500).

50. For Manet's copies after Chardin genre scenes in the Louvre see J. Mathey, *Graphisme de Manet*, 2 vols. (Paris: Librairie des Quatre-Chemins-Editart, 1963), 2:*Peintures réapparues*, nos. 95–97. On the influence of Chardin on Manet's still lifes see Gabriel P. Weisberg with William S. Talbot, *Chardin and the Still-Life Tradition in France* (Cleveland: Cleveland Museum of Art, 1979), p. 31. On Manet's still lifes as prototypes for Elstir's see Albert Feuillerat, *Comment Marcel Proust à composé son roman* (New Haven: Yale University Press, 1934), p. 61.

51. As quoted in J.-L. Vaudoyer, *E. Manet* (Paris: Éditions du Dimanche, n.d.), no. 20. Proust's preface to Blanche's book *Propos de peintre* (Paris: Émile-Paul, 1919) is reprinted in *Contre Sainte-Beuve*, pp. 570–86.

52. The interest of nineteenth-century Realist painters in Chardin is demonstrated by the fact that *Still Life with Herrings* was in the collection of Alexis Vollon between 1904 and 1909.

53. Warner translation, p. 332, with some changes by the author. *Contre Sainte-Beuve*, p. 379.

54. Rosenberg, *Chardin*, pp. 157–86.

55. René Huyghe, "Vermeer et Proust," *L'Amour de l'Art* 17 (1936): 7–15.

56. Marcel Proust, *Jean Santeuil*, trans. Gerard Hopkins (New York: Simon and Schuster, 1956), p. 649. For French see *Jean Santeuil*, p. 808.

57. H. Kopman, *Rencontres with the Inanimate in Proust's Recherche* (The Hague, Paris: Mouton, 1971). On the alteration of social occasions and privileged moments in *Remembrance*, see Harold March, *The Two Worlds of Marcel Proust* (London: Oxford University Press, 1948), pp. 145–48. See Joseph H. McMahon, "From Things to Themes," *Yale French Studies* 34 (Summer 1965): 5–17 for a discussion of "things" in *Jean Santeuil* and *Remembrance*.

58. It is significant that Proust had thought of entitling the end of *Remembrance* "L'Age des Choses" ("The Age of Things").

Chapter 10. Conclusion

1. For visual sources in Monet's paintings for the two ways in Combray, see Helen O. Borowitz, "The Rembrandt and Monet of Marcel Proust," Cleveland Museum of Art *Bulletin* 70 (February 1983): 73–95.

2. Marcel Proust, *Remembrance of Things Past*, trans. C. K. Scott Moncrieff and Frederick A. Blossom, 2 vols. (New York: Random House, 1934), 2:1030. Hereafter volume and page numbers of this translation will appear before the slash, after which will appear volume and page numbers of the French edition: Marcel Proust, *A la recherche du temps perdu*, 3 vols. (Paris: Gallimard, Pléiade, 1954), 3:920.

3. Proust, *Remembrance*, 2:1013/ 3:895–96.

4. Ibid., 2:559/ 3:258.

Select Bibliography

Adam, Antoine. *Histoire de la littérature française au XVII siècle.* 5 vols. Paris: Mondiales, 1962.

Adhémar, Jean. "Balzac et les images." *Arts* (January 26, 1951).

——. "Balzac et la peinture." *Revue des Sciences Humaines* (April–June 1953), pp. 149–62.

——. "Le Cabinet de M. de Scudéry Manifeste de la Préciosité." *Gazette des Beaux-Arts* 70 (December 1967): 370–76.

The Age of Neo-Classicism. Exhib. cat. London: Arts Council of Great Britain, 1972.

Alley, John N. "Proust and Art. The Anglo-American Critical View." *Revue de littérature comparée* 37 (1963): 410–30.

Andlau, Béatrice d'. *La Jeunesse de Madame de Staël (de 1766 à 1786) avec des documents inédits.* Geneva: Droz, 1970.

Andréoli, Max. "Balzac, Cousin et L'Éclecticisme." *L'Année Balzacienne* (1971), pp. 37–81.

Angrand, Pierre. *Le comte de Forbin et le Louvre en 1819.* Lausanne, Paris: La Bibliothèque des Arts, 1972.

Aragonnès, Claude. *Madeleine de Scudéry, reine de Tendre.* Paris: Colin, 1934.

Aronson, Nicole. *Mademoiselle de Scudéry.* Translated by Stuart R. Aronson. Boston: Twayne, 1978.

——. "Mlle. de Scudéry et l'histoire romaine dans *Clélie.*" *Romanishche Forschungen* 88 (1976): 183–94.

Autret, Jean. *L'Influence de Ruskin sur la vie, les idées et l'oeuvre de Marcel Proust.* Geneva: Droz, 1955.

Backer, Dorothy Anne Liot. *Precious Women.* New York: Basic Books, 1974.

Bacou, Rosaline. *Odilon Redon.* 2 vols. Geneva: Pierre Cailler, 1956.

Balzac, Honoré de. "Le Chef-d'oeuvre inconnu." *L'Artiste, Journal de la Littérature et des Beaux-Arts* (1831). Reprint (2 vols. in 1). Geneva: Slatkine Reprints, 1972. Pt. 1, "Maître Frenhofer," 1 (July 31, 1831): 319–23; pt. 2, "Catherine Lescaut," 2 (August 4, 1831): 7–10.

——. *Le Chef-d'oeuvre inconnu suivi de, Pierre Grassou, Sarrasine, Gambara et Massimilla Doni.* Preface by Robert André, notice and notes by Samuel de Sacy. Paris: Gallimard livre de poche, 1970.

———. *Lettres à l'Etrangère.* 2 vols. Paris: Calmann-Lévy, 1899.

———. *Oeuvres complètes.* Edited by M. Bouteron and H. Longnon. 40 vols. Paris: Conard, 1912–40.

———. *Sarrasine.* Translated by Richard Miller. In *S/Z* by Roland Barthes. Preface by Richard Howard. New York: Hill and Wang, 1974.

Barbey d'Aurevilly, Jules Amédée. "Mme. Desbordes-Valmore." In *Les Poètes. Les Oeuvres et Les Hommes,* pt. 3, pp. 145–58. Paris: Amyot, 1862.

Beebe, Maurice. "The Lesson of Balzac's Artists." *Criticism* 2, no. 3 (Summer 1960): 221–41.

Belayé, Simone. "La Génie et la gloire dans l'oeuvre de Mme. de Staël." *Rivista de Letterature Moderne e Comparate* (December 1967), pp. 202–14.

Bell, William S. "Proust's *Un Amour de Swann:* A Voyage to Cythera." *L'Esprit créateur* 5 (Spring 1965): 26–37.

Bellessort, André. *Heures de parole.* Paris: Perrin, 1929.

Berger, Klaus. *Géricault and His Work.* Translated by Winslow Ames. Lawrence: University of Kansas Press, 1955.

———. *Odilon Redon, Fantasy and Colour.* Translated by Michael Bullock. New York: McGraw Hill, n.d.

Bernard, Suzanne J. "Une énigme balzacienne: la spécialité." *L'Année Balzacienne* (1965), pp. 61–82.

Besser, Gretchen R. *Balzac's Concept of Genius: The Theme of Superiority in the "Comédie humaine."* Geneva: Droz, 1969.

Bezard, Yvonne. *Mme. de Staël d'après ses portraits.* Paris: Victor Attinger, 1938.

Blunt, Anthony F. "The *Précieux* and French Art." In *Fritz Saxl, 1890–1948: A Volume of Memorial Essays from His Friends in England,* edited by D. J. Gordon, pp. 326–38. London: Thomas Nelson, 1957.

Boas, George. *French Philosophies of the Romantic Period.* Baltimore: Johns Hopkins University Press, 1925.

Boime, Albert. *The Academy and French Painting in the Nineteenth Century.* London, New York: Phaidon, 1971.

———. *Thomas Couture and the Eclectic Vision.* New Haven and London: Yale University Press, 1980.

Borel, Jacques. *Proust et Balzac.* Paris: José Corti, 1975.

———. *Séraphita et le mysticisme Balzacien.* Paris: José Corti, 1967.

Borowitz, Albert. "Henri de Latouche and the Murder Memoirs of Clarisse Manson." In *Innocence and Arsenic,* pp. 132–62. New York: Harper and Row, 1977.

Borowitz, Helen O. "The Rembrandt and Monet of Marcel Proust." Cleveland Museum of Art *Bulletin* 70 (February 1983): 73–95.

Bowie, Theodore Robert. *The Painter in French Fiction.* Chapel Hill: University of North Carolina Press, 1950.

Boyancé, Pierre. *Le Culte des Muses chez les philosophes Grecs.* Paris: de Broccard, 1937.

———. *Études sur le Songe de Scipion, thèse complémentaire*. Limoges: A Bontemps, 1936.

Brée, Germaine. *Women Writers in France: Variations on a Theme*. New Brunswick: Rutgers University Press, 1973.

Brookner, Anita. *The Genius of the Future—Studies in French Art Criticism: Diderot, Stendhal, Baudelaire, Zola, Brothers Goncourt, Huysmans*. London and New York: Phaidon, 1971.

———. *Jacques-Louis David*. London: Chatto and Windus: 1980.

Bucknall, Barbara J. *The Religion of Art in Proust*. Illinois Studies in Language and Literature 60. Urbana, Chicago, London: University of Illinois Press, 1969.

Bush, Douglas. *Mythology and the Renaissance Tradition in English Poetry*. New York: Pageant Book, 1957.

Busst, A. J. L. "The Image of the Androgyne in the Nineteenth Century." In *Romantic Mythologies*. Edited by Ian Fletcher. New York: Barnes and Noble, 1967, pp. 1–95.

Cassagne, Albert. *La Théorie de l'art pour l'art en France chez les derniers romantiques et les premiers réalistes*. 1906. Reprint. Paris: Lucien Dorbon, 1959.

Cattaui, Georges. *Marcel Proust*. Translated by Ruth Hall. New York: Funk and Wagnalls, 1968.

Charlier, Gustave. "La fin de l'Hôtel de Rambouillet." *Revue Belge de Philosophie et d'histoire* 18 (1939): 409–26.

Charlton, D. G. "The personal and general in French Romantic literary theory." In *Balzac and the Nineteenth Century: Studies in French Literature Presented to Herbert J. Hunt*, edited by D. G. Charlton, J. Gaudon, and Anthony R. Pugh, pp. 269–81. Leicester: Leicester University Press, 1972.

———. "Victor Cousin and the French Romantics." *French Studies* 17 (October 1963): 311–23.

Chénier, André. *Poésies précédées d'une notice par H. de Latouche*. 1820. New edition. Paris: Charpentier, 1888.

Chernowitz, Maurice E. *Proust and Painting*. New York: International University Press, 1945.

Clark, Charles Newell. "Elstir: The Role of the Painter in Proust's 'A la recherche du temps perdu.'" Ph.D. diss., Yale University, 1952.

Clognenson, Yves. "Proust et Huysmans." *Revue de Paris* 70 (September 1963): 50–62.

Cocking, John. "Proust and Painting." In *French 19th-Century Painting and Literature*, edited by Ulrich Finke, pp. 305–24. Manchester: Manchester University Press, 1972.

Cohn, Robert Greer. *Toward the Poems of Mallarmé*. Berkeley: University of California Press, 1965.

Comberousse, Charles de. "Notice sur la vie de H. de Latouche." In H. de

Latouche, *Oeuvres complètes.* 4 vols. 1867. Reprint. Geneva: Slatkine Reprints, 1980. 1 : i–li.

Cousin, Victor. *La Société française au XVIII siècle d'après Le Grand Cyrus.* 6th ed. 2 vols. Paris: Perrin, 1886.

———. *Du Vrai, du beau et du bien.* 21st ed. Paris: Didier, 1879.

Cumont, Franz. *After Life in Roman Paganism.* New Haven: Yale University Press, 1923.

———. *Recherches sur le symbolisme funéraires des Romains.* Paris: Paul Geuthner, 1942.

David, J. L. Jules. *Le peintre Louis David 1748–1825, souvenir et documents inédits.* 2 vols. Paris: Victor Havard, 1880.

Delaborde, Henri, Comte. *L'Académie des Beaux-Arts depuis la fondation de l'Institut de France.* Paris: Plon, 1891.

Delécluze, Étienne-Jean. *Journal de Delécluze 1824–1828.* Edited by Robert Baschet. Paris: Bernard Grasset, 1948.

———. *Louis David, son école et son temps.* Paris:. Didier, 1855.

———. *Souvenirs de soixante années.* Paris: Michel Lévy, 1862.

des Granges, Ch.-M. *La Presse littéraire sous la Restauration 1815–1830.* Paris: Mercure de France, 1907.

Dorbec, Prosper. *Les Lettres Françaises dans leur contacts avec l'atelier de l'artiste.* Paris: Presses Universitaires de France, 1929.

Dubos, J. B. *Réflexions critiques sur la poésie et sur la peinture.* 2 vols. Utrecht: Étienne Neaulme, 1732.

Duncan, Carol. *The Pursuit of Pleasure: The Rococo Revival in French Romantic Art.* New York and London: Garland, 1976.

Easton, Malcolm. *Artists and Writers in Paris: The Bohemain Idea. 1803–1867.* London: Edward Arnold, 1964.

Edwards, Peter J. *"L'Artiste* (1831–1861): The Literary Role of an Artistic Review." Ph.D. diss., Fordham University, 1973.

Egglie, Edmond, and Martino, Pierre. *Le Débat romantique en France 1813–1830.* 2 vols. Paris: Société d'Édition "Les Belles Lettres," 1933.

Eitner, Lorenz. *Géricault's Raft of Medusa.* London: Phaidon, 1972.

Ferré, André. *Les Années de college de Marcel Proust.* Paris: Gallimard, 1951.

Festa-McCormick, Diana. "Proustian Aesthetics of Ambiguity: Elstir's Miss Sacriphant." *International Fiction Review* 3 (1977): 92–99.

Feuillerat, Albert. *Comment Marcel Proust a composé son roman.* New Haven: Yale University Press, 1934.

Focillon, Henri. *La peinture au XIX siecle.* Paris: Renouard, 1927.

Fosca, François. *De Diderot à Valery: les écrivains et les arts visuel.* Paris: Édition Albin Michel, 1960.

French Painting 1774–1830: The Age of Revolution. Exhib. cat. Detroit: Wayne State University, 1975.

Gaste, Armand. *Madeleine de Scudéry et le "Dialogue des Héros de Roman" de Boileau*. Rouen: Cagniard, 1902.

Gauthier, Patrick. "Proust et Gustave Moreau." *Europe* (August–September 1970), pp. 237–41.

Gautier, Paul. *Madame de Staël et Napoleon*. Paris: Plon, 1933.

Gay, Sophie. *Salons célèbres*. Brussels and Leipzig: C. Hochausen, 1837.

Genlis, Stephanie Félicité Ducrest, Mme. de. *De L'Influence des femmes sur la littérature française*. Paris: Mardan, 1811.

Gennari, Geneviève. *Le Premier Voyage de Madame de Staël en Italie et la genèse de Corinne*. Paris: Boivin, 1947.

Girard, E., and Roux, P. "Sainte-Beuve et H. de Latouche ou les souffrances de l'homme de lettres." *Revue d'Histoire littéraire de la France* (July–September 1934), pp. 424–40.

Girard, Henri. *Un Bourgeois diléttante à l'Époque romantique, Émile Deschamps 1791–1871*. Paris: Champion, 1921.

Girodet-Trioson, Anne-Louis. *Oeuvres posthumes*. Edited by P. A. Coupin. 2 vols. Paris: Jules Renouard, 1829.

Godenne, René. "Les Nouvelles de Mademoiselle de Scudéry." *Revue des Sciences Humaines* 37, no. 148 (October–December 1972): 503–14.

———. *Les Romans de Mademoiselle de Scudéry*. Geneva: Droz, 1983.

Goncourt, Edmond and Jules de. *L'Art du XVIII siècle*. 2 vols. Paris: A. Quantin, 1880–82.

Graham, Victor E. *Bibliographie des études sur Marcel Proust et son oeuvre*. Geneva: Droz, 1976.

Grate, Pontus. *Deux critiques d'art de l'époque romantique: Gustave Planche et Théophile Thoré*. Stockholm: Almqvist and Wiksell, 1959.

Gutwirth, Madelyn. *Madame de Staël, Novelist: The Emergence of the Artist as Woman*. Urbana, Chicago, London: University of Illinois Press, 1978.

———. "Mme. de Staël, Rousseau, and the Woman Question." *PMLA* 86, no. 1 (January 1971): 100–109.

Haskell, Francis. *An Italian Patron of French Neoclassic Art*. Oxford: Clarendon Press, 1972.

Hatin, Eugène. *Histoire politique et littéraire de la presse en France*. Paris: Poulet-Malassis et de Broise, 1864.

Haussonville, Gabriel-Paul-Othenin de Cléon, Comte d'. *Madame de Staël et M. Necker d'après leur correspondance inédite*. Paris: Calmann-Lévy, 1925.

———. *The Salon of Madame Necker*. Translated by Henry M. Trollope. 2 vols. London: Chapman and Hall, 1882.

Hautecoeur, Louis. *Littérature et peinture en France du XVII au XX siècle*. Paris: Armand Colin, 1942.

———. *Louis David*. Paris: La Table Ronde, 1954.

Hawley, Henry. "Antonio Canova, Terpsichore." Cleveland Museum of Art *Bulletin* 56 (October 1969): 287–305.

———. "Additions and Corrections, Canova's Terpsichore." Cleveland Museum of Art *Bulletin* 57 (March 1970): 103.

Hemmings, F. W. J. *Culture and Society in France 1848–1898.* New York: Charles Scribner's, 1971.

Herold, Christopher J. *Mistress to an Age: A Life of Mme. de Staël.* Indianapolis and New York: Bobbs-Merrill, 1958.

Honour, Hugh. "Canova and David." *Apollo* 96 (October 1972): 312–17.

———. *Neo-classicism.* London: Penguin, 1968.

———. *Romanticism.* New York: Harper, 1979.

Howard-Johnston, Paulette. "Bonjour M. Elstir." *Gazette des Beaux-Arts* 69 (April 1967): 247–50.

Huber, Catherine Rilliet. "Notes sur l'enfance de Mme. de Staël." *Occident et cahiers staëliens* 2, no. 2 (1932): 41–47.

Hubert, Gérard. *Les Sculpteurs Italiens en France sous la Revolution, l'Empire et la Restauration, 1790–1830.* Paris: de Boccard, 1964.

Huysmans, J[oris]-K[arl]. *Against Nature (A rebours).* Translated by Robert Baldick. Baltimore: Penguin, 1966.

Images of Romanticism. Verbal and Visual Affinities. Edited by Karl Kroeber and William Walling. New Haven and London: Yale University Press, 1978.

Iung, Th. *Lucien Bonaparte et ses Mémoires 1775–1840.* 3 vols. Paris: G. Charpentier, 1882.

Jal, Auguste. *Souvenirs d'un homme de lettres.* Paris: Techener, 1877.

James, A. R. W. "La 'Fraternité des Arts' et La Revue 'L'Artiste.'" *Gazette des Beaux-Arts* 65 (March 1965): 169–80.

Jasenas, Eliane. *Marceline Desbordes-Valmore devant la critique.* Geneva: Droz, 1962.

Johnson, J. Theodore, Jr. "From Artistic Celibacy to Artistic Contemplation." *Yale French Studies* 34 (1965): 81–89.

———. "Marcel Proust et Gustave Moreau." Société des Amis de Marcel Proust et des Amis de Combray *Bulletin* 28 (1978): 614–39.

———. "The Painter and His Art in the Works of Marcel Proust." Ph.D. diss., University of Wisconsin, 1964.

———. "Proust's Early *Portraits de peintres.*" *Comparative Literature Studies* 4, no. 4 (1967): 397–408.

Johnson, Lee McKay. *The Metaphor of Painting: Essays on Baudelaire, Ruskin, Proust, and Pater.* Ann Arbor: UMI Research Press, 1980.

Jullian, Philippe. *Dreamers of Decadence.* Translated by Robert Baldick. New York: Praeger, 1971.

———. *Prince of Aesthetes: Count Robert de Montesquiou 1855–1921.*

Translated by John Haylock and Francis King. New York: Viking Press, 1965.

Kadi, Simone. *La Peinture chez Proust et Baudelaire.* Paris: la pensée universelle, 1973.

Keating, Rebecca Tingle. "The Literary Portraits in the Novels of Mlle. de Scudéry." Ph.D. diss., Yale University, 1970.

Kératry, A.-H., Comte de. *Annuaire de l'école française de peinture ou Lettres sur le Salon de 1819.* Paris: Maradan, 1820.

Kermode, Frank. *Shakespeare, Spenser, Donne.* London: Routledge & Kegan Paul, 1971.

Kopman, H. *Rencontres with the Inanimate in Proust's Recherche.* The Hague, Paris: Mouton, 1971.

Lanes, Jerrold. "Art Criticism and the Authorship of the *Chef-d'oeuvre inconnu:* A Preliminary Study." In *The Artist and the Writer in France: Essays in Honor of Jean Seznec,* edited by Francis Haskell, Anthony Levi, and Robert Shackleton, pp. 86–99. Oxford: Clarendon Press, 1974.

Langle, Fleuriot de. *Alexandrine Lucien-Bonaparte, Princesse de Canino (1778–1855).* Paris: Plon, 1939.

Laubriet, Pierre. "Balzac et la sculpture." *Gazette des Beaux-Arts* 57 (May–June 1961): 331–58.

———. *Un Catechisme esthétique: le Chef-d'oeuvre inconnu de Balzac.* Paris: Didier, 1961.

———. *L'Intelligence de l'art chez Balzac.* Paris: Didier, 1958.

Lathuillière, Roger. *La Préciosité, étude historique et linguistique.* Geneva: Droz, 1966.

Latouche, Henri de. "Des Artistes." *Mercure du XIX siècle* 10 (1825): 34–39.
———. "De la Camaraderie Littéraire." *Revue de Paris* (October 1829), pp. 102–10.

———. "Des Femmes et des Arts." *Revue de Paris* 18 (September 1830): 144–59.

[———]. *Clement XIV et Carlo Bertinazzi, correspondance inédite.* Paris: P. Mongie ainé, Baudouin, 1827.

[———]. *Dernières lettres de deux amans de Barcelone, publiées à Madrid par le Chevalier Henares Y de L., traduites de l'espagnol.* Paris: Ambroise Tardieu, 1821. Reprint edition: Latouche, H. de. and L'Héritier, L.-F. *Dernières lettres de deux amans de Barcelone.* Paris: Presses Universitaires de France, 1966.

[———]. *Fragoletta, Naples et Paris en 1799.* Paris: Levavasseur et Canel, 1829.

[———]. *Lettres à David sur le salon de 1819, par quelques élèves de son école.* Paris: Pillet, 1819.

———. *Oeuvre de Canova.* Paris: Audot, 1825.

[———]. "Salon de 1817." *Constitutionnel* (May 3, May 8, May 13, June 6, July 5, July 16, 1817). All articles signed "N."

Laubriet, Pierre. "Balzac et la sculpture." *Gazette des Beaux-Arts* 57 (May–June 1961): 331–58.

Lee, Rensselaer W. *Ut Pictura Poesis: The Humanistic Theory of Painting.* New York: W. W. Norton, 1967.

Lethève, Jacques. *Daily Life of French Artists in the Nineteenth Century.* Translated by Hilary E. Paddon. New York and Washington: Praeger, 1972.

Levin, Harry. *The Gates of Horn: A Study of Five French Realists.* New York: Oxford University Press, 1963.

Levitine, George. *Girodet-Trioson: An Iconographical Study.* New York: Garland, 1978.

———. "The Influence of Lavater and Girodet's *Expression des Sentiments de l'Ame.*" Art Bulletin 36 (March 1954): 33–44.

———. "The *Primitifs* and Their Critics in the Year 1800." *Studies in Romanticism* 1, no. 4 (Summer 1962): 209–19.

MacLean, Ian. *Woman Triumphant: Feminism in French Literature 1610–1652.* Oxford: Clarendon Press, 1977.

Madame de Staël et l'Europe. Exhib. cat. Paris: Bibliothèque Nationale, 1966.

Magne, Émile. *Voiture et l'Hôtel de Rambouillet.* 2 vols. Paris: Émile-Paul, 1929–30.

Mallarmé, Stephane. *Mallarmé, Selected Prose, Poems, Essays and Letters.* Translated by Bradford Cook. Baltimore: Johns Hopkins University Press, 1956.

Malo, Henri. *Une Muse et sa mère, Delphine Gay de Girardin.* Paris: Émile-Paul, 1924.

Marcel Proust. Exhib. cat. Paris: Bibliothèque Nationale, 1965.

Marcel Proust en son temps. Exhib. cat. Paris: Musée Jacquemart-André, 1971.

March, Harold. *The Two Worlds of Marcel Proust.* Philadelphia: University of Pennsylvania Press, 1948.

Marrou, Henri-Irénée. *Mousikos aner: Études sur les scènes de la vie intellectuelle figurant sur les monuments funéraires Romains.* Grenoble: Didier and Richard, 1938.

Marrow, Deborah. *The Art Patronage of Maria de' Medici.* Ann Arbor: UMI Research Press, 1982.

Mathieu, Pierre-Louis. *Gustave Moreau.* Translated by James Emmons. Oxford: Phaidon-Oxford, 1977.

Martino, Pierre. *L'Époque romantique en France 1815–1830.* Paris: Boivin, 1944.

Maurois, André. "Proust et Ruskin." *Essays and Studies by Members of the English Association.* Pp. 25–32. Oxford: Clarendon Press, 1932.

McDougall, Dorothy. *Madeleine de Scudéry, Her Romantic Life and Death.* London: Methuen, 1938.

McMahon, Joseph H. "From Things to Themes." *Yale French Studies* 34 (Summer 1965): 5–17.

Mein, Margaret. *A Foretaste of Proust: A Study of Proust and His Precursors.* London: Saxon House, 1974.

Mellerio, André. *L'Oeuvre graphique complète d'Odilon Redon.* Paris: Secrétariat, 1913.

Ménard, Jean. "Mme. de Staël et la peinture." In *Colloque de Coppet: Mme. de Staël et l'Europe,* pp. 253–62. Paris: Klincksieck, 1970.

Meyers, Jeffrey. *Painting and the Novel.* Manchester: Manchester University Press, 1975.

Moers, Ellen. *Literary Women.* New York: Anchor Press, 1977.

Monglond, André. *Le Préromantisme française.* 2 vols. Grenoble: B. Arthaud, 1930.

Mongrédien, Georges. *Madeleine de Scudéry et son salon.* Paris: Tallendier, 1946.

Monnier, Henry. *Mémoires de Monsieur Joseph Prudhomme.* 2 vols. Paris: Librairie Nouvelle, 1857.

Monnin-Hornung, Juliette. *Proust et la peinture.* Geneva: Droz, 1951.

Necker, Suzanne Curchod de Nasse. *Nouveaux mélanges extraits des manuscrits de Mme. Necker.* 3 vols. Paris: Pougens, 1801.

Niderst, Alain. *Madeleine de Scudéry, Paul Pellison et leur monde.* Paris: Presses Universitaires de France, 1976.

Nower, Esther Ellie. "The Artist as Politician: The Relationship between the Art and the Politics of the French Romantic Literary and Artistic Figures." Ph.D. diss., University of California, Berkeley, 1975.

Odilon Redon, Gustave Moreau, Rodolphe Bresdin. Exhib. cat. New York: Museum of Modern Art, 1961.

Painter, George D. *Proust, the Early Years,* vol. 1; *Proust, the Later Years,* vol. 2. Boston: Little Brown, 1959–65.

Peyre, Henri. *What is Romanticism?* Translated by Roda Roberts. University of Alabama Press, 1977.

Picard, Roger. *Les Salons littéraires et la société française 1610–1789.* New York: Brentano's, 1943.

Piétri, Francois. *Lucien Bonaparte.* Paris: Plon, 1939.

Planche, Gustave. "Salon de 1831." In *Études sur l'école française (1831–1852).* 2 vols. 1:7–172. Paris: Michel Lévy, 1855.

Poulet, Georges. *Proustian Space.* Translated by Elliott Coleman. Baltimore and London: Johns Hopkins University Press, 1977.

Pouquet, Jeanne Maurice. *The Last Salon: Anatole France and His Muse.* Translated by Lewis Galantière. New York: Harcourt, Brace, 1927.

Praz, Mario. *On Neoclassicism.* Translated by Angus Davidson. Evanston: Northwestern University Press, 1969.

———. *The Romantic Agony.* London: Oxford University Press, 1933.

Proust, Marcel. *Contre Sainte-Beuve précédé de Pastiches et mélanges et suivi*

de Essais et articles. Edited by Pierre Clarac and Yves Sandre. Paris: Gallimard, Pléiade, 1971.

———. *Correspondence, I, 1880–1895.* Edited by Philip Kolb. Paris: Plon, 1970.

———. *Correspondance, II, 1896–1901.* Edited by Philip Kolb. Paris: Plon, 1976.

———. *L'Indifférent.* Paris: Gallimard, 1978.

———. *Jean Santeuil précédé de Les Plaisirs et les jours.* Edited by Pierre Clarac and Yves Sandre. Paris: Gallimard, Pléiade, 1971.

———. *Marcel Proust on Art and Literature.* Translated by Sylvia Townsend Warner. New York: Meridian Books, 1958; Delta paperback, 1964.

———. *Pleasures and Regrets.* Translated by Louise Varese. New York: Crown, 1948.

———. *A la recherche de temps perdu.* 3 vols. Paris: Gallimard, Pléiade, 1954.

———. *Remembrance of Things Past.* 2 vols. Translated by C. K. Scott Moncrieff and Frederick A. Blossom. New York: Random House, 1934.

Quatremère de Quincy, Antoine Chrysostome. *Canova et ses ouvrages.* Paris: Adrien Le Clere, 1834.

Rathery and Boutron. *Mademoiselle de Scudéry: sa vie et sa correspondance.* Paris: Techener, 1873.

Redon, Odilon. *A soi-même.* Paris: H. Floury, 1922.

Regard, Maurice. *L'Adversaire des romantiques, Gustave Planche 1808–1857.* 2 vols. Paris: Nouvelles Éditions Latines, 1955.

Renfrew, Esther, and Balayé, Simone. "Madame de Staël et la Sibylle du Dominiquin." *Cahiers staëliens* (January 1964): 34–36.

Rosenblum, Robert. "Painting During the Bourbon Restoration, 1814–1830." In *French Painting 1774–1830: The Age of Revolution,* pp. 231–44. Exhib. cat. Detroit: Wayne State University Press, 1975.

———. *Transformation in Late Eighteenth-Century Art.* Princeton: University Press, 1967.

Rosenthal, Léon. *Louis David.* Paris: Librairie de l'art ancien et moderne, n.d.

———. *Le Peinture romantique, essai sur l'evolution de la peinture française de 1815 à 1830.* Paris: Thorin, 1900.

Rubin, James H. "An Early Romantic Polemic: Girodet and Milton." *Art Quarterly* 35 (Autumn 1972): 210–38.

———. "Endymion's Dream as a Myth of Romantic Inspiration." *Art Quarterly* 1–2 (Spring 1978): 47–84.

Les Salons littéraires au XVII siècle. Exhib. cat. Paris: Bibliothèque Nationale, 1968.

Sainte-Beuve, Charles-Augustin. "M. de Latouche." In *Causeries du lundi.* 15 vols. Rev. ed. 3:474–502. Paris: Garnier, n.d.

———. "Madame de Staël." In *Critiques et portraits littéraires.* 3 vols. 3:247–367. Paris: Eugene Renduel, 1832.

———. "Mademoiselle de Scudéry." In *Causeries du lundi.* 15 vols. 3d ed. 4:121–43. Paris: Garnier, n.d.

Sand, George. *Autour de la table, Oeuvres complètes.* Paris: Calmann-Lévy, 1882.

———. *Histoire de ma vie.* Edited by Noelle Roubaud. Paris: Éditions Stock, 1949.

———. *Les Sept cordes de la lyre.* Paris: Flammarion, 1973.

Sandström, Sven. *Le Monde imaginaire d'Odilon Redon.* Lund: CWK Gleerup, New York: G. Wittenborn, 1955.

Scott, Mary Wingfield. *Art and Artists in Balzac's "Comédie Humaine."* Chicago: University of Chicago Libraries, 1937.

Scudéry, Georges de. *Le Cabinet de M. de Scudéry.* Paris: Courbé, 1646.

Scudéry, Madeleine de. *Artamène ou Le Grand Cyrus.* 10 vols. 1649–53. Reprint. Geneva: Slatkine Reprints, 1972.

———. *Clélie, Histoire romaine.* 10 vols. 1654–60. Reprint. Geneva: Slatkine Reprints, 1973.

———. *La Promenade de Versailles.* 1669. Reprint. Paris: Devambez, 1920.

Ségu, Frédéric. *Un Journaliste diléttante, H. de Latouche et son intervention dans les arts.* Paris: Société d'Édition "Les Belles Lettres," 1931.

———. *Un Maitre de Balzac méconnu, H. de Latouche.* Paris: Société d'Édition "Les Belles Lettres," 1928.

———. *Un Romantique républicain, H. de Latouche (1785–1851).* Paris: Société d'Édition "Les Belles Lettres," 1931.

Jean Seznec. *Essais sur Diderot et l'Antiquité.* Oxford: Clarendon Press, 1957.

———. *Literature and the Visual Arts in Nineteenth-Century France.* Hull, England: Hull University Press, 1963.

Seznec, Jean, and Adhémar, Jean. *Diderot Salons.* 4 vols. Oxford: Clarendon Press, 1957–67.

Shattuck, Roger. *Proust's Binoculars.* New York: Random House, 1963.

Shroder, Maurice Z. *Icarus: The Image of the Artist in French Romanticism.* Cambridge, Mass.: Harvard University Press, 1961.

Simches, Seymour O. *Le Romantisme et le gout esthétique du XVIII siècle.* Paris: Presses universitaires de France, 1964.

Simon, Jules. *Victor Cousin,* Great French Writer series. London: George Routledge and Sons, 1888.

Spenser, Michael Clifford. *The Art Criticism of Théophile Gautier.* Geneva: Droz, 1969.

Staël, Anne-Louise-Germaine Necker, Mme. de. *Les Carnets de voyage de Madame de Staël.* Edited by Simone Balayé. Geneva: Droz, 1971.

———. *Oeuvres complètes de Mme la baronne de Staël-Holstein.* 2 vols. Paris: Firmin Didot, 1838.

Steiner, Arpad. *"Les Idées esthétiques de Mlle de Scudéry."* *Romanic Review* 16 (1925): 174–84.

Strauss, Walter A. *Proust and Literature: The Novelist as Critic.* Cambridge, Mass.: Harvard University Press, 1957.

Sullerot, Eveyne. *Histoire de la presse feminine en France des origines à 1848.* Paris: Armand Colin, 1966.

Sypher, Wylie. *Rococo to Cubism.* New York: Vintage Books, 1960.

Taillasson, Jean-Joseph. *Observations sur quelques grands peintres.* Paris: Duminil-Lesueur, 1807.

Tieghem, Paul Van. *Le Mouvement romantique.* Paris: Librairie Vuibert, 1923.

Tourneux, Maurice. *Salons et expositions d'art à Paris (1801–1870) essai bibliographique.* Paris: Jean Schemit, 1919.

Ullmann, Stephen. *The Image in the Modern French Novel: Gide, Alain-Fournier, Proust, Camus.* New York: Barnes and Noble, 1963.

Verdi, Richard. "Poussin's Life in Nineteenth-Century Pictures." *Burlington Magazine* 111 (December 1969): 741–50.

Viatte, Auguste. *Les Sources occultes du romantisme.* 2 vols. Bibliothèque de la Revue de Littérature Comparée, pp. 46–47. Paris: Champion, 1928.

Vinge, Louise. *The Narcissus Theme in Western European Literature up to the Early 19th Century.* Lund: Gleerups, 1967.

Wakefield, David. *Stendhal and the Arts.* London: Phaidon Press, 1973.

Wegner, Max. *Die Musensarkophage.* Berlin: Gebr. Mann, 1966.

Weinberg, Bernard. *French Realism: The Critical Reaction, 1830–1870.* 1937. Reprint. New York: Modern Language Association of America, 1971.

Weisberg, Gabriel P., with Talbot, William S. *Chardin and the Still-Life Tradition in France.* Exhib. cat. Cleveland: Cleveland Museum of Art, 1979.

Whiteley, J. J. L. "Light and Shade in French Neo-Classicism." *Burlington Magazine* 117 (December 1975): 768–73.

Wildenstein, Georges. "Les Davidians à Paris sous la Restauration." *Gazette des Beaux-Arts* 53 (April 1959): 237–46.

Wilhelm, Jacques. *La Vie quotidienne au marais au XVII siècle.* Paris: Hachette, 1966.

Will, Frederic. *Flumen Historicum: Victor Cousin's Aesthetic and Its Sources.* Chapel Hill: University of North Carolina Press, 1965.

Wilson, Edmund. *Axel's Castle.* New York: Charles Scribner's, 1947.

Wilson, Lawrence A. "The *Cyrus* and the *Clélie* of Mademoiselle de Scudéry as Reflections of XVIII Century Life, Ideas and Manners." Ph.D. diss., University of Minnesota, 1941.

Winternitz, Emanuel. *Musical Instruments and Their Symbolism in Western Art.* New York: W. W. Norton, 1967.

Wright, Ralph. "A Sensitive Petronius." In *Marcel Proust: An English Tribute*, compiled by C. K. Scott Moncrieff, pp. 31–52. New York: Thomas Seltzer, 1923.

Zeldin, Theodore. *France: 1848–1945*. Vol. 1: *Ambition, Love and Politics*. Vol. 2: *Intellect, Taste and Anxiety*. Oxford, Clarendon Press, 1973, 1977.

Index

Page numbers in italics refer to illustrations.